DESTINATIONS
OF A
LIFETIME

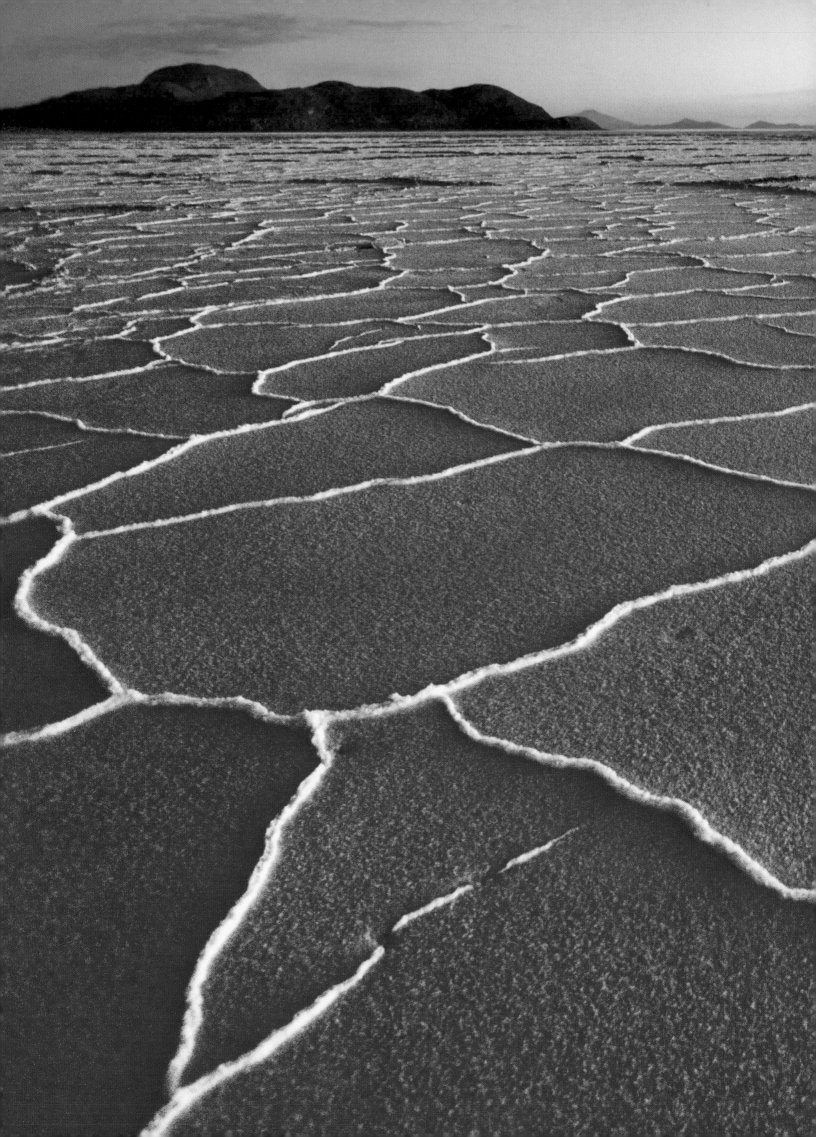

DESTINATIONS
OF A
LIFETIME

225 OF THE WORLD'S MOST AMAZING PLACES

Foreword by Dan Westergren, Director of Photography,
National Geographic Traveler magazine

NATIONAL GEOGRAPHIC

WASHINGTON, DC.

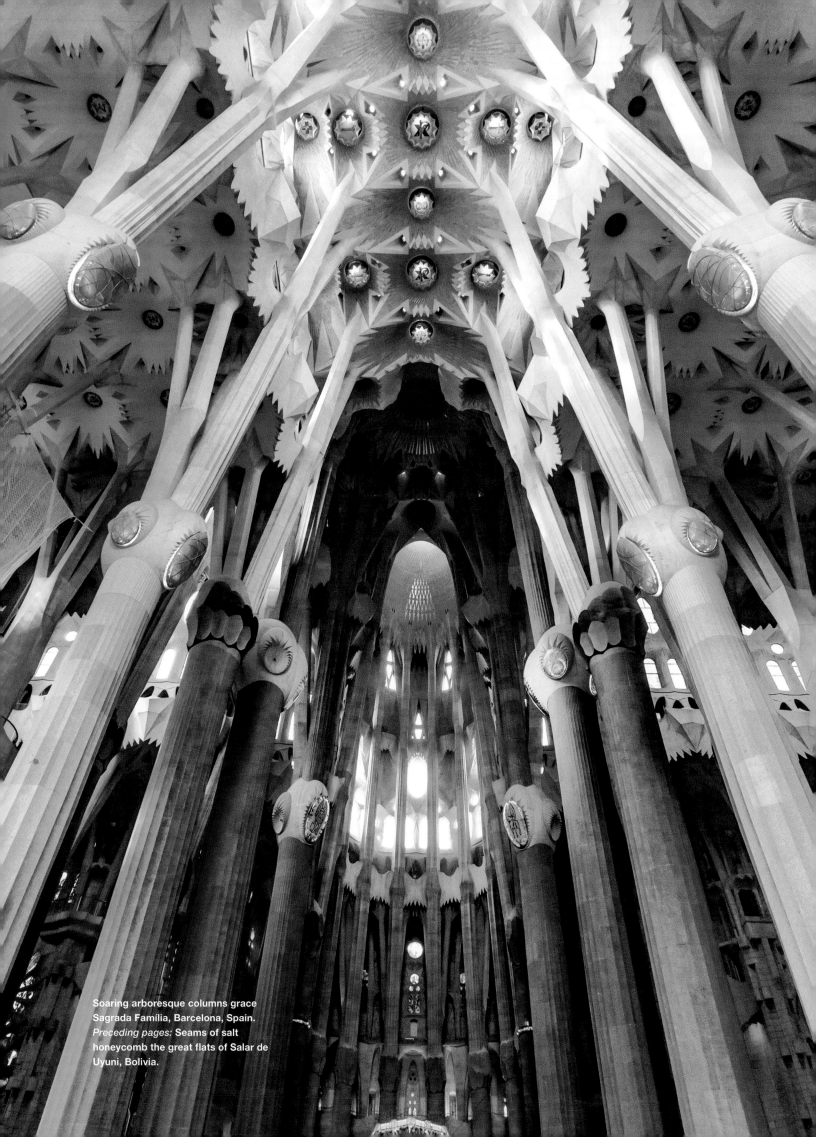

Soaring arboresque columns grace
Sagrada Família, Barcelona, Spain.
Preceding pages: Seams of salt
honeycomb the great flats of Salar de
Uyuni, Bolivia.

CONTENTS

FOREWORD

by Dan Westergren, Director of Photography, *National Geographic Traveler* magazine

A place so windy, they've had to chain the buildings down to the rocks. This was the reason I first visited New Hampshire's Mount Washington. I wanted to see buildings with leashes. And when would be the best time to visit the windiest place on the planet? In the middle of winter, of course, when the 80-mile-an-hour winds can—literally—blow you away. There was something about the raw extremes on what felt like the top of the world that jolted me to the core. I felt alive!

This book is full of such places of inspiration. You'll discover superlative iconic spots, places so amazing that all you can do is stand there in openmouthed wonder at the sheer beauty of it all. Take, for example, the plunging cascade of Earth's highest waterfall at Venezuela's Angel Falls; the swirling, multihued rock faces at Arizona's Antelope Canyon; and Namibia's Sossusvlei sand dunes, with giant sand hills as tall as 100-story skyscrapers.

Other destinations are participatory, enticing you to explore. You need to climb the step pyramids poking above the tree lines in the ancient Maya city of Cobá; paddle the interlocking lakes, canals, and quiet rivers of Kerala, India; or taste the just-caught lobster at a Prince Edward Island community supper in the Canadian Maritimes to discover the soul of these amazing places and make yourself part of their ongoing story.

National Geographic photographers personally chose a selection of the destinations. These individuals are experience collectors. Their job is to dig beneath the iconic and find the true essence of a place. Then, if they're lucky, they'll be able to bring back a photograph and an experience at the same time. In this collection, you'll see these images and hear how they made these favorite destinations their own.

I have been back to Mount Washington. This time, on one of the most beautiful summer days imaginable. I was glad to be there—the views stretched for miles, and a cool breeze tempered the midday sun. But I kept thinking about what it was like the last time I had visited. On one of the most miserable days of my life, when I was cold, wet, and tired. When I was thinking that maybe I needed to be chained to the rocks. But it was a REAL day. A day of trying to weave my life into the fabric of the world.

Here are 225 incredible places across the globe for you to seek out, explore, and make your own.

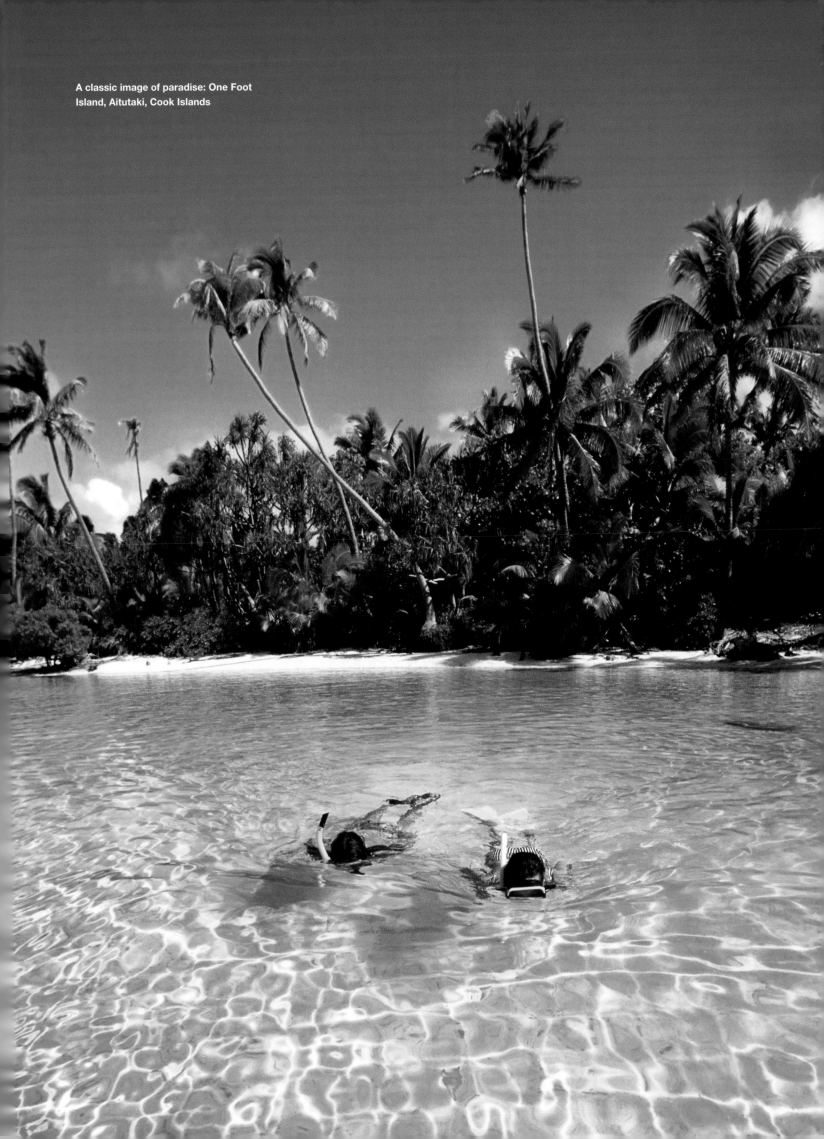

A classic image of paradise: One Foot
Island, Aitutaki, Cook Islands

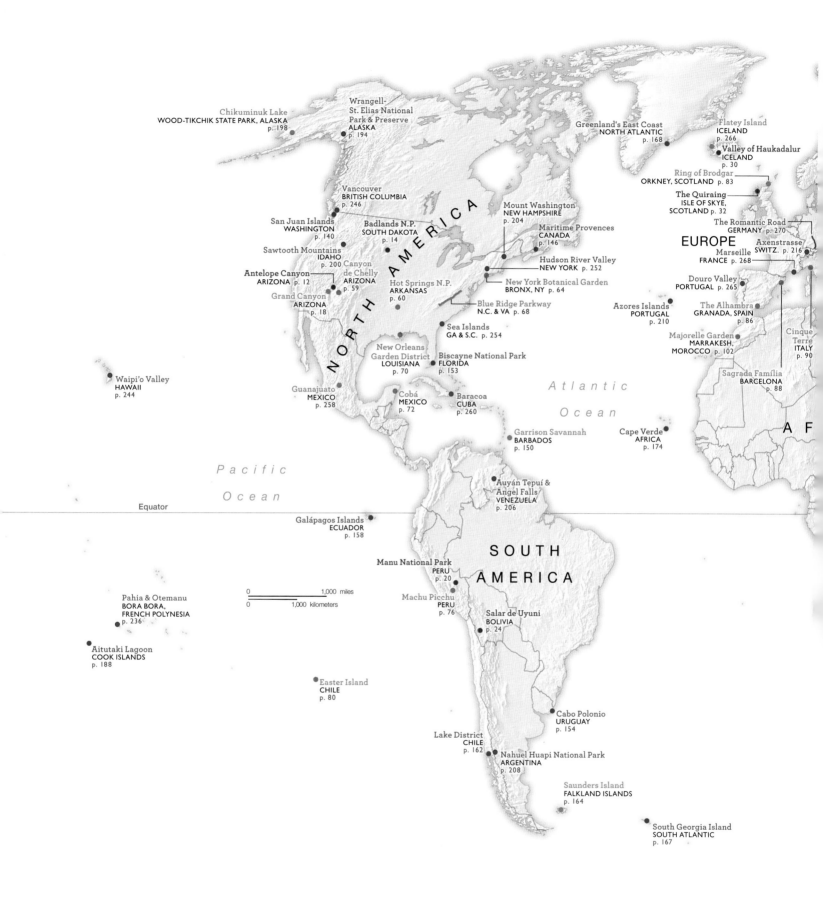

Chikuminuk Lake
WOOD-TIKCHIK STATE PARK, ALASKA
p. 198

Wrangell-
St. Elias National
Park & Preserve
ALASKA
p. 194

Greenland's East Coast
NORTH ATLANTIC
p. 168

Flatey Island
ICELAND
p. 266

Valley of Haukadalur
ICELAND
p. 30

Ring of Brodgar
ORKNEY, SCOTLAND p. 83

The Quiraing
ISLE OF SKYE,
SCOTLAND p. 32

Vancouver
BRITISH COLUMBIA
p. 246

Mount Washington
NEW HAMPSHIRE
p. 204

The Romantic Road
GERMANY p. 270

San Juan Islands
WASHINGTON
p. 140

Badlands N.P.
SOUTH DAKOTA
p. 14

Maritime Provences
CANADA
p. 146

EUROPE

Axenstrasse
SWITZ. p. 216

Sawtooth Mountains
IDAHO
p. 200

Canyon
de Chelly
ARIZONA
p. 59

Hudson River Valley
NEW YORK p. 252

Marseille
FRANCE p. 268

Antelope Canyon
ARIZONA p. 12

Hot Springs N.P.
ARKANSAS
p. 60

New York Botanical Garden
BRONX, NY p. 64

Douro Valley
PORTUGAL p. 265

Grand Canyon
ARIZONA
p. 18

Blue Ridge Parkway
N.C. & VA p. 68

The Alhambra
GRANADA, SPAIN
p. 86

Azores Islands
PORTUGAL
p. 210

Sea Islands
GA & S.C. p. 254

Atlantic

Cinque
Terre
ITALY
p. 90

Waipi'o Valley
HAWAII
p. 244

New Orleans
Garden District
LOUISIANA
p. 70

Biscayne National Park
FLORIDA
p. 153

Majorelle Garden
MARRAKESH,
MOROCCO p. 102

Ocean

Sagrada Família
BARCELONA
p. 88

Guanajuato
MEXICO
p. 258

Cobá
MEXICO
p. 72

Baracoa
CUBA
p. 260

A F

Garrison Savannah
BARBADOS
p. 150

Cape Verde
AFRICA
p. 174

Pacific

Ocean

Equator

Galápagos Islands
ECUADOR
p. 158

Auyán Tepuí &
Angel Falls
VENEZUELA
p. 206

SOUTH

AMERICA

Manu National Park
PERU
p. 20

Pahia & Otemanu
BORA BORA,
FRENCH POLYNESIA
p. 236

0 1,000 miles
0 1,000 kilometers

Machu Picchu
PERU
p. 76

Salar de Uyuni
BOLIVIA
p. 24

Aitutaki Lagoon
COOK ISLANDS
p. 188

Easter Island
CHILE
p. 80

Cabo Polonio
URUGUAY
p. 154

Lake District
CHILE
p. 162

Nahuel Huapi National Park
ARGENTINA
p. 208

Saunders Island
FALKLAND ISLANDS
p. 164

South Georgia Island
SOUTH ATLANTIC
p. 167

Arctic Ocean

Spitsbergen
NORWAY
p. 34

Museum Island
ERLIN, GERMANY
85

Olomouc
MORAVIA, CZECH REPUBLIC
p. 274

Curonian Spit
LITHUANIA
p. 170

Lake Hallstattersee
AUSTRIA p. 172

Painted Monasteries
of Bucovina
ROMANIA p. 100

Albania
EUROPE
p. 284

Hagia Sophia
ISTANBUL, TURKEY
p. 108

Mardin
TURKEY p. 292

Sochi
RUSSIA p. 220

Ushguli
CAUCASUS MOUNTAINS
GEORGIA
p. 226

South Gobi Desert
MONGOLIA
p. 297

Pribilof Islands
ALASKA
p. 138

Kanazawa
JAPAN
p. 300

Jigokudani Monkey Park
JAPAN
p. 233

Terra-Cotta
Warriors
XI'AN, CHINA
p. 128

Rovinj
CROATIA
p. 280

Sarajevo
BOSN. &
HERZG.
p. 288

Baalbek
LEBANON p. 116

Western Wall
JERUSALEM,
ISRAEL p. 121

Petra
JORDAN
p. 114

Sistine Chapel
VATICAN CITY
p. 96

Doha
QATAR
p. 124

Majlis al Jinn
OMAN
p. 41

Jaipur
INDIA
p. 131

Lijiang
CHINA
p. 234

Hangzhou
CHINA
p. 306

Pacific

Ocean

Abu Simbel
EGYPT
p. 110

Bagan
MYANMAR (BURMA)
p. 134

Old Goa
INDIA
p. 298

Tonle Sap
CAMBODIA
p. 184

RICA

Lalibela
ETHIOPIA
p. 107

Kerala
INDIA
p. 178

Golden Temple of Dambulla
SRI LANKA
p. 132

Yap Island
MICRONESIA
p. 310

Nyungwe Forest
National Park
RWANDA
p. 228

Serengeti N.P.
TANZANIA
p. 49

Ngorongoro Crater
TANZANIA
p. 230

Indian

Ocean

Equator

Komodo National Park
INDONESIA
p. 50

Kimbe
NEW BRITAIN ISLAND,
PAPUA NEW GUINEA
p. 52

Lower Zambezi N.P.
ZAMBIA
p. 42

Uluru-Kata Tjuta
National Park
AUSTRALIA
p. 238

Sossusvlei Dunes
NAMIBIA
p. 47

- Nature Unbound
- Hand of Man
- Sea & Shore
- Mountain Majesty
- Town & Country
- My Shot

AUSTRALIA

Ulva Island
NEW ZEALAND
p. 54

DESTINATIONS
OF A
LIFETIME

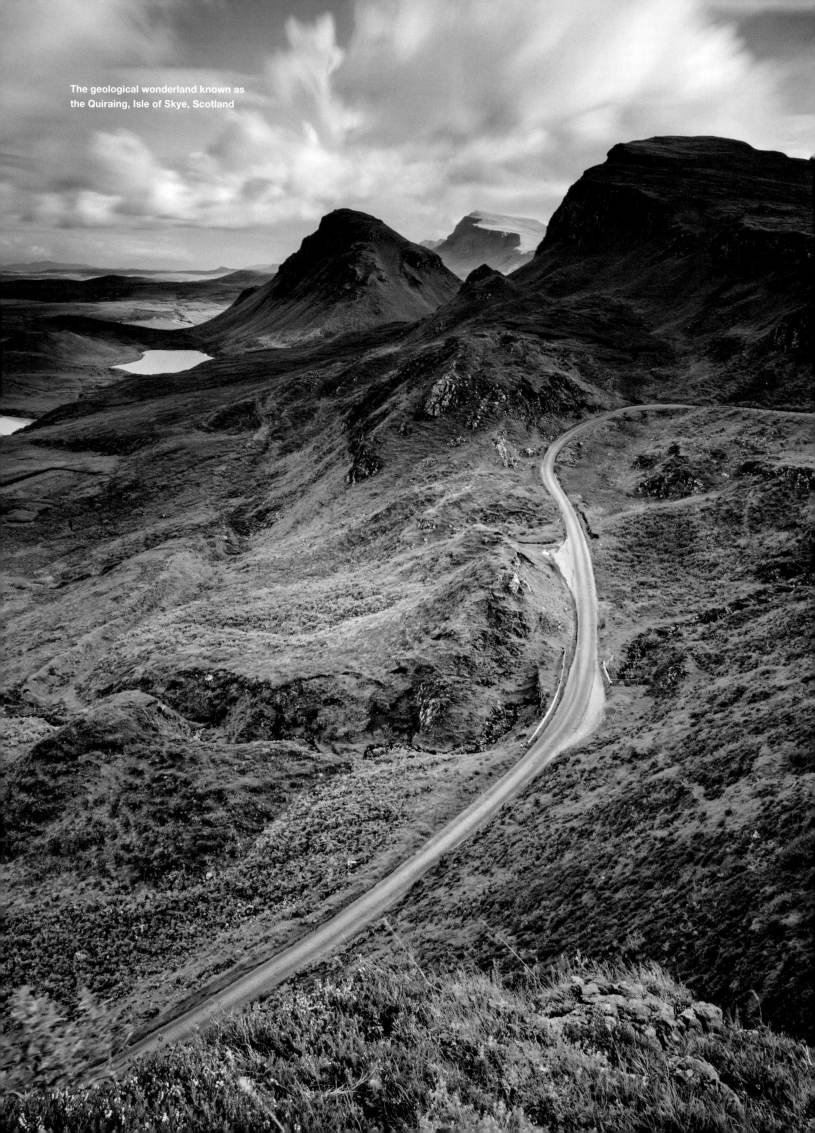

The geological wonderland known as
the Quiraing, Isle of Skye, Scotland

NATURE UNBOUND

Feel the primeval siren call back to the basic beauty of the land around us. From South Dakota's multihued Badlands to the bright white vistas of Bolivia's salt flats, step into some of the most beautiful spots on Earth.

ANTELOPE CANYON
A sinuous canyon cathedral

Carved into the reds and golds of northern Arizona, Antelope Canyon is among the world's most photogenic natural landscapes. Formed by water rushing through rock, it's a slot canyon—a narrow gash in the earth—its swirling ridged rock walls a canvas of extraordinary colors in subtle grades from muted purple to bright orange. When the sun is at its highest point, beams of light shoot down from above so brightly and powerfully that they look tangible.

The canyon has two parts, both located on the Navajo Indian Reservation and both reachable only by guided tour. Upper Antelope Canyon—called Tse' bighanilini, or "the place where water runs through rocks," in Navajo—is the more accessible of the two, with an entrance at ground level (Lower Antelope requires descending stairs), and it's more prone to those magnificent beams of sunlight. The twirling walls of Lower Antelope Canyon, known as Hasdestwazi ("spiral rock arches"), glow in waves of light and shadow. At the bottom, the width varies from a hallway to a space just wide enough for one person to walk through; at points, all that's visible above is a thin sliver of sky. The sensuously curving, corrugated walls give a sense of movement, with color and air now rushing through where water once flowed.

▶ UNFORGETTABLE EXPERIENCES

Not far from Antelope Canyon, on the other side of the town of Page, is Horseshoe Bend, a dramatic curve in the Colorado River. A 1.5-mile (2.4 km) hike along a well-traveled trail leads to a spectacular and unusual overlook. Down below, the river curves in what is close to a full circle around a high mass of land (in fact, it's 270 degrees). It's possible to step right up to the ledge and look down—or even to lie down on the ground for better photographic access.

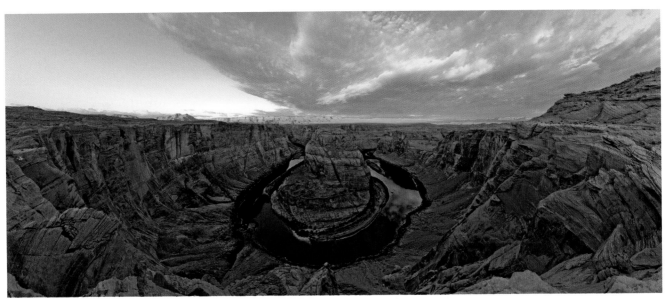

Millennia of slow wear by the mighty Colorado River have exposed Antelope Canyon's spectacular colors at Horseshoe Bend (above). Entering the canyon's walls (opposite) is akin to dropping into a giant's ear canal.

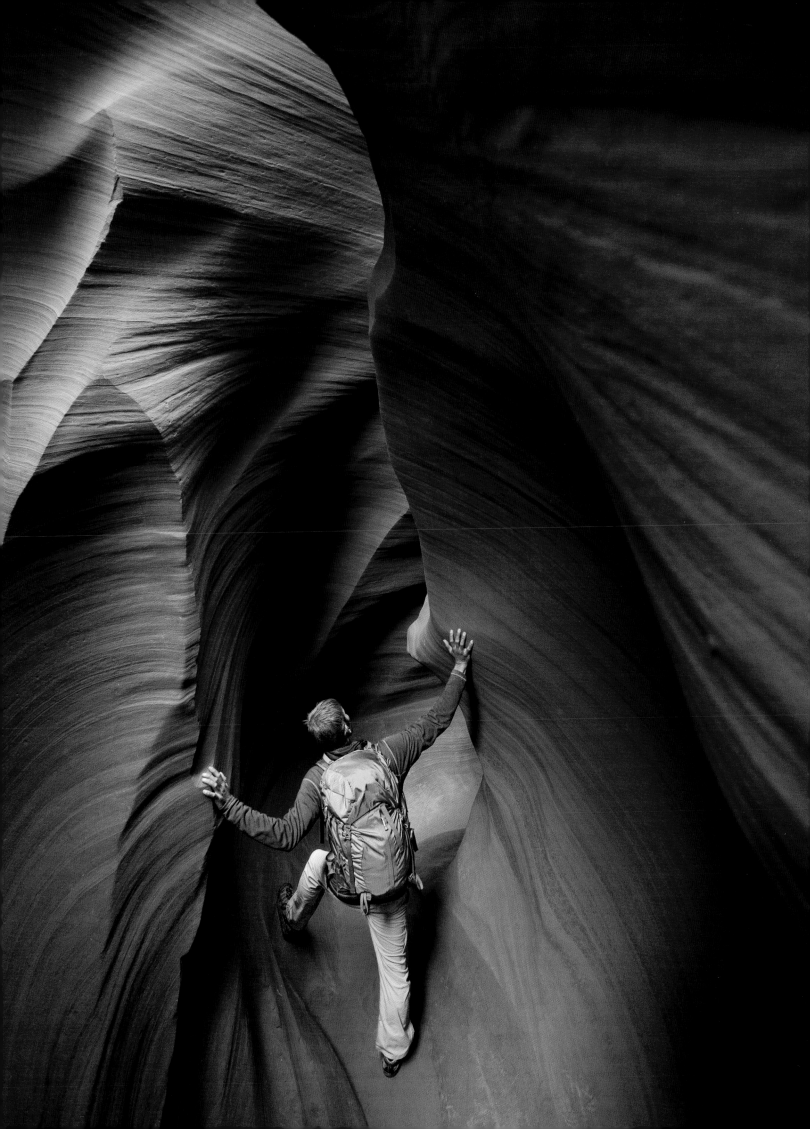

BADLANDS NATIONAL PARK
A tortured terrain on the edge of the Great Plains

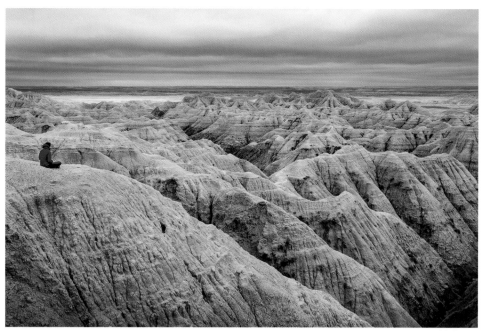

The Badlands' White River Valley Overlook rewards with a fantastical vista (above). The park is home to a growing number of American bison (opposite). At an estimated 80 million strong in 1800, the number of bison dropped to about 500 a century later owing to overhunting.

TRAVELER'S NOTEBOOK

✻WHEN TO GO
Visitation is highest during summer, but spring and fall travelers get the bonus of mild weather and lighter crowds. Winter weather varies but can bring punishing storms. The South Unit's White River Visitor Center is open in summer only; check with the Ben Reifel Visitor Center for specific times.

✻PLANNING
The park is located 6.8 miles (11 km) south of Interstate 90, 75 miles (120 km) east of Rapid City, South Dakota. A 40-mile (64 km) loop drive on State Route 240 can take most of a day, with stops for hikes and overlooks.

✻WEBSITES
nps.gov/badl

With soaring pinnacles, twisted valleys, and towering buttes, it's easy to understand how the Badlands got its name. French fur traders, who encountered this landscape on the edge of the Great Plains, indeed found it "bad land" to cross. Now it's a geologic theme park of sorts, where erosion reveals a beauty in the passage of time.

Perhaps it's no surprise that such an otherworldly setting once held an ancient sea and was later home to prehistoric animals like alligators and three-toed horses, whose remains turn up regularly. In 2010, seven-year-old park visitor Kylie Ferguson found a saber-toothed cat skull in what has since become a rich fossil quarry.

Today travelers often encounter startlingly large bison, which can weigh 2,000 pounds (907 kg), grazing by the road. This part of South Dakota is also home to eagles, rattlesnakes, and bighorn sheep. You might want to use your GPS to locate another wildlife highlight, Roberts Prairie Dog Town, off unpaved Sage Creek Rim Road. Everywhere the landscape amazes, with fantastical shapes and colors ranging from yellow-and-gray mounds to red rocks and black shale.

▶ UNFORGETTABLE EXPERIENCES

The scenery is certainly spectacular viewed from a car, but a hike is really the only way to experience the Badlands. Adventurers on the 1.5-mile (2.4 km) Notch Trail snake their way through a canyon and then face the intimidating prospect of scaling a log ladder up a cliff. *Caution:* The trail is slippery after rain and has sheer drops. But once atop the butte, the path leads to a notch in the canyon wall, framing a panoramic view of the White River Valley.

Indeed, this is easily accessible wilderness. A 40-mile (64 km) loop, connecting at both ends to Interstate 90, takes you through the heart of this once impassable outback. The sights come quickly when starting from the east, beginning with the Badlands Wall, an eroding cliff stretching out over 100 miles (161 km), mostly within the park. The formation marks a break in the prairie, pulling back the ground cover to reveal the stark beauty of a half million years of erosion—a process that is continuing even now, with some areas losing up to one inch (2.5 cm) every year. In another half million years, the Badlands will be gone.

Learn much more at the park's Ben Reifel Visitor Center, which (along with welcome water and air-conditioning) features great exhibits outlining the relentless natural forces responsible for the strange scenery. If you come during the summer, you may see paleontologists carefully working with artifacts, eager to share their discoveries with the public.

Although remote, the park can be busy during summer days. Savvy visitors know to camp out or at least arrange to be on-site at dusk: There's an undeniable beauty here toward sunset, when the harsh light of midday yields to a more forgiving view and long shadows soften the landscape. It still feels like another planet, but it's a welcoming one.

> *"My favorite thing is doing the park loop on my motorcycle. It's just different all the time."*
>
> – Rick Hustead,
> *third-generation owner of Wall Drug Store*

▶ VISIT LIKE A LOCAL

Few travelers make it to the park's remote Stronghold District, located on the Oglala Sioux's Pine Ridge Indian Reservation. But if you have a 4x4 vehicle and the nerve to drive dirt tracks across a former military bombing range, you'll find the region's most spectacular scenery at Sheep Mountain Table. Nearby, it's history that stirs the soul at Stronghold Table, which preserves the site of one of the last known Ghost Dances of the 19th century, a mystical Native American ceremony outlawed by the U.S. government.

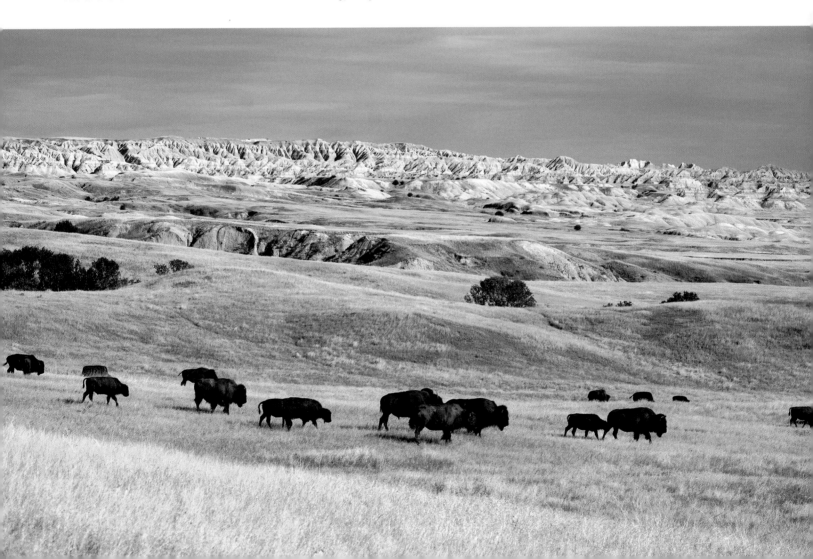

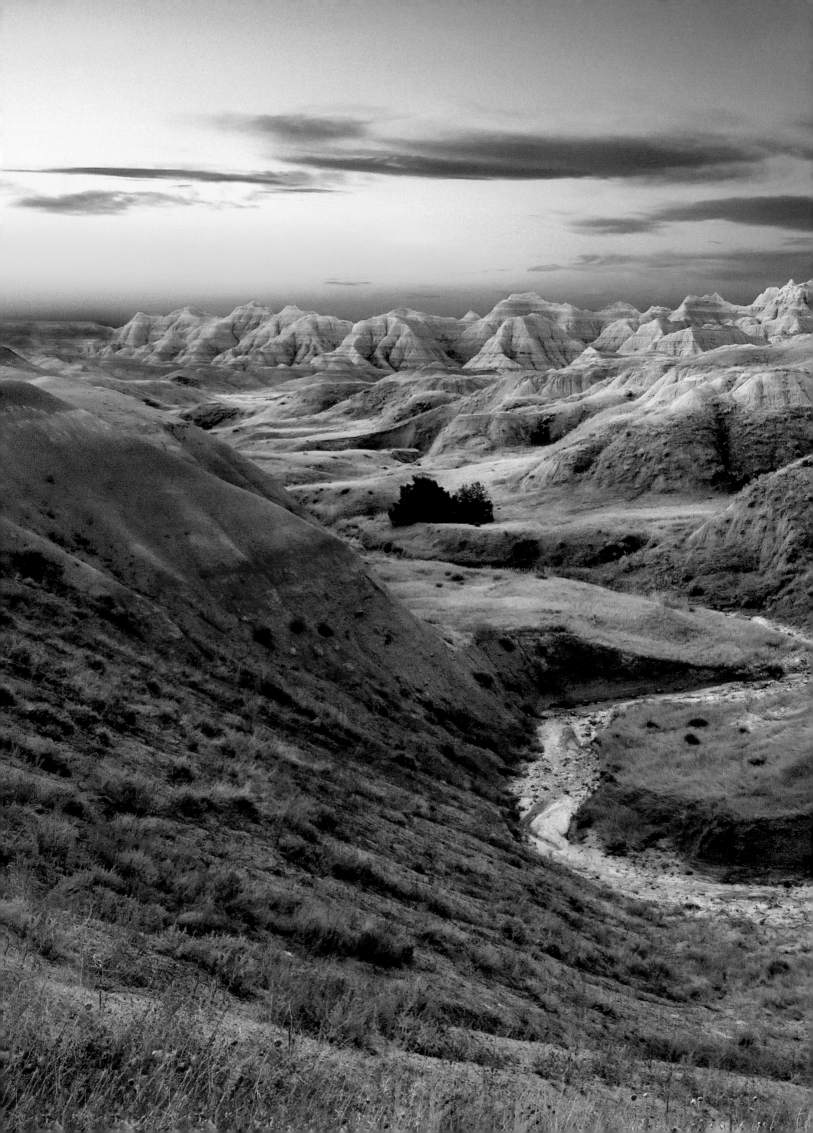

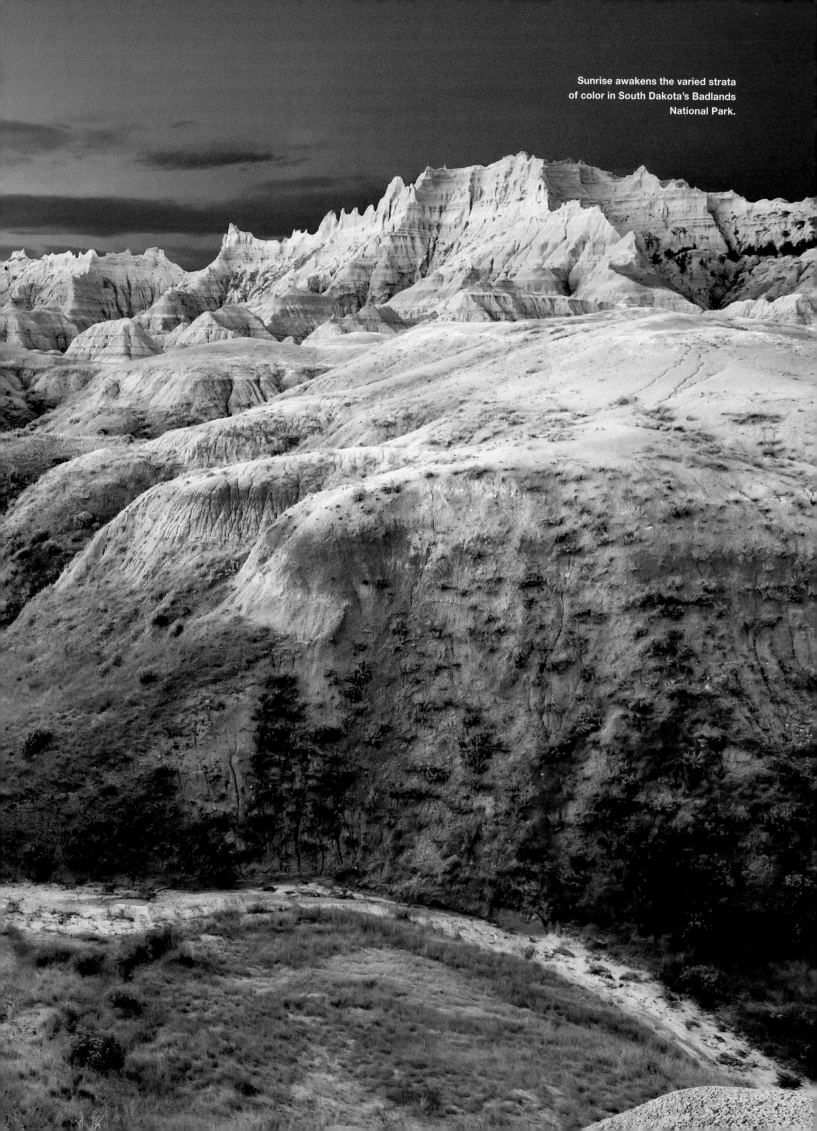

Sunrise awakens the varied strata of color in South Dakota's Badlands National Park.

MY SHOT

Grand Canyon, Arizona

The 900-year-old cliffside granaries at Nankoweap are quiet reminders that the Grand Canyon has been inhabited and viewed as a sacred place by Native Americans for centuries. I dreamed up this image years earlier when I first visited this site. It took half a decade to get the boating and campsite permits and the moon to align. Since you can't touch the granaries, I used small lasers to light the windows and, with the help of a full moon and a long exposure (almost a minute), got the shot.

— Pete McBride, *National Geographic* photographer

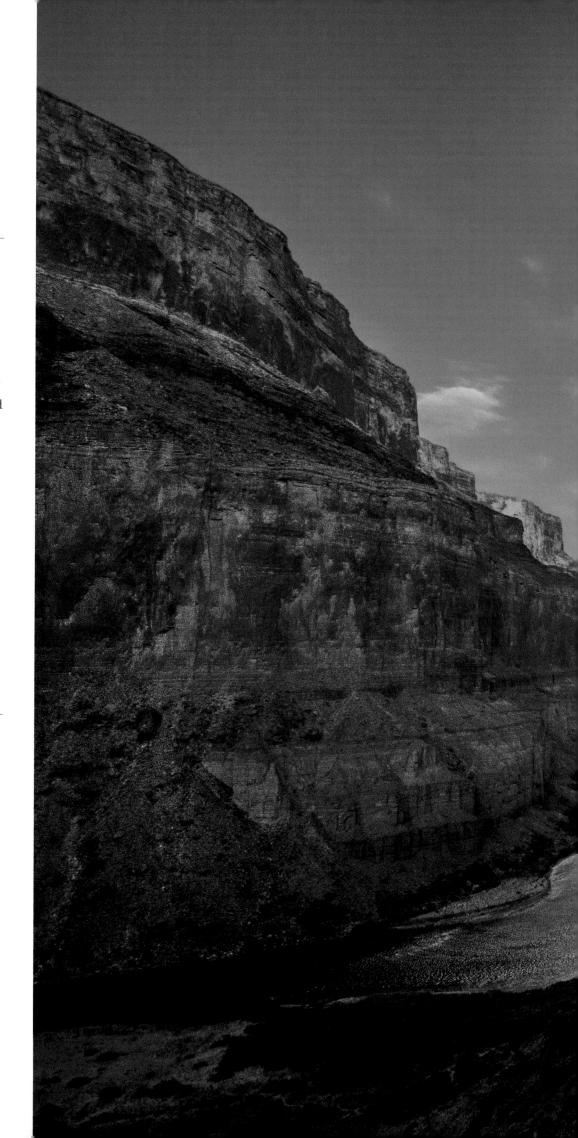

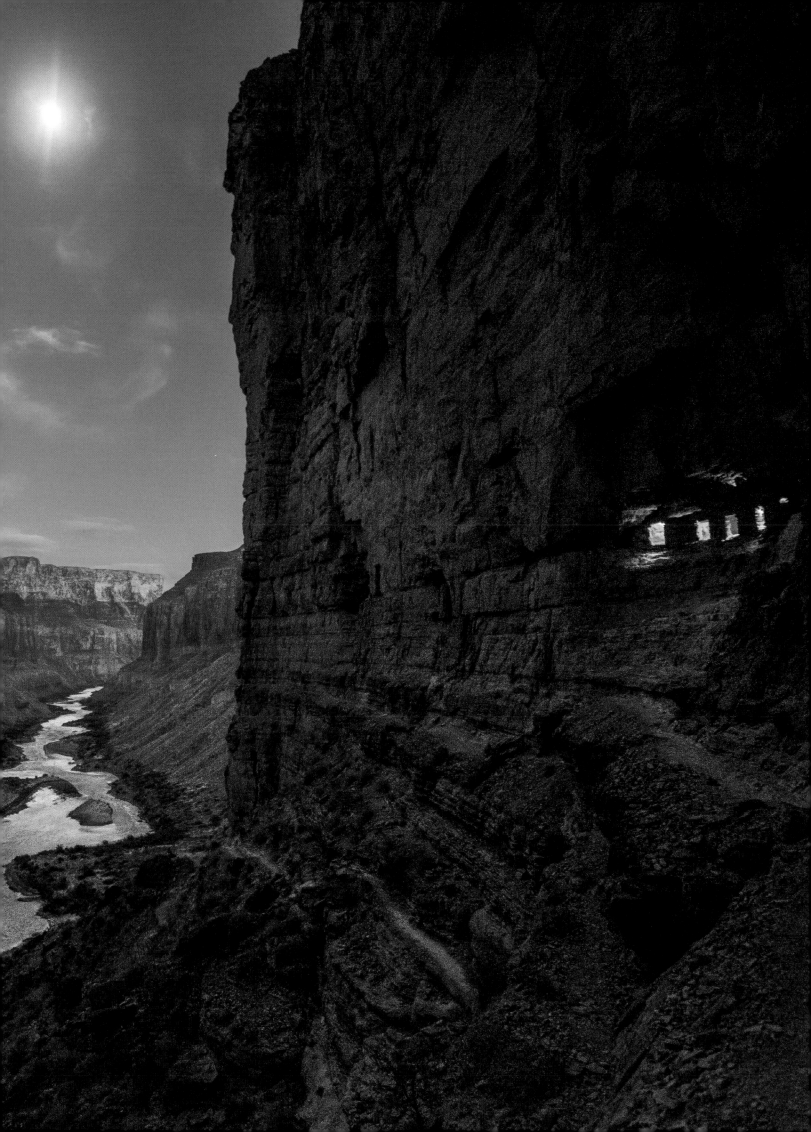

MANU NATIONAL PARK
From Andes to Amazon in the imperiled Peruvian wilderness

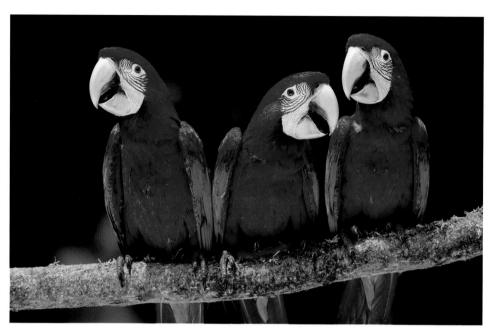

Bird-watchers flock to view red-and-green macaw juveniles (above) along with the some 1,000 other bird species thriving in the diverse ecosystems of Manu National Park (opposite).

Perhaps nowhere on the planet displays a better definition of the term "biodiversity" in action than Manu National Park in southeastern Peru. Sweeping from the chilly Andes down to the sweltering Amazon lowlands, the park crams an incredible array of flora and fauna into an area smaller than the state of New Jersey. Located just over the crest of the Andes from Cusco, Manu was declared a UNESCO Biosphere Reserve in 1977 and a World Heritage site a decade later.

The natural variety is astounding, almost too great to comprehend. About a thousand bird species have been counted at Manu—greater than found in all of the United States. *Biota Neotropica* announced that Manu is also the king of herpetological biodiversity—155 amphibian species and 132 varieties of reptiles like snakes and lizards. Jaguars, giant otters, and spectacled bears count among the 200-plus species of mammal inhabiting the park. As many as 250 tree species have been recorded in a single hectare (2.47 acres) of Manu's rain forest, with up to 40 ant species recorded in a single tree.

Park ecosystems are also diverse. At the upper extreme is a windswept tundra, called puna, that tops out at Tres Cruces, an 11,800-foot (3,600 m) peak where the Inca once admired the winter and summer solstice. Below that lies the constantly drenched cloud forest, which itself

TRAVELER'S NOTEBOOK

***WHEN TO GO**
The dry season May–Sept. brings less rainfall and slightly cooler temperatures to the Peruvian Amazon and is also a time when it's easier to spot wildlife along the riverbanks.

***PLANNING**
The fastest and easiest way to reach Manu is a 45-minute flight from Cusco to Boca Manu's grassy airstrip, where water taxis are waiting to whisk visitors to riverside lodges. It's also possible to drive about six hours into the park's western sector via a twisting mountain road from Cusco to Manu on the upper reaches of the Río Madre de Dios.

***WEBSITES**
peru.travel

UNFORGETTABLE EXPERIENCES

The Río Madre de Dios is world renowned for *colpas*—exposed clay riverbanks—where parrots gather to feast on minerals needed in their daily diets in a shimmering gathering of neon-green, blue, and red. Macaws are the primary diners, but colpas also attract smaller parrots, toucans, and jacamars, as well as avian predators like vultures and eagles. From Blanquillo Colpa, about a 25-minute boat ride downstream from the park's Boca Manu gateway, floating hide platforms render a close-up look without disturbing the birds.

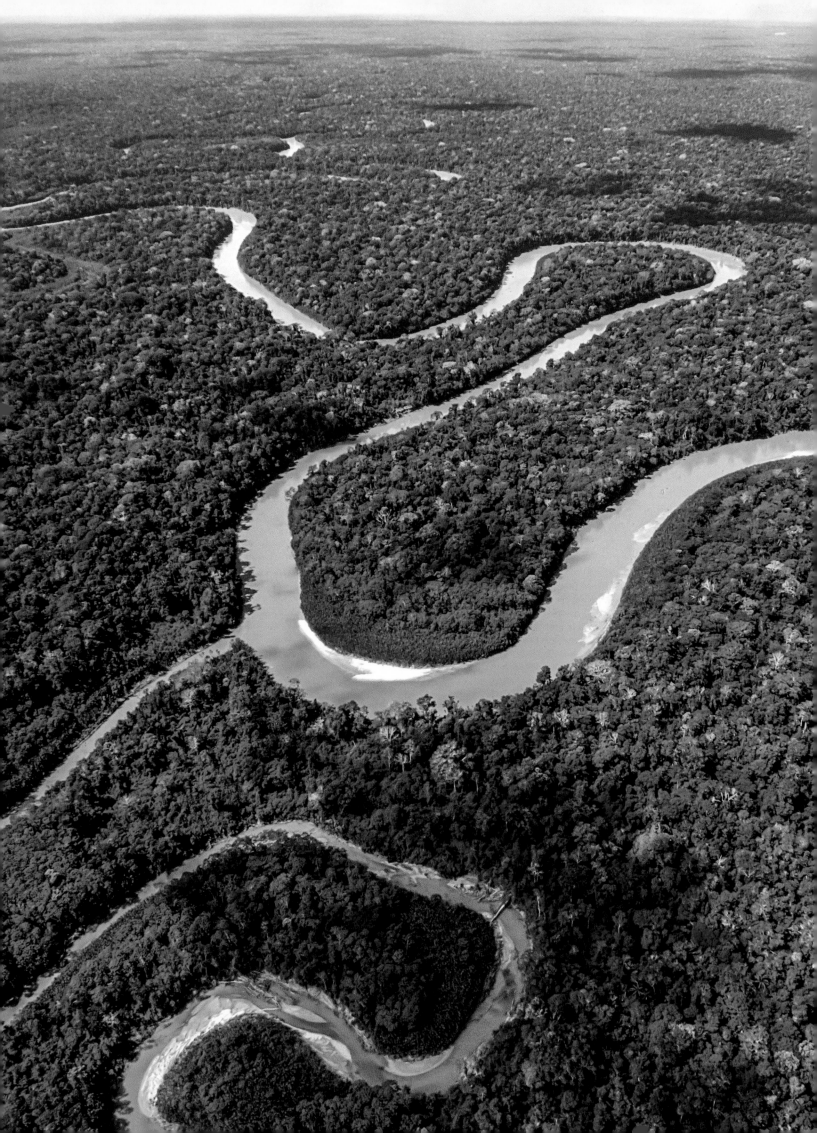

Río Madre de Dios (opposite) and Río Pinquen (above) snake through the lowland tropical rain forest of Peru's Manu National Park, home to several indigenous Amazonian groups and an astonishing diversity of plants and wildlife.

tumbles down into a rain forest spangled with wildlife-rich oxbow lakes and *colpas* (clay licks). The Río Manu meanders through the heart of the park, flowing into the much larger Río Madre de Dios, which eventually makes its way through Bolivia toward Brazil.

Rugged topography and extreme isolation helped preserve Manu far into the 20th century, mostly sparing it the deforestation and human colonization that have overtaken so much of South America's wilderness. That's not to say that humans haven't tried to conquer the region. Peruvian entrepreneur Carlos Fermín Fitzcarrald, for example, famously attempted to exploit the area's rubber resources in the 1890s (a spectacular failure portrayed in the Werner Herzog movie *Fitzcarraldo*). The latest threat to Manu is a decision by the Peruvian government to allow natural gas extraction in an adjacent reserve and the park's buffer zone, a move that could have a huge impact inside the park.

Several indigenous groups still live within the park and are allowed to fish, hunt, and gather for their own subsistence. A "reserved zone" near the confluence of the two rivers is where most of the tourist facilities are located. Everyone but scientists and indigenous residents is currently barred from a much larger and incredibly pristine—and wonderfully named—"intangible area" on the upper reaches of the Río Manu, which may save the abundant wildlife for generations to come.

> "We're discovering new species all the time. New kinds of frogs, orchids, butterflies, and mosquitoes—the variety of life here is truly astounding."
>
> – Daniel Blanco, *ornithologist*

▶ UNFORGETTABLE EXPERIENCES

While most visitors fly into Boca Manu and explore the national park on boating day trips, some undertake a private river expedition that includes skipper, cook, naturalist guide, and enough supplies for however long you wish to cruise. Expeditions embark from Atalaya village, at the end of the road over the Andes from Cusco, continue down the Río Madre de Dios, and then travel up the Río Manu into the heart of the park. InkaNatura and others organize full-scale river trips. *inkanatura.com/en*

BOLIVIA

SALAR DE UYUNI

A crisp white world, with more than a pinch of salt

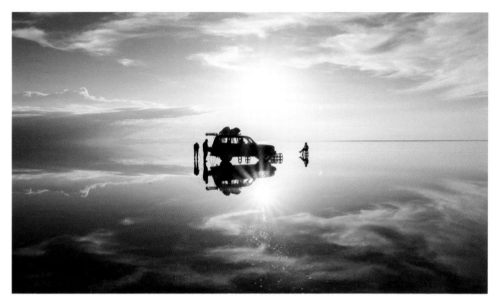

Some 25,000 tons (22,675 tonnes) of edible salt are extracted each year from surreal Salar de Uyuni (above and opposite), the largest salt flat in the world.

Vast, surreal, and whiter than freshly laundered sheets, Bolivia's Salar de Uyuni is a landscape so dazzlingly bright that sunglasses aren't a luxury—they're a vital piece of safety equipment. At 4,086 square miles (10,583 sq km) and with 11 billion tons (10 billion tonnes) of salt, the world's largest salt flats, in southwestern Bolivia, are rightly marked out as one of South America's natural wonders not to be missed. To explore here is to feel as if you've stepped into a toothpaste commercial or a dream, a brilliant white world that stretches to, and beyond, the horizon.

The massive *salar* (salt flats, or salt desert) formed from the remains of prehistoric (now evaporated) Lake Minchin—though local legend claims it's composed of the breast milk and tears of Tunupa, the mountain goddess, after she was betrayed by her husband. This area is rich with Andean cultures, including Quechua and Aymara, and the little islands across the salar contain shrines to Pachamama (Earth Mother) where locals leave gifts, including cigarettes and coca leaves.

Light fills the sky, bouncing off the salt lake's glistening surface. Time your visit right and a surface layer of rainwater, which evaporates again by the summer, means a perfectly reflective sheen that mirrors the sky. The cool high-altitude (11,985-foot/3,653 m) air of the Altiplano is as pure as the landscape. There's little vegetation, except the island's tall,

▶ UNFORGETTABLE EXPERIENCES

You could see the Salar de Uyuni from the confines of a 4x4, or you could experience it with the adrenaline rush and sense of freedom it deserves, riding a motorbike across what feels like the world's biggest ice rink (the surface looks like ice and snow, but it's solid and crunchy). Open up the throttle and soar across this beautiful landscape—on a motorcycle, you can go anywhere on the giant white plain, exploring far away from any other tourists or signs of civilization. *motorcycletoursbolivia.com*

slow-growing, thorny cacti, and not much wildlife, apart from stray vicuñas and llamas or the pink flamingoes feeding close to shore.

Salt is all around, though, from the stalls in "lakeside" villages selling salt trinkets and souvenirs right up to the local hotels crafted—in both bricks and furniture—from the abundant white stuff. Men with shovels dig piles of salt at the edge of the lake. Around 28,000 tons (25,400 tonnes) of salt are mined from the flats each year; up to 70 percent of the world's lithium reserves are found here, with China, Japan, and others lining up to help mine it (hopefully without destroying one of the world's most pristine and beautiful landscapes).

There are no roads across the salt, just faint tracks where vehicles have traveled. Outsiders would easily get lost; local drivers navigate using Tunupa volcano and other jagged distant peaks beyond the shoreline.

With no markers on the salt flats, the whiteness and light play tricks on the eyes; something far away can look close, and vice versa. Travelers can take playful advantage of this, with quirky photographs that toy with perspective, snapping their "tiny" friends tumbling out of Coke bottles or cradling them in the palm of their giant hands.

"Some of the better 4x4 tours cross the salt lake to the sacred volcano—there's also a cave close by containing the remains of mummies from the Chalpa tribe dating back 1,300 years, with the clothing, skin, and hair still in remarkably good condition."

– Robin Thomas, *motorcycle guide*

▶ **VISIT LIKE A LOCAL**

Standard 4x4 tours ship travelers across to Isla Incahuasi, which has a restaurant on it but can get quite crowded. Oddly, there's another island (there are dozens across Salar de Uyuni), Isla del Pescado (Fish Island), just a few minutes' drive from Incahuasi where far fewer tours go. Here it's likely you'll have the island to yourself. Climb the cliff tops for absolute silence and views over what feels like an Arctic wilderness, just with an added pinch or two of salt (an understatement) instead of ice and snow.

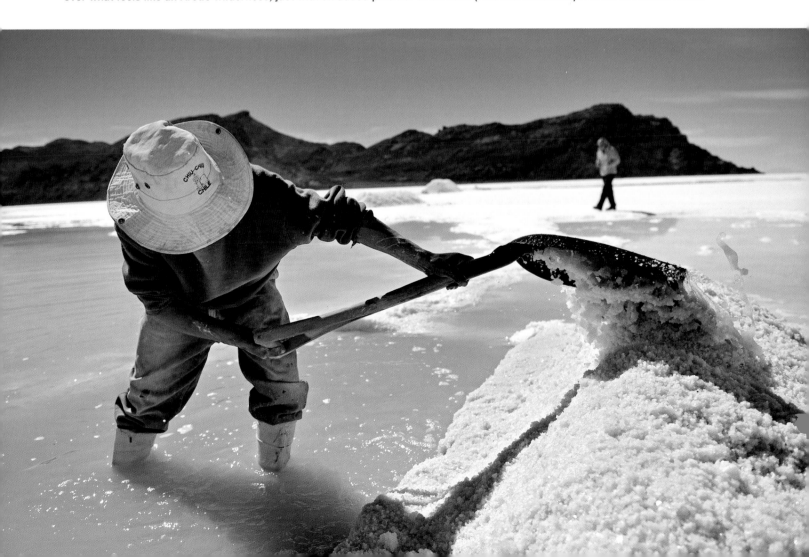

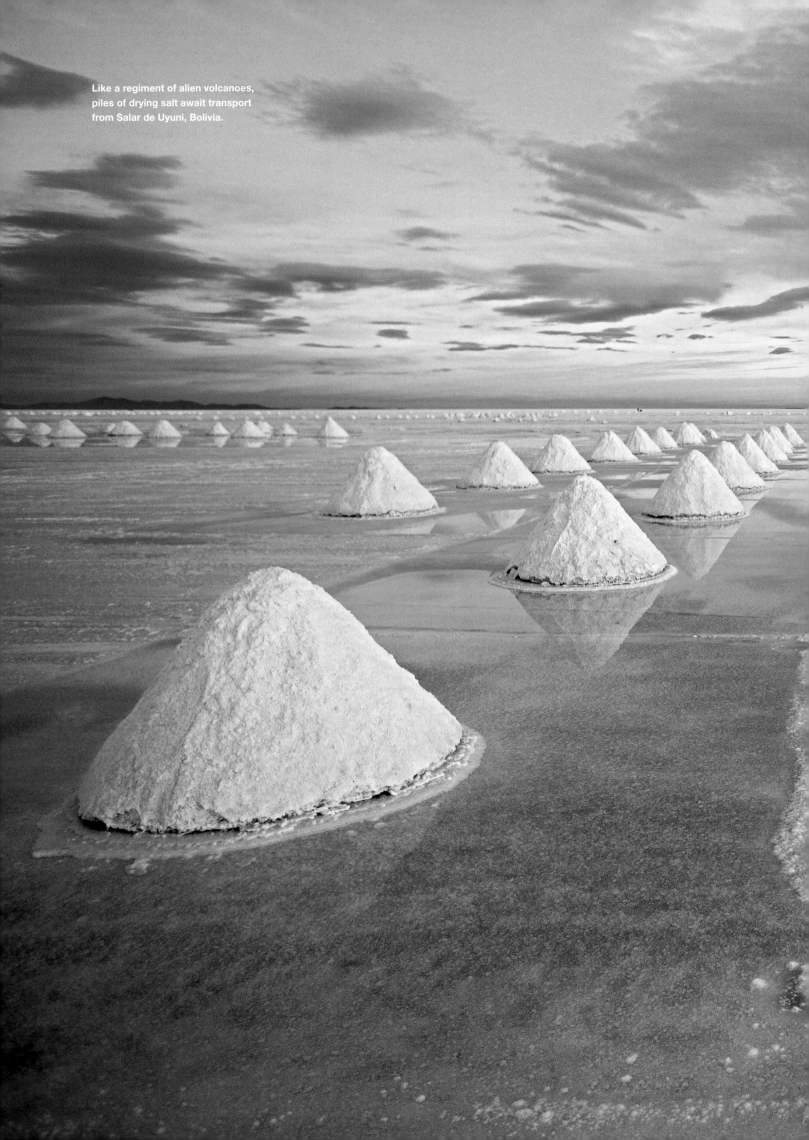

Like a regiment of alien volcanoes, piles of drying salt await transport from Salar de Uyuni, Bolivia.

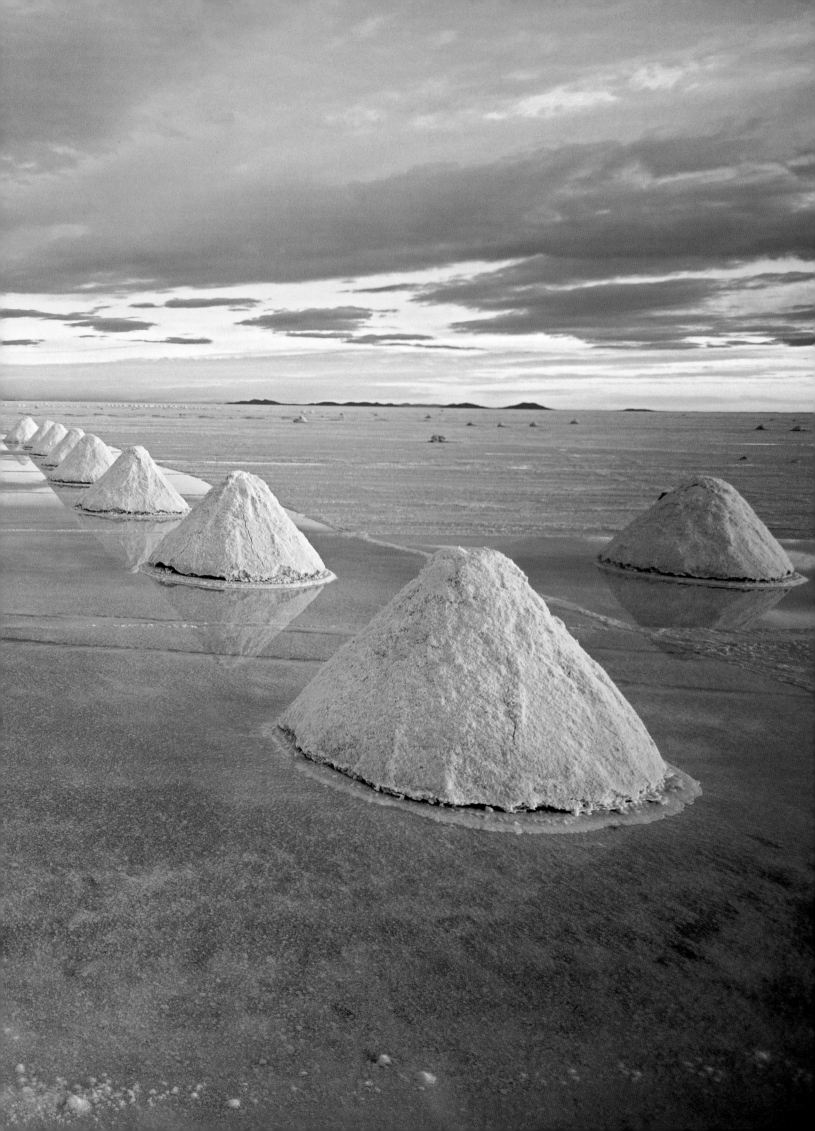

EXPLODING IN COLOR

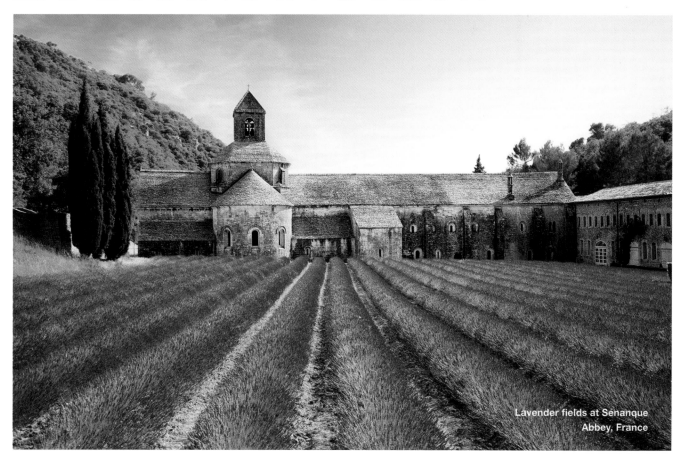

Lavender fields at Sénanque Abbey, France

Christmas Island, Australia

Each rainy season Christmas Island in the Indian Ocean witnesses one of the world's most spectacularly colorful migrations as a moving tide of millions of crimson red crabs make their yearly pilgrimage from the island's central forests to breed at the ocean shore.

Lake Nakuru, Kenya

In the heart of the Kenyan Great Rift Valley, Lake Nakuru hosts one of the greatest bird spectacles on the planet as hundreds of thousands of greater and lesser pink flamingos flock, in blankets of pink, to the water's edge to feed on the lake's algae.

The Lubéron, France

Across the seasons the Lubéron Massif is alive with color—with almond blooms, red poppies, fall foliage, and more. July is no exception; it is when regimented rows of fragrant lavender bushes peak in vibrant purple across the picturesque Provence landscape. The fields of Sénanque Abbey near Gordes provide the quintessential display.

Mallory Square, Key West, Florida

Each night this buzzing Key West square fills with vendors, street performers, and acrobats. But the star of the show is the sky, transformed into blazing oranges, pearly pinks, and velvety purples as the sun drops into the Gulf of Mexico.

Yellowknife, Northwest Territories, Canada

Directly under the "Aurora Oval," Yellowknife is a northern lights hot spot where curtainlike waves of the aurora borealis twist and writhe across the vast skies of the Canadian wilderness in dazzling shades of green, yellow, purple, and red.

Erg Chebbi Dunes, Morocco

Constantly shifting in the North African winds, the golden dunes of the Moroccan Sahara take on a different hue every hour but are at their most spectacular at sunrise and sunset, when their curved shadows contrast with the sun-burnished sand.

Grand Prismatic Spring, Wyoming

Yellowstone National Park's Grand Prismatic is the largest—and most colorful—hot spring in the United States. Its rainbow halo is the consequence of pigmented bacteria in the microbial mats that grow around its edge, its deep blue center the result of its depth and purity.

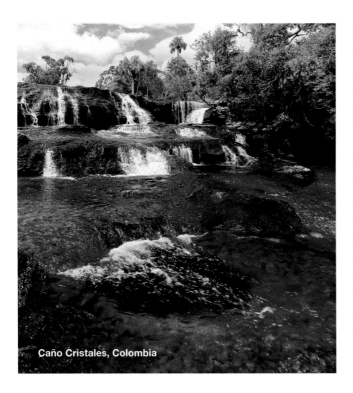

Caño Cristales, Colombia

Caño Cristales, Colombia

Caño Cristales, the river of five colors, runs through Macarena National Park in central Colombia. On sunny days from July to November, the combination of the *Macarenia clavigera* plant, the chemistry of the rocks, and the sunlight turns this river into a liquid rainbow.

Hitsujiyama Park, Japan

Blooming close to the ground in glorious blankets of pink, white, and magenta, the shibazakura flowers of Hitsujiyama Park in Chichibu are truly sublime. Commonly known as moss pink, the 400,000 or so vivid blooms, arranged in bold patterns, are best in April and May.

Vatnajökull National Park, Iceland

This is one of the best places to experience Iceland's magnificent crystal-blue ice caves. Their fantastical formations, in vibrant tones of cerulean, cobalt, and aquamarine, last only for the winter season, before melting in the warmth of spring.

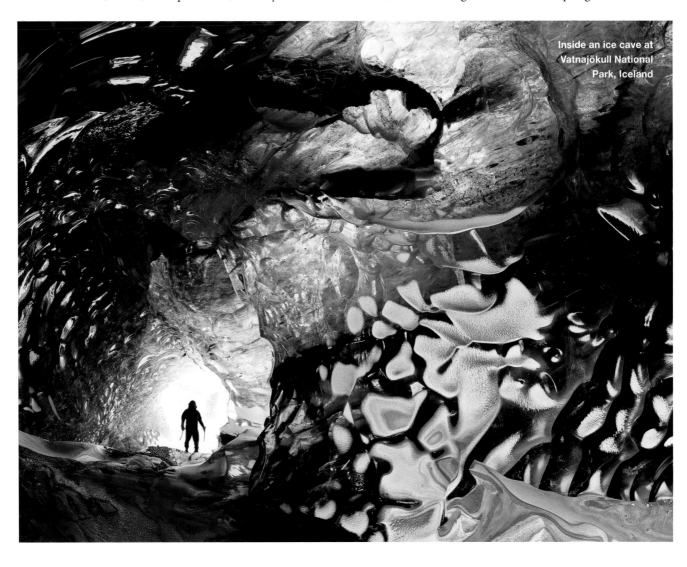

Inside an ice cave at Vatnajökull National Park, Iceland

VALLEY OF HAUKADALUR
Staggering displays of Earth's energy

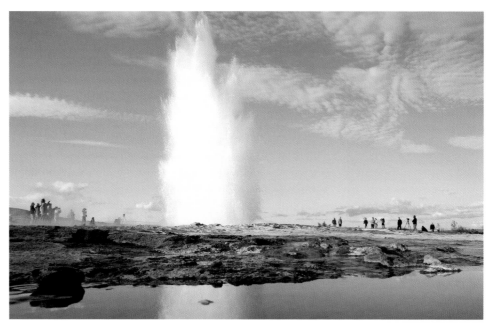

Strokkur, in Iceland's restless valley of Haukadalur, is known for its geysers of boiling water (above), turquoise geothermal pools (opposite), and deep fissures releasing the Earth's steamy breath.

On active volcanic terrains across the world, a curious natural phenomenon causes hot water to shoot up into the air. Iceland gave the world the very word to describe the spectacle—"geyser"—from its famous Stori Geysir, or Great Geysir.

Like all the other magma-triggered activities that shape Iceland's landscapes, there are no predictable patterns as to when geysers erupt—or stop, for that matter. Great Geysir has been mostly dormant for nearly a century, though plenty of others in Iceland continue to gush water, astonishing the viewers with their sheer power.

Steps away from Great Geysir is Strokkur, dutifully spewing boiling water as high as 98 feet (30 m) every ten minutes or so. The valley of Haukadalur, in which Great Geysir and Strokkur find themselves, is full of fissures and vents that belch and hiss sulfurous steam. It is not uncommon for such openings to suddenly become geysers after an earthquake.

The whole island of Iceland is studded with forceful geothermal fountains big and small, with white columns of scalding liquid defying gravity for a few seconds before plunging back to ground. Together these geysers hint at the irrepressible energy that simmers under our feet, ready at any moment to remind us who is really in charge.

▶ UNFORGETTABLE EXPERIENCES

The same geothermal forces that propel geysers shaped the otherworldly landscapes of Landmannalaugar, inside Fjallabak Nature Reserve. Multicolored rhyolite peaks and sharp crags punctuate this hot spring–dotted terrain in the highlands. The multiday Laugavegur trail down to Thórsmörk showcases Iceland's geological diversity, from petrified lava fields to lush sheep pastures, bright blue lakes to boiling streams. After an arduous hike, you can poach inside natural hot pools. *fi.is*

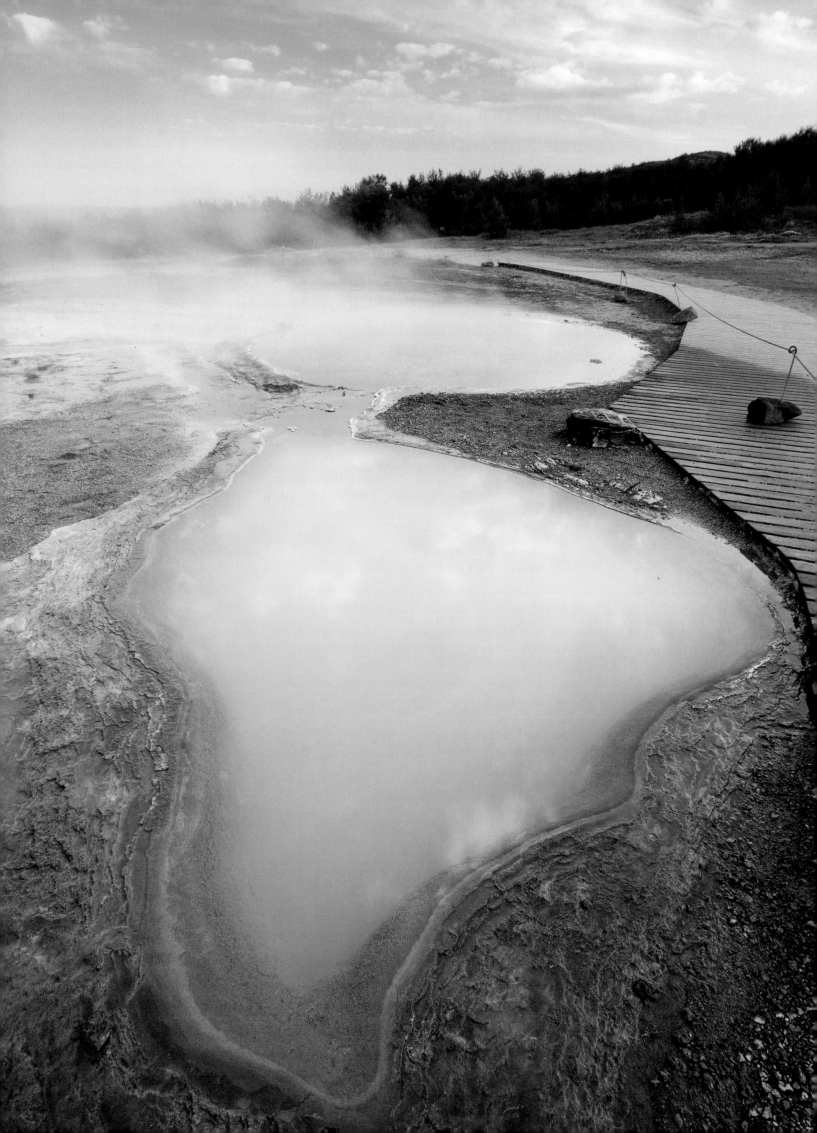

THE QUIRAING

A geological wonderland in the north of Skye

Just above Staffin Bay in the northeast of the Scottish Isle of Skye rises the Quiraing, part of the Trotternish Ridge geologic phenomenon, formed when the weight of volcanic lava flow on the region's sandstone and limestone caused massive landslips. The result was this statuary of basalt pinnacles—towering rock pillars and overgrown obelisks on a most majestic green carpet unraveling down steep slopes to the sea. Closer to shore, ice scouring of Jurassic rock rounded lower gully formations, leaving rolling hills and bumps while other high rises of the Quiraing, like the 120-foot (37 m) so-called Needle, are still "young" and a bit, er, unstable. Even today shifting slips still morph the landscape, as evidenced by frequent road repairs.

From the Bealach Ollasgairte car park, a circuitous 4.3-mile (7 km) footpath weaves through the Quiraing's geological folds to its summit, crisscrossing nicknamed sites like the Table, a football field–size plateau hidden amid this stone stadium. The so-called Prison got its name from the rock walls that form a surrounding "fortress," perhaps used as such against Viking invaders in earlier centuries. Beyond the Quiraing, other curious formations jut from the Trotternish Ridge, including the Old Man of Storr, Kilt Rock, and the plummeting Mealt Waterfall. And don't miss the rippled terrain of Fairy Glen—a miniature Quiraing—outside the nearby village of Uig.

▶ UNFORGETTABLE EXPERIENCES

Many anchor south in Portree, but you'll find the Flodigarry Hotel *(hotelintheskye.co.uk)* much closer to the Quiraing, with newly renovated circa-1895 lodge rooms named for such revered Scots as William Wallace and a pub serving whiskeys fireside from Talisker Distillery. To the north are spectacular viewpoints at Rubha Hunish—Skye's northernmost point. Finish up in Uig with a pint by the pier at Isle of Skye Brewing Co. *skyeale.com*

⟫⟫ TRAVELER'S NOTEBOOK ⟪⟪

✱WHEN TO GO
The Isle's Highland Games in August are enough reason to head here in the summer, but you'll also find the Fèis an Eilein, or Skye Festival, July–Aug. in south Skye.

✱PLANNING
The Quiraing is not on a direct bus route. Come by car from the Scottish mainland via the Skye Bridge in Kyle; the Mallaig–Armadale Ferry; or the ferry from the Outer Hebrides (Tarbert or Lochmaddy) into the port at Uig. Park at Bealach Ollasgairte.

✱WEBSITES
seall.co.uk, theskyeguide.com

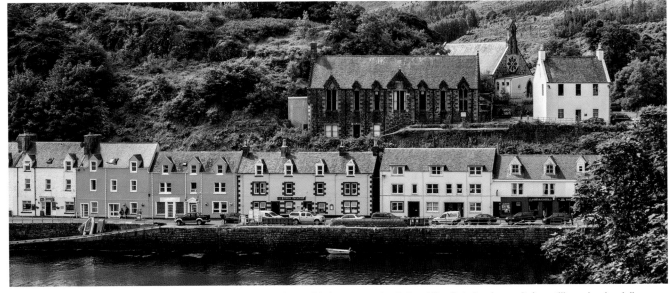

The colorful houses of Portree harbor (above) pale in comparison with the nuanced palette of the Quiraing (opposite), a still moving landslip on the Isle of Skye.

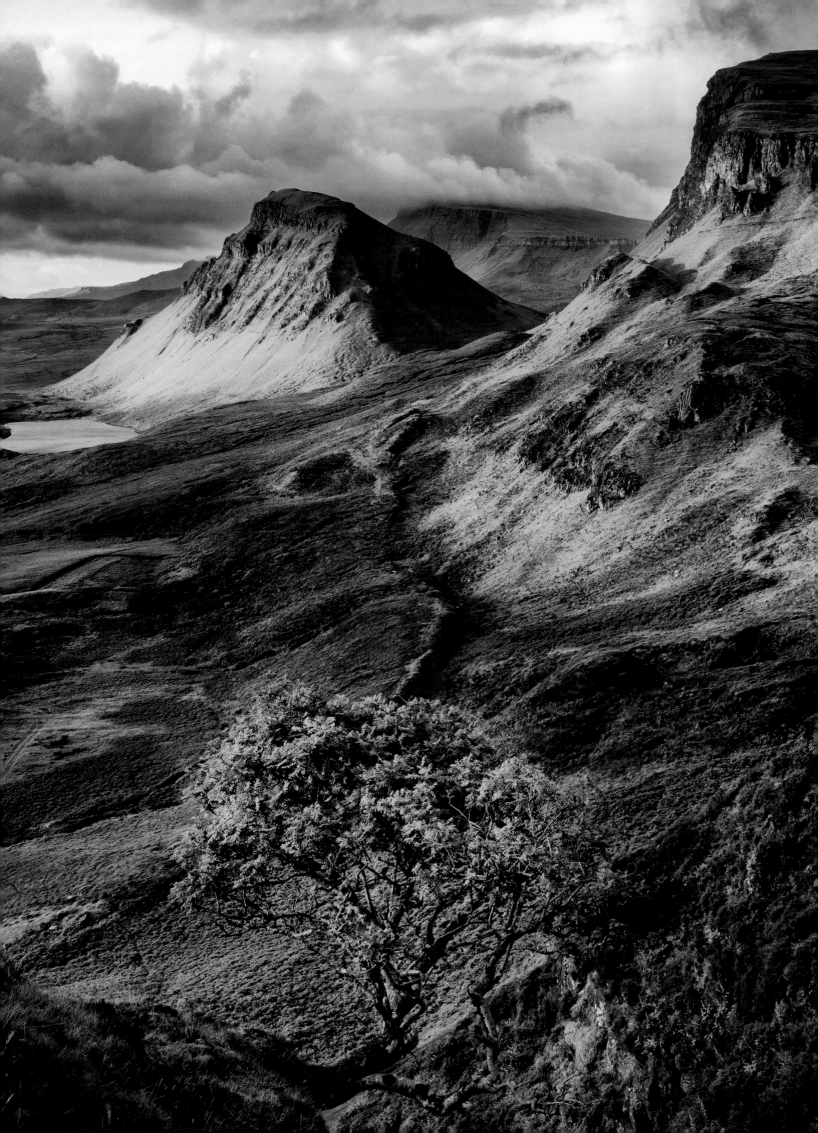

NORWAY
SPITSBERGEN
Arctic wonderland at the top of Europe

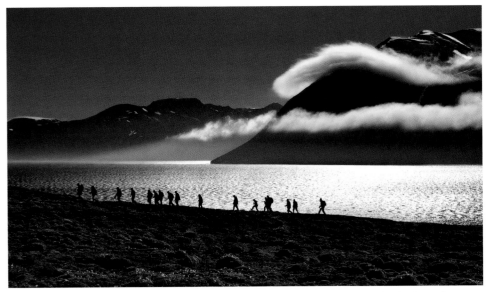

Cloud-wreathed mountains of the remote Svalbard archipelago greet hikers along the Arctic tundra (above), where Spitsbergen hosts some 3,000 polar bears each year (opposite).

N orway's northern extreme is an Arctic version of the Galápagos, a vast and untamed island where wildlife is abundant—and people insignificant—amid a landscape of glaciers, snowcapped mountains, and iceberg-choked fjords.

Part of the Svalbard archipelago, Spitsbergen counts more polar bears (some 3,000 pass through) than year-round human residents, a testament to both its extreme climate and utter isolation hundreds of miles north of the European mainland. From walrus and reindeer herds that run a hundred strong to bearded seal, arctic fox, beluga whales, and more than a dozen seabird species, animal life is rich and varied thanks to the island's unique geography. After its long journey across the North Atlantic, the Gulf Stream finally peters out on Spitsbergen's western shore, releasing the region from the clutches of polar ice for a few sun-splashed months each summer and generating wildflowers on land and abundant food in the surrounding sea.

Although European whalers established temporary bases here in the early 17th century, the first permanent settlers didn't arrive until the early 20th century, to work coal deposits. Founded by American industrialist John M. Longyear, one of the those early mining towns evolved into Longyearbyen, the archipelago capital, recently revived as a funky wilderness

▶ UNFORGETTABLE EXPERIENCES

With crisp, clean air and little artificial light, Spitsbergen is ideal for stargazing, especially the period from mid-November through late January, when the Arctic isle experiences 24 hours of darkness. The aurora borealis (northern lights) is best seen between September and March; go online to see the Kjell Henriksen Observatory's daily online aurora forecast *(visit-lyngenfjord.com).* Svalbard Villmarkssenter organizes northern lights evenings including a meal served around an open fire. *svalbardvillmarkssenter.no*

town with art galleries, gourmet restaurants, and the planet's northernmost music festival (October's Dark Season Blues). The island's only other town is nearby Barentsburg, an old Russian coal-mining colony that's a charming throwback to Soviet days.

Most of Spitsbergen is an uninhabited wilderness accessible mainly by boat in summer and snowmobile in winter. Seven national parks protect its natural treasures, including a north-west coast spangled with spectacular landforms. Surrounded by glaciers, Magdalenefjorden preserves the ruins of a 17th-century British whaling station called Gravneset. Scattered along a white-sand strand are old stone blubber ovens and a cemetery holding some 130 graves.

Framed by jagged snow-covered peaks at the head of Liefdefjord, Monacobreen glacier, more than 5 miles (8 km) across, was discovered during an 1899 scientific voyage organized by Prince Albert I of Monaco. NASA tests space suits, instruments, and techniques for future Mars missions amid Bockfjord's alien landscape of rust-colored desert hills, black volcanic peaks, and simmering hot springs. Sandbars off the north coast swarm with walrus and predatory polar bear, in a bleak landscape on the cusp of 80 degrees north latitude only some 600 miles (965 km) from the North Pole.

"When I was growing up here, there was no reason to stay. I couldn't wait to get out. But when I did, I realized what I was missing and after only one year I came back. I couldn't live without the nature, the simple life, the quiet."

– Ingrid Kårstad, *wilderness guide*

▶ VISIT LIKE A LOCAL

Most in Longyearbyen own their own snowmobile, used for getting around town as well as weekend recreation in the great white wilderness that surrounds the territorial capital. Snowmobile trails along the southern edge of the Isfjord lead to glaciers, ice caves, and wildlife areas, as well as Pyramiden ghost town, the towering snowcapped cliffs of Tempelfjord, and the Russian settlement at Barentsburg. Spitsbergen Travel offers rentals and excursions. *spitsbergentravel.com*

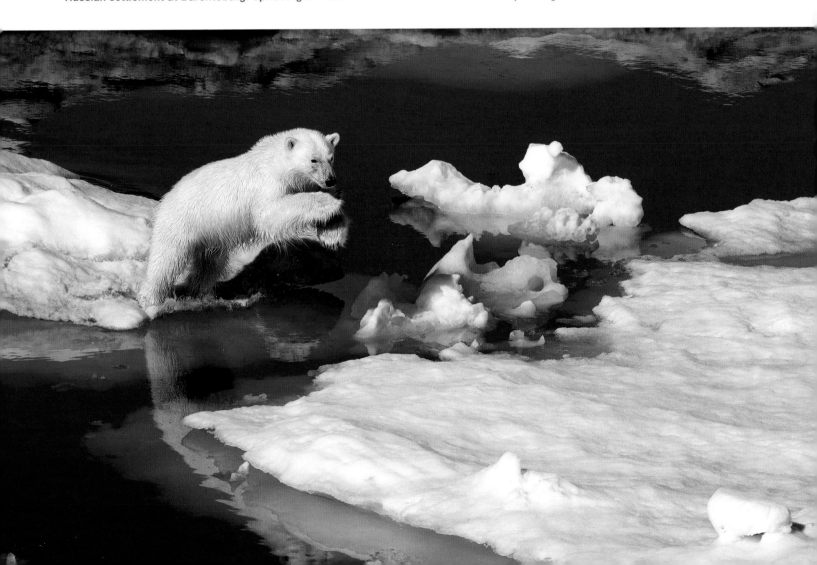

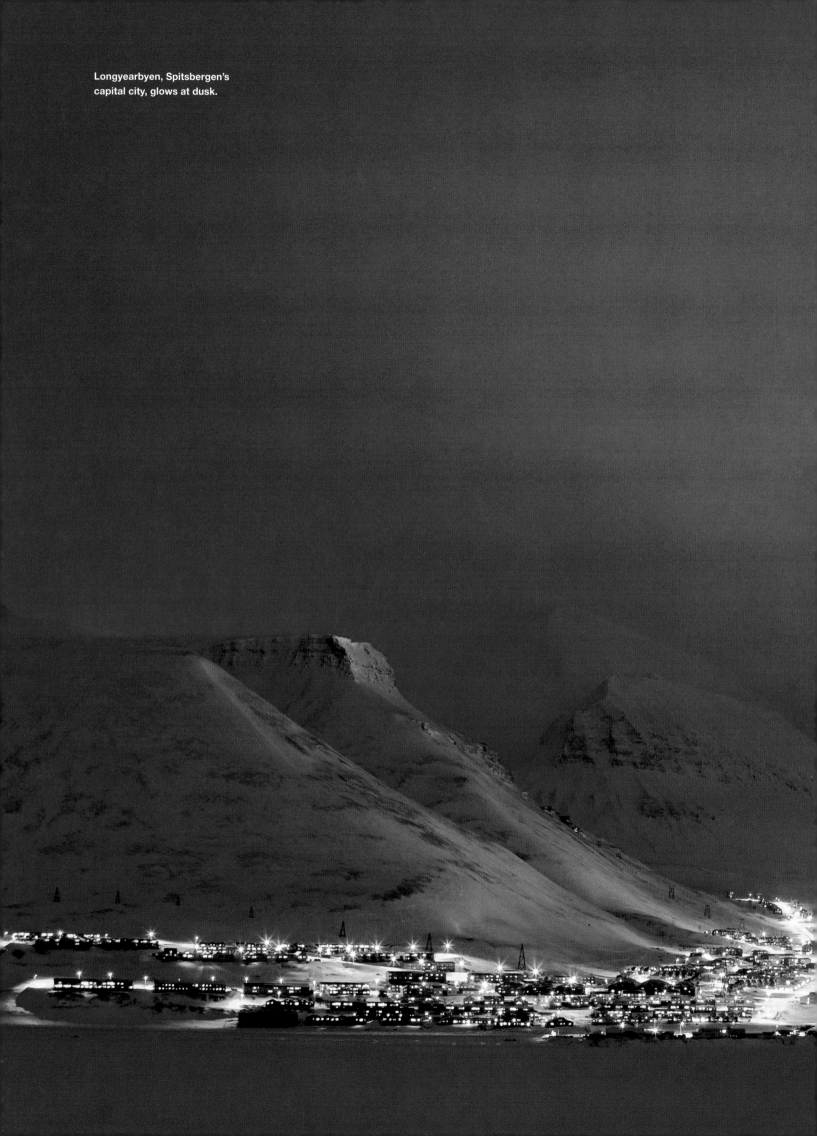

Longyearbyen, Spitsbergen's
capital city, glows at dusk.

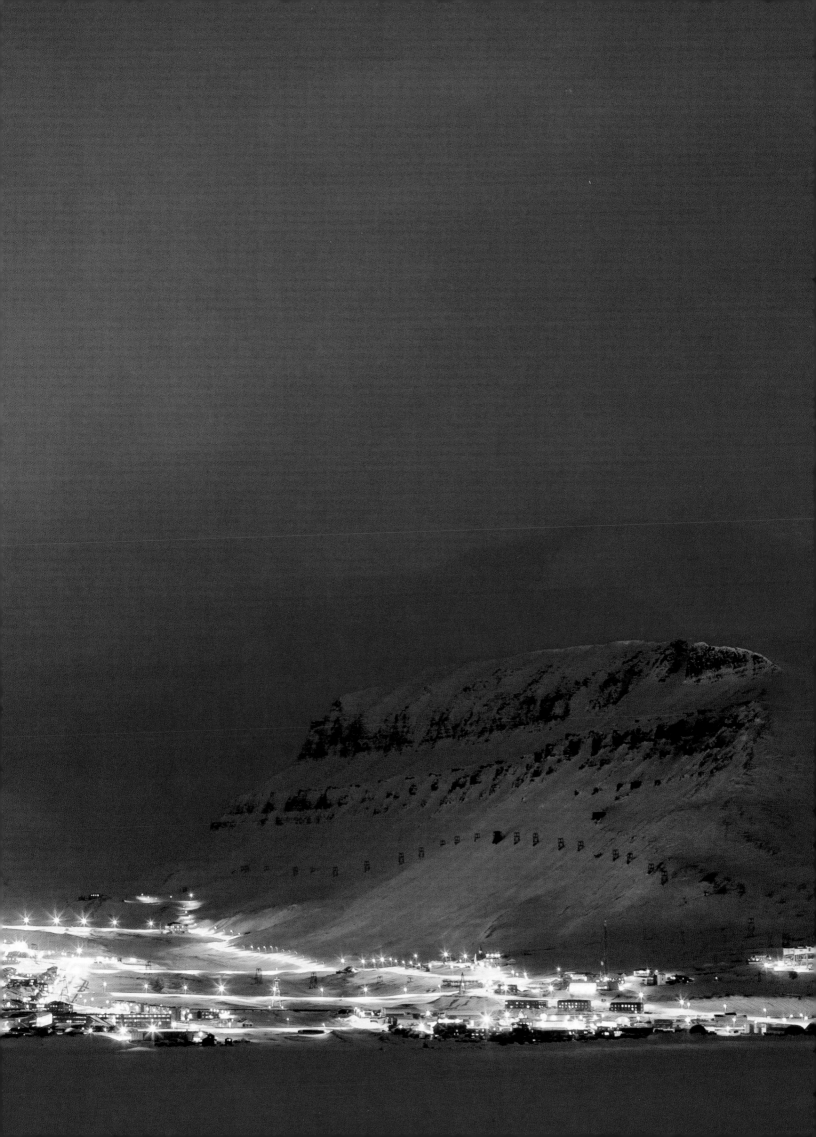

UNFORGETTABLE ANIMAL-WATCHING

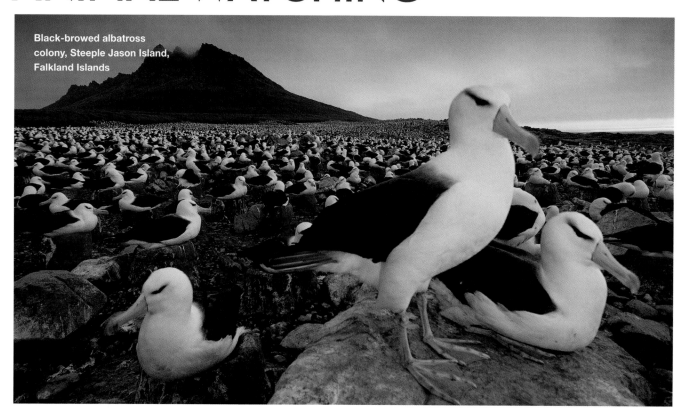

Black-browed albatross colony, Steeple Jason Island, Falkland Islands

Black-browed Albatross, Falkland Islands

In the short season between hatching and first flight, 70 percent of the world's black-browed albatross population cover cliffs on the Falklands, sitting on Dr. Seussish tufts and stretching their wings. Once they hit the air, they may not land again for months or even years.

Porcupine Caribou Migration, Canada

In Canada's remote Vuntut National Park, and across the border into Alaska, porcupine caribou migrate in herds so wide they trample ground flat as an interstate. Some 130,000 animals move more than 1,500 miles (2,414 km) annually.

Salmon Spawn, Southeast Alaska

In late summer, millions of salmon return to their birth streams to spawn and die. At the end of each summer a quarter million fish and a hundred bears show up at Anan Wildlife Observatory, near the town of Wrangell.

Mexican Free-Tailed Bats, New Mexico

Every summer's twilight, about a half million bats pour out of the entrance to Carlsbad Caverns in southern New Mexico. The bats swirl, orient, and then form a river of life in the sky.

Monarch Butterflies, Mexico

Millions of monarch butterflies, each not much heavier than a postage stamp, migrate up to 3,000 miles (4,828 km) to winter in the Monarch Butterfly Biosphere Reserve, about 60 miles (97 km) northwest of Mexico City, covering the trees so thickly the trunks can bend under the orange-and-black wings.

Puffins, Scotland

Ask a cartoonist to draw a bird, and odds are it will look like a puffin, with a bright, striped beak, and unlikely flights. The Shetland Islands have seven main puffin colonies, with perhaps the most scenic at Foula, where they cover Britain's highest cliff.

Humpback Whales, Hawaii

Humpbacks summer in southeastern Alaska and winter in Maui—not a bad life. Best spots to see these leviathans with their new calves are off west Maui, around Wailea and Lahaina. Nothing like watching a 30-ton (27 tonne) mom teach her 10-ton (9 tonne) baby how to jump out of the water.

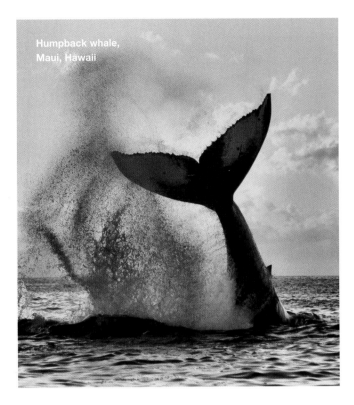

Humpback whale, Maui, Hawaii

Lemurs, Madagascar

More than 100 species of lemur live in Madagascar—and nowhere else on Earth. With huge eyes, long tails, and a face somewhere between a squirrel and a cat, lemurs range from the 3-foot (0.9 m) indri to Madame Berthe's mouse lemur, which weighs about the same as an AA battery.

Leatherback Sea Turtles, Trinidad

As many as 10,000 of these armored giants come ashore in Trinidad, an awesome concentration of the largest turtle species left, weighing up to 2,000 pounds (907 kg). A female may lay some 80 eggs a dozen times during the six-month breeding season, with the babies hatching about two months later.

Mountain Gorillas, Uganda

The Bwindi Impenetrable National Park is home to roughly half the 750 mountain gorillas remaining in the wild. Expect thick jungle, a lot of sweat, and then the miracle of going eye to eye with the very deep gaze of a watchful silverback.

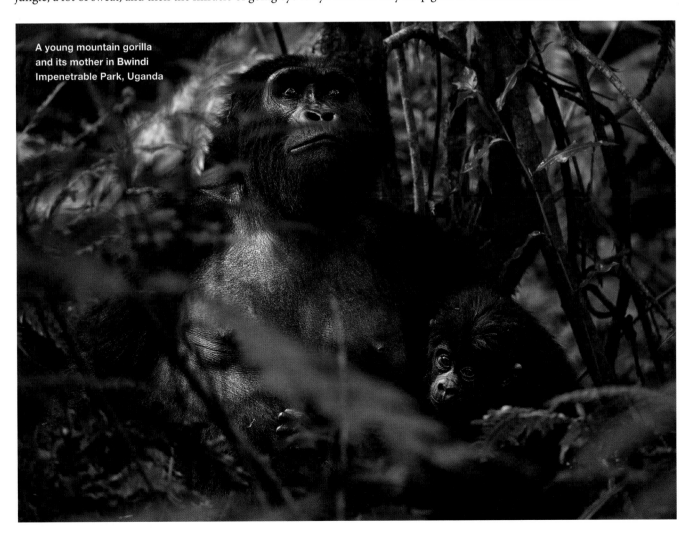

A young mountain gorilla and its mother in Bwindi Impenetrable Park, Uganda

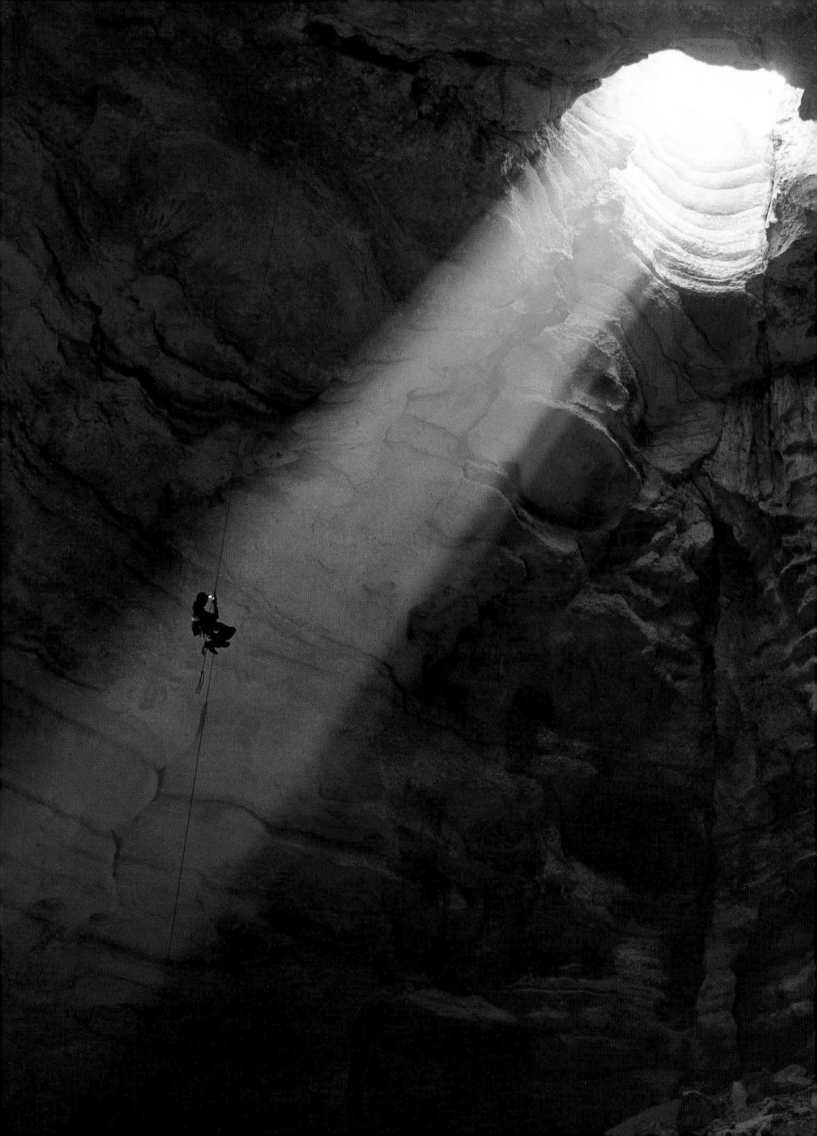

MY SHOT

Majlis al Jinn, Oman

Majlis al Jinn in the Sultanate of Oman is not only one of the largest cave rooms on Earth, it is also among the most beautiful. The dimensions are truly staggering: In this image the climber is ascending a 600-foot (183 m) rope toward the ceiling. The shaft of sunlight behind him occurs only at certain times of the year, which is why I was in the Arabian Peninsula in August, when outside temperatures were over 120°F (49°C). But inside the cave was cool and nice.

– Stephen Alvarez,
National Geographic
photographer

LOWER ZAMBEZI NATIONAL PARK
A mosaic of water and wildlife in southern Africa

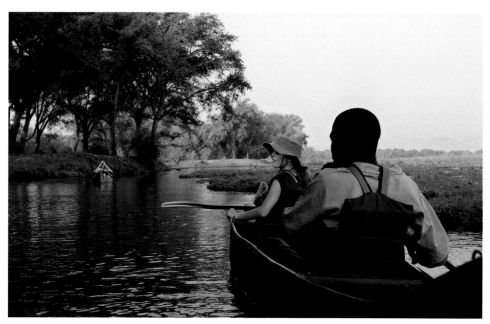

The easiest way to traverse the wilds—and to see the abundant wildlife—of the Lower Zambezi is by water (above). Elephants, hippos, baboons, and more are likewise drawn to the wetlands (opposite).

E lephant herds that run a hundred strong, thousands of cantankerous crocs and hippos, and riverside woods flush with apex predators make the Lower Zambezi one of the continent's richest and most varied nature preserves. Other parks may boast copious wildlife, but not in concert with so much water, a factor that adds a whole different dimension to the safari experience.

Plunging down from eastern Angola, the Zambezi River spills over Victoria Falls into a broad flood plain that divides the Zambia and Zimbabwe highlands. A 140-mile (225 km) stretch of the river beneath Lake Kariba remains thoroughly wild and incredibly scenic. Both sides of the river are protected within the confines of national parks, Mana Pools on the south bank and Lower Zambezi on the north. Other than riverfront camps and a couple of unpaved airstrips, this watery wilderness remains largely untouched by civilization. Given the thickness of the bush and prevalence of water, especially during the rainy season, roads are also rare. The easiest way to get around is by water, via canoes and small powerboats that ply the main river and tributaries like the meandering Chongwe River and slow-flowing Nkalange Channel.

Animals flock to the water, not just at dusk and dawn but also throughout the day. You are likely to see elephants swimming out to grassy islands in the middle of the Zambezi,

TRAVELER'S NOTEBOOK

＊WHEN TO GO
The park is fully operational April–Nov., but June–Sept. is considered best for both game viewing and river fishing. Many lodges, camps, and boating outfitters are closed during rainy season (Dec.–March) when park roads are largely impassible.

＊PLANNING
Lower Zambezi National Park is about 88 miles (142 km) east of Lusaka. You can reach the park via a rough-and-tumble overland journey on dreadful roads, but the most common way is via small plane from Lusaka to several dirt airstrips beside the Zambezi. All accommodation is along the river, either inside the park or west of the Chongwe River.

＊WEBSITES
zambiatourism.com

▶ UNFORGETTABLE EXPERIENCES

With architecture that falls somewhere between Antoni Gaudí and the Flintstones, Chongwe River House is not your average African safari lodge. Perched on a meandering tributary, the funky four-bedroom guesthouse comes with its own manager, chef, and safari guide. A communal living area opens onto a wooden deck and swimming pool shaded by a massive winterthorn tree. With one side of the suites open to the elements, guests can lie in bed or linger in their waterfall shower as wildlife wander by. *chongweriverhouse.com*

crocodiles basking on barely submerged sandbanks, hippos mowing through patches of riverfront grass, baboon troops in the waterfront trees, and fish eagles swooping down to make a meal of some unsuspecting fish. After dark the predators come out, lions, leopards, and hyenas moving silently through the riverside bush in search of antelope and other prey. Once upon a time humans also lived here, many in the scattered waterfront villages of the Nsenga people, before a 1950s sleeping sickness epidemic decimated the tribe. Those who didn't perish were relocated to other parts of Zambia—and over the three decades that followed, the area was primarily a hunting reserve. Since national park status was granted in 1983, most of the animal populations have rebounded in spectacular fashion. One creature that didn't survive is the black rhino, now extinct in the Lower Zambezi.

Inland from the river the park sprawls through savanna woodland, gradually rising to the Zambezi Escarpment. Above the cliffs, the park continues northward all the way to the Great East Road, the major east-west highway across Zambia. This interior section is threatened by a long-running (and highly controversial) proposal to develop an open-pit copper mine within the park boundary.

"The biggest difference from Lower Zambezi to parks in Kenya or South Africa is the number of people. Instead of half a dozen Land Rovers around a single lion, you're lucky if you see one other vehicle the whole day driving around here."

– Anet van Niekerk, *Lower Zambezi National Park camp manager*

▶ **VISIT LIKE A LOCAL**

Canoes have been a way of life on the Zambezi for thousands of years, and paddling remains the best way to explore the park's waterfront regions and experience closer views of the elephants, hippos, crocodiles, and other riverine wildlife than is possible from a noisy vehicle. Prime areas include the Chongwe River and Nkalange Channel as well as the sandbars and grassy islands in the Zambezi. Chiawa Camp offers one of the park's best paddling programs, as well as catch-and-release river fishing. *chiawa.com*

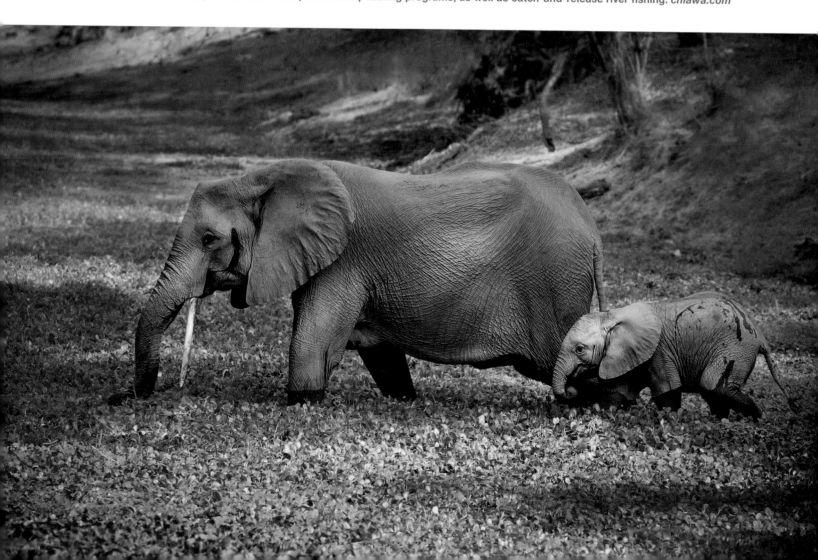

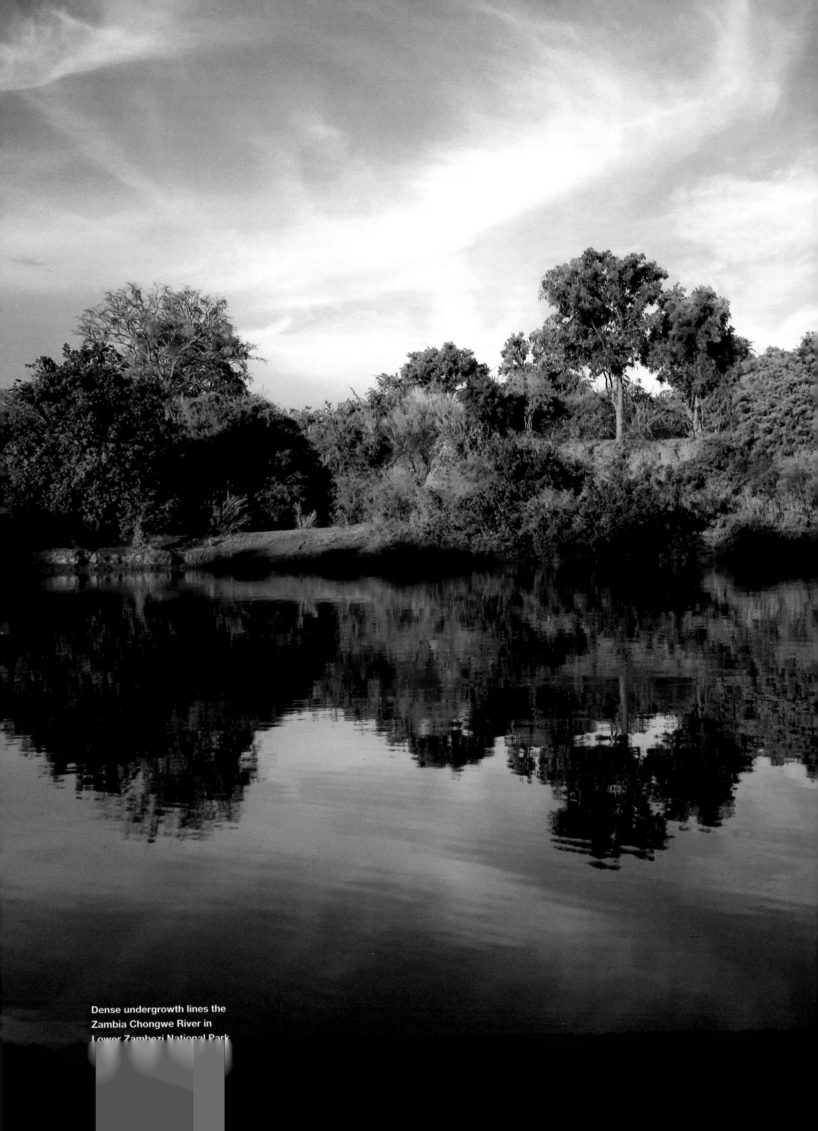

Dense undergrowth lines the
Zambia Chongwe River in
Lower Zambezi National Park

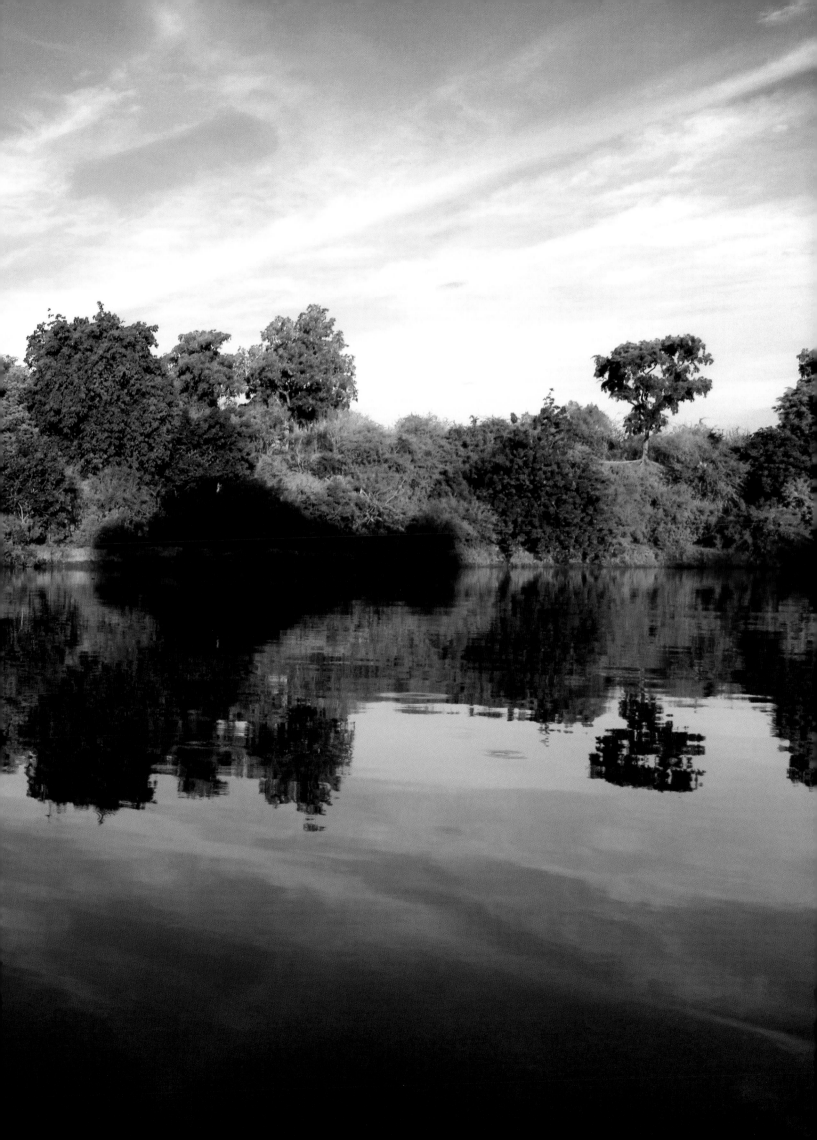

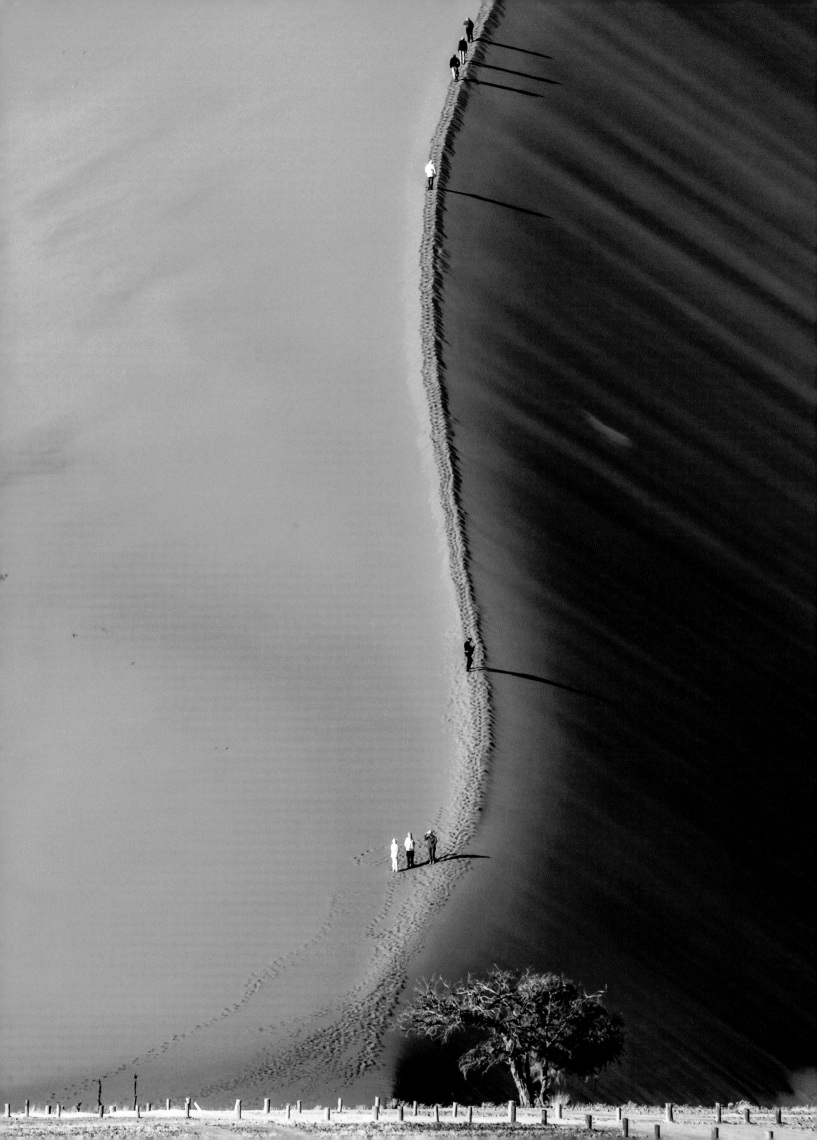

NAMIBIA

SOSSUSVLEI DUNES
Sandy summits along Africa's southwest coast

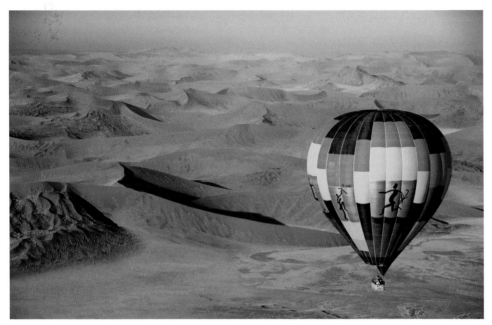

Sossusvlei (opposite and above) is home to the largest sand dunes in the world, shaped by the wind. High levels of iron in the sand create its distinctive glowing hue.

Colossal orange, red, and pink sand dunes flank the Tsauchab River Valley of west-central Namibia, an area collectively called Sossusvlei after a large salt pan that simmers among the shifting sands. Nearly as high as the Empire State Building, several of the granular formations tower more than a thousand feet (305 m), including the mammoth Big Daddy and the ethereal Dune 45, which seems like a landform on Mars rather than planet Earth.

Created by Orange River silt flowing into the Atlantic Ocean and then spread along the coast by the Benguela Current, the Sossusvlei dunes are the most striking feature of the Namib Desert. The wind shapes and moves them from every direction, sometimes into crescents or radiating stars. The ruddy colors derive from a high degree of iron in the sand, with the older dunes showing off even more vivid hues than the younger mounds.

Entirely enclosed within Namib Naukluft National Park, Sossusvlei also harbors desert-adapted rare or unusual flora and fauna. Among the creatures that roam the dunes are the shovel-snouted lizard, ostrich, jackal, and gemsbok (oryx) antelope. Another salt pan, called Dead Vlei, shelters a ghost forest of camelthorn trees, some more than eight centuries old.

TRAVELER'S NOTEBOOK

***WHEN TO GO**
The national park is open year-round, but extreme summer heat makes April–Oct. the best time to visit, especially for those who wish to hike the dunes.

***PLANNING**
A good paved road connects Sossusvlei and Sesriem Gate, the main entrance to the park, which is about 200 road miles (322 km) from Windhoek. Most visitors drive themselves to the area in cars or RVs rented in Windhoek; a 4x4 is not necessary. African Profile Safaris arranges private road and air transfers to the park. *profilenamibia.com*

***WEBSITES**
sossusvlei.org

▶ **UNFORGETTABLE EXPERIENCES**

Sunrise brings out the most intense colors at Sossusvlei and also the coolest temperatures for climbing the dunes. Vehicles start queuing at the park village of Sesriem in the early morning dark—and when rangers finally open the gate, there is a slow-motion rush (everyone keeping to the national park speed limit) to the best viewpoints and trailheads. An alternative to the terrestrial view is a sunrise hot air balloon flight with Namib Sky, run by an experienced Belgian balloonist and his family. *namibsky.com*

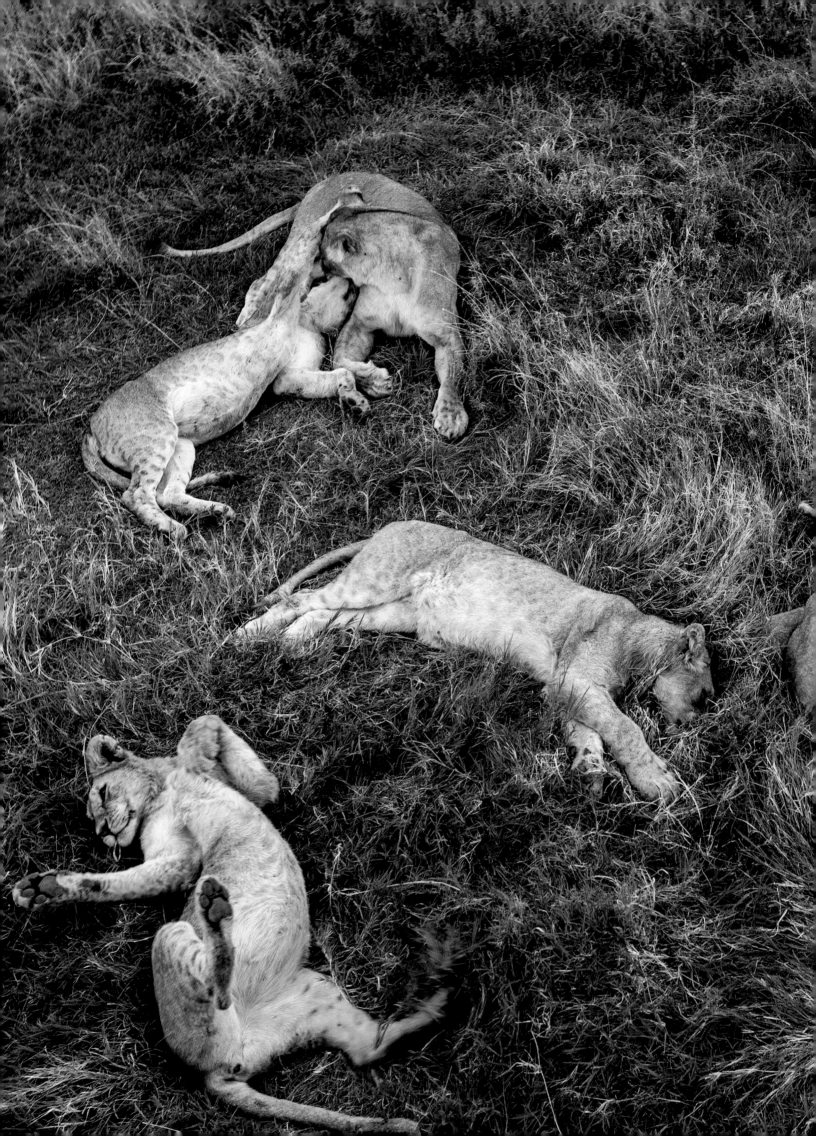

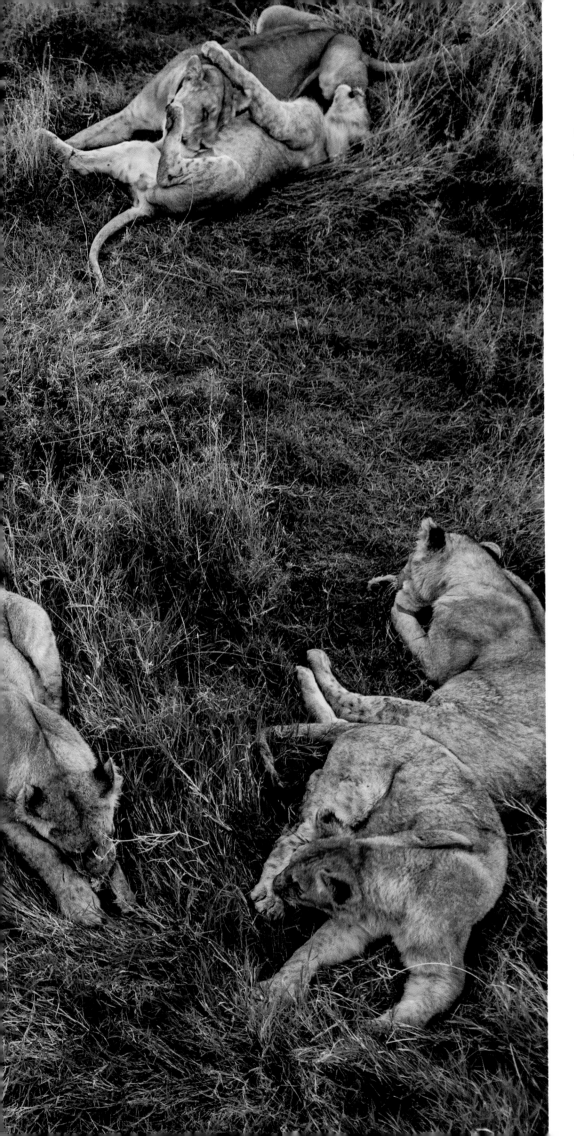

MY SHOT

Serengeti National Park, Tanzania

For two years I watched this remote Vumbi pride of 5 female lions cooperatively raise 13 cubs in Serengeti National Park. Wild lions are disappearing, and the great Serengeti ecosystem may well be one of their last stands. This image is one of my favorites because it shows the close bonds we saw every day. For this shot I was able to gradually move our specially converted Land Rover close to the lions' resting site hidden near a water hole, then to carefully climb onto the roof and shoot straight down, as if from a balloon.

– Michael Nichols,
National Geographic
photographer

49

KOMODO NATIONAL PARK
Indonesia's real-life land of dragons

The world's largest lizards, pink-sand beaches, and primeval landscapes set Komodo National Park apart from the rest of the vast Southeast Asian archipelago. The park comprises 3 main islands (Padar, Rinca, and Komodo) and 26 smaller ones, plus the marine areas between. Volcanic in origin, the islands blend savanna grasslands, wooden ravines, and thick mangrove swamps.

The most striking attraction of this real-life Jurassic Park is the Komodo dragon, a monitor lizard that can grow up to 10 feet (3 m) and 150 pounds (68 kg). Hunting in packs and equipped with sharp teeth and claws, the lizards are among the globe's most fearsome carnivores: Komodo dragons have been known to stalk and devour humans, even in recent times.

All of the hoopla surrounding the lizards overshadows the park's other wildlife wonders—crab-eating macaque monkeys, vast colonies of fruit bats, the Javan spitting cobra, and more than 70 bird species, including the rare orange-footed scrub fowl and the lesser sulphur-crested cockatoo. The warm tropical waters around the islands are equally rich with life, a mosaic of coral reefs, shallow bays, and deep channels that harbor ten dolphins species, five different types of sea turtle, the endangered Indonesian dugong, and migrating blue and sperm whales.

▶ UNFORGETTABLE EXPERIENCES

Although dragons gather around the visitor area at Loh Liang Bay, the best way to view them in their natural habitat is a hike into the Komodo Island wilderness. Hire a guide at the ranger station and set off into the bush on walks that can vary from one hour to an entire day. All the guides carry a long forked pole to push dragons away should they venture too close. Along the way you might see mother dragons tending their nests, youngsters perched in trees, or a group of dragons stalking prey.

≫ TRAVELER'S NOTEBOOK ≪

***WHEN TO GO**
July–Oct. is the mating and nesting season for Komodo dragons, when they are not as easy to see. The rainy season runs Jan.–March, leaving April–June the best time to visit.

***PLANNING**
Komodo National Park is about 250 miles (402 km) east of Bali. The most common way to visit the park is via multiday boat tours originating in Bali or Lombok through companies like Peramatour. Scuba excursions are also organized by Dive Komodo and other outfitters.

***WEBSITES**
komodo-park.com, peramatour.com, divekomodo.com

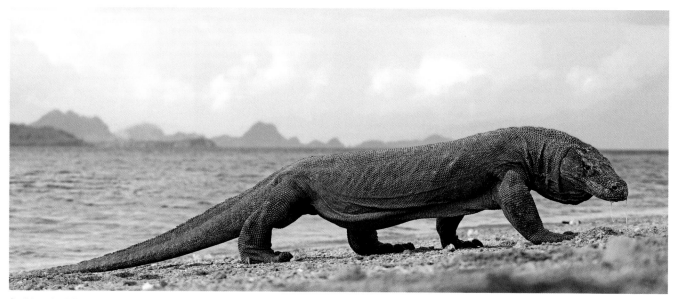

Stalking the islands of Komodo National Park (opposite), the fearsome Komodo dragon (above) can reach lengths of 10 feet (3 m).

KIMBE
Where trees of fireflies flicker

Known for its spectacular diving, New Britain Island (opposite) also hosts dense forests, beautiful waterfalls, and trees of fireflies (above).

TRAVELER'S NOTEBOOK

***WHEN TO GO**
Avoid the wet season and visit May–Oct., when festivals take advantage of the generally cooler and drier weather all around Papua New Guinea.

***PLANNING**
Kimbe is on the island of New Britain, 340 miles (547 km) away from Papua New Guinea's capital and largest city, Port Moresby. Air Niugini flies at least once a day between Port Moresby and Kimbe's Hoskins Airport. Airlines PNG flies to Kimbe from Lae, Papua New Guinea's second largest city, 230 miles (370 km) away.

***WEBSITES**
papuanewguinea.travel

n select few spots across the globe, from Southeast Asia to the United States, fireflies gather in trees and mangroves at dusk. The forestland near Kimbe in Papua New Guinea, unspoiled by urbanization, is one of the prime places to watch nature's light spectacle. Instead of fleeting flashes of individual fireflies, you can encounter a whole chain of trees flickering well into the night. Join the locals to watch the bioluminescent creatures blush and radiate bright rays—more brilliantly and elegantly than any Christmas tree.

The *Pteroptyx effulgens,* the firefly species found here, gather in trees after spending days resting on blades of grass, and flare more than once a second. They are a communal bunch, automatically synchronizing with one another until the forest glows to a regular rhythm.

These flashes are, in fact, males and females sending mating signals to one another. Perhaps the fireflies' percussions are a love song for us, the primal pulse of nature at its best and rawest. As the trees pulsate to the inaudible logic of nature, you may also spot mushrooms that glow in the dark in the forest while, offshore, the brilliant coral reefs and nocturnal marine life for which Kimbe Bay is famous continue to dazzle night divers.

▶ **UNFORGETTABLE EXPERIENCES**

Walindi Plantation Resort brings together spectacular diving with a taste of rural life. Many staff hail from surrounding villages and are glad to bring guests to their towns to get to know the local people. Most come for Kimbe Bay's rich, diverse marine life, which includes more than half of the world's coral species and more than 820 species of coral reef fish—far exceeding the diversity of the Hawaiian Islands and the entire Caribbean—accessible via the on-site dive center. *walindi.com*

ULVA ISLAND
Paradise regained for endangered plants, birds, and serenity

n New Zealand, a country already synonymous with unspoiled nature, there is an island known to be even more pristine than the rest. Ulva Island, an uninhabited nature reserve, is a one-square-mile (2.6 sq km) haven for plants and birds that have become endangered elsewhere. Best of all, this precious nature reserve is open to human visitors.

In the folds of the isle's thick podocarp forest thrive New Zealand's native birds like the emblematic kiwi, the boisterous toutouwai (New Zealand robin), the sturdy weka (Maori hen), and the brown tieke (saddleback), which has bounced back from the brink of extinction. The endangered yellow-eyed penguins likewise use the island as breeding grounds to the enchanting sound track of birdsong seldom heard near human settlements.

Visiting Ulva, also known as Te Wharawhara, isn't only about bird-watching. In the warm water that surrounds the isle, brachiopods—found elsewhere as fossils hundreds of millions of years old—continue to grow abundantly, as does a canopy of kelp. Fur seals and sea lions also thrive in this designated marine sanctuary.

The utopian idyll is, however, fragile. For flightless birds that lay eggs on the ground, any invasive species can be a deadly predator. Luckily, New Zealand's Department of Conservation stays vigilant, determined to protect the world's southernmost bird sanctuary.

▶ UNFORGETTABLE EXPERIENCES

Together with a trained ornithologist guide, bird-watchers can hike Ulva's well-maintained trails in search of winged creatures. They don't have to walk very far before they spot the territorial tūī swooping about, chasing other birds. The tiny rifleman, the gregarious kaka, the red-crowned parakeet, and the flamboyant fantail are some other species to be seen. During the boat transfer from Stewart Island, be on the lookout for penguins, shearwaters, petrels, and many other seabirds. *ulva.co.nz*

TRAVELER'S NOTEBOOK

∗WHEN TO GO
Temperate yet unpredictable, Ulva Island's climate tends to be wet year-round. Jan.–Feb. are the warmest months, with a median temperature of about 63°F (17°C).

∗PLANNING
Ulva has no overnight options on the island. The closest base is Stewart Island, which has a range of accommodations and can be reached in ten minutes by water taxi from Ulva. Stewart Island is a 24-mile (39 km) ferry ride from Bluff on New Zealand's South Island.

∗WEBSITES
*newzealand.com,
doc.govt.nz/parks
-and-recreation*

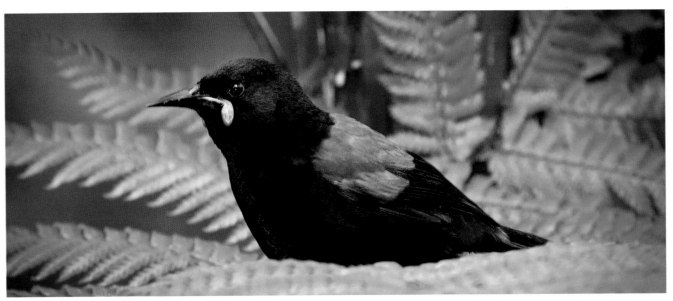

The thick podocarp forest of Ulva Island (opposite) protects such native birds as the New Zealand saddleback (above). It remains predator free thanks in part to the vigilance of nearby Stewart Islanders.

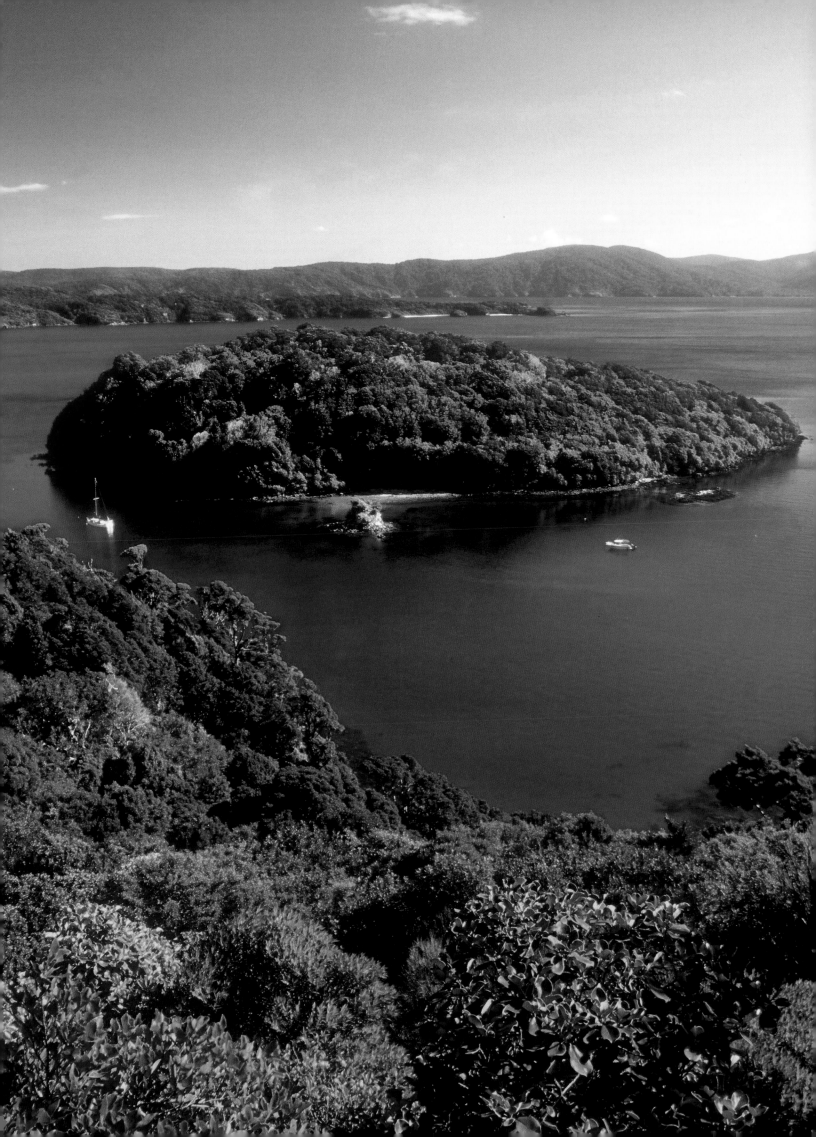

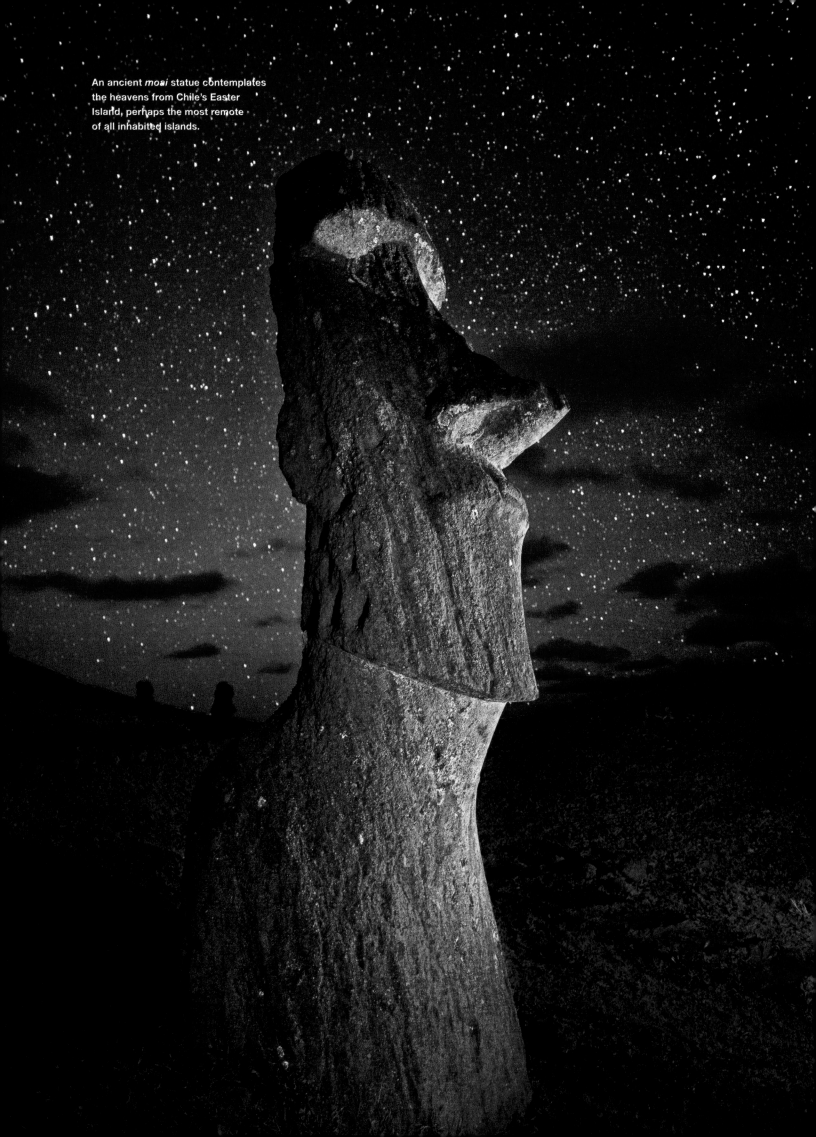

An ancient *moai* statue contemplates the heavens from Chile's Easter Island, perhaps the most remote of all inhabited islands.

HAND OF MAN

Whether evoking ancient Navajo legends
in Arizona's Canyon de Chelly or fulfilling
the vision of the übermodern in Qatar, human-
kind's artistic innovations reflect the creative
legacy of all people, places, and times.

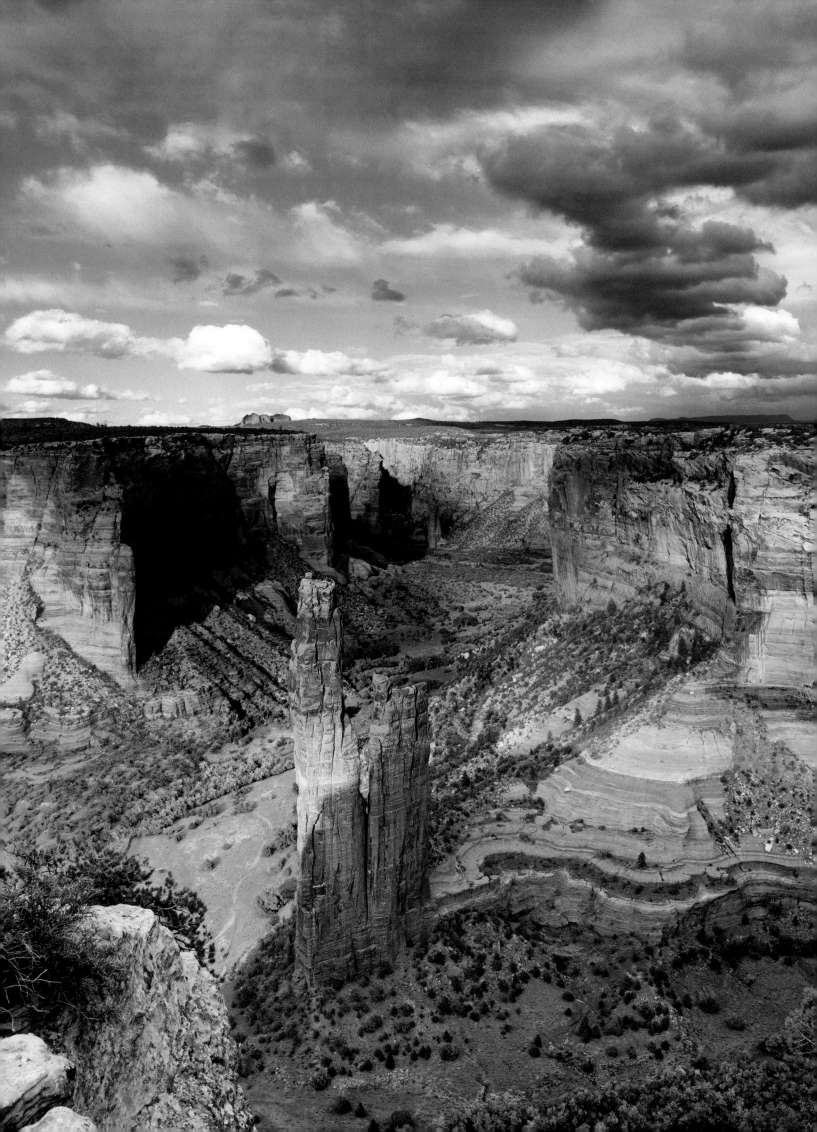

ARIZONA
CANYON DE CHELLY
Navajo legends come to life in a scarred red-rock canyon

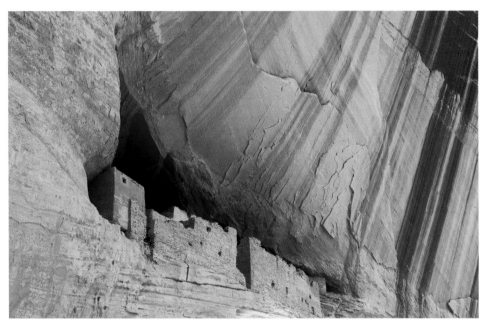

Tucked into a cliff, the White House ruins (above) at Canyon de Chelly give evidence to the presence of Native Americans for nearly 5,000 years. Opposite: The canyon's 800-foot-tall (244 m) Spider Rock.

TRAVELER'S NOTEBOOK

✻WHEN TO GO
Although the park is open year-round, try to avoid the heart of summer, when temperatures can exceed 100°F (38°C). Winters can be pleasant, although temperatures can drop below freezing, and occasionally there's a dusting of snow.

✻PLANNING
The canyon is 3 miles (4.8 km) from the tiny town of Chinle, Arizona, a drive of about 1 hour 40 minutes from Gallup, New Mexico, and just over 3 hours from Flagstaff, Arizona. Along with the park hotel, the area has campgrounds and a few motels.

✻WEBSITES
nps.gov/cach, navajo nationparks.org/htm /canyondechelly.htm

Like a skyscraper standing in the desert, Spider Rock towers over Arizona's red-rock landscape. The 800-foot (244 m) sandstone spire forms the spiritual heart of Canyon de Chelly National Monument, run jointly by the National Park Service and the Navajo Nation. As in a cathedral, visitors to the remote overlook are typically silenced by the sight spread before them—and once the wind picks up, it's easy to believe the Native American legend of a supernatural woman who inhabits the rock and weaves fabric with rays of the sun.

This place, located near the Four Corners region, is still held sacred by the Navajo people, who continue to live seasonally in the canyon bottoms, growing corn, squash, and beans. Traditional foods such as posole (a hominy stew), blue corn pancakes, and fry bread are served in the cafeteria of the park's Native-run hotel, providing you with a taste of the rich culture that once dominated the American Southwest.

Native Americans have lived in the area for nearly 5,000 years, building shelters in the sheer rock faces. Over the centuries, they faced invasions from neighboring tribes, the Spanish, and later U.S. colonel Kit Carson, who laid waste to the canyon in 1864. Today visitors to this sacred land can drive the canyon rim roads, along a landscape that seems frozen in time.

► **UNFORGETTABLE EXPERIENCES**

Except for a short hike to White House Overlook, the only way to enter the canyon interior is via Indian-led tours, which offer a chance to experience the majesty firsthand and learn about Navajo life. Look out for pictographs on the canyon walls and inside the ancient dwellings. The popular 4x4 excursions may cover territory but lack intimacy. Instead, join a guide on foot or horseback and slowly descend into the spirit of the place. The park website provides a list of authorized tours and guides.

HOT SPRINGS NATIONAL PARK
History worth soaking up

Natural hot groundwater pools in Hot Springs National Park (above). To sample the waters, head to the grand Arlington Resort Hotel & Spa (opposite), where Al Capone used to hang out.

TRAVELER'S NOTEBOOK

***WHEN TO GO**
The spas and national park are open year-round, but the area is at its most beautiful when the fall foliage comes out to play.

***PLANNING**
Hot Springs sits 55 miles (89 km) southwest of Little Rock. Many visitors fly commercially to Little Rock and rent a car from there. Hot Springs itself has a small airport for private planes.

***WEBSITES**
nps.gov/hosp, hotsprings .org, tgmoa.com, superior bathhouse.com

There's no room for modern life's dizzying pace in Hot Springs, Arkansas —at least not at the north end of town, where the city spills over into a national park. Known in the 1800s and early 1900s as the American Spa, the historic section of town is anchored by Bathhouse Row, where elegant buildings sit atop a paved-over creek of thermal mineral water. These were elaborately constructed between 1892 and 1923, of marble, stained glass, and other high-end materials, a definite upgrade from the original canvas tents and wood-frame bathhouses attracting those who wanted to soak in—and drink up —the healing waters.

Nowadays, Hot Springs is equal parts spa town, historic record, and shopping destination. The National Park Service provides plenty of background on Hot Springs' heritage, but the best way to get a feel for the place is to dive—or really, slip—in and truly soak up the aroma and history. Though the town practically overflows with spas, just two of the original eight— the Buckstaff Bath House and Quapaw Baths & Spa—still use actual hot springs water, providing a historic connection between America's first go-round with spa fervor and our modern-day love of treatments.

▶ VISIT LIKE A LOCAL

Open for soaking since 1912, the (no reservations accepted) Buckstaff provides a how-it-was-way-back-when hot spring experience. Relax in one of the tubs before moving on to a sitz bath or vapor cabinet. For a more luxurious take on the bathing tradition, call Quapaw Baths & Spa to book a private bath time. For more time in the waters, a thermal pools day pass gives access to four tiled community pools that sit under a canopy of stained glass. *buckstaffbaths.com, quapawbaths.com*

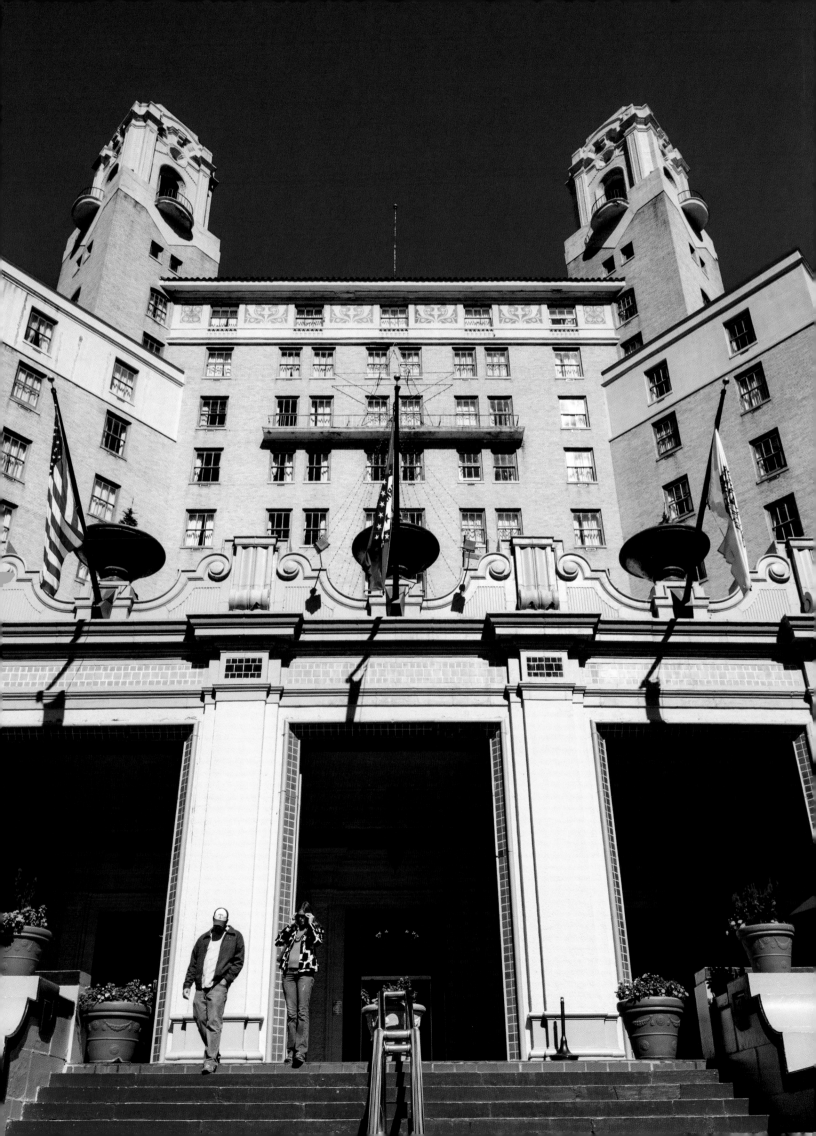

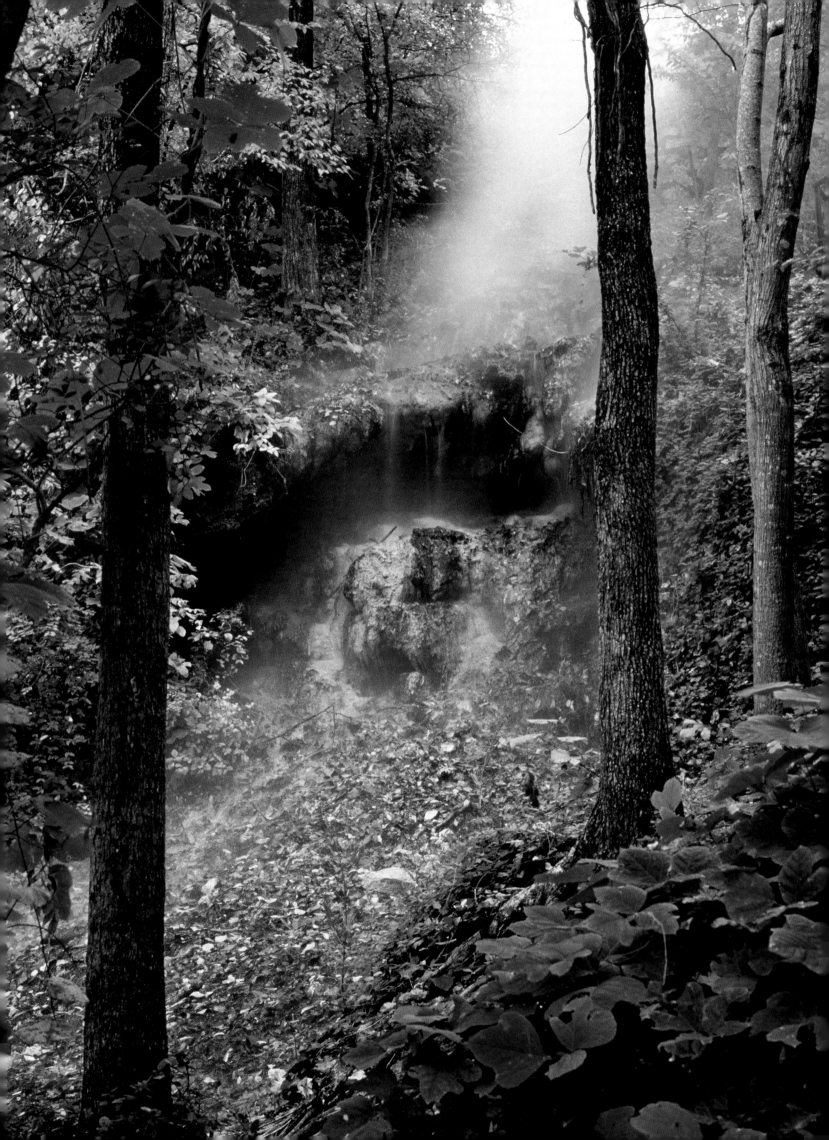

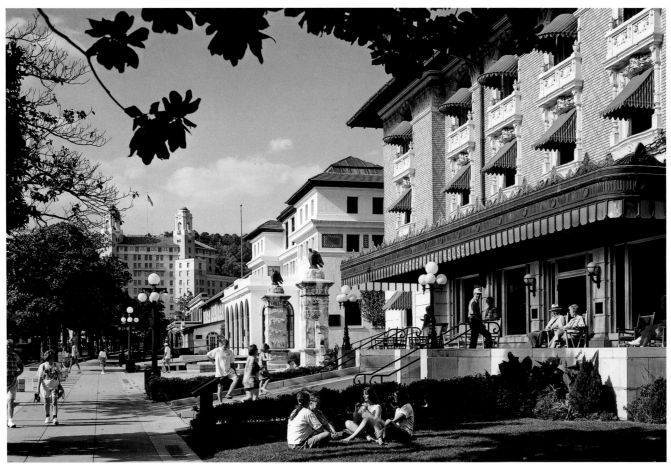

Hot Springs' Bathhouse Row (above) offers a multitude of options to enjoy the area's natural hot springs (opposite), a steamy 143°F (62°C).

But Bathhouse Row isn't the only attraction on Central Avenue, and the town wasn't known just for its hot water—it was also a hotbed of gangster activity and, coincidentally or not, a favorite hangout of politicians aplenty. A wander down the boulevard should include stops at the grand Arlington Resort Hotel & Spa to walk among the columns where Al Capone and his buddies used to hang out, and, for a deep dive into all things illicit, spend some time at the informative Gangster Museum of America.

While the buildings may look suspended in a bygone era, the National Park Service has gone modern with its dedication to finding new uses for some of the former bathhouses. Several contemporary businesses have set up shop in these old spaces, including the Superior Bathhouse Brewery and Distillery—a fine place to top off a bathhouse day with more fiery waters (and a bite to eat).

As you explore, don't be surprised to see people toting water jugs around. Several spigots around town welcome locals and visitors alike to take their waters to go. Even the National Park Service sells memento water jugs in its gift shop. But keep in mind that Hot Springs got its name for a reason—the water runs an average 143°F (62°C).

> *"The birthplace of spring training, Hot Springs welcomed every major league baseball team from 1886 up through the 1940s as players like Honus Wagner, Babe Ruth, and Jackie Robinson came here to get fit."*
>
> – Liz Robbins, *Executive Director, Garland County Historical Society*

▶ UNFORGETTABLE EXPERIENCES

Having soaked out all modern-day angst, head to the former Fordyce Bathhouse for a National Park Service guided tour. Open from 1915 to 1962, the marble-everywhere spa was one of the Row's most luxurious experiences—where, as you'll see, electrotherapy was once part of the luxury massage experience. Then head to the Lamar Bathhouse—now the official park store—for hot spring water products or one of the only National Park Service–logoed bathrobes available in the country.

NEW YORK BOTANICAL GARDEN
Vibrant plant life in New York City

The multipaned Enid A. Haupt Conservatory (opposite) is equally sparkling after dark, particularly during special exhibits such as the springtime Orchid Show (above).

n 1888, married botanists Nathaniel Lord Britton and Elizabeth Gertrude Britton visited the Royal Botanic Gardens, Kew, in London, and were inspired to give New York its own majestic, great garden. The result was the New York Botanical Garden, a sprawling, luxurious 250-acre (101 ha) landscape designed on a native forest site cut through by the Bronx River, with an unparalleled array of more than a million plants and architecturally magnificent historic buildings.

The Garden's crowning glory is the soaring, light-filled Enid A. Haupt Conservatory, an enormous Victorian glasshouse that houses 11 habitats, including American and African deserts, rain forests, and aquatic and carnivorous plants. Also of note and particularly vibrant when burning red and orange in autumn, the Thain Family Forest, at the Garden's center, is the largest remaining piece of New York City's original wooded landscape. The NYBG's 50 gardens include a conifer arboretum, gorgeous in winter snowfalls and resplendent with cherry trees in the spring; a meticulously designed rose garden; and an azalea garden, which erupts into a canvas of bright pink, purple, and coral flowers in late April and early May, intertwined with nearly a mile of walking paths. Truly a year-round delight.

▶ UNFORGETTABLE EXPERIENCES

Every winter, the Enid A. Haupt Conservatory hosts the exquisite Holiday Train Show, a family-friendly extravaganza that kids love and that brings out the child in adults, too. The landmark greenhouse, reminiscent of a glass palace, becomes a vast cityscape, with intricate miniatures of more than 150 New York City landmarks, all made from natural materials and surrounded by lush plant life. Model trains weave among the buildings and chug overhead on bridges that are, like the buildings, uncanny NYC replicas.

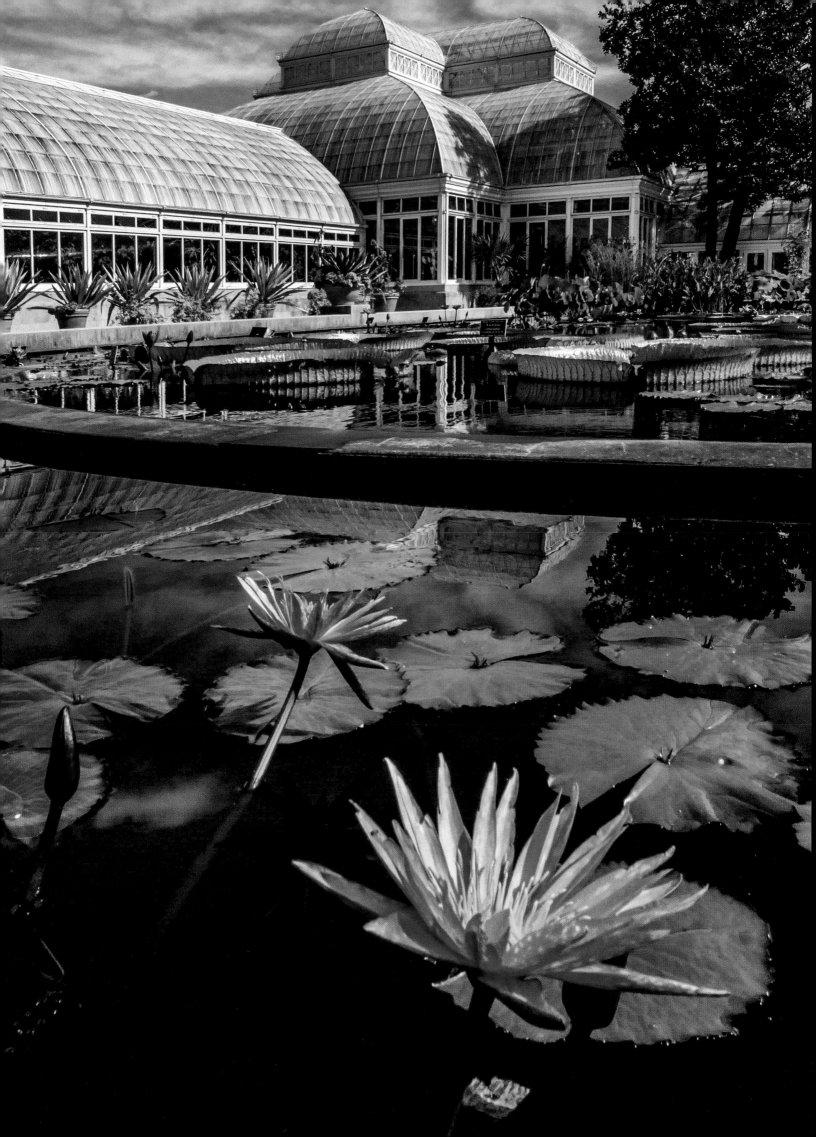

WORLD'S BEST BOOKSTORES

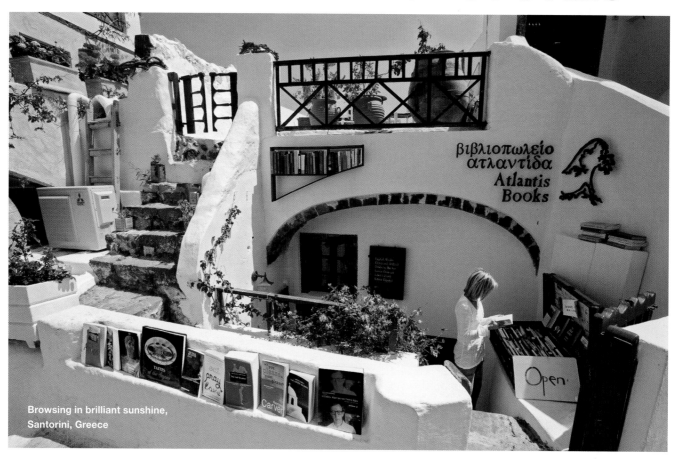

Browsing in brilliant sunshine, Santorini, Greece

Atlantis Books, Santorini, Greece

A decade ago, a group of friends from Cyprus, England, and the United States founded this bookshop, now in a gorgeous home overlooking the water in Oia, Santorini. The store has hosted readings on the terrace, bookbinding classes, and food and film festivals.

Cafebrería el Péndulo, Mexico City, Mexico

This beautiful Mexico City bookstore is large, light, and open, with sagging bookshelves flush with volumes in both Spanish and English and a pendulum suspended from the ceiling. Give it a nudge to trace your literary musings in the air.

Munro's Books, Victoria, Canada

In 1963, exactly a half century before she won the Nobel Prize in literature, Alice Munro cofounded a bookstore with her then husband, Jim. Munro's has since moved into a magnificent, neoclassical former bank, decorated with gorgeous fabrics, in Old Town, Victoria, British Columbia.

El Ateneo Grand Splendid, Buenos Aires, Argentina

El Ateneo's magnificent Buenos Aires home used to serve as a performing arts theater, and it shows: the Grand Splendid has retained the ornate trappings, including frescoed ceilings and red stage curtains.

Powell's City of Books, Portland, Oregon

The flagship of the world's largest independent bookstore chain stretches over an entire city block in downtown Portland. The color-coded rooms are stocked with a huge selection of used and new books; the store also hosts readings, story times for kids, and book groups.

Prairie Lights, Iowa City, Iowa

Iowa City, home to renowned Iowa Writers' Workshop, is drenched in literary life. Prairie Lights is arguably the hub of it all, with readings by star writers and up-and-comers and staffed by famed bookseller Paul Ingram.

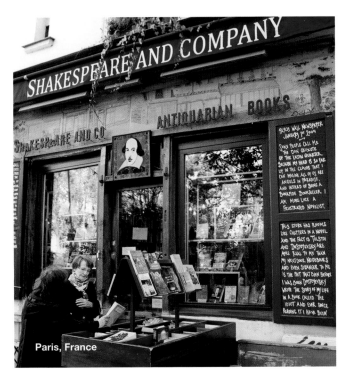

Paris, France

Shakespeare and Company, Paris, France

With its 17th-century facade and rustic decorations, Shakespeare and Company of Paris is a font of old-world charm. It also has a vibrant history: It's been a veritable home to such writers as Allen Ginsberg, Richard Wright, William Styron, and Langston Hughes.

Gertrude & Alice, Sydney, Australia

In 1998, two new friends, inspired by the famous partnership of Gertrude Stein and Alice B. Toklas, decided to open a bookstore. Gertrude & Alice, a cozy shop that's also home to a café, is now a fixture in the seaside Bondi Beach neighborhood of Sydney.

Librairie Avant-Garde, Nanjing, China

Housed in a former underground parking garage and bomb shelter, Librairie Avant-Garde has been transformed into the most beautiful bookstore in China. It also has a ton of reading chairs, so you can snuggle in for the afternoon.

Cook & Book, Brussels, Belgium

Per its name, Cook & Book is a combination restaurant and bookstore near the Metro in Brussels. Nine different spaces offer their own distinct vibes, from a whimsical kids' area to a room with books suspended from the ceiling.

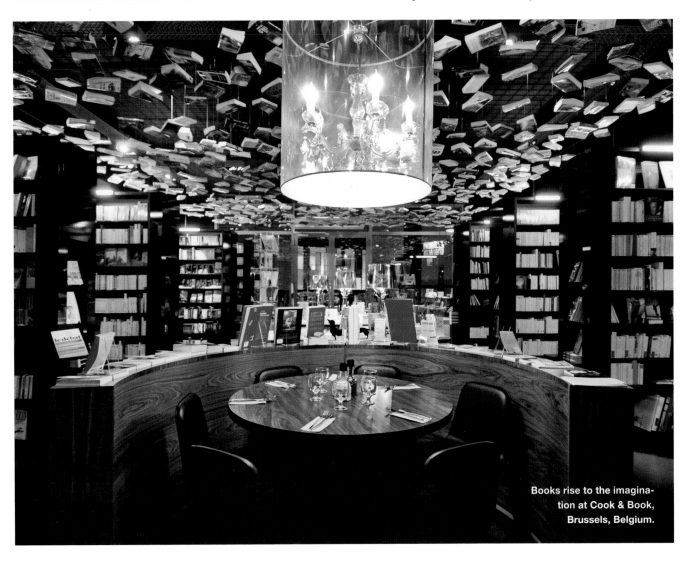

Books rise to the imagination at Cook & Book, Brussels, Belgium.

BLUE RIDGE PARKWAY
Taming Appalachia's rugged ridgeline

Swooping gracefully into valleys from raptorlike heights, the carefully curated vistas of the Blue Ridge Parkway have become iconic American images. Rolling from western Virginia into North Carolina, the scenic road overlooks fields farmed by Native Americans centuries ago, 19th-century pioneer homesteads and mills, and the hazy peaks of the southern Alleghenies. Dubbed America's Favorite Drive, the parkway offers a slow road through a spectacular landscape with its leisurely 45-mph (72 kph) speed limit.

Bridged in stone and curved around the highest peaks in the eastern United States, the 469-mile (755 km) road—commissioned in 1935 and originally built by the Civilian Conservation Corps—took a full half century to complete. Parkway engineers blasted 26 tunnels through the solid mountain rock, leaving other summits to punctuate the views. Landscape architect Stanley Abbott strategically repositioned silvery weathered cabins and other built elements along the course of the highway as he orchestrated a series of pastoral panoramas.

Today's visitors can trace the first blush of purple rhododendrons creeping up the hillsides in spring or contrast the ridgelines' brilliant autumn foliage with still summery meadows below. Period signage guides you to a series of well-maintained hiking trails.

▶ UNFORGETTABLE EXPERIENCES

The Blue Ridge's mountain music traditions enrich its landscape. The Blue Ridge Music Center in Galax, Virginia *(blueridgemusiccenter.org),* includes an outdoor amphitheater and interactive exhibits. Two regional music trails—Virginia's The Crooked Road *(myswva.org/tcr)* and Blue Ridge Music Trails of North Carolina *(blueridgemusicnc.com)*—suggest stages where you can hear spirited performances of old-time, gospel, and string band music and enjoy high-energy clogging and flatfooting.

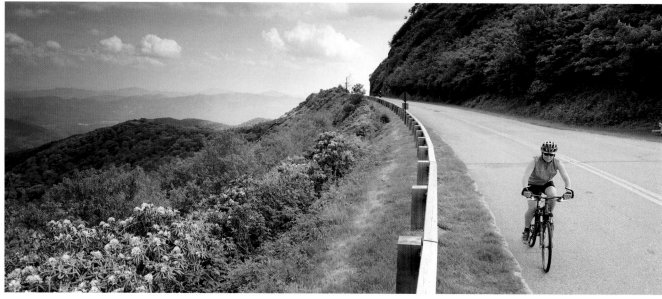

Whatever your mode of transport, the fluid curves of the Blue Ridge Parkway (above) offer beautiful vistas of the southern Alleghenies (opposite).

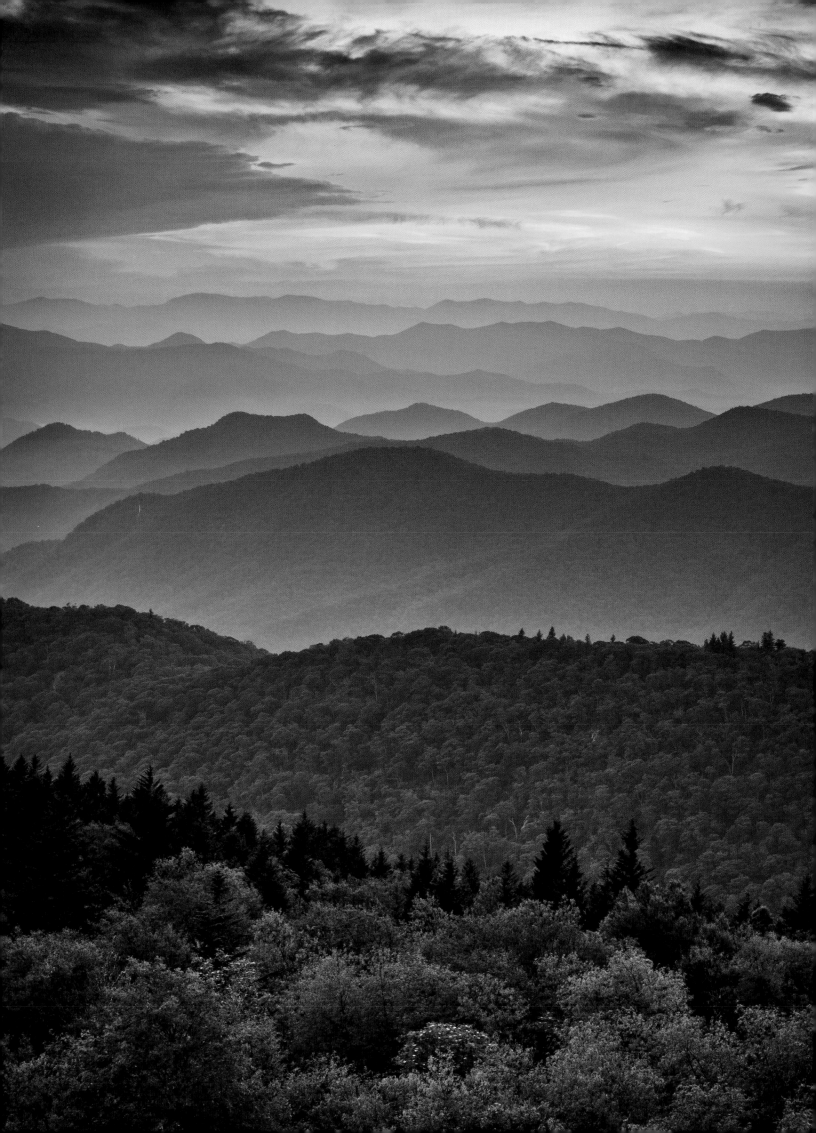

GARDEN DISTRICT
A neighborhood of southern grace

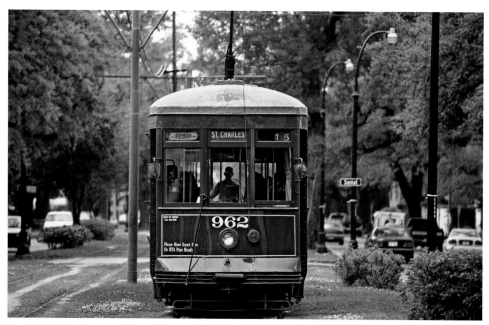

The St. Charles Streetcar (above) is a genteel way to visit New Orleans' gracious Garden District, populated by mansions such as the filigreed Gilmour-Parker House (opposite).

TRAVELER'S NOTEBOOK

❋WHEN TO GO
The district is at its most beautiful in spring, when its namesake gardens are in bloom. Aim for a March or April visit, but be aware Mardi Gras brings enormous crowds. With tropical heat and humidity, it's best to avoid New Orleans during the summer.

❋PLANNING
New Orleans is easy to visit, with major connections by air, rail, and car. The Garden District itself is easily reached from the rest of the city.

❋WEBSITES
neworleansonline.com

Rowdy Crescent City reveals its elegant side in the Garden District, where you can wander streets shaded by palms and live oaks. Once home to a plantation, the district was carved into a residential community of mansions in the 19th century. Over the decades, the large lots filled in with gingerbread Victorians, creating a pleasantly jumbled mixture of styles rubbing architectural shoulders. Like the fine wines served at neighborhood restaurants, its appeal has only intensified over the years. Unlike most of the city, the district emerged from Hurricane Katrina largely unscathed owing to its slightly higher elevation. Money, indeed, flows uphill.

It's fun to stroll by such must-sees as the commanding Robinson House, built between 1859 and 1865 for a tobacco baron; an exquisite fence of ironwork cornstalks; or the storied Lafayette Cemetery No. 1, home to fictional vampires and plenty of believable ghost stories. To the south, Magazine Street can keep shoppers busy all day, with galleries to browse and restaurants to sample.

But the district is perhaps best experienced on a Saint Charles Avenue streetcar, a rolling landmark of polished wood and brass that proceeds just fast enough to generate a cross breeze through open windows. It's the best deal in town.

▶ UNFORGETTABLE EXPERIENCES

In a city famous for restaurants, Commander's Palace occupies another league. The Victorian mansion where stellar chefs like Paul Prudhomme and Emeril Lagasse both did duty is a must-stop for any foodie. The elegant setting could be nowhere but New Orleans, with Audubon Park scenes painted on the wall. The weekend jazz brunch is a meal you'll remember for decades, with classics like turtle soup, pecan-crusted Gulf fish, and legendary Creole bread pudding soufflé. *commanderspalace.com*

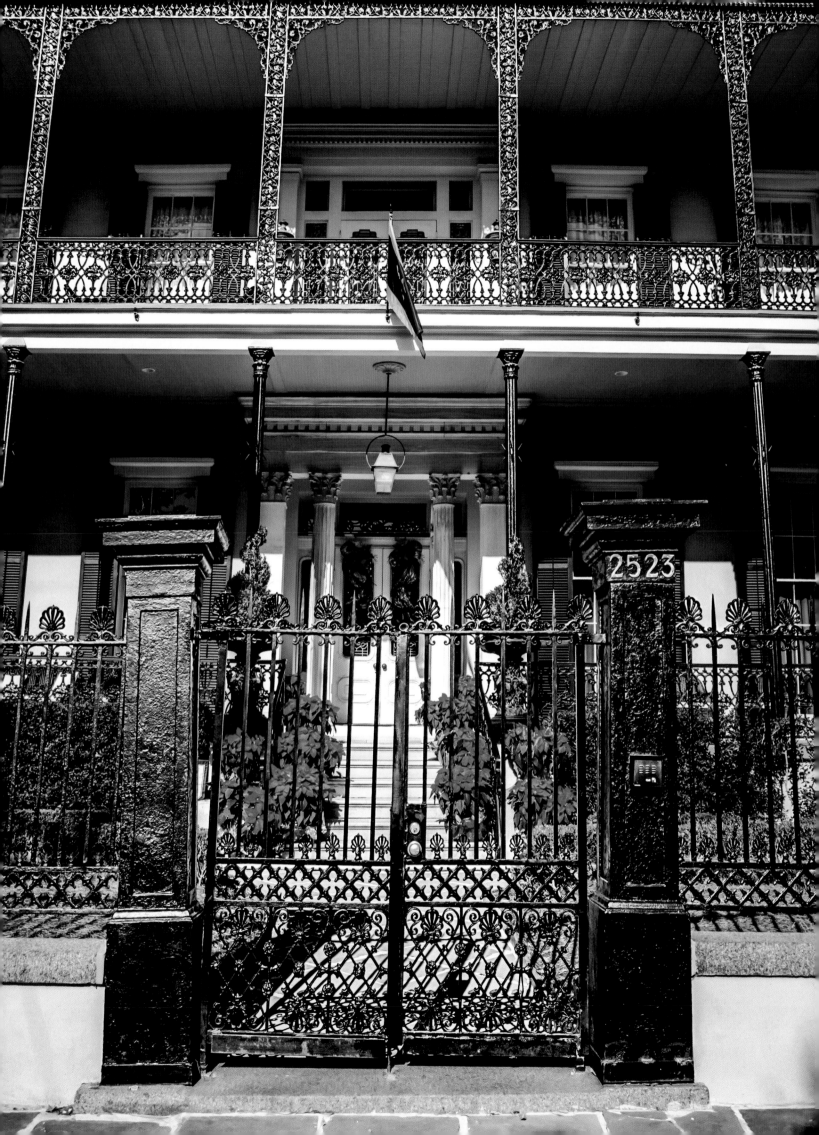

COBÁ

Soaring temples and astonishing white roads

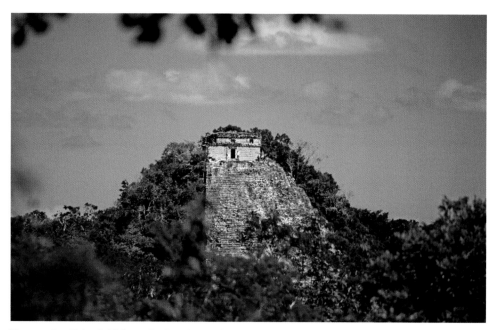

The massive Nohoch Mul temple, from its perch at 137 feet (42 m) the tallest pyramid in the Yucatán Peninsula, rises above the jungle-embraced ancient Maya city of Cobá (above and opposite).

Hidden deep within the jungle of the Yucatán Peninsula lies a forgotten piece of Maya history: the ancient city of Cobá. The Maya flourished here for hundreds of years between about A.D. 600 to 1500, at the heart of a powerful trading ring that linked the Caribbean coast and inland cities and competed with nearby Chichén Itzá. Finally a new road in the 1970s connected tourists to the largely unexcavated ruins of this extensive complex that at its peak stretched over 50 miles (80 km) and was home to some 50,000 people.

In the Mayan language, Cobá means "water stirred by wind." The inland city was named for its two large lagoons, Lago Cobá and Lago Macanxoc, that supplied water to its busy settlements. Some archaeologists estimate more than 6,000 original structures, ranging from temples to ball courts, still exist within the vast site. Towering above them all is the main pyramid, Nohoch Mul, meaning "large mound" in Mayan. At more than 130 feet (40 m) in height, the massive pile of crumbling gray stone is the tallest pyramid in the Yucatán Peninsula.

Linking the settlements to Nohoch Mul and each other is Cobá's most striking and unusual feature: the *sacbe,* or white roads. Made with limestone between 10 and 30 feet (3–9 m) wide, these roads form the largest network of stone causeways of the classic Maya

▶ **UNFORGETTABLE EXPERIENCES**

A visit to Cobá isn't complete without summiting its principal pyramid, Nohoch Mul. The 137-foot-high (42 m) pyramid is the tallest in the Yucatán Peninsula, and visitors are welcome to climb it. Scrambling up (or down) its very steep, 120 stone stairs in the tropical heat is no easy feat, but climbers who reach the top are rewarded with magnificent views over the surrounding jungle canopy—a vast, unbroken sea of green that stretches to the horizon.

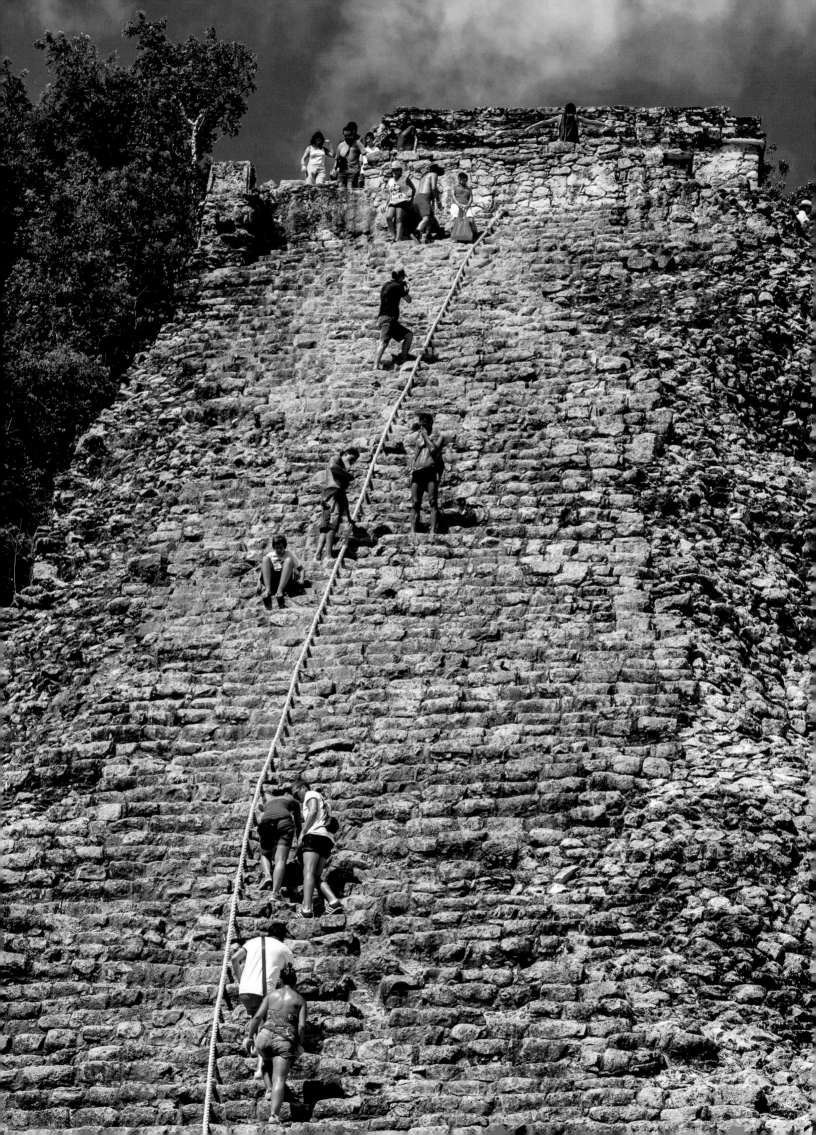

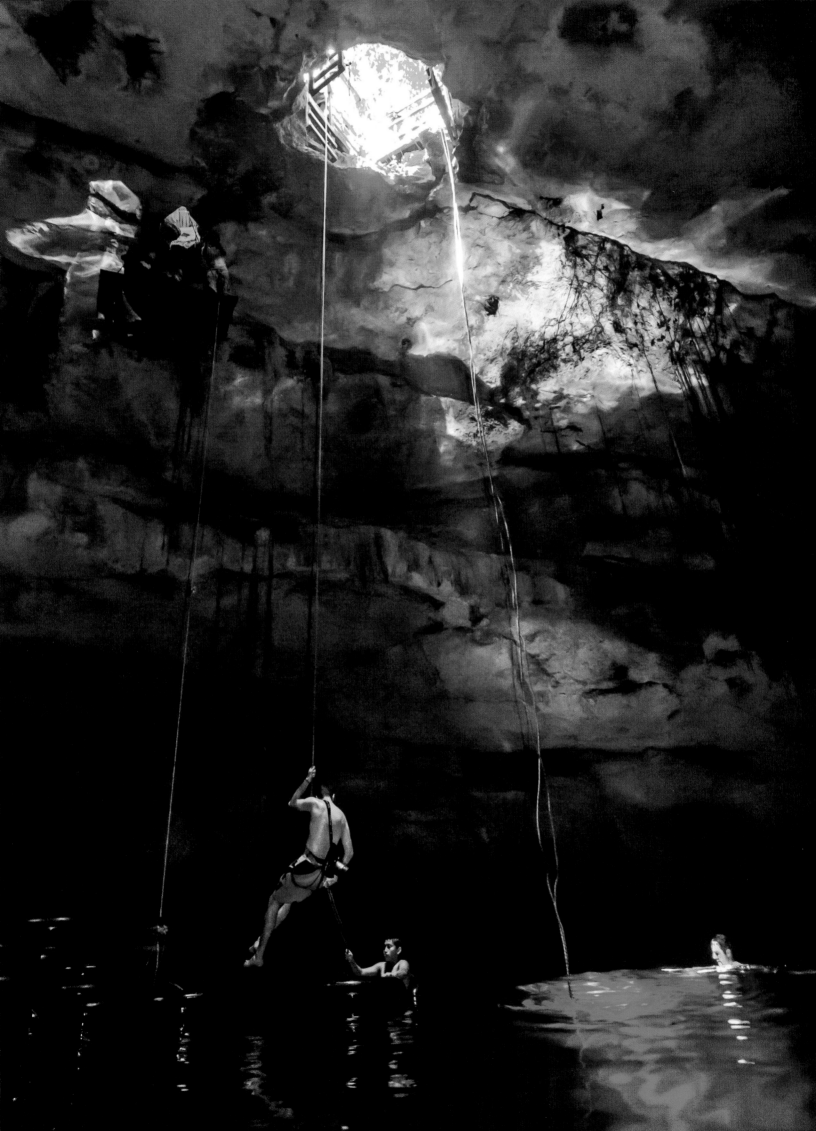

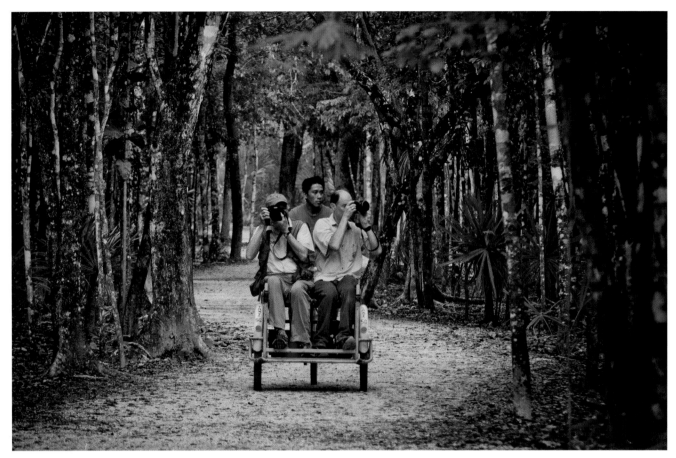

Guided pedicabs tour along Cobá's famed *sacbe,* an extensive network of white roads made of crushed limestone (above). The cool waters of a nearby subterranean cenote (opposite) provide relief from Mexico's hot sun.

world. Solidly built to withstand the elements and elevated from about 1.5 to 8 feet (0.5–2.4 m) above the forest floor, the sacbe radiate outward from the city in remarkably straight lines. The longest of the roads runs some 60 miles (97 km) in a direct path to the ancient city of Yaxuná.

But the ancient Maya did not use the wheel for transportation, so why expend such intensive time and effort to build such elaborate roads? Perhaps they had a ritual purpose now lost in time. Or they may have made it easier for residents to travel and transport goods, particularly at night when temperatures dip and the white limestone glows softly in the moonlight, illuminating a clear pathway through the dark forest.

For modern-day visitors, the sacbe form the perfect road map for exploring the city. The wide avenues cut through the dense underbrush, allowing you to be free to stroll beneath the jungle canopy between the three major areas open to the public, accompanied by tropical birds and howler monkeys. To beat the heat, rent a bicycle or hire a tricycle pedicab to be royally pedaled about—leaving you more energy to attempt the dizzying climb of Nohoch Mul.

"Cobá is a very special place. It's very lush with plant life, lakes surround the site, and the stars at night are very bright—there is a peacefulness about the ruins."

– Eric Werner, *chef*

VISIT LIKE A LOCAL

After trekking throughout Cobá's vast complex, cool off with a dip in the turquoise waters of one of many cenotes—cooling subterranean swimming holes that were revered by the Maya. The underground cavern of Choo Ha cenote, a short drive from Cobá, is ringed by stalactites and stalagmites. Or try the recently opened Multum-Ha cenote; its name means "hill of stones in the water," which here look like a Maya ruin. You can descend nearly 60 feet (18 m) down wooden stairs to reach its crystal-clear pool.

MACHU PICCHU
The mysterious aerie of a lost, ancient civilization

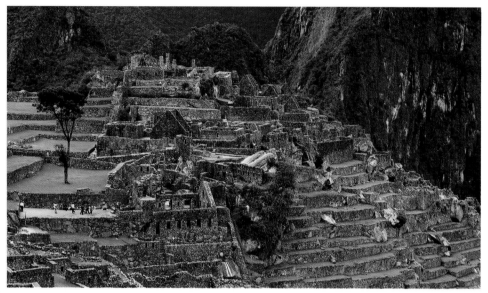

The haunting ruins of Machu Picchu (above and opposite). The complex, built around 1450 using precisely cut granite, without mortar, was perhaps used as a royal retreat.

Few places match the allure of the cloud-scraping settlement of Machu Picchu, its name meaning "old peak" in the native Inca Quechua language. Its isolated jagged mountain setting and its mysterious significance in ancient Inca lore make this city one of the world's most fascinating and spiritual destinations. Luckily for present-day explorers, this mystical place was somehow overlooked by the plundering Spanish conquistadores who destroyed the pre-Columbian Inca Empire in the early 1500s. It remains the most intact vestige of this South American culture, a window into one of the world's most important civilizations.

Also called the "lost city of the Incas," Machu Picchu is considered to have been a place of ritual, built around 1450 at the empire's height, but its true purpose remains unknown. Constructed without mortar, the structures of precisely cut granite stones were perhaps commissioned as an elaborate royal retreat for the Inca emperor Pachacuti, a cooler refuge for his court and entourage close to the imperial capital of Cusco yet protected by deep ravines and steep mountains. By the late 1500s the site was eventually abandoned from official royal or religious usage, following the destruction of the Inca Empire.

Local Indians continued to till its surrounding irrigated, terraced fields for centuries; then a local child brought American explorer Hiram Bingham to the mountaintop in 1911. The

▶ UNFORGETTABLE EXPERIENCES

There is only one hotel directly at Machu Picchu, the modern, rustic-luxurious Belmond Sanctuary Lodge, decorated in wood and in earth tones, situated right at the gate to the complex. Almost all other tourists who arrive at Machu Picchu are bussed there. Set amid lush gardens, the Sanctuary allows you to witness spectacular sunrises and sunsets without the crowds of day-trippers, feeling at one with the ancients. Most rooms provide breathtaking views of the surrounding verdant mountain peaks. *belmond.com*

legendary site had been on local maps for decades, and lesser known adventurers may have reached it a few years before, but Bingham was credited for the "discovery" of what was hardly a mystery to natives at all. Controversy and jealousy ensued during excavations, with locals rightly worried their precious heritage would be exported to other countries. Today the complex continues to yield new finds, including a series of tombs as well as buildings on surrounding mountains and ledges. The entire protected area encompasses 80,000 acres (32,375 ha) of land. Set under two high peaks is the Citadel, a grassy plateau of now partly rebuilt stone temples made from cut white granite, with trapezoidal windows, irrigation terraces, and winding stairs. The Temple of the Sun is the main highlight, even in ruins, with its central rounded tower built over protruding granite bedrock that may have served as an altar. The Inti Watana, thought to be part of an astronomic clock or calendar, also dominates the ancient retreat.

As a whole the site, built more than 7,900 feet (2,408 m) above sea level, imparts a sense of tranquillity, particularly away from the main areas patted down with the feet of the thousands who have visited for more than a century. To break the silence, stand on the edge of the cliffs and listen to the roar of the Urubamba River thousands of feet below.

> *"Machu Picchu happens to be one of the most enigmatic, spiritual, beautiful, and mysterious places on earth and we Peruvians are very proud to be part of its legacy to the world."*
>
> – Ylan Chrem, *Lima tour operator*

▶ VISIT LIKE A LOCAL

Plan ahead to be at Machu Picchu for June 24, when locals celebrate the Inca sun festival Inti Raymi, one of the most important of the ancient festivals. This is also the Catholic feast of St. John, also known as Day of the Indian. Ceremonies including dancing and the reenactment of ancient rituals in traditional garb abound throughout the city and are centered on the old Inca Sun Temple, or Coricancha, now the site of the Church of Santo Domingo.

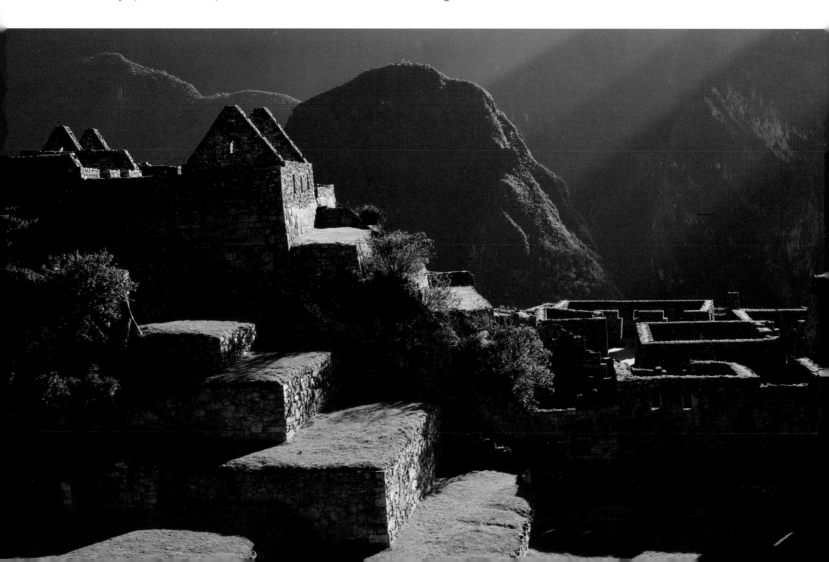

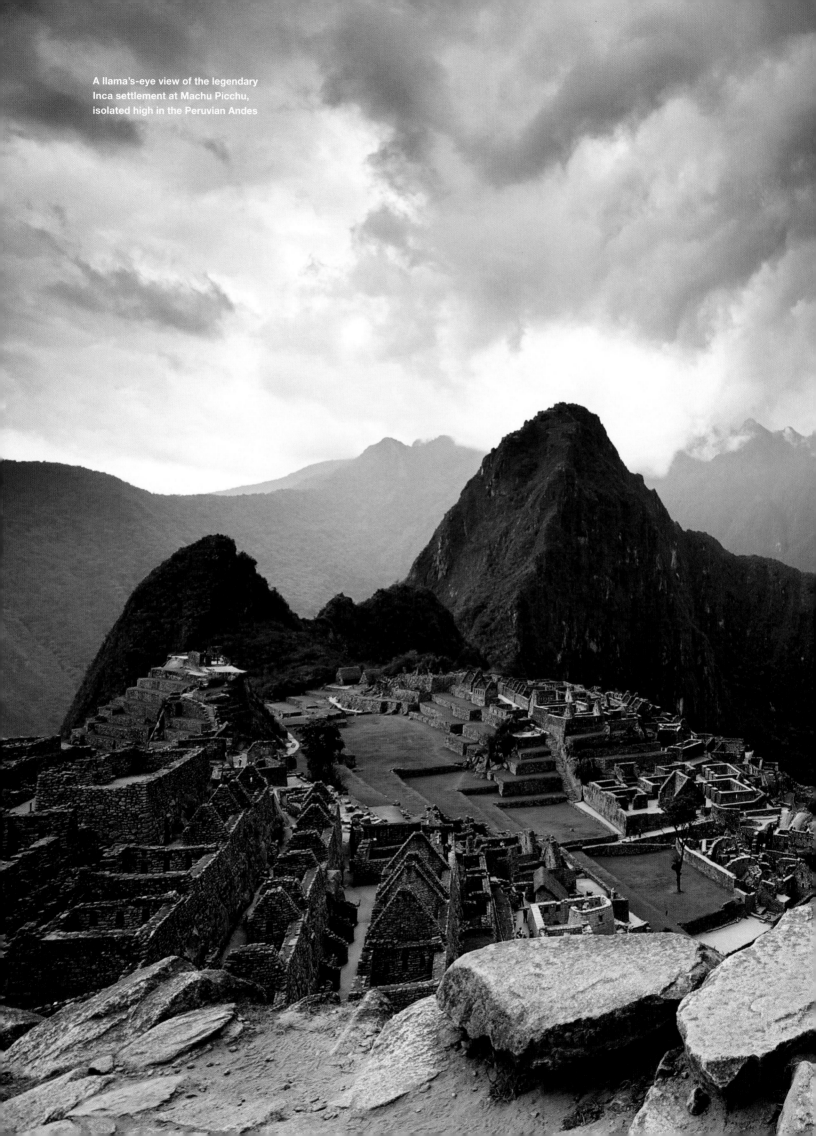

A llama's-eye view of the legendary Inca settlement at Machu Picchu, isolated high in the Peruvian Andes

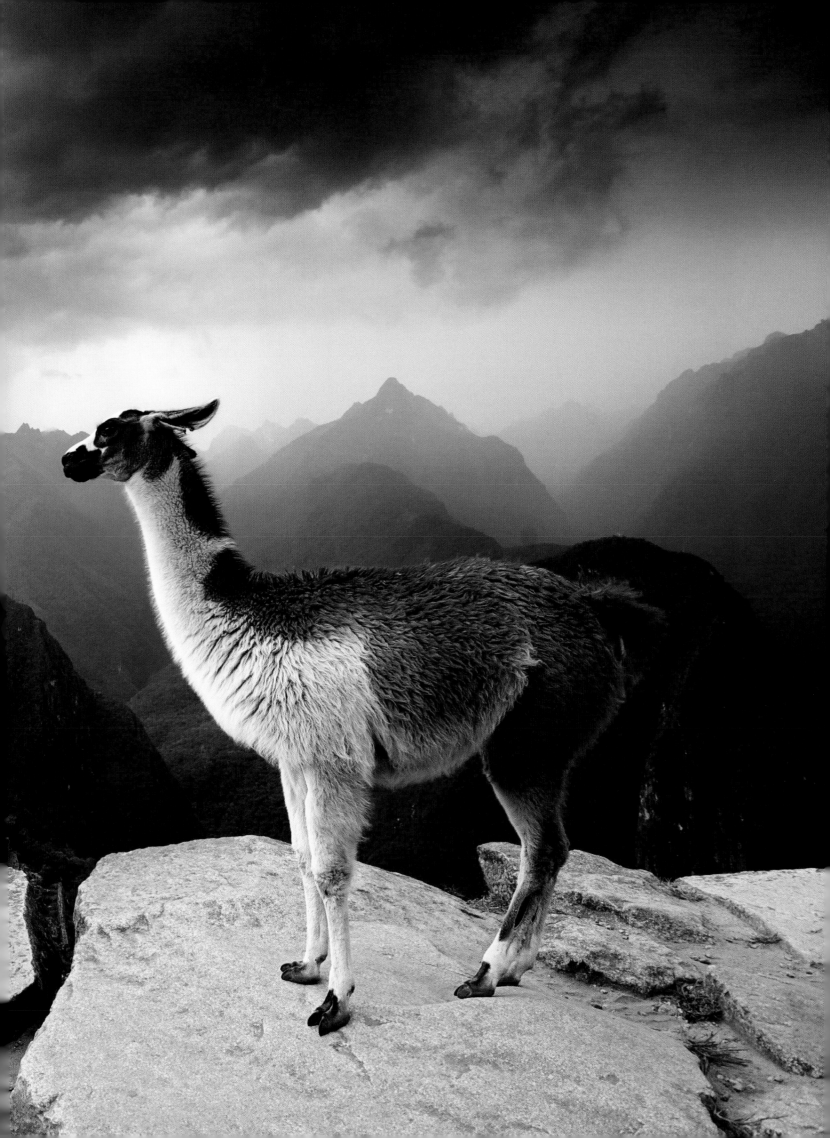

EASTER ISLAND
Where giant heads stare mournfully at the sea

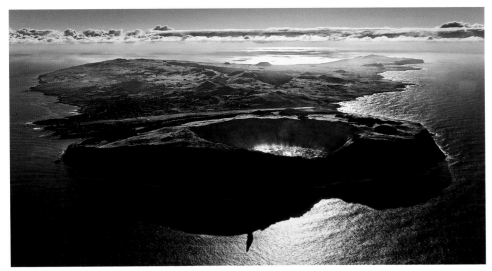

Three volcanoes, quiet now, formed Easter Island (above and opposite) half a million years ago. Polynesians settled here during the first millennium, leaving a legacy of nearly 900 stone heads, called *moai*.

TRAVELER'S NOTEBOOK

∗WHEN TO GO
It's best to visit Dec.–March, which is summer in South America, when temperatures will be in the 80s (26°–31°C) and relatively dry. Plan early to time your trip for the festival season late Jan.–early Feb.

∗PLANNING
Hanga Roa is the capital of Easter Island, connected to Santiago by LAN Airlines every day. It takes less than five hours for the 2,335-mile (3,757 km) trip.

∗WEBSITES
chile.travel, easterisland.southpacific.org, easter islandspirit.com, lan.com

Perhaps the most remote of all inhabited islands, Easter Island—named by the first Dutch explorer to match his date of arrival in 1722—was settled long ago during the first millennium by Polynesians who thought of the volcanic island as the navel of the world. Known as the Rapa Nui, the indigenous people created the nearly 900 giant *moai*, or stone heads, their expressions stoic and pinched, with prominent brows and noses and slit-lipped faces. All are nearly nude men, with tiny arms over what appear to be bellies, just above carvings that give the sense of an ornamental belt around what would be waists, their legs almost an afterthought. Rising on average some 13 feet (4 m) and each weighing about 14 tons (12.7 tonnes), it must have taken enormous effort to carve even a single figure out of the hard volcanic ash, let alone to transport it into position upright atop an *ahu*, or stone platform. No one really knows what compelled the creation of this huge collection of statues here, but the intense logging that went along with using logs to roll them into place was an ecological disaster for the isolated island, with trees stripped away and agriculture laid to waste.

Today much of the island is protected within Rapa Nui National Park. Its most enigmatic area is Rano Raraku, the volcanic crater that served as quarry for the immense stone faces. Scattered along its slopes nearly 400 heads, in various stages of carving, seem to be marching to the ocean, stuck frozen in their path and sinking back into the ground.

▶ **UNFORGETTABLE EXPERIENCES**

Much of the Rapa Nui culture has disappeared, but late January and early February bring reenactments of the Tangata Manu, or Birdman festival—part of the larger Tapati Rapa Nui Festival—where the island's population revives ancient traditions of dance, song, and competitions of strength and bravery. Where strong men once competed to retrieve sooty tern or manu tara eggs and swim back to shore, today local athletes race reed canoes and run against each other carrying heavy loads of bananas up volcano slopes.

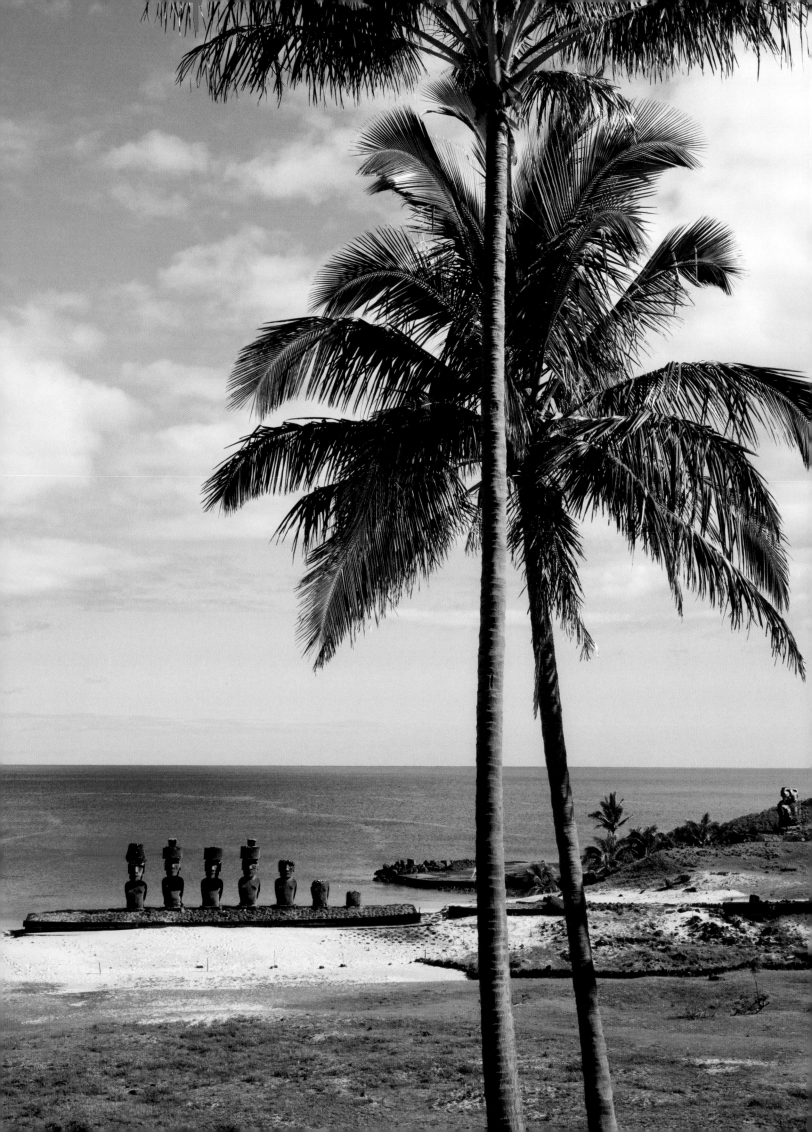

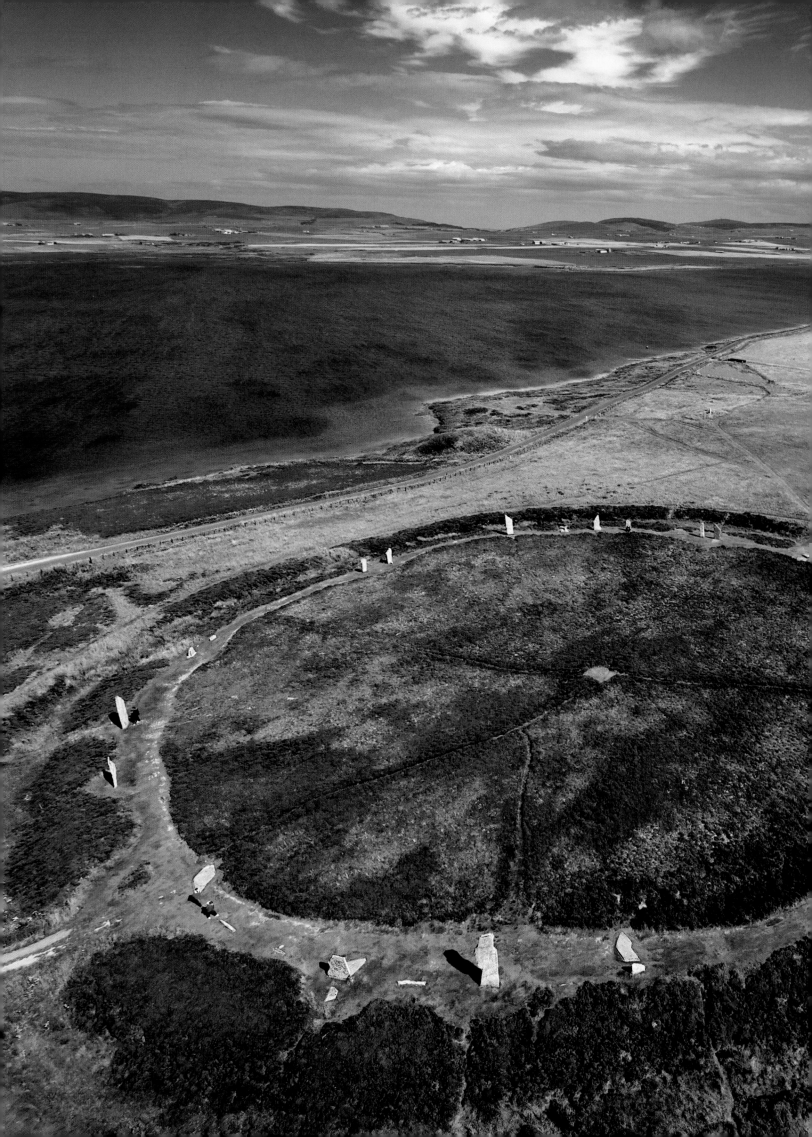

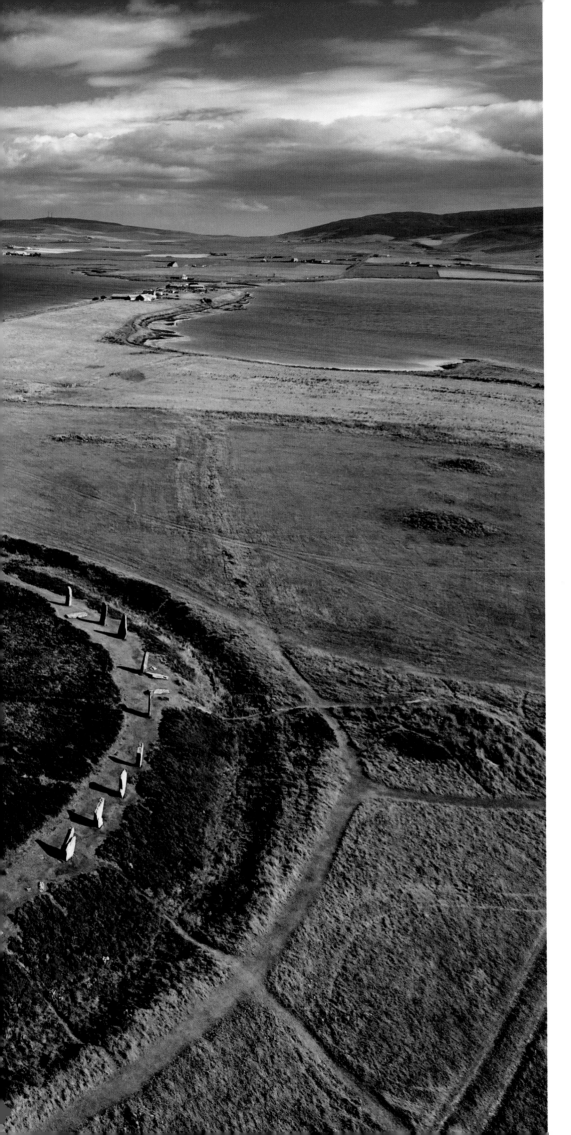

MY SHOT

Orkney, Scotland

From 100 feet (30 m) in the air, the Ring of Brodgar stands out like a beacon from another age—and it is. My camera, dangling from a kite, caught the great Neolithic stone circle on a narrow neck of land in the Orkney Islands. I was thrilled to see it from this vantage, as the sea eagles soaring overhead might have five thousand years ago, when the ancient stone circle was part of a sacred pilgrimage route to a temple complex and ancestral tombs nearby.

– Jim Richardson,
National Geographic
photographer

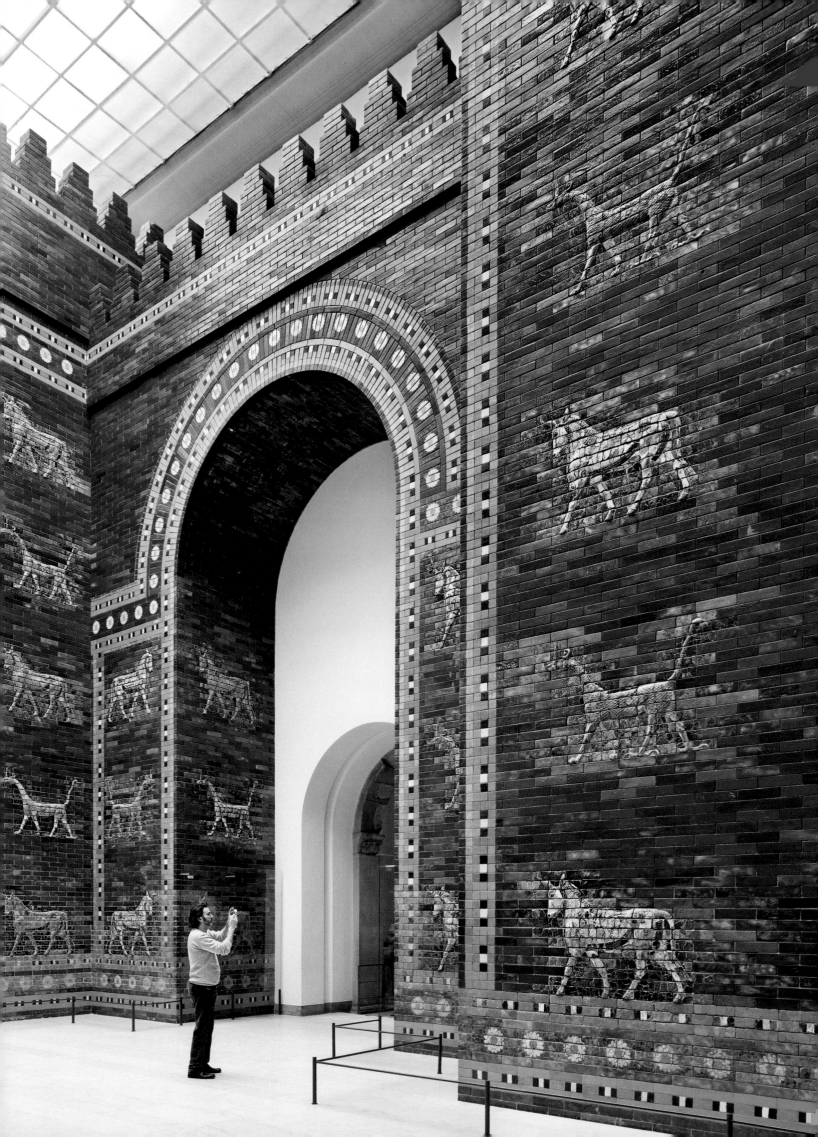

BERLIN, GERMANY

MUSEUM ISLAND
Classic antiquities in an avant-garde city

The famed bust of Nefertiti, dubbed the "most beautiful Berliner," is star of the Neues Museum (above). Nearby, the imposing Ishtar Gate rises again at the Pergamon Museum (opposite).

Thanks to Germany's interest in archaeology at the turn of the 20th century, Berlin has amassed an embarrassment of antique riches, many housed in impressive buildings cradled by the Spree River on what is known as Museum Island. As you roam their vast galleries filled with restored monuments from around Europe and the Near East, appreciation of their beauty and age is in some cases dwarfed by awe of their sheer scale.

One memorable experience is walking through the massive 46-foot (14 m) Ishtar Gate at the Pergamon Museum, famous for its eponymous Greek temple. Constructed around 575 B.C. and later reduced to rubble, the Babylonian gate is here reconstructed to its former glory, with glazed tiles made from precious lapis lazuli stones interspersed by lions, aurochs, dragons, and other significant symbols. Nearby, the Neues Museum, specializing in Egyptian and Etruscan sculptures, is home to the 3,300-year-old bust of Queen Nefertiti, which locals praise to be the "most beautiful Berliner." The stately, neoclassical Altes Museum contains Greek and Roman antiquity, while the eclectic Bode Museum brings together Byzantine art with a precious-coin collection. Particularly now, as its multidecade renovation plan is under way, this cluster of buildings housing ancient treasures sets the world standard in celebrating and conserving world heritage for posterity.

TRAVELER'S NOTEBOK

*WHEN TO GO
As a city, Berlin is a year-round destination with plenty to do any season. Summers are especially glorious, with long days and warm weather that bring out the best in the city and its people.

*PLANNING
The public bus 100, a route served by a double-decker, connects Berlin's many famed sites, including the Alexanderplatz TV tower, Brandenburg Gate, the Reichstag, and Museum Island.

*WEBSITES
visitberlin.de/en/spot /museum-island, whc .unesco.org/en/list/896

▶ VISIT LIKE A LOCAL

Lines to get into Museum Island's exhibitions can often stretch for hours. With the current renovation work at the Pergamon, the queue has only grown longer. To skip the long wait, purchase a time-slotted ticket in advance, which grants the purchaser a window of 30 minutes to enter the museum. Holders of a Museum Pass *(berlinpass.com),* which opens doors to more than 50 attractions, including the museums on Museum Island, for three days should also sign up online for an appointment for free entry.

THE ALHAMBRA
European Islamic architecture at its most sublime

The sheer walls of the Alhambra citadel—described by Moorish poets as "a pearl set in emeralds"—rise majestically amid cypress and elm forests. Framed to perfection by the peaks of the Sierra Nevada behind, this fascinating multibuilding complex overlooks the Spanish city of Granada.

Although certainly impressive from the outside, the real splendor of the Alhambra lies within. Interconnected by irrigated gardens, quadrangles, pillars, and porticoes, these Mudéjar palaces are a frenzy of elaborate geometrical designs covering every available surface. Exquisitely carved wood and stucco, interlocking glazed *azulejos* (tiles), arabesque reliefs, and cedar wood marquetry ceilings overwhelm the senses at every turn.

Rebuilt in the 11th century by Muslim emirs, Calat Alhambra (meaning Red Castle in Arabic) reached its zenith in the 14th century, when the Nasrid kings, the last of the Moorish dynasties to rule on Iberian territory, added the magnificent palace compound. Their mission: to create a piece of paradise on earth. The gentle sound of running water, scintillating fountains, still pools reflecting the blue Andalusian skies, and the recently renovated Court of the Lions—with its 124 slender marble pillars and breathtaking filigree walls—ensure the spirit of the emirs lives on.

▶ UNFORGETTABLE EXPERIENCES

No trip to Granada and the Alhambra would be complete without a hike through the narrow cobbled lanes of the Albayzín quarter to the Mirador de San Nicolás. This is the place of the picture postcards, the Alhambra perched on its hill with the majestic, and often snowcapped, Sierra Nevada as a backdrop. If possible, time your arrival for sunset, when the distant palace is tinged golden orange, the cafés are buzzing, and the Spanish guitars and dancers are out in force.

⟫ TRAVELER'S NOTEBOOK

✴WHEN TO GO
For most amenable temperatures visit in spring or autumn. In summer, remember sunblock, as temperatures can climb over 100°F (38°C); winter requires a warm jacket.

✴PLANNING
International flights land in Malaga, 90 minutes by car, or in Madrid or Barcelona, from where there are connections to Granada. The number of visitors to the Alhambra is limited, so it is important to book in advance, especially April–June, as tickets often sell out.

✴WEBSITES
alhambradegranada.org/en, whc.unesco.org/en/list/314, renfe.com

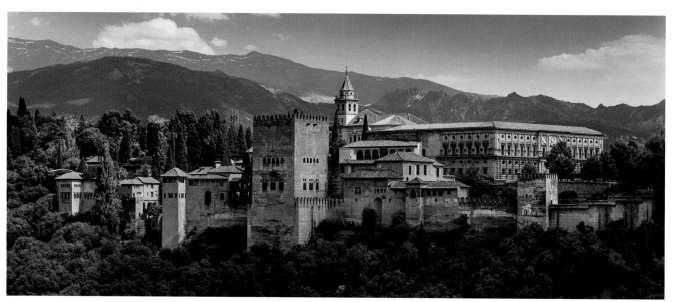

High above the city of Granada, the glowing walls of the Alhambra (above) comprise multiple Moorish palaces connected by gardens, porticoes, and pools, as in the Court of the Myrtles (opposite).

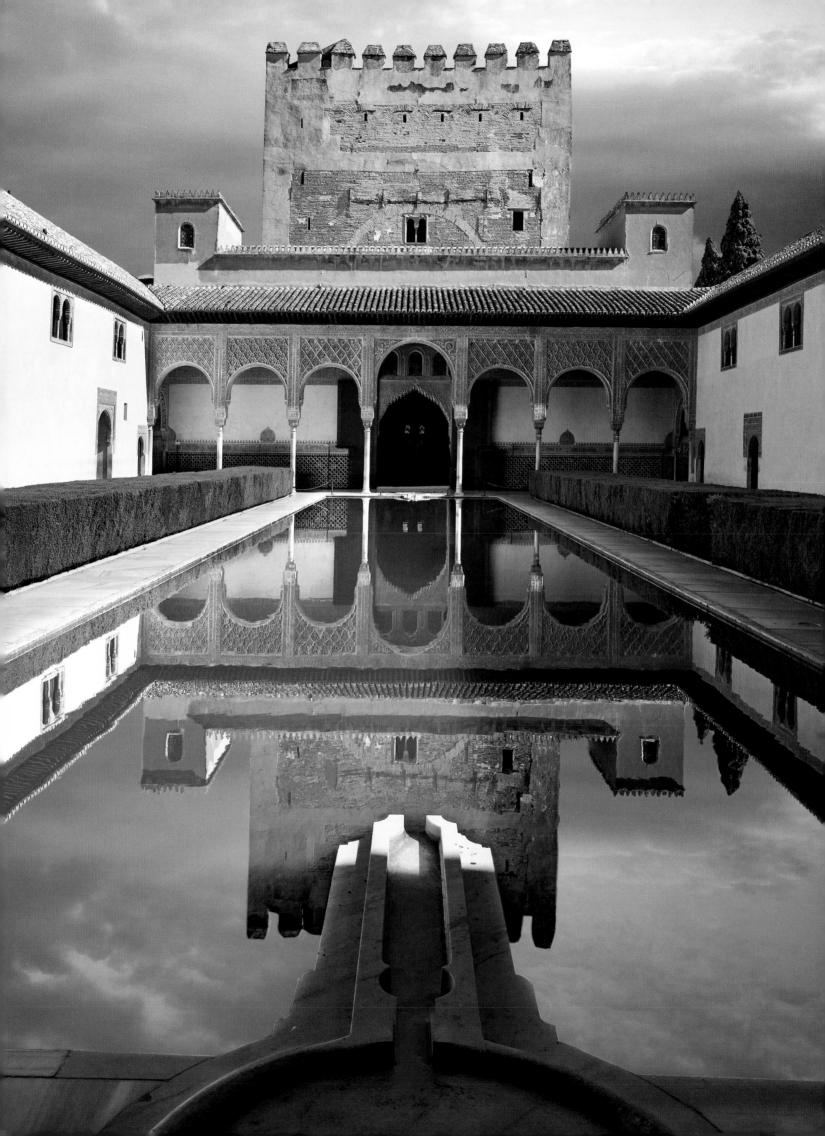

SAGRADA FAMÍLIA

A dazzling monument to ingenuity and faith

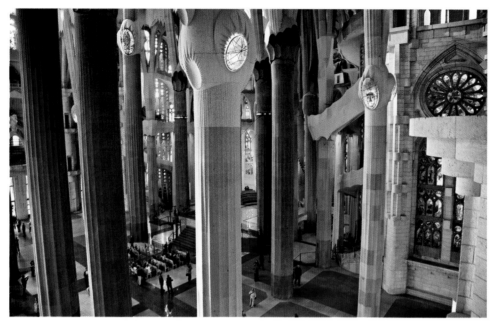

The talent and passion of Catalan architect Antoni Gaudí take form in the soaring carved columns and swirling towers of Barcelona's beloved Basilica of the Sagrada Família (above and opposite).

Well over 100 years in the making, Spain's most beloved icon—the fantastically outlandish Basilica of the Sagrada Família in Barcelona—has entered a new phase of its tumultuous existence. Although the ever present towering cranes continue to carry out the whimsical plans of Catalan architect Antoni Gaudí long after his death, the otherworldly building can now hold religious services, fulfilling its true purpose as a Roman Catholic basilica.

Gaudí, a devout Catholic, once described his masterpiece as an expression of the "divine history of the salvation of man through Christ incarnate." His passion can be seen in the countless elements that ornament the church, ranging from grandiose twirled towers dedicated to the Apostles to delicate stained-glass windows depicting the Resurrection. Its consecration as a minor basilica by Pope Benedict XVI on November 7, 2010, attended by nearly 60,000 people inside and out, cemented its position as a pillar of the faith as it edges toward its target completion date of 2026. The nearly 150-foot-high (46 m) central nave, renowned for its carved columns soaring like stylized trees, now hosts daily Mass in Spanish and Catalan, as well as welcoming thousands of fascinated daily visitors.

▶ VISIT LIKE A LOCAL

After dark, when the hordes of tourists depart, the grounds of the Sagrada Família are blissfully quiet. It's the perfect time to contemplate the church's perforated and sculpted multifaceted facades, brilliantly illuminated at night. Relax in the two parks that bookend the basilica, the Plaça de la Sagrada Família, facing the Passion facade and holding a tree-filled garden featuring about 150 rosebushes, or the Plaça de Gaudí, with its large pond that reflects the marvelously intricate Nativity facade.

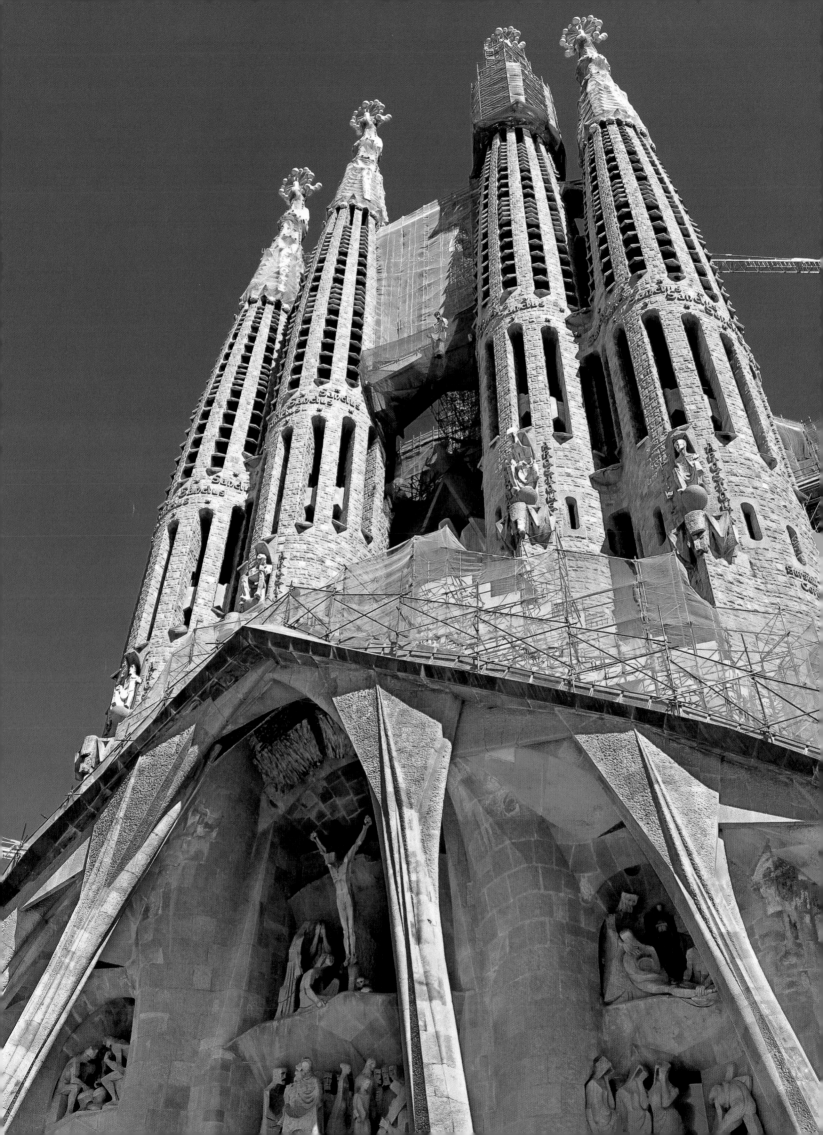

CINQUE TERRE

Five medieval towns hanging over the Mediterranean

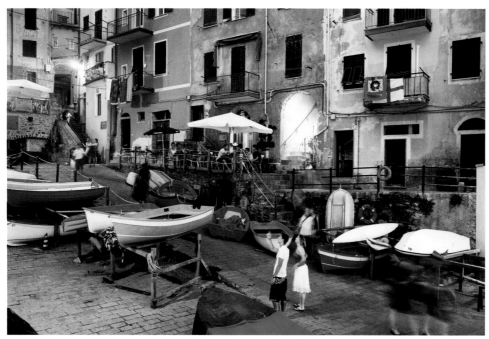

The five picturesque towns that compose Cinque Terre hold their own special appeal, from the pastel colors of Riomaggiore (above) to the beach at Monterosso al Mare (opposite).

TRAVELER'S NOTEBOOK

*WHEN TO GO
Summer months are hot and crowded—try for late spring or early autumn. If possible, avoid the very crowded month of August and Italian national holidays.

*PLANNING
Cars aren't allowed in the towns. From the airport in Genoa, catch the train to La Spezia. A local train runs frequently to link the villages of Cinque Terre, with stops about five minutes apart. A footpath also connects all five villages, but check with the park before visiting to make sure all segments are open. A boat ferry also connects all the villages but Corniglia, which doesn't have water access. cinqueterre.eu.com/en/boat-excursions

*WEBSITES
parconazionale5terre.it, cinqueterre.eu.com

n the Italian Riviera, five medieval villages cling to the rocky coastline of the Ligurian Sea, an arm of the Mediterranean. The hills rising sharply behind them were carved into agricultural terraces in the 12th century, with arable strips of land contained by drystone walls built of sandstone and beach pebbles. These thousands of miles of walls, nearly the length of the Great Wall of China, have allowed villagers over the years to make their livelihood cultivating grapes and olive trees, along with fishing.

Strung out over 9.3 miles (15 km) of the rugged coast, the towns and terraces of Cinque Terre are a marvel of human audacity and medieval engineering. The pastel-colored houses of Manarola and Riomaggiore are stacked into crazy tiers that step down the stony terrain to the sea. Corniglia, the only town without sea access, is perched on a rock promontory more than 300 feet (91 m) over the sea. Make your way through the villages via steep stone staircases and narrow cobblestone streets—cars are not permitted—flanked by yellow-, blue-, and salmon-colored homes. A local rail line connects the towns efficiently, and a system of footpaths traverse the hilly terraces above. These trails are challenging hikes, but the views are spectacular—buildings dangle over the water far below, and the green

▶ **UNFORGETTABLE EXPERIENCES**

The most stunning views of Cinque Terre are from far above. Walk the steep No. 3 trail (part of an old mule track once used to transport goods to and from La Spezia) from Riomaggiore up to the 14th-century church Santuario della Madonna di Montenero. The views from the top are dizzying—the Ligurian Sea stretches off into the horizon, and all five villages are within view far below. It's a heart-pounding climb of more than 1,000 feet (305 m) to the top, so be prepared with water and sturdy shoes.

cultivated terraces of vines and orchards climb steeply up the hills behind. If you think you're out of breath, consider the exertions of the laborers, who for centuries have grown, harvested, and packed 50-pound (23 kg) baskets of grapes up and down this unforgiving terrain.

The towns of Cinque Terre were built around monumental medieval buildings still standing today. A medieval castle overlooks the bay in Vernazza, and you can visit its watchtower, used by villagers to scan the horizon for the pirate ships that threatened the coastal region. The Ligurian Gothic church of San Pietro still anchors Corniglia, and the waterfront church of Santa Margherita d'Antiochia remains Vernazza's spiritual center. Worth the climb are the 17th-century Capuchin Monastery and graveyard, on a steep hill overlooking Monterosso al Mare.

Cinque Terre, now protected as Italy's first national park, is so photogenic it's hard to find a bad time of year to see it. The colorful towns and green water are stunning in full summer sun, but earlier in the spring and later in the fall, gray skies and raw winds stir the sea into choppy waves, and the cliffs take on a brooding quality that's no less romantic.

"You should go into all the churches while visiting the villages. Each tells its own story. You will see that they are not as ornate as churches in other towns of Italy— these were simple and hard-working people."

– Pall Forloney, *Riomaggiore resident and guide*

▶ **VISIT LIKE A LOCAL**

Settle into a harborside bar and savor a glass of the local vintage Sciacchetrà, a full-bodied, honey-colored dessert wine found very few places outside Cinque Terre. The difficulty of raising and harvesting grapes on this rugged terrain, combined with it taking a lot of grapes to produce relatively little wine, keeps production to a minimum. Enjoy while you can—while the production of Sciacchetrà dates back centuries in Cinque Terre, its future is uncertain in the rapidly modernizing towns.

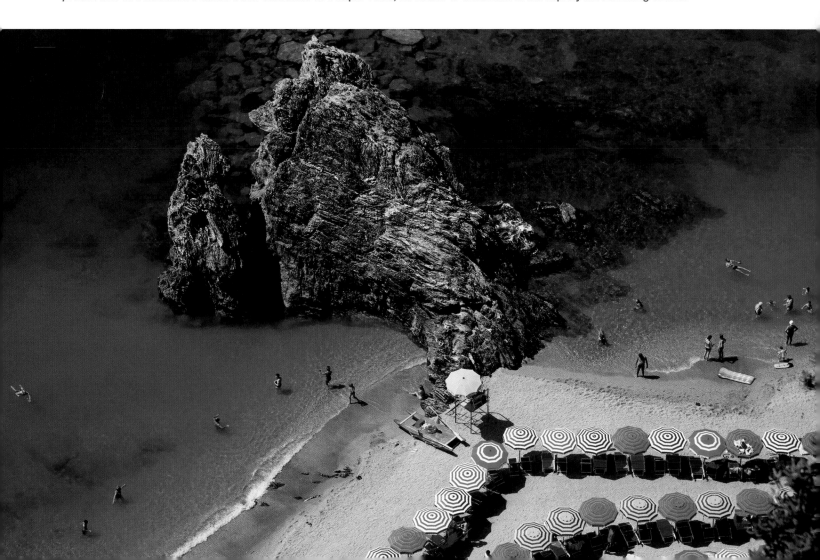

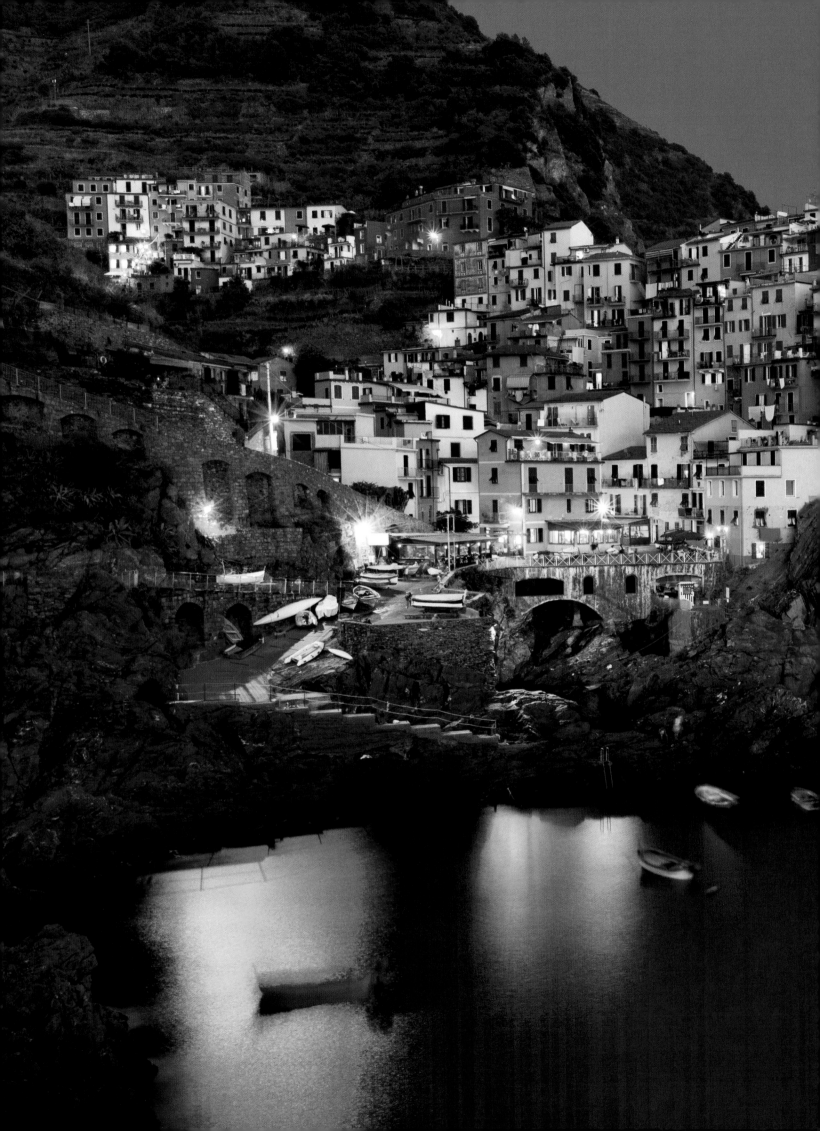

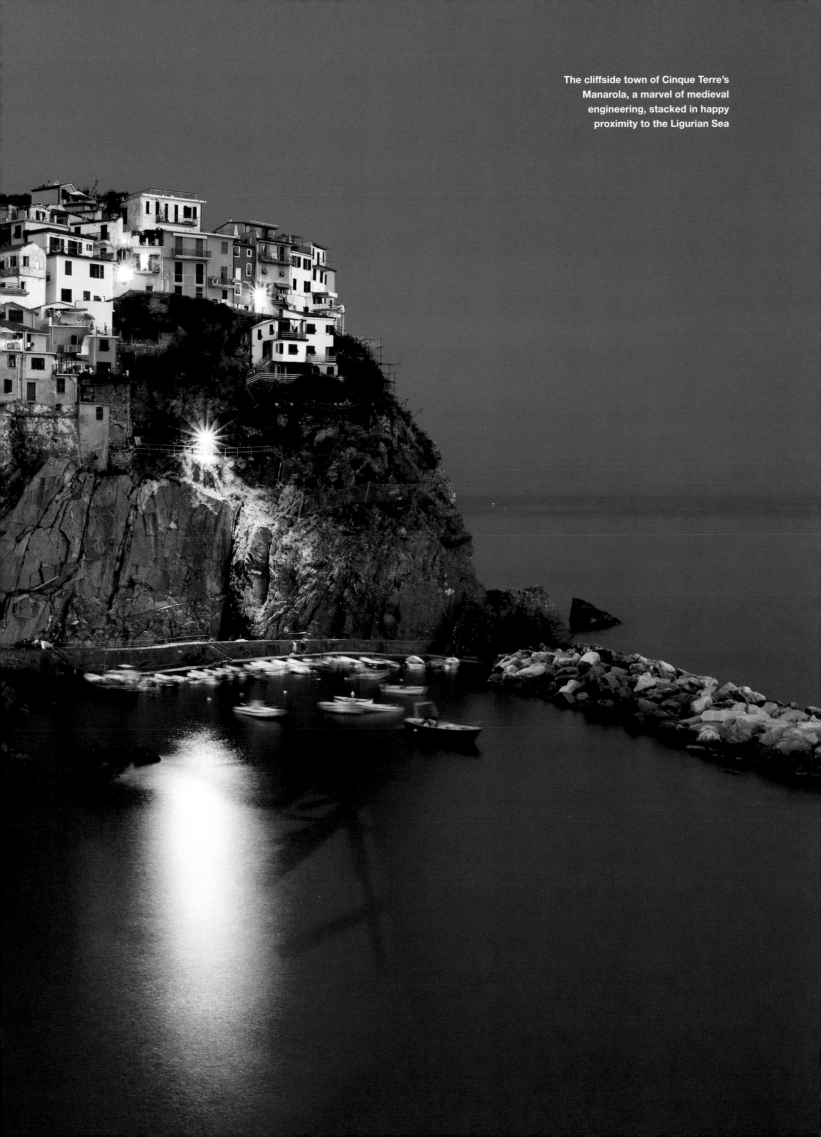

The cliffside town of Cinque Terre's Manarola, a marvel of medieval engineering, stacked in happy proximity to the Ligurian Sea

UNFORGETTABLE FAIRYLAND CASTLES

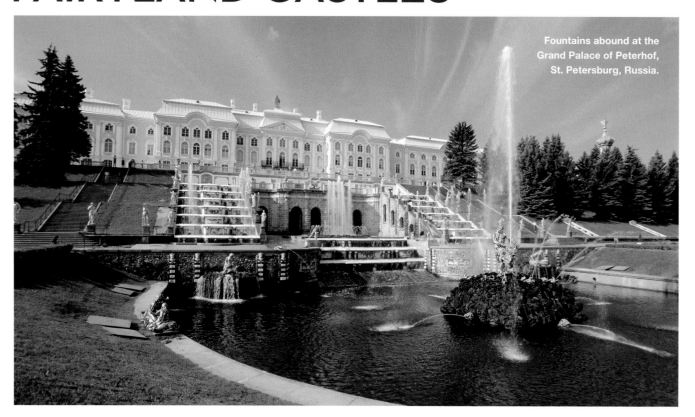

Fountains abound at the Grand Palace of Peterhof, St. Petersburg, Russia.

Peterhof, St. Petersburg, Russia

Known as the Russian Versailles, Peterhof's dazzling ensemble of palaces, gardens, and series of 64 fountains represents Peter the Great's drive to match the French court's elegance in his own imperial city, St. Petersburg.

Château de Chenonceau, France

The pinnacle of the glorious châteaus of the Loire Valley, 16th-century Chenonceau gracefully spans the River Cher with storybook towers and turrets. Its exquisite gardens include two created for noble residents Diane de Poitiers and Catherine de' Medici.

Grand Palace, Bangkok, Thailand

Home of the Kings of Siam for generations, this massive Bangkok palace measures over 2.3 million square feet (213,677 sq m). Among its dizzying array of pavilions and courtyards, Wat Phra Kaew, the Temple of the Emerald Buddha, enshrines sculptures (left) and a 15th-century jade Buddha image.

Mysore Palace, India

Deep pink marble domes, delicately crafted arches, sculptures of Hindu goddesses, and a five-story tower distinguish this magnificent Royal Seat of the Maharajas of Mysore, illuminated during the festival of Dasara each fall with more than 96,000 lights.

Chapultepec Castle, Mexico City, Mexico

The only castle in North America to be called home by royal sovereigns, Chapultepec towers over Mexico City from atop a hill that was sacred to the Aztec. Emperor Maximilian I and his wife redesigned the castle in its neoclassical style in the mid-19th century.

Warwick Castle, England

First built in wood by William I in 1068, the castle was remade in stone in the 12th century. From this stronghold, the earls of Warwick faced attacks, grappled with the black plague, and withstood a siege during the English Civil War in 1642.

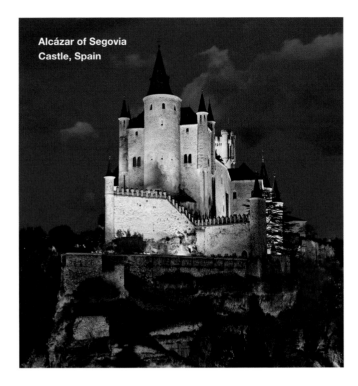

Alcázar of Segovia
Castle, Spain

Alcázar of Segovia, Spain

Like the bow of a ship cresting atop a rocky wave, this 12th-century fortress soars above the confluence of two rivers. The favorite residence of the crown of Castile throughout the Middle Ages, its Hall of Kings holds a frieze with 52 intricate portraits of Spanish monarchs.

Neuschwanstein, Hohenschwangau, Germany

"Mad" King Ludwig II's dream castle was designed in the 1860s as a private refuge on a dramatic mountaintop location in Hohenschwangau, with fairy-tale architecture and frescoes inspired by the operas of Richard Wagner.

Potala Palace, Tibet

Soaring over the Lhasa River Valley from its perch atop Red Mountain, this former home of the Dalai Lama continues to symbolize Tibetan Buddhism. The 17th-century Red and White Palaces contain more than a thousand rooms, which hold countless treasures, including sacred statues and painted scrolls.

Himeji Castle, Japan

For more than 400 years, through wars, fires, and earthquakes, Himeji has remained standing, surviving in its original form. The brilliant white plaster walls of its main tower have earned it the nickname "white heron castle."

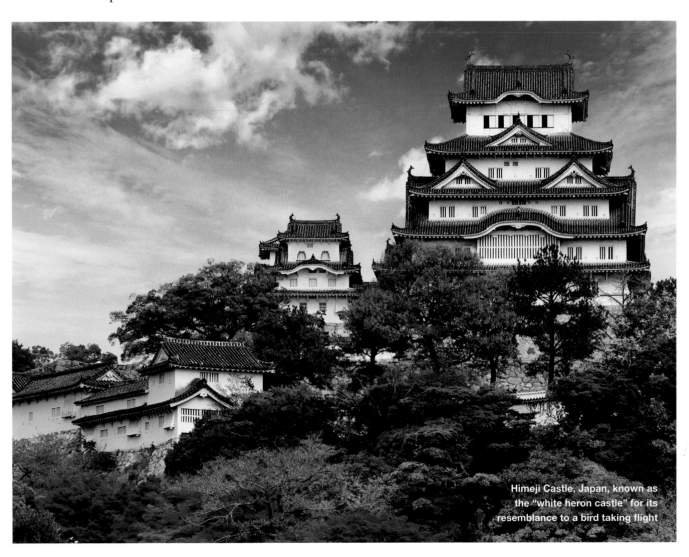

Himeji Castle, Japan, known as the "white heron castle" for its resemblance to a bird taking flight

SISTINE CHAPEL
Michelangelo's enduring masterpiece in the heart of the Vatican

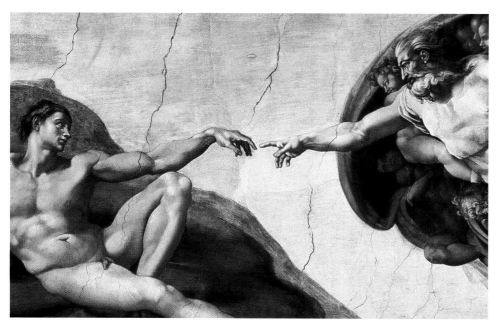

Michelangelo's "Creation of Adam" (above), centerpiece of the Sistine Chapel ceiling. His vision of the Last Judgment covers the back wall (opposite).

TRAVELER'S NOTEBOOK

*WHEN TO GO
The Sistine Chapel, part of the Vatican Museums, is open Mon.–Sat. and the last Sunday of each month.

*PLANNING
To visit the Sistine Chapel, you must purchase an admission ticket to the Vatican Museums. Because lines can be long, consider purchasing tickets online (available up to 60 days before your visit). Tickets include a guided tour.

*WEBSITES
mv.vatican.va

Visitors walk into the Sistine Chapel expecting to be wowed. Indeed, you are entering the legendary holy space of popes through the ages, adorned with a riot of priceless frescoes covering the ceiling as well as the walls.

But it's hard to be prepared for the emotion that comes rolling in as you crane your neck, taking in the ceiling's vibrant colors, the multitude of intricate figures depicting age-old stories of the Bible, the complex architectural framework created through trompe l'oeil techniques. This is, after all, the greatest artwork of the High Renaissance, if not of all times, right above your head.

The irony is that its creator, Michelangelo Buonarroti (1475–1564), had no desire to paint the Sistine Chapel. He felt it was beneath him, preferring to pursue his passion for sculpture. When the formidable Pope Julius II ordered that he paint the ceiling of the small chapel in 1508, Michelangelo had to be dragged back to town by papal soldiers.

And so the artist returned. His revenge: He was going to do it his way. And this decidedly was not to follow the pope's limpid vision of the Twelve Apostles as simplistic single figures and leave it at that. Michelangelo's way was to dramatize the rise and fall and subsequent

▶ UNFORGETTABLE EXPERIENCES

Michelangelo is the Sistine Chapel's undisputed star, but the chapel's side walls radiate with the works of other gifted Renaissance artists. Ghirlandaio—who apprenticed the young Michelangelo—painted "Vocation of the Apostles." Botticelli, famed artist of "Primavera" and "Birth of Venus," painted three frescoes, including the action-packed "Temptation of Christ." Signorelli, Rosselli, and Perugino all contributed dazzling frescoes that, anywhere else, would be considered the hands-down talk-of-the-town chefs d'oeuvre.

salvation of humankind through the stories of Genesis (the most iconic of which is, of course, the creation of Adam), throwing in depictions of the ancestors of Christ, prophets, and pagan sibyls. His frescoes, painted in a bright rainbow of colors, took more than four years, demonstrating acute skill in foreshortening, perspective, and shading, which, in effect, give an appearance more like sculpture than painting.

Completing the ceiling in 1512, Michelangelo was summoned some three decades later by another pope, Paul III, to depict the Last Judgment on the end wall behind the altar. In it, with a golden-haired Apollo-like Christ in the center, angels push the damned into the dark crevices of hell on one side, the saved toward heaven's glimmering light on the other. It's said that the pope was so moved when he saw this archetype of Mannerism that he fell to his knees.

Others, alas, weren't so impressed. With the Counter-Reformation under way throughout Europe and nudity condemned in religious art, the tortured jumble of naked bodies was declared scandalous. Soon after Michelangelo died, Mannerist artist Daniele da Volterra, "the breeches maker," painted over the objectionable elements with drapery—though no matter what, the power and fury of Michelangelo's paintbrush will never be erased.

> *"Under the dome of the Sistine Chapel, we are lost, bewildered by the beauty, power and majesty of Michelangelo's genius. Like children, we are enchanted, reading tales of harmony and passion, of a book that is part of us. Thanks, Michelangelo. Thanks, Rome."*
>
> – Lucia Leonelli, *lecturer*

▶ VISIT LIKE A LOCAL

From early on, Michelangelo chose sculpting over painting. His "Pietà" in St. Peter's and "Moses" in San Pietro in Vincoli are exemplary examples of his otherworldly skill. Although crowds in Rome flock to admire those works, few know that hidden inside the blank-fronted Santa Maria sopra Minerva, near the Pantheon, is Michelangelo's powerful statue "Christ the Redeemer," which was sculpted in 1521. Its "knees alone were worthy of more than the whole Rome," according to contemporary artist Sebastiano del Piombo.

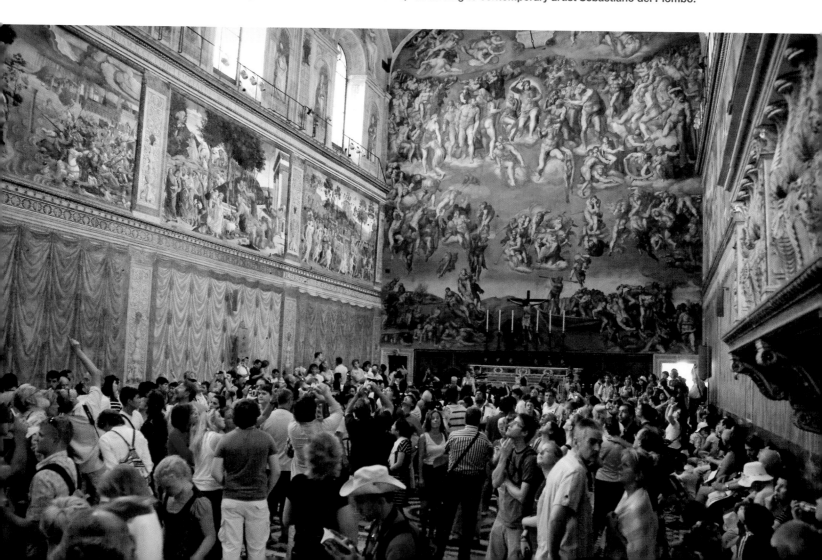

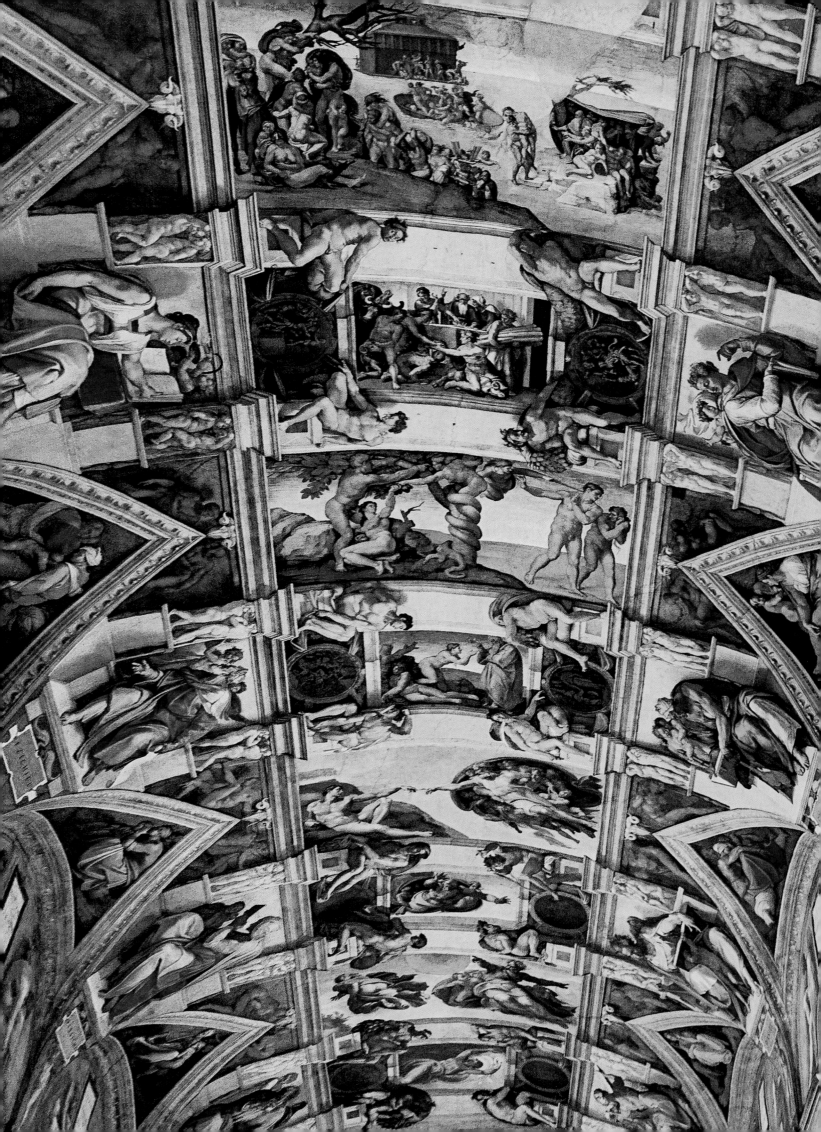

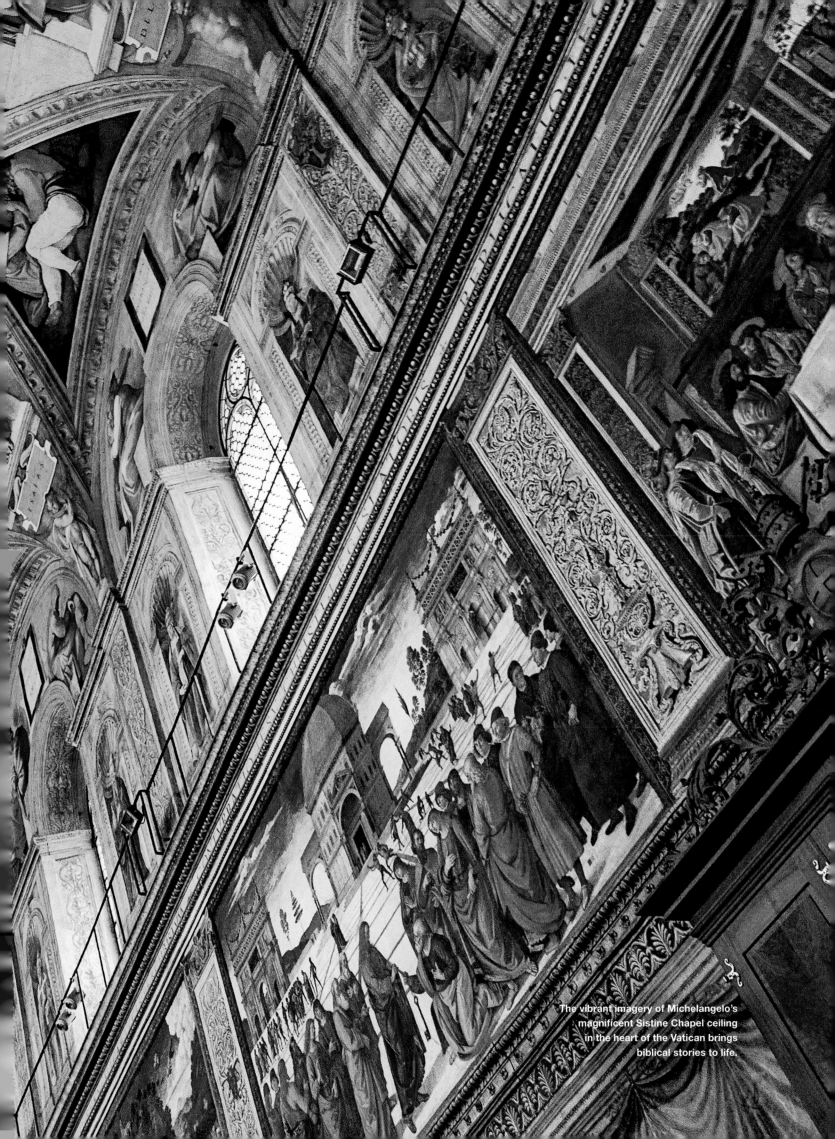

The vibrant imagery of Michelangelo's magnificent Sistine Chapel ceiling in the heart of the Vatican brings biblical stories to life.

PAINTED MONASTERIES OF BUCOVINA
Vibrant biblical imagery for all to see

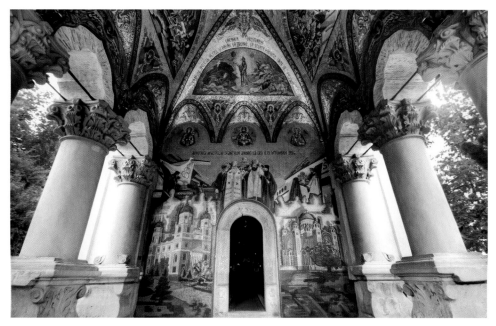

Bucovina's St. George Church (above) and Moldovita Monastery (opposite), two of the eight vividly painted houses of worship commissioned by Stephen the Great in the 15th century

TRAVELER'S NOTEBOOK

***WHEN TO GO**
Winters in Romania can be bracing, and transportation is difficult, so aim to visit mid-April–early Oct.

***PLANNING**
Suceava, the closest city to the monasteries, can be reached by air or train from Bucharest. Alternatively, the city of Iasi has air connections with Bucharest and Vienna, Austria, and is about 100 miles (161 km) from the monasteries. Once in the region, it's best to rent a car, as the sites are spread out and difficult to reach on public transportation.

***WEBSITES**
romaniatourism.com/painted-monasteries .html, paintedmonasteries .ro, whc.unesco.org/en/ list/598

A masterpiece awaits in the remote village of Voronet, in the northern Romanian region of Moldova. A mural shows angels and devils on opposite sides of a scale, scrutinizing a man's life, good deeds weighed against sins. At stake, heaven or hell. Around them, corpses rise from graves, joining scores of others awaiting their fate. It's a graphic, gripping scene and it's no wonder the 500-year-old painting has earned the Voronet Monastery the title Sistine Chapel of the East.

It's one of eight similarly painted monasteries that together make up a UNESCO World Heritage site, the Churches of Moldavia. The modest buildings were commissioned in the 15th century by Stephen the Great, who defended the region against invaders and even formed an alliance with Vlad the Impaler, a historic figure also known as Dracula. Because few peasants could read, the Eastern Orthodox Church covered the buildings inside and out with graphic paintings to teach religious themes, creating a biblical comic book of Byzantine art.

Wandering through church grounds, you may encounter nuns and monks who announce prayer times by beating a hammer on a wooden board, a tradition dating to the time when occupiers banned the ringing of bells.

▶ VISIT LIKE A LOCAL

Although the area is scattered with churches, a few stand out, telling their tale in living color. Voronet's monastery uses a blue-gray shade so distinctive that it has given its name to a color: Voronet blue. The Humor Monastery has an entirely different feel, with a terra-cotta red. And colors decorating the church at Sucevita remain the brightest, with pigments expertly derived from crushed minerals, semiprecious stones, and rare clays.

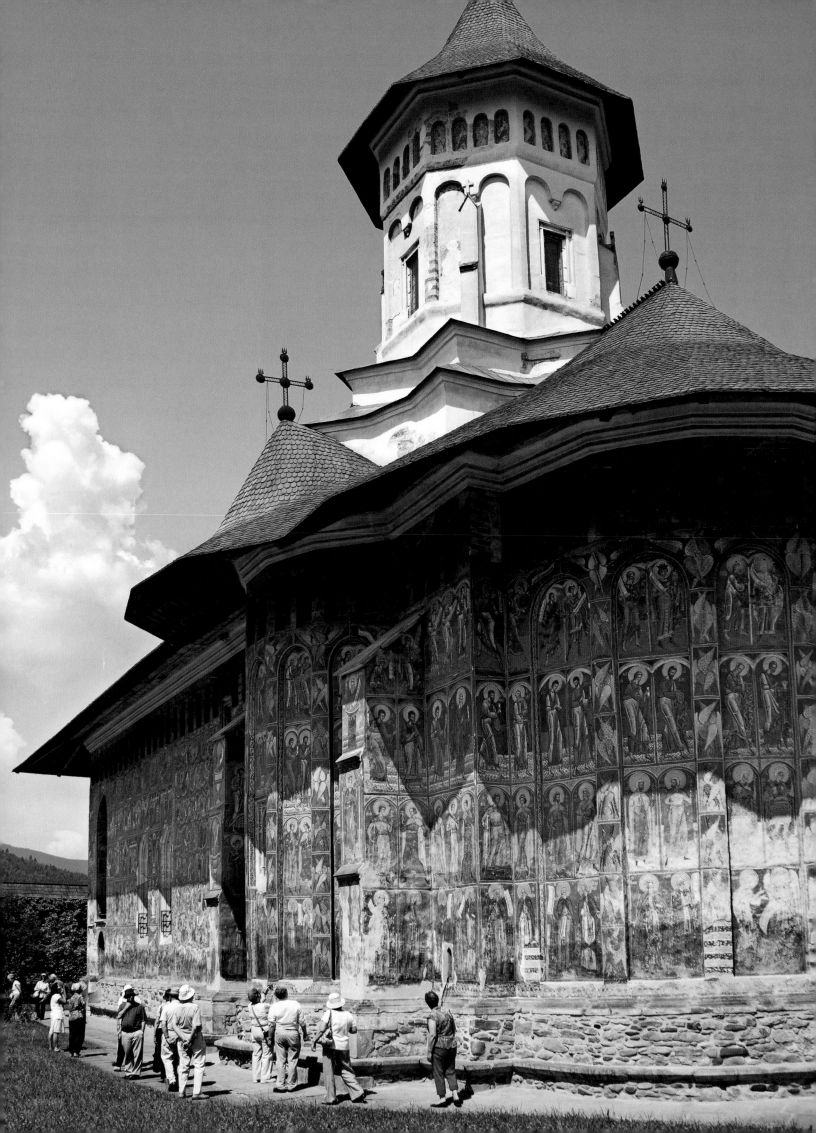

MAJORELLE GARDEN
A Frenchman's painterly garden in the desert

Majorelle Garden (above) features pools, fountains, and plants from around the world. A museum (opposite) houses the North African collection of owners Yves Saint Laurent and Pierre Bergé.

A 12-acre (4.9 ha) oasis in the middle of contemporary Marrakech, Majorelle Garden has given the world its own vibrant and distinctive color: Majorelle blue. It is this intense cobalt that accents the buildings, fountains, and edges of the garden. Its French creator, Jacques Majorelle, was an illustrator and artist, but this elegant refuge he fashioned in the desert is his true masterpiece. Meticulously restored by its later owners, French designer Yves Saint Laurent and Pierre Bergé, it honors Moorish traditions in an intriguing tropical setting.

In Marrakech, a city backed by the arid Atlas Mountains, water is a sacred luxury. Every Moroccan village centers on a fountain for ablutions before Islamic prayer. Majorelle's marble pools and channels reflect that tradition, along with an astonishing variety of greenery: banana trees, bougainvillea, bamboo, coconut palms, cacti, and water lilies. Birdsong provides a natural sound track, as bulbuls, gray wagtails, warblers, blackbirds, and turtledoves all call the garden home. The dense foliage deflects both sun and outside noise, inviting you to linger along the site's raised pathways, admire its precise geometries, and marvel at a botanical collection transplanted from across the globe.

TRAVELER'S NOTEBOOK

***WHEN TO GO**
The shoulder seasons of spring and fall are preferable for visiting Marrakech, as midsummer temperatures in the Red City routinely reach 100°F (38°C).

***PLANNING**
Majorelle Garden is open daily year-round. Both the garden and the museum are wheelchair accessible. The complex includes a gallery of Yves Saint Laurent's artwork and an elegant gift shop. An outdoor restaurant, Café Bousafsaf, serves breakfast, brunch, and lunch in a peaceful setting.

***WEBSITES**
jardinmajorelle.com/ang

▶ VISIT LIKE A LOCAL

A short distance from Majorelle Garden on Angle Boulevard el Mansour Eddahbi in the Gueliz District, the upscale Le Grand Café de la Post offers patrons rattan chairs, lazy ceiling fans, and a wrought-iron staircase that evoke the city's colonial era. Serving Parisian dishes, traditional Moroccan *tagines,* and French and Moroccan wines, the eatery's sheltered balcony allows for the best people-watching in this cosmopolitan town. *grandcafedelaposte-marrakech.com/en*

Though much influenced by art nouveau, Majorelle painted many images of the local Berbers over his 40 years in the city; he built his home and studio in their traditional style. The high adobe tower flanking the garden evokes the character of the nearby casbahs, mountain fortresses that were home to fiercely independent Berbers who call themselves Imazighen, or free men. Majorelle's former villa now houses a museum of artifacts, costumes, and jewels that illuminate the ancient North African culture. Hundreds of objects illustrate the variance of traditional Berber societies from the Rif to the Sahara, including elegant silver jewelry representing a 9,000-year-old heritage in dazzling designs. Created by itinerant silversmiths, often women, they are worn not only as a display of wealth but also as a shield for the wearer's health. Saint Laurent and Bergé, who collected the museum's offerings, also acquired an array of tribal finery that reflects their interest in international couture.

North Africa's history of colonization extended from the ancient Romans to the 20th-century French. A monument to St. Laurent, who died in 2008, is a reminder of both: A Roman column taken from the designer's Tangier home that now commands a peaceful corner of the garden, alongside a pair of marble benches.

"Seeing the garden, I instantly understood Yves Saint Laurent's love of Marrakech. His designs and color palette came to mind right away."

– Robert Berry,
fashion designer

▶ **UNFORGETTABLE EXPERIENCES**

The exquisite La Maison Arabe in the Marrakech medina evokes an elegant *riad,* an Islamic home built around the traditional courtyard. It was opened in 1946, a decade before Morocco's independence from France. The hotel's vaulted arched doorways, smooth *tadelakt* (lime-plastered) walls, and cedar ceilings spotlight Moroccan craftsmanship. The contemporary spa includes a traditional hammam, or steam bath, and the hotel's cooking school specializes in Moroccan cuisine. *lamaisonarabe.com*

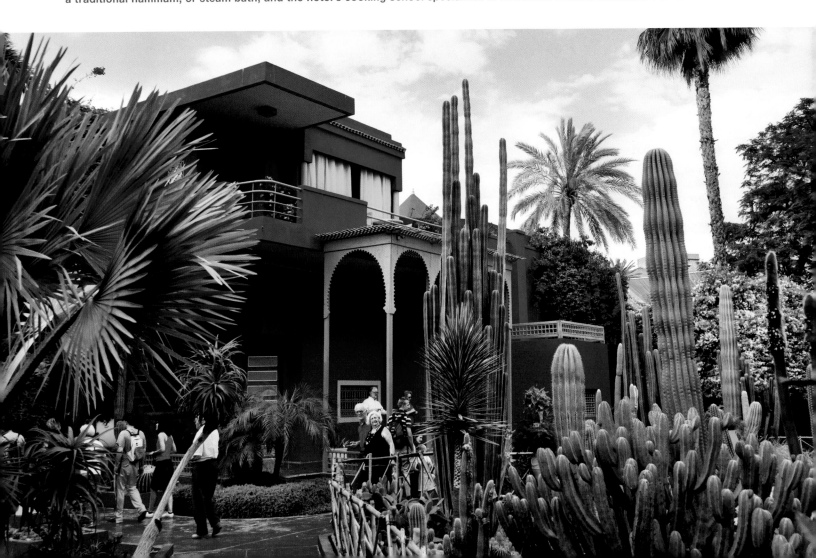

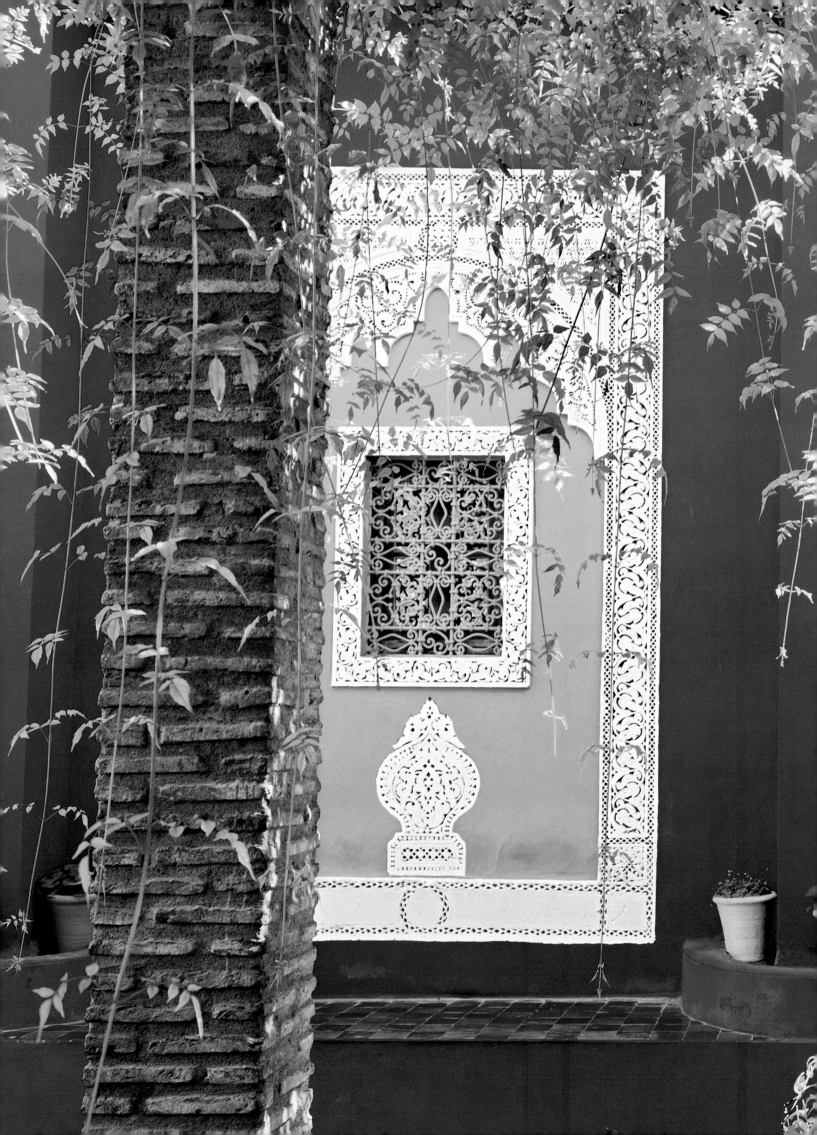

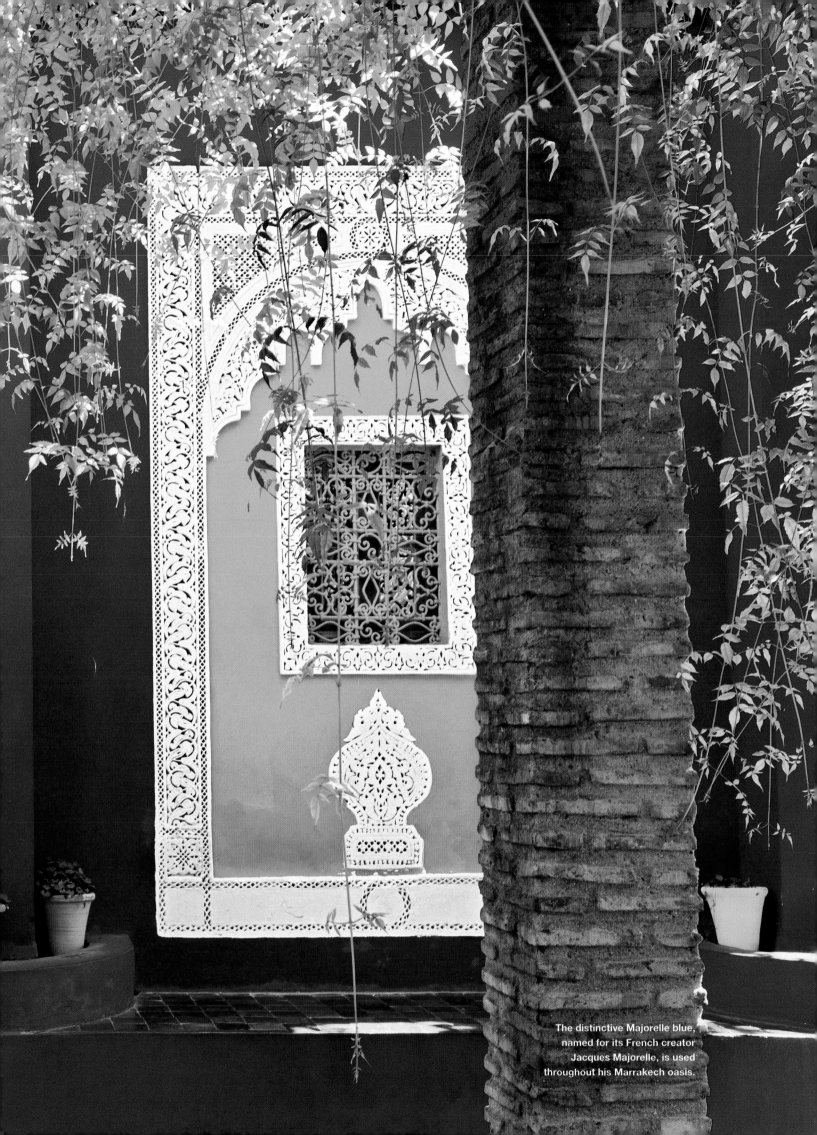

The distinctive Majorelle blue, named for its French creator Jacques Majorelle, is used throughout his Marrakech oasis.

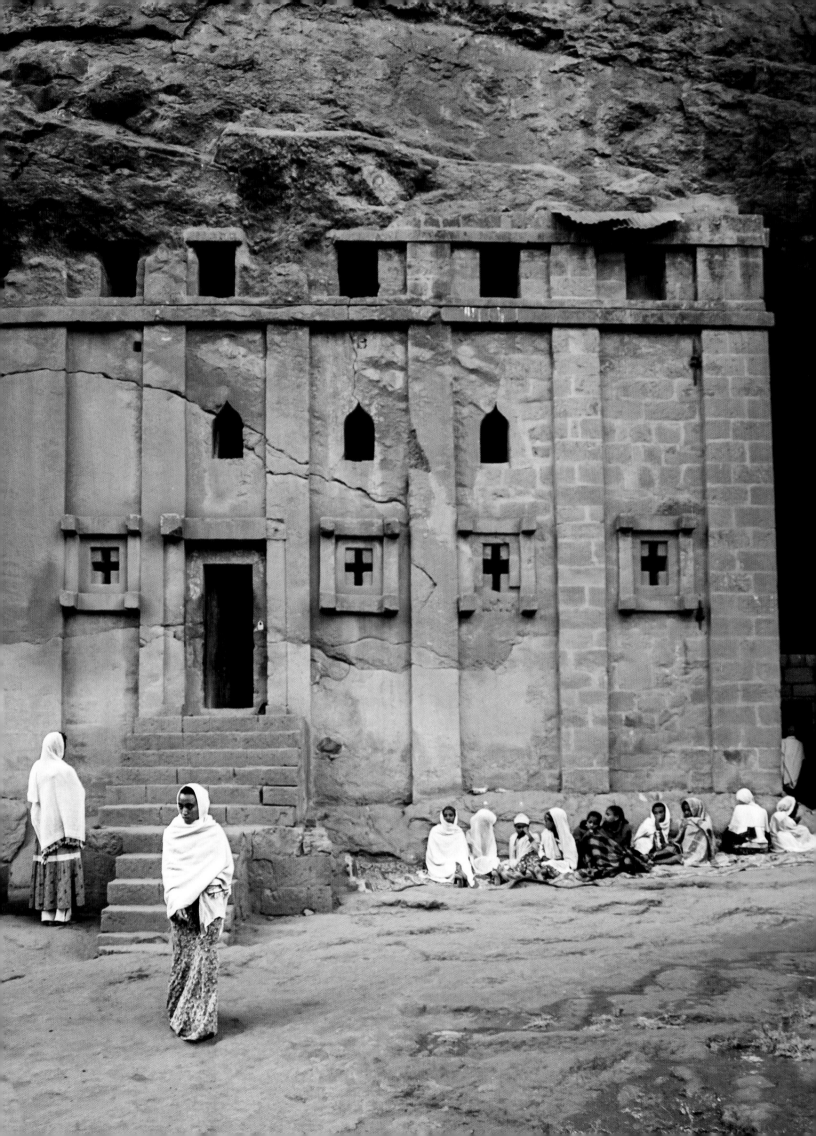

LALIBELA
A holy city carved from solid rock

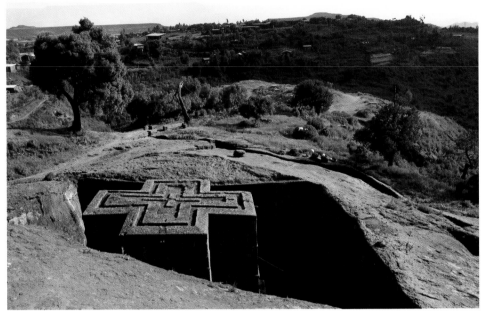

Excavated rather than constructed, Lalibela's St. George Church (above) and Bet Abba Libanos (opposite) were sculpted from solid volcanic tuff as an alternative pilgrimage site to far-off Jerusalem.

I n the folds of the imposing Lasta Mountains, a dusty town in rural Ethiopia is the surprising home of one of the world's most distinctive sacred sights—11 imposing churches, hewn top-down and inside-out from solid rock. Excavated rather than built, each church was carved out of volcanic tuff rock, some by digging into the ground and others chiseled into a rocky slope. The sanctuary was then whittled by hand into ornate decoration inside and out, complete with a sophisticated system of drains and subterranean passageways. One, St. George's, is shaped in the form of a Greek cross, cut 40 feet (12 m) belowground.

Their creation is credited by some to be the work of angels, by others to the labor of approximately 40,000 artisans attracted here from around the world by 12th-century ruler King Lalibela. His goal was to create a new Jerusalem for pilgrims who could not make that long journey.

The faithful did come, and they continue to make their way, many by foot, to this remote region. Here they pray within cavernous halls covered with Byzantine frescos, traverse the tunnels and walkways between the sacred structures, and gaze at the multitude of symbols on the facades and the interiors of the buildings—elaborate Stars of David, Arabesque windows, Greek crosses, and Hindu ciphers, all pointing to this remote town's once cosmopolitan population.

▶▶ TRAVELER'S NOTEBOOK

✳WHEN TO GO
With temperate climates, the northern highlands of Ethiopia are best visited during the dry season, Oct.–April.

✳PLANNING
Lalibela is 420 miles (676 km) north of Addis Ababa and has regular air connections via Ethiopian Airlines. Roads can be rough, and public buses take two days from the capital, with an overnight stop. Cox & Kings offers individually tailored trips around Ethiopia's historic sites, including Lalibela.

✳WEBSITES
whc.unesco.org/en/list/18, coxandkingsusa.com

▶ UNFORGETTABLE EXPERIENCES

Rich in spices, Ethiopian cuisine is among the world's most flavorful and colorful culinary traditions. Treat yourself to a 360-degree valley vista at Ben Abeba, where you can try superb examples of Ethiopian staples, like *doro wat,* a tender chicken stew slowly simmered in onions, dried red peppers, and herbs, served on moist *injera* sourdough flatbread. Home-brewed mead, called *tej,* is followed by espresso, roasted on the spot. Ethiopia, after all, is credited with giving the world the coffee bean. *benabeba.com*

HAGIA SOPHIA

Possibly the most perfect building ever erected

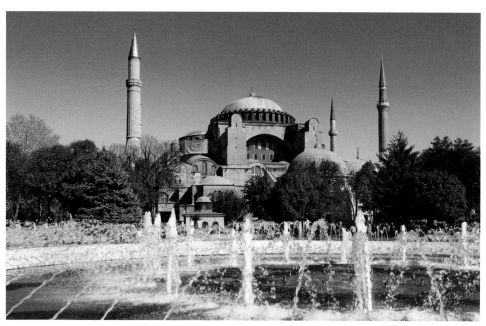

The multifaceted Hagia Sophia (above and opposite), opened to worship in A.D. 537, melds elements from its Christian and Islamic heritage.

TRAVELER'S NOTEBOOK

＊WHEN TO GO
Hagia Sophia is open every day but Monday, year-round. Last tickets are sold an hour before closing.

＊PLANNING
Hagia Sophia is in the center of the Sultanah-met District, across from the Blue Mosque and around the corner from the Topkapi Palace. Once here, you'll have no trouble spending a day. Istanbul is served by dozens of major airlines.

＊WEBSITES
ayasofyamuzesi.gov.tr/en

From the outside, with an abundance of sharp-angled corners meeting the soft curves of the cathedral domes, the legendary Hagia Sophia (or Church of the Holy Wisdom) almost looks as if someone's finally found a way to put a square peg in a round hole. From the inside, the proportions, art, and paving stones actually worn smooth by a thousand years of people coming to pray support its claim as the building that mirrored heaven most closely.

The Hagia Sophia rose in its present form around A.D. 537. After centuries as a Christian church, a conquering sultan, Mehmed II, claimed this masterpiece of Byzantine architecture as his imperial mosque in 1453, ordering acres of its intricate mosaics simply plastered over to cover the prohibited figurative imagery. The mosque years also show themselves in the bold flowing lines of Arabic calligraphy on hanging roundels near the second level and in the beautiful marble mihrab, indicating the direction of Mecca. The sweeping 1930s reforms of Atatürk secularized the building and brought museum status; today partially cleaned mosaics peek out from the plaster with glints of gold along the high upper gallery. From here, the air pouring through the windows around the dome looks almost milky thick as it pools on the tiles below.

▶ UNFORGETTABLE EXPERIENCES

The area between Hagia Sophia and the Blue Mosque is the old Hippodrome, once the center of all Istanbul. It's still the center of the action, buzzing with activity: Here vendors sell *simit,* a round bread, off what look like broomsticks; squeeze fresh pomegranate juice; and scoop Turkish ice cream called *dondurma,* which has a high mastic content and a strong taste and texture all its own, for dessert. Meanwhile, all around enjoy the best people-watching in Turkey.

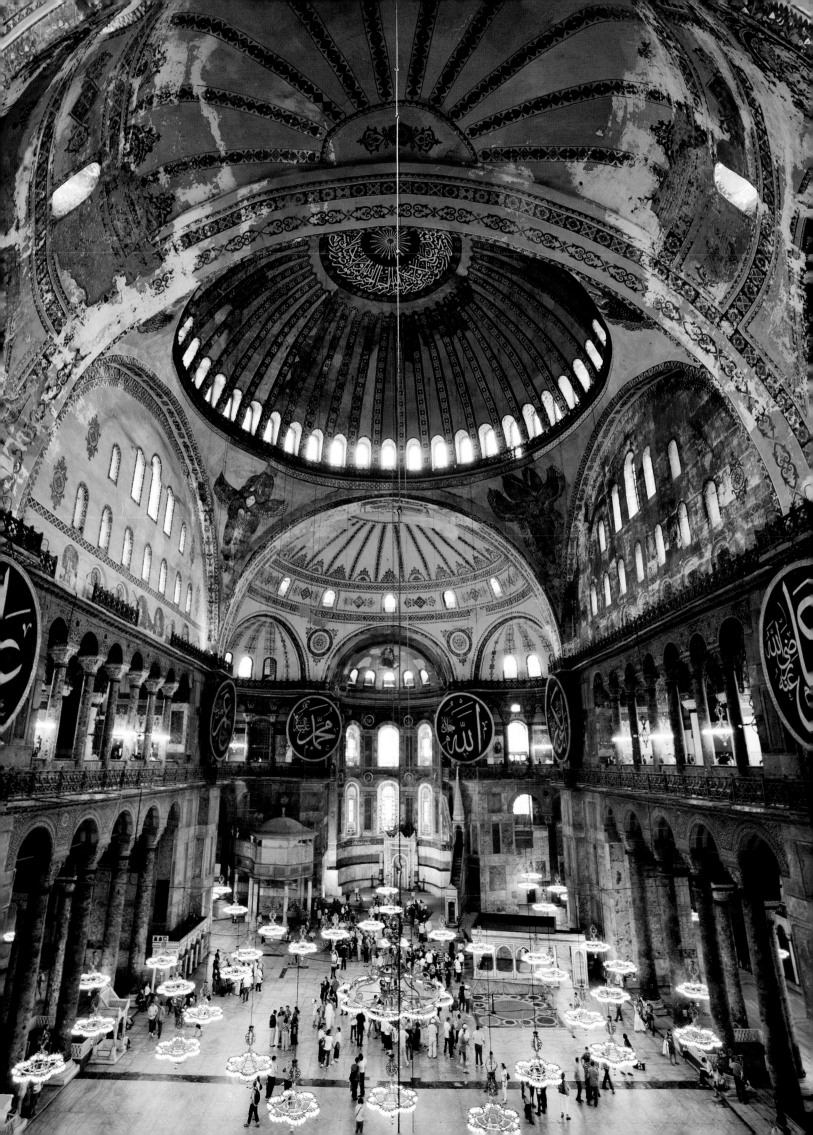

ABU SIMBEL
Immortality in stone on the Upper Nile

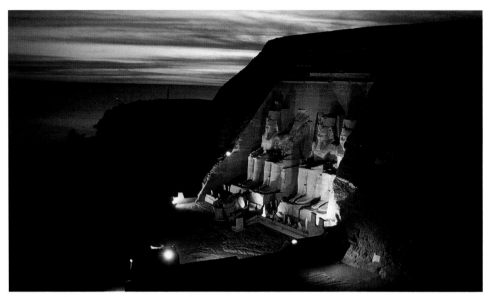

Enormous statues front Abu Simbel's Great Temple of Ramses II (above). Inside, a phalanx of pharaohs (opposite) lines the central corridor leading to the innermost sanctuary.

►► TRAVELER'S NOTEBOOK ◄◄

＊WHEN TO GO
With the temperature hitting triple digits nearly every day in May–Sept., summer is not the time to visit Abu Simbel. Winter nights can get surprisingly cold, leaving spring and autumn as the best time to see the temples.

＊PLANNING
Abu Simbel sits on the west side of the Nile River 180 miles (290 km) southwest of Aswan. The drive from Aswan takes about three hours on a modern, paved highway. Various agencies run day trips from Aswan via road and air. Multiday cruises on Lake Nasser are another option for reaching the temples.

＊WEBSITES
whc.unesco.org/en/ list/88, lakenassercruise .com

For more than 3,000 years, four giant stone figures of Ramses the Great have been intimidating would-be invaders and astonishing awestruck visitors to the Upper Nile. The 66-foot (20 m) statues are especially striking at sunrise as the early morning light transforms the supersize faces into a lifelike portrait of Egypt's greatest pharaoh. The statue on the far left almost seems to smile as Ramses beholds his desert domain.

The twin temples that compose Abu Simbel loom atop a sun-drenched plateau overlooking the turquoise waters of Lake Nasser, 180 miles (290 km) southwest of Aswan. The larger shrine is dedicated to Ramses II and his alleged victory over the Hittites at the Battle of Kadesh (1274 B.C.), the smaller one built in honor of his wife Nefertari and the fertility goddess Hathor. Their main aim was to glorify the reigning pharaoh, but the huge temples also served to emphasize Egyptian dominance over Nubia and its people.

In addition to the four colossi—one of the bodies broken and strewn across the ground—the facade of the main temple is adorned with many smaller figures. Walk through the towering entrance and you are dwarfed again in the long inner passageway, flanked by more giant Ramses statues and murals of his triumph at Kadesh. At dawn on just two days each year—February 22 and October 22— crowds of locals and tourists alike gather for the

► UNFORGETTABLE EXPERIENCES

A charming Egyptian take on the B&B, **Eskaleh Nubian Ecolodge** lies on the outer edge of Abu Simbel village just over a mile (1.6 km) from the temples. The mud brick architecture and traditional furnishings lend the lodge an authentic feel, as does a restaurant featuring local dishes like grilled lake fish, *tagine* hot pots, and ginger coffee. Nubian singers and musicians on the outdoor patio add another exotic touch, along with the romantic roof terrace with views of Lake Nasser. *eskaleh.net*

biannual sun festival. This is when the rising sun penetrates all the way down the central corridor to the innermost sanctuary, illuminating seated statues of the pharaoh and three gods. Smaller—but still imposing—sandstone statues of Ramses and Nefertari front the queen's temple (apparently the only instance in ancient Egyptian art where a pharaoh and his wife are the same size). Within, the interior bas-reliefs are perhaps even more vivid than those in the larger temple, depicting processional scenes and religious rites.

With the decline of pharaonic power, Abu Simbel became largely covered by sand and all but forgotten, until 1813, when Swiss explorer Johann Ludwig Burckhardt announced his rediscovery of the site. When development of the Aswan High Dam and Lake Nasser threatened to flood the temples in the 1960s, a massive modern engineering project began when, like a giant puzzle, the temples were carefully cut into 16,000 pieces and reassembled at their current position 210 feet (64 m) higher and 650 feet (198 m) northwest of the original site. Brought to world attention by the move, Abu Simbel became a "rock star," with appearances in movies like *The Mummy Returns* and *The Spy Who Loved Me.* Now part of a UNESCO World Heritage site, the temples continue their mission to astonish all those who stand before them.

"Sometimes we go swimming in the lake with our children and our friends. In January and February when they open the High Dam, the lake goes down and there are small beaches everywhere, very clean and natural."

– Fekry Kachif, *innkeeper and musician*

▶ **VISIT LIKE A LOCAL**

After visiting the temples, turn to the water. As an important stopover on the migratory route between Africa and the Arctic, avian life on Lake Nasser is rich and diverse, with yellow-billed storks, pink-backed pelicans, herons, ibis, and geese among the prominent species. The lake's game fish include Nile perch, tilapia, catfish, and moonfish. Abu Simbel hotels can arrange boating on Lake Nasser for fishing, bird-watching, and visits to other World Heritage sites like Amada and Wadi es-Sebua.

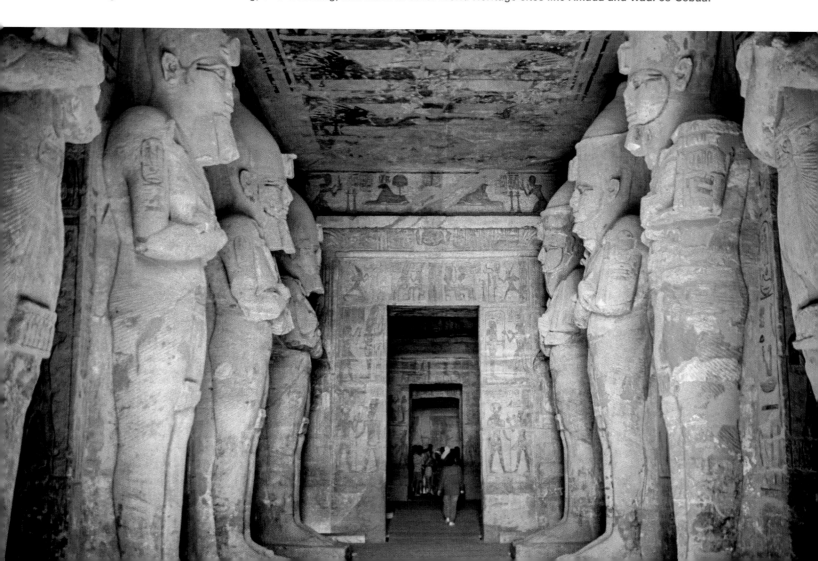

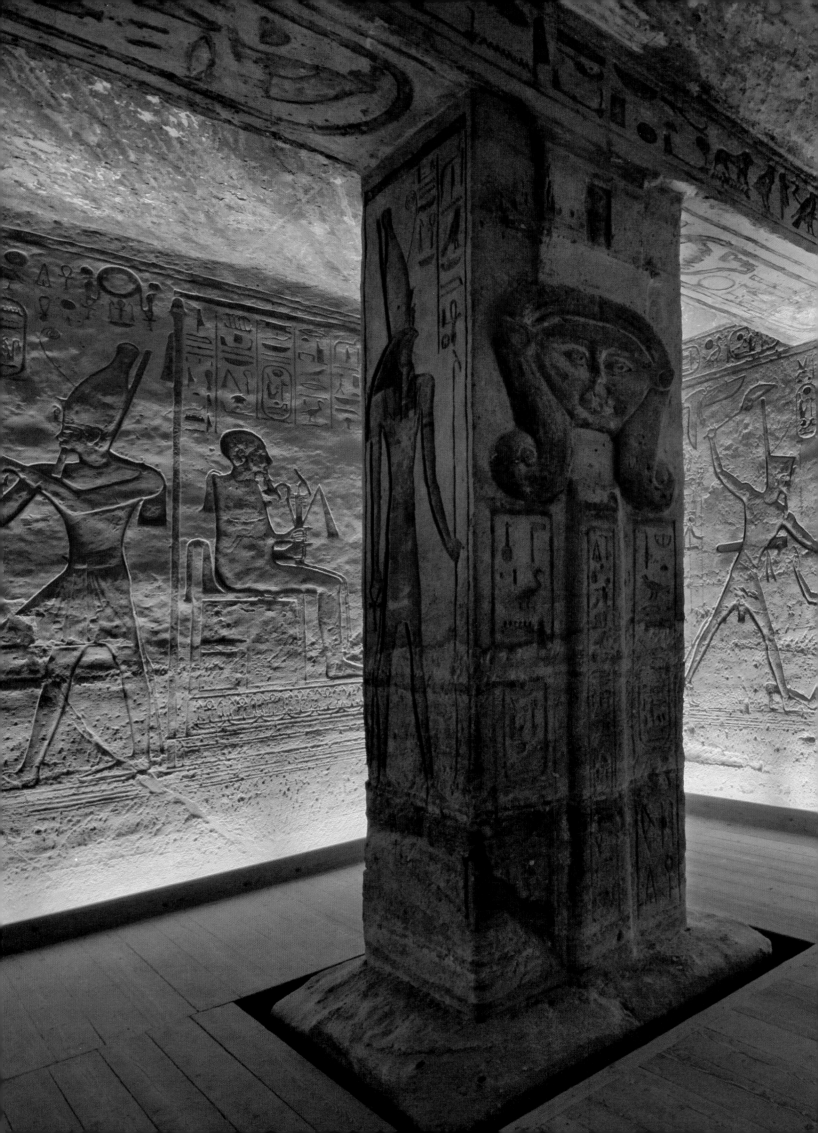

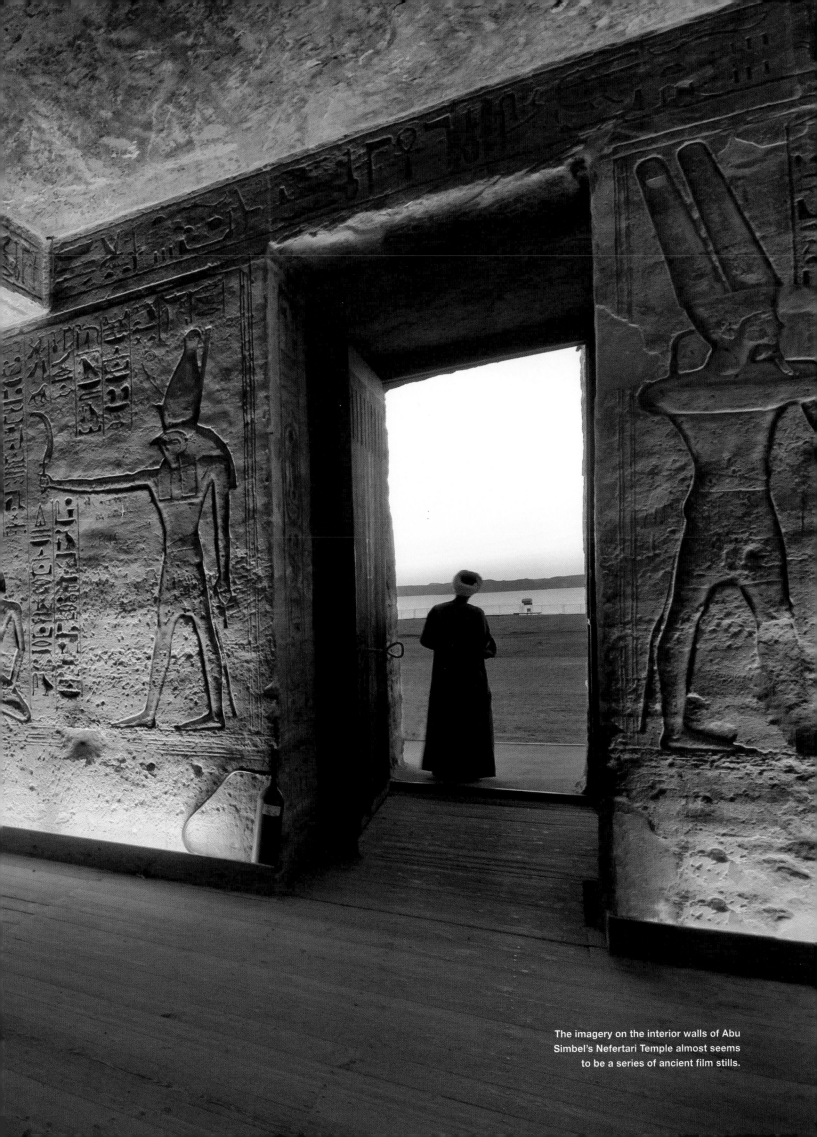

The imagery on the interior walls of Abu Simbel's Nefertari Temple almost seems to be a series of ancient film stills.

MY SHOT

Petra, Jordan

When visiting Petra, I heard about the night concerts and thought I'd try to photograph the Treasury by the light of the many luminaria candles lining the area. They really didn't provide a lot of illumination, making the image very difficult to frame and focus—the long exposure is what allows for the detail. I love this shot because to me it captures the mystery and mood of this amazing site, expressing not only what the place looks like, but what it feels like as well.

– Bob Krist, *National Geographic* photographer

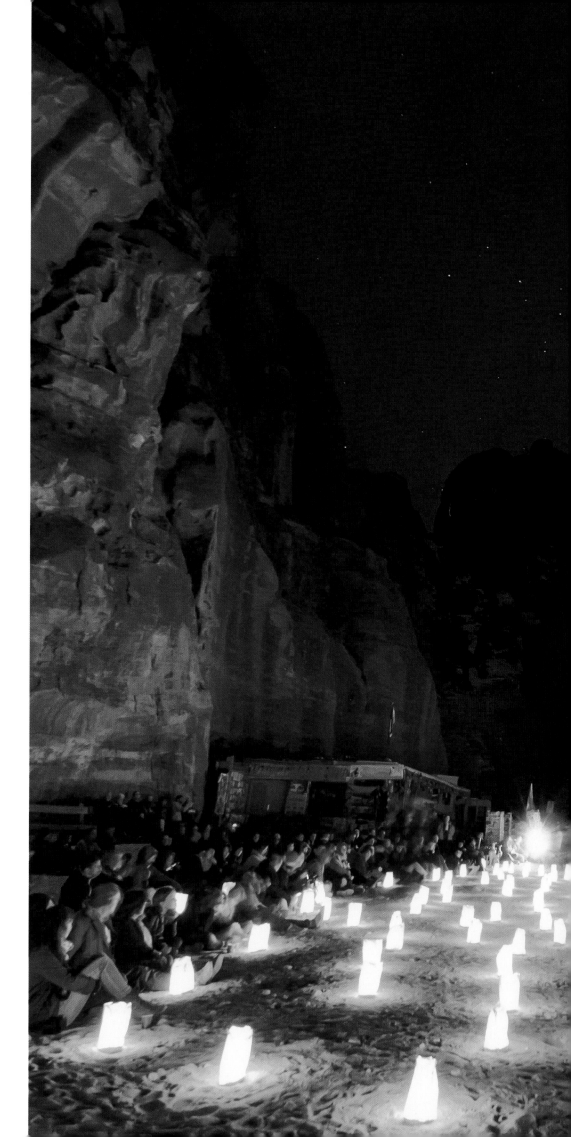

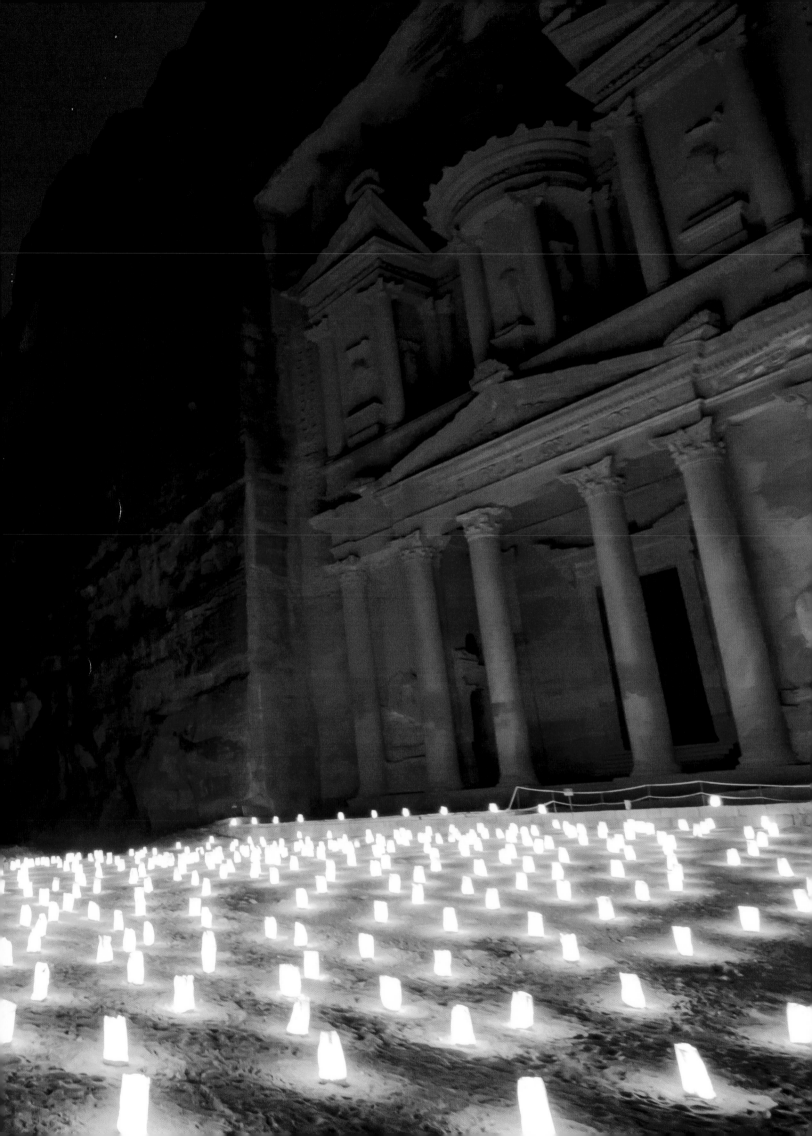

BAALBEK
In praise of Roman gods

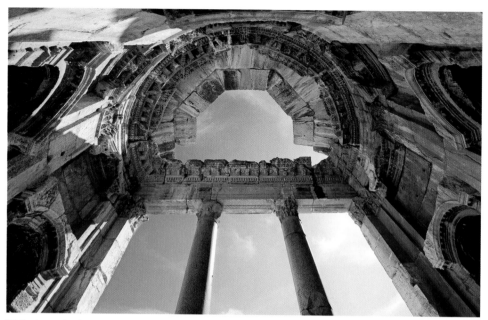

High above the fertile Bekaa Valley, the extensive ruins at Baalbek (above and opposite) are testament to the long reach of the Roman Empire.

TRAVELER'S NOTEBOOK

***WHEN TO GO**
Among the best—but crowded—times to visit is during the annual Baalbek International Festival, a music event held in late July or early August. Spring and summer bring the liveliest atmosphere, with outdoor cafés and hookah bars open in the areas surrounding the ruins and the weather at its driest, especially in April. Nov.–Feb. will be less crowded, but expect moderate rain.

***PLANNING**
Baalbek is about 55 miles (88 km) northeast of the capital of Beirut, about a 1.5-hour drive. Use a tour company or hire a taxi; shared taxis or vans depart from the Cola intersection in Beirut.

***WEBSITES**
mot.gov.lb, en.baalbak .org

t's one of the most spectacular temple complexes of the Roman Empire, a sentinel of the past standing at attention on the other side of the Mediterranean, far from the European city that once ruled this region. Also called Heliopolis (City of the Sun) in ancient times, it once boasted three magnificent temples to the Roman gods Jupiter, Venus, and Bacchus. Today their ruins—elaborate cornices, columns, archways, roads, and toppled monoliths—make for an archaeological playground with few rivals, and one of the most important UNESCO World Heritage sites in the Middle East.

The modern town of Baalbek surrounds the sprawling ruins, which are cordoned off into a parklike giant rectangle. Indeed, the changing fortunes of Baalbek form a history of the Mediterranean, as the site fell under the power of one empire after another, growing in importance along with each subsequent conqueror. Baalbek began under the Phoenicians, the seafaring ancestors of the modern Lebanese who invented the modern writing system that inspired what we use today. The root of the name, Baal, roughly translated to master or lord, is a reference to the ancient Gods worshipped in the region. Around 331 B.C., the city became a Greek colony, receiving its name Heliopolis. The Romans took over in 16 B.C. and built this sprawling acropolis to the gods on a small hill overlooking the Bekaa Valley. The

▶ UNFORGETTABLE EXPERIENCES

For a mysterious, nostalgic atmosphere stay at the Palmyra Hotel overlooking the ruins. With more than 135 years of history, the late Ottoman-era 1879 hostelry is among Lebanon's oldest, marked by three-pointed arched windows and a high gabled roof, with a honey-colored limestone interior set off by photos of the hotel in its early days. In spite of continued hardships the guesthouse, formerly a pilgrimage site for Christians on their way to Jerusalem, has never closed its doors. *hotel-palmyra.com*

collapse of the Roman Empire set in motion the city's decline, until a revival of the region under the Ottomans.

Today Baalbek's Temple of Bacchus is one of the most intact and complete of Roman temples still existing from the ancient world. Processional steps lead to the columned sanctuary and interior rooms where religious ceremonies took place. This column-crested rectangular ruin was just an aside to the far larger temple of Jupiter, which once dominated the complex but now lies in ruin. Portions of its soaring columns still reach to the sky, while the stone arches and ceilings they once supported are in pieces on the ground around them, their broad-mouthed lions and acanthus leaves still impressive despite the millennia in the open air. Sculptures within the coffered ceiling, their faces no longer clear, are said to represent Cleopatra and Mark Antony.

The multisided temple to Venus, the goddess of love, completed the complex. Today visitors pose within its high stone niches, which might once have held statues of the goddess or other deities. The quarry next to the complex is also worth a visit, to marvel at some of the largest stones ever worked by humankind still in place, waiting to be moved thousands of years later.

"A magical Roman city packed with history and memories. Nestled between mountains, Baalbek remains a jewel for Lebanese tourism and the country's cultural heritage."

– Bertho Makso, *tour guide company owner*

▶ VISIT LIKE A LOCAL

The Bekaa Valley is the heart of one of the oldest wine regions in the world, and it bears many more recent French touches from the shared colonial history. Join in with the locals celebrating in the vineyards during the Vendange, the grape-harvesting season in September. Unlike some other Middle Eastern countries, alcohol flows freely in Lebanon. Ksara, one of the largest wineries that helped modernize Lebanon's wine industry, welcomes visitors any time of year for a tour and tasting. *ksara.com.lb*

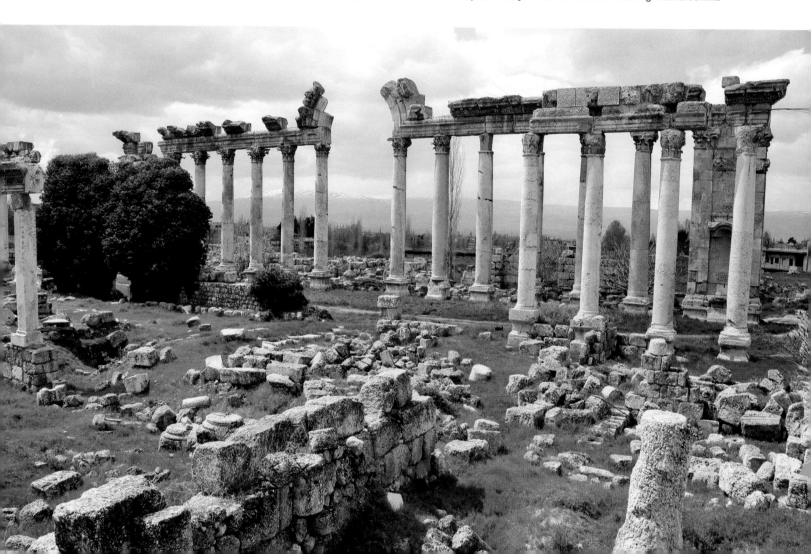

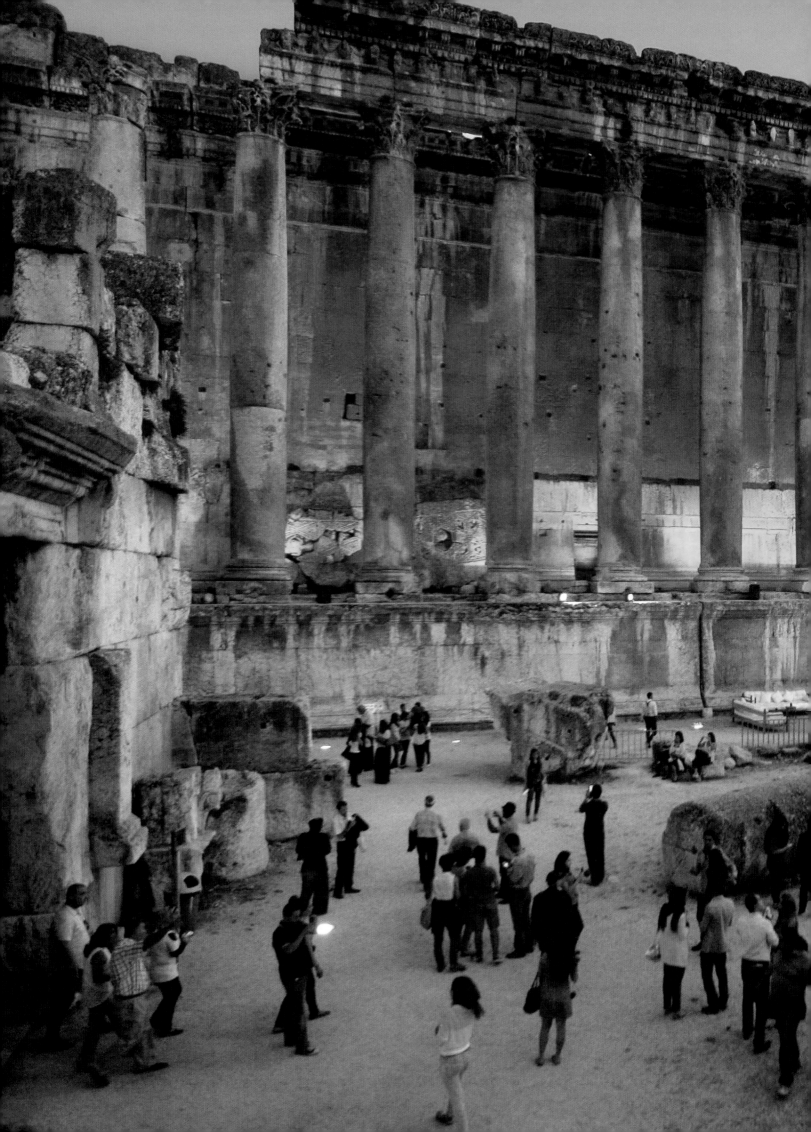

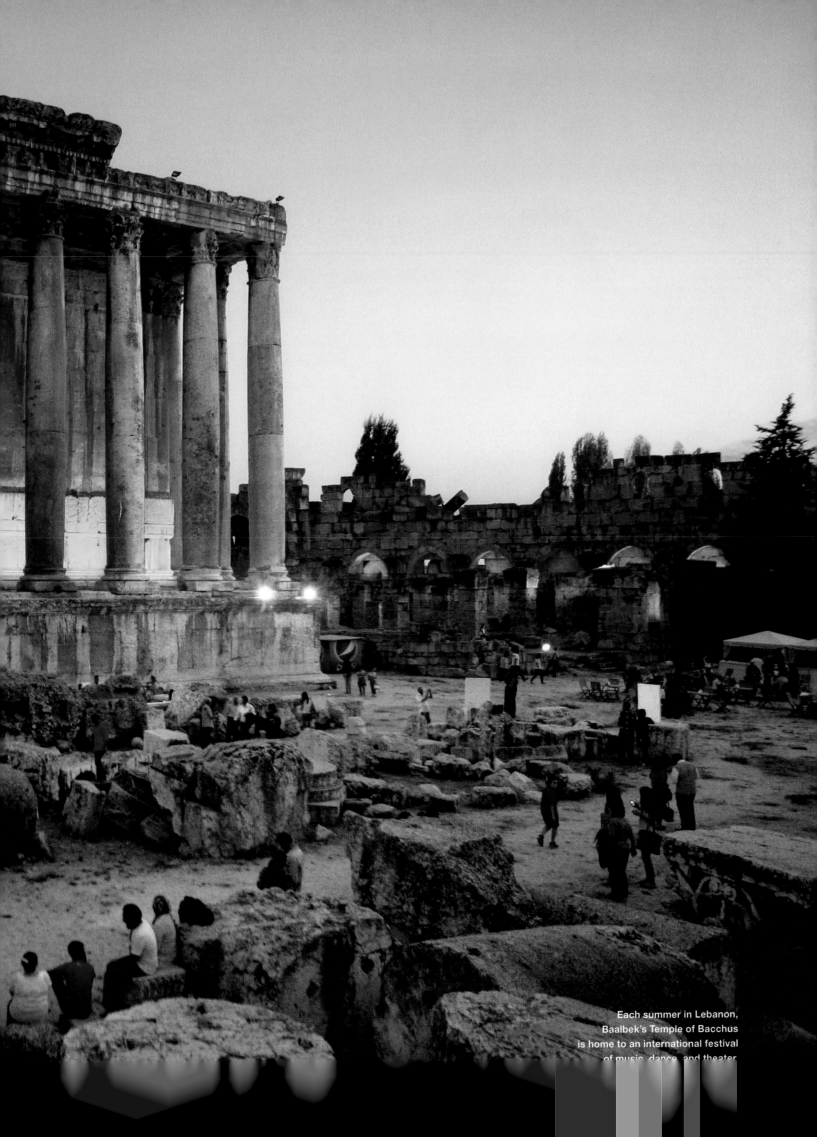

Each summer in Lebanon, Baalbek's Temple of Bacchus is home to an international festival of music, dance, and theater

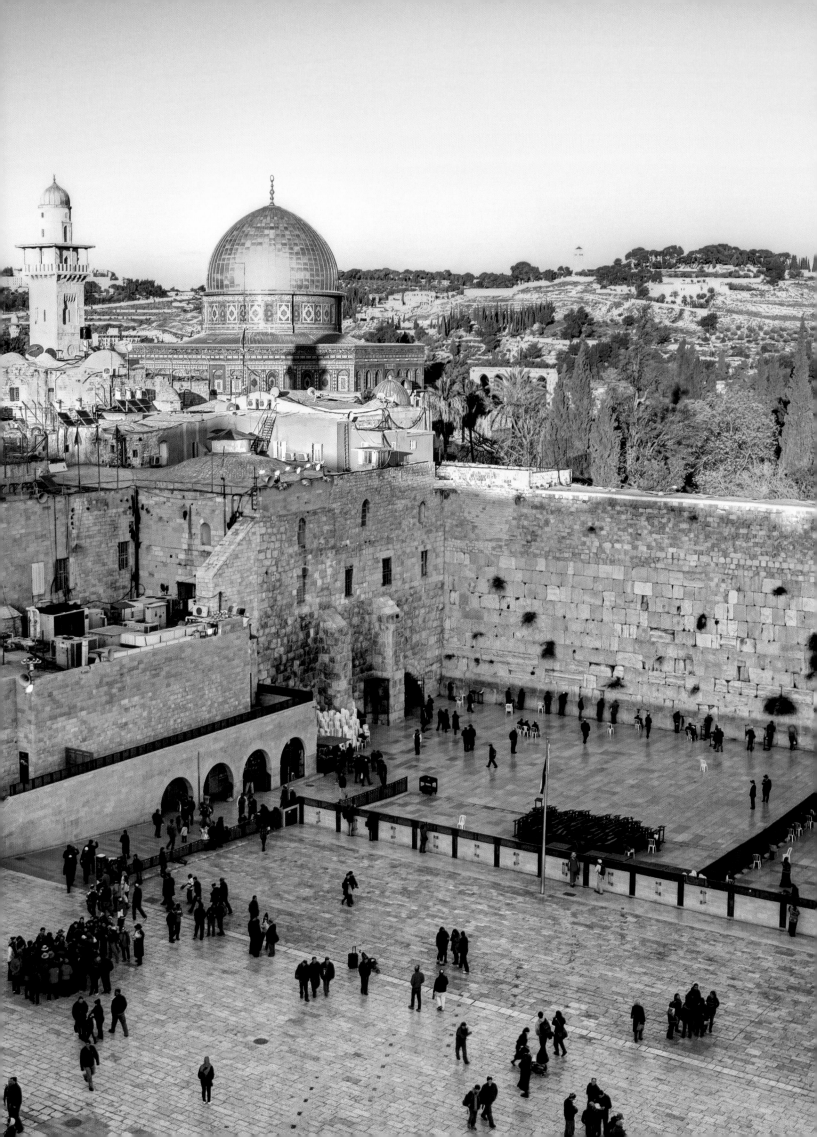

WESTERN WALL
Judaism's holy site attracts pilgrims of all faiths

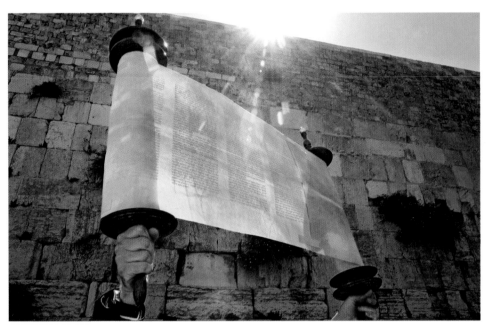

A ceremonial reading of the Torah (above) rings out at the Jewish Quarter of the Western Wall Plaza, Jerusalem (opposite).

As the sun sets on Friday afternoon, bearded young men dressed in traditional black garb make their way across the Old City of Jerusalem. They come to welcome the Sabbath bride at the towering 62-foot (19 m) wall built about 2,000 years ago during King Herod's expansion to enclose the Holy Temple. The Romans destroyed the structure in the first century, and pilgrims throughout the centuries began to visit the ruins, their heartfelt yearning leading to the name Wailing Wall. Even today Jews around the world face Jerusalem when they pray. The district is sacred to Muslims as well, who in the seventh century built the Dome of the Rock mosque atop the Temple Mount, the area enclosed by the wall.

The plaza fronting the wall is the spiritual heart of the city, where visitors from world leaders to pop stars to humble supplicants arrive to slip their handwritten prayers between the honey-colored stones. (It's even possible to email them.) The pleas are removed regularly and buried in a Jewish cemetery.

Early Monday and Thursday mornings, as well as on the first of the month, joyous families come to witness bar mitzvah ceremonies of 13-year-old boys who are recognized as Jewish adults, although mothers must watch from afar, as men and women remain segregated at the Wall.

▶ VISIT LIKE A LOCAL

Only part of the wall is exposed, but you can see the full length by heading underground into a tunnel system that runs beneath the plaza. Tours take you into a labyrinth of what were once ancient Roman streets and arches that remained hidden for centuries. Now it's possible to see the literal foundation of the wall, passing by an underground synagogue, a cistern, and a massive rock, estimated at 570 tons (517 tonnes), that was somehow moved to the site. *english.thekotel.org*

THE WORLD'S OLDEST SITES

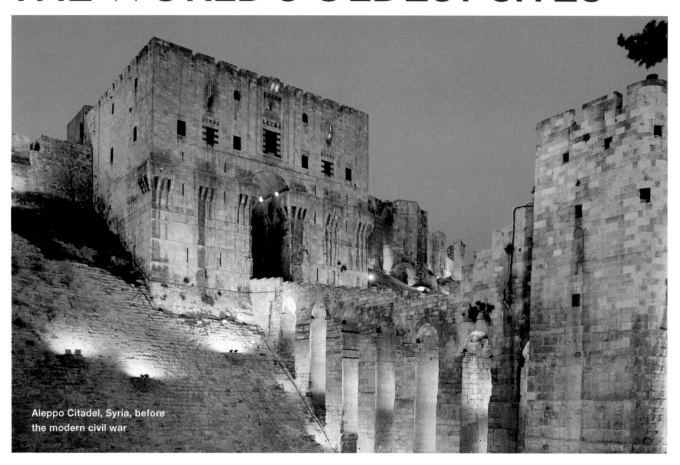

Aleppo Citadel, Syria, before the modern civil war

Aleppo, Syria

At time of press, this ancient city, a crossroads of civilization, thought to date back over 8,000 years, is off-limits to most tourists. Once a gem of the Middle East, the fortress overlooking modern Aleppo is partly destroyed owing to the ongoing Syrian civil war.

Burrup Peninsula, Australia

Murujuga, also known by the modern name Burrup Peninsula, in northwestern Australia, is home to potentially the world's oldest and most endangered petroglyphs. Some of the more than one million images are more than 40,000 years old.

Göbekli Tepe, Turkey

Built beginning in the tenth millennium B.C., Göbekli Tepe seems a re-creation of paradise, with stelae carved in images of exotic plants and animals. Now in a desert, the giant temple complex is thought by some to be the inspiration for the biblical Garden of Eden. Ancient human figurines (left) have been found.

Erbil Citadel, Kurdistan, Iraq

Among the oldest continually inhabited areas on Earth, this walled settlement looming over modern Erbil, in Iraq's northern Kurdish region, shows signs of occupation dating to the fifth millennium B.C. It is among the newest UNESCO sites, inscribed in 2014.

Cave of El Castillo, Spain

The oldest known paintings in the world are in the Cave of the Castle, in Cantabria in the north of Spain. Thought to be more than 40,000 years old, many of the images are stencils of ancient hands made by artists blowing paint from their mouths.

Ġgantija Temples, Malta

Somewhere around 3600 B.C. the ancient temples of Ġgantija were built on Gozo Island in Malta, among the oldest Neolithic structures in the world. They are thought to be dedicated to the Great Earth Mother goddess and, legend says, constructed by giants.

Lascaux Caves, France

Over 2,000 images of horses, cows, cats, birds, and their human hunters seem as vivid today as when they were painted in these caves more than 17,000 years ago. Discovered in 1940 in what is today southwest France, the cave is closed to the public, but a replica is open for visitors.

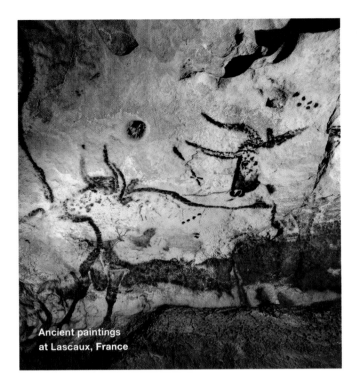
Ancient paintings at Lascaux, France

Potok Cave, Slovenia

Cro-Magnon people—the first anatomically modern humans—found shelter in this central European cave complex, using the nearly 23,000 feet (7,010 m) of limestone tunnels as a ritual site or hunting station some 36,000 years ago in what is modern Slovenia.

Jericho, Israel

Jericho's walls came tumbling down, and their ruins are the major tourist venue in this West Bank city established perhaps 11,000 years ago, among the oldest inhabited sites in the world. A nearby cable car takes visitors west to the Mountain of Temptation, where Jesus is said to have been tempted by the devil.

Skara Brae, Scotland

Inhabited more than 5,000 years ago, the Neolithic town of Skara Brae flourished on Mainland, the largest island in the Orkney archipelago. Strong storms in 1850 led to its discovery, revealing intricate stone roofs, ceremonial structures, and even furniture.

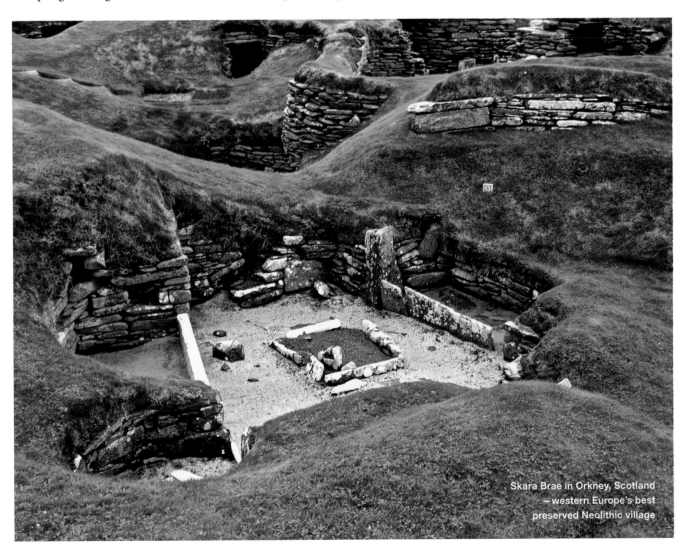
Skara Brae in Orkney, Scotland —western Europe's best preserved Neolithic village

QATAR

DOHA
A futuristic city soaring out of the desert

The glittering, ultramodern skyline of Doha, capital city of the Persian Gulf state of Qatar, is the signature image of the richest country in the world. The behemoth skyscrapers of Doha's West Bay district have shot up from a site that just decades ago was a desert hamlet of one-story, stone-and-mud homes. Doha was a small pearl-diving and fishing town until it began exporting petroleum and then natural gas; seemingly overnight it vaulted to glitzy First World status. International architecture firms jumped into Doha's building boom to design gravity-defying skyscrapers that channel the city's frenetic culture of expansion and growth.

The towering silhouettes piercing the desert sky today are kinetic, sculptural, and extravagantly lit. A sense of movement is everywhere: The cylindrical 656-foot (200 m) Tornado Tower puts on a dynamic light display nightly that evokes the vortex of a cyclone in a variety of color combinations. Nearby, the glass-sheathed Al Bidda Tower works a sense of torque and upward rotation into its profile, and the 46-story, 758-foot (231 m), dome-topped Doha Tower is clad in a patterned steel skin that recalls the design of ancient Islamic sunscreens. Doha's tallest skyscraper of the moment (several others that may rise higher are under

TRAVELER'S NOTEBOOK

＊WHEN TO GO
The summer heat of Qatar's desert climate is searing. Visit Nov.–March, when temperatures are milder.

＊PLANNING
Visitors need a tourist visa to visit Qatar, which you can purchase at Doha International Airport when entering the country. Doha has a public bus system that links important sites; a metro system currently under construction should be operational in the next decade. For sites off the beaten track, hire a taxi or walk—driving in Qatar on a foreign license is not advised.

＊WEBSITES
qatartourism.gov.qa

▶ UNFORGETTABLE EXPERIENCES

The Bird Market in Souk Waqif gives visitors a window into the centuries-old Bedouin tradition of falconry. Rows of falcons for sale are lined up on perches, their heads encased in hoods. Nearby is an area where the birds are exercised daily, with a hospital just for the falcons. The raptors, once used to hunt small game, are today kept for sport. But falcons are still so treasured that some sell for the price of a car, and Qatar Airways permits them to fly in the main cabin with their owners.

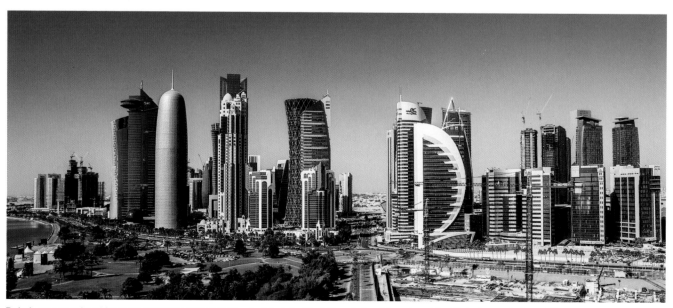

Doha's renowned architectural variety is evidenced by its futuristic West Bay skyline (above) and the Victorian-style Grand Heritage Hotel (opposite).

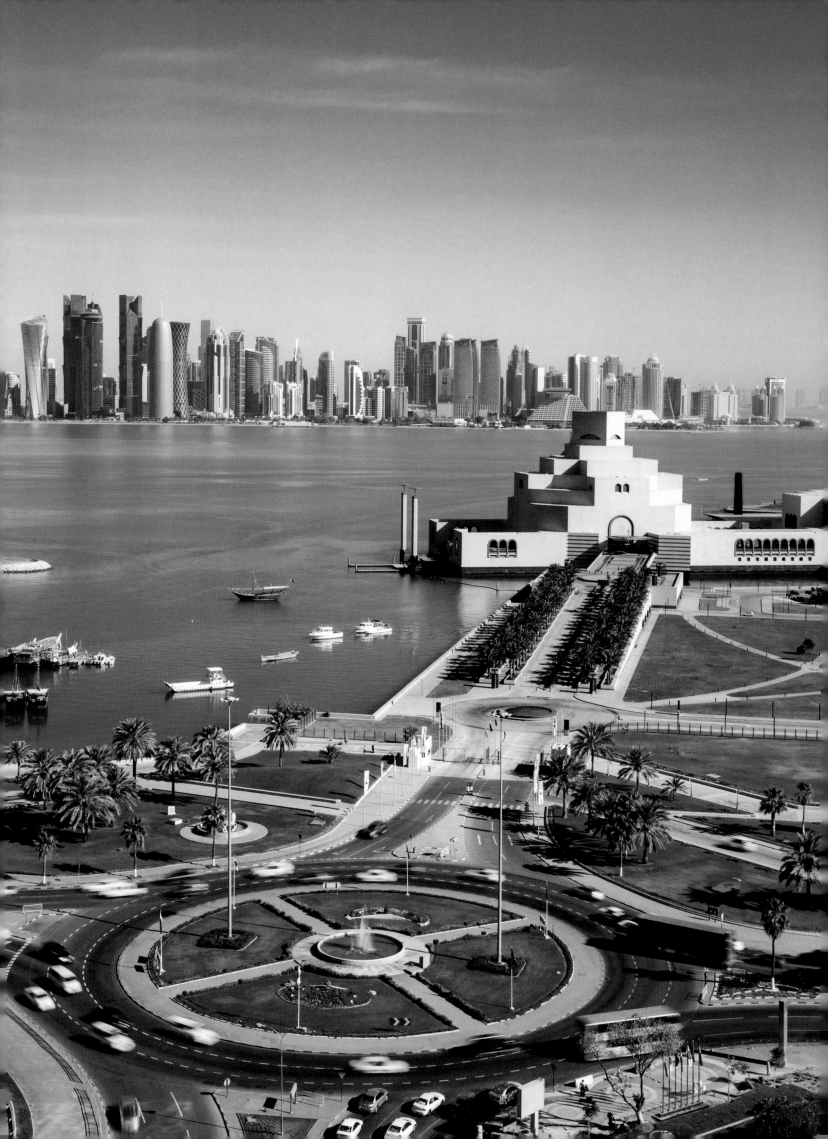

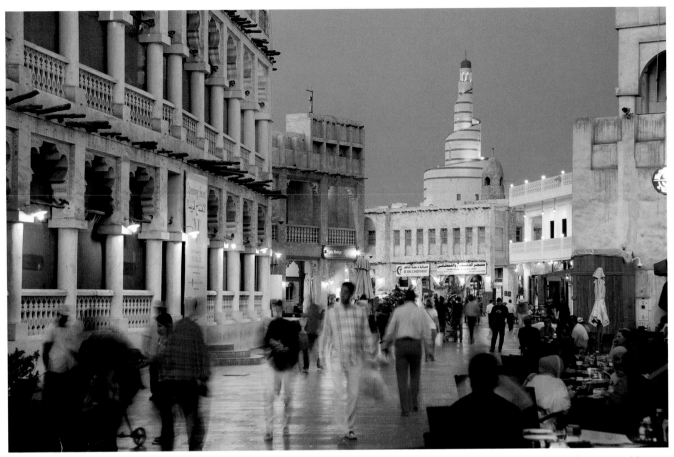

Doha's open-air Souk Waqif (above), watched over by the illuminated spiral mosque of the Kassem Darwish Fakhroo Islamic Centre, provides a curling contrast to the cubist Museum of Islamic Art (opposite), designed by I. M. Pei.

construction) is the 980-foot (299 m) torch-shaped Aspire Tower in the Doha sports complex, which housed an enormous flame at its top for the 2006 Asian Games.

There's more to Doha's architecture than flashy high-rises. Across the bay, on its own little island, is one of city's most celebrated architectural feats, the Museum of Islamic Art. Understated but imposing, it was designed by architect I. M. Pei, who undertook the project when he was in his 90s. He drew on influences of classic Islamic architecture, blended them with a modern aesthetic to reflect Doha's character, and arrived at an abstract cubist pyramid of crisp angles and clean lines. The geometry is as blocky and chiseled as the city's high-rises are slim and soaring.

One of the closest things Doha has to a historic quarter is the revitalized Souk Waqif (standing market), an open-air exchange that was a Bedouin trading center a century ago. The market had fallen into disrepair by the late 20th century but was rebuilt in 2006 to restore its 19th-century character, incorporating details of traditional Qatari architecture—like exposed timber, whitewashed mud-rendered facades, and wood roofs—in an attempt to recall a heritage fast fading from view.

"For a genuine experience that's not touristy, walk through Souk Al Ahmed and Souk Al Asiery, behind the Fanar center; old souks with lovely fabric stores."

– Vani Saraswathi, *journalist*

▶ **VISIT LIKE A LOCAL**

Set aside one whole evening to walk along Le Corniche, the broad, palm-lined 4.3-mile (6.9 km) pedestrian promenade that arcs around Doha Bay. By late in the day the temperatures have cooled to tolerable, and after dark Doha's cityscape is set off to spectacular advantage. The blazing vertical profile of the West Bay district is reflected in the dark water for double the spectacle, and the glowing white limestone of the Museum of Islamic Art looms like a massive ghost ship in the harbor.

TERRA-COTTA WARRIORS
A life-size army of Qin dynasty warriors

O utside the city of Xi'an in north-central China, thousands of intricately modeled ceramic warriors stand vigil outside the still undisturbed tomb of China's first emperor, Qin Shi Huang Di. He carried the monumental feats of his reign (221–210 B.C.) into death by constructing a 22-square-mile (57 sq km) burial complex to house an elaborate replica of his military and political retinue.

As emperor, Qin consolidated warring states into a unified empire, established a system of roads to link them, and built the earliest version of the Great Wall of China. A ruthless military leader, he commissioned the construction of his mausoleum and ghost army decades before his death. Some 700,000 laborers crafted more than 7,000 life-size terra-cotta warriors, each colored in bright pigments (although the colors do not survive today, techniques are being developed to re-create them) and each carrying a wood and metal crossbow, lance, or sword. Remarkably, subtle differences in facial features and other characteristics have led archaeologists to believe that each warrior had its own unique likeness and may have been modeled on a real-life member of the Qin dynasty. The emperor's actual tomb still lies undisturbed, a vast burial complex that awaits the advancement of excavation technology.

▶ VISIT LIKE A LOCAL

While you're in Xi'an, pay a visit to the much less famous tomb of Emperor Jingdi, a ruler of the Han dynasty, which succeeded the Qin dynasty. The pits of this tomb, which is also an active archaeological site, are covered in glass platforms for a unique perspective on the relics. Miniature ceramic figures of servants, animals, and soldiers tell a detailed story of court life that's more domestic than it is warfaring. Blessedly, the crowds here are small scale too.

TRAVELER'S NOTEBOOK

*WHEN TO GO
This is always a busy site, though crowds peak in May–Oct. If possible, avoid weekends and major Chinese holidays.

*PLANNING
Fly in to Xi'an Xianyang International Airport. The terra-cotta warriors are located about 30 miles (48 km) outside the city. You can take either a taxi (more pricey) from the airport or a shuttle bus from the airport to the Xi'an North Railway Station. From there, take Bus 306 (also identified as Tourist Bus 5) directly to the site.

*WEBSITES
whc.unesco.org/en/list/441, cnto.org

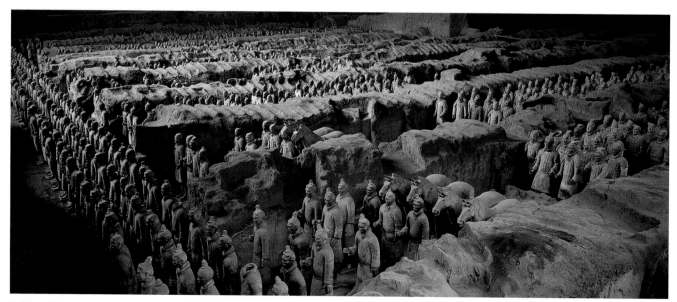

In Xi'an, China, the 2,200-year-old great terra-cotta army, face the rising sun (above). Each of the 7,000 warriors is different in some way, with individual features (opposite) that give credence to the theory that they were modeled on real-life members of the Qin dynasty court.

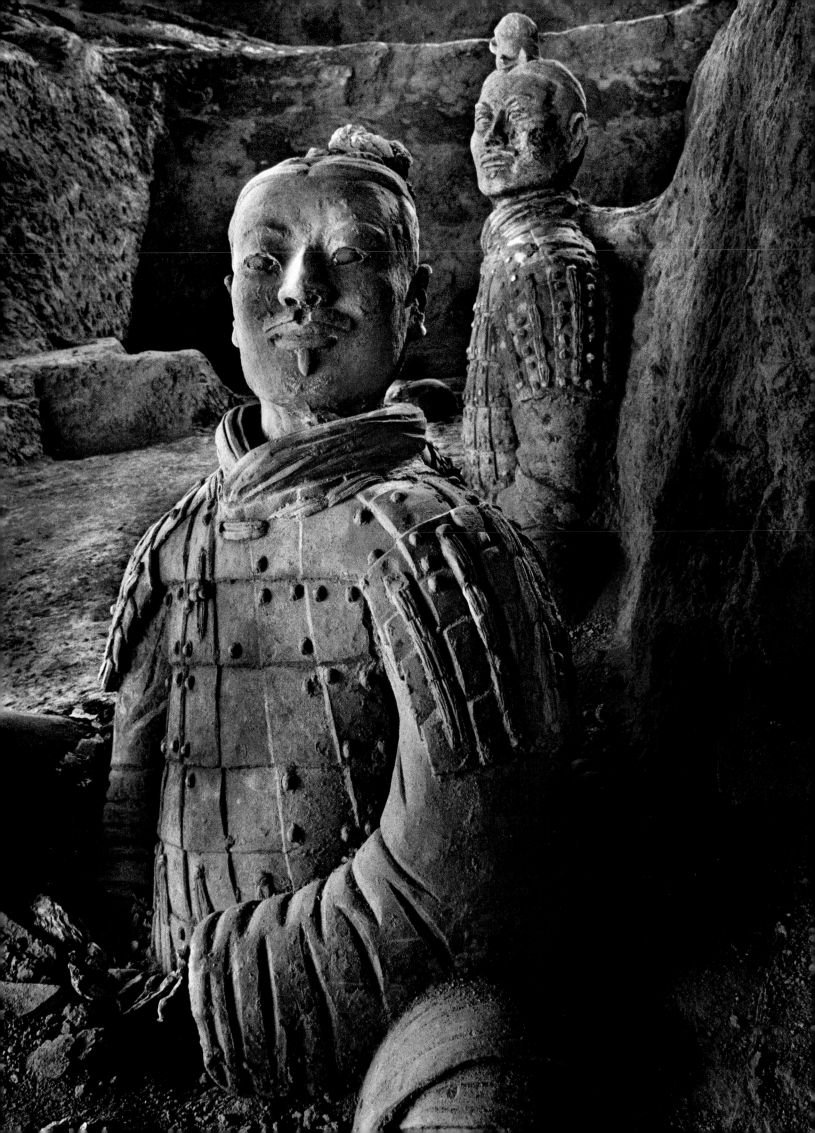

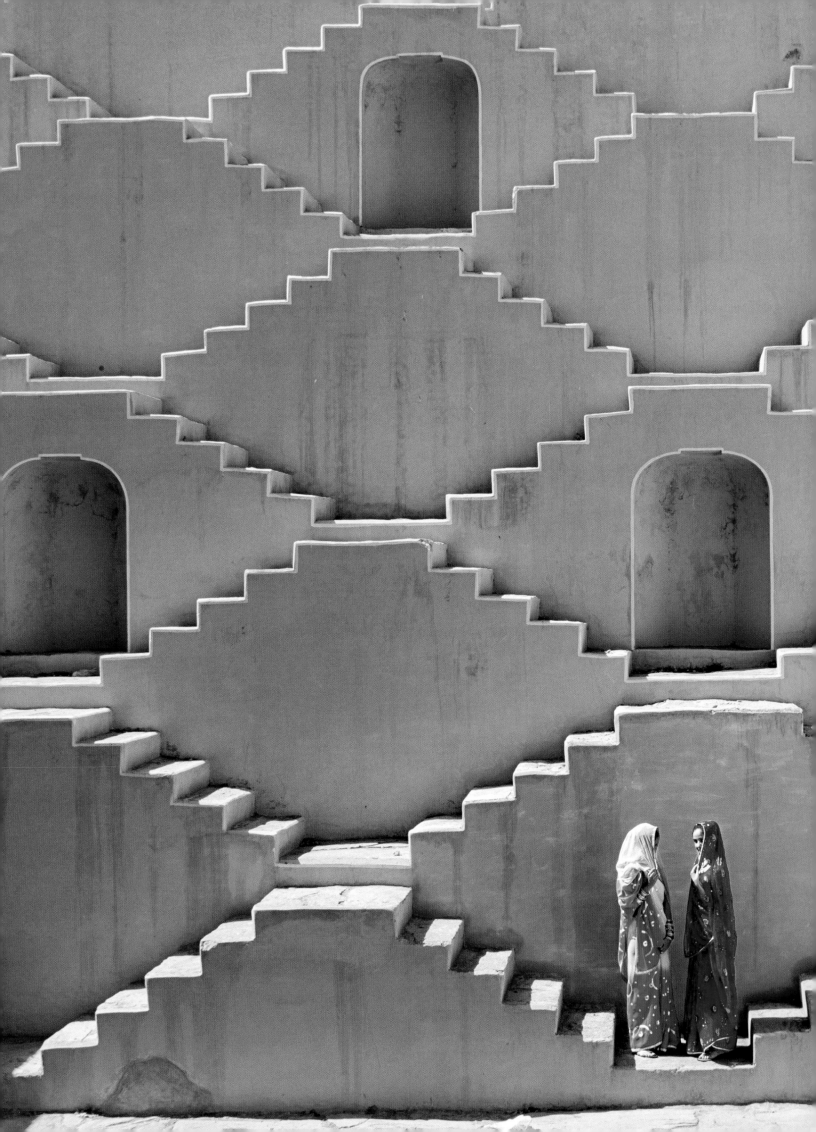

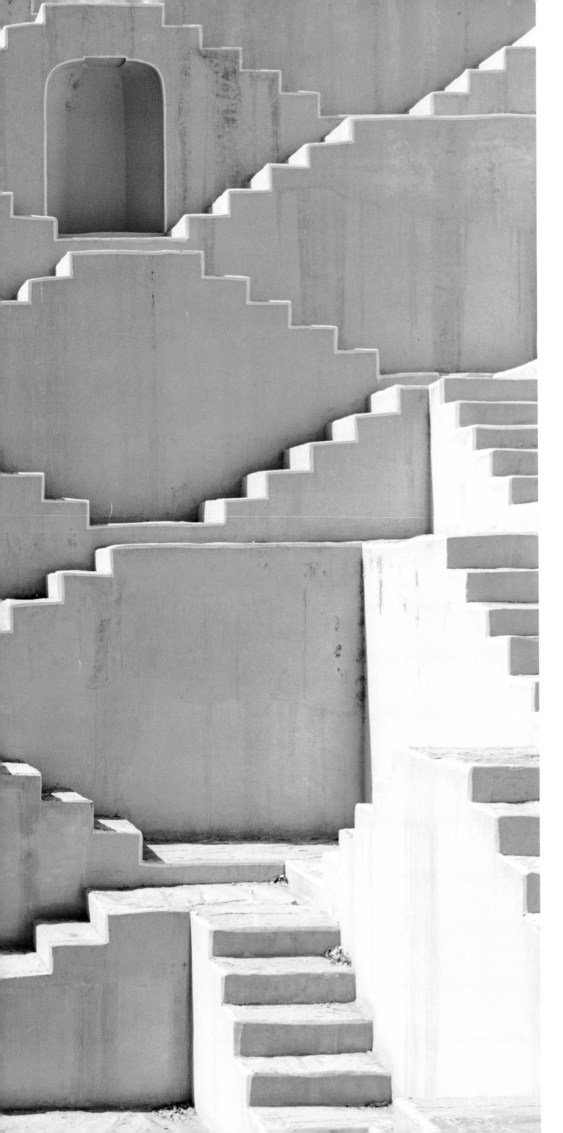

MY SHOT
Jaipur, India

For this shot, I liked how the contrast and shadows of the afternoon sun emphasized the lines of an ancient step well in Jaipur, in the Indian state of Rajasthan. I had been living in India for almost six years and wanted to explore how our changing environment is impacting women. The image of women standing at the bottom of a once full well raises the question: As water becomes scarcer on the planet, how far will they have to walk to find it?

– Ami Vitale, *National Geographic* photographer

GOLDEN TEMPLE OF DAMBULLA
Adorned and hidden Buddhist cave temples

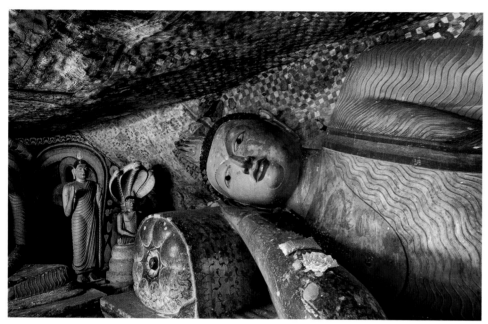

An enormous reclining Buddha (above) almost 50 feet (15 m) long, elaborate frescoes, and more await those who brave the entrance to Dambulla's massive cave temple complex (opposite).

Deep in the tropical undulating interior of Sri Lanka lurks a vast complex of richly decorated and Buddha-stuffed cave temples dating back to the third century B.C. The largest and best preserved of them can be found at the Golden Temple of Dambulla, 47 miles (76 km) north of the city of Kandy. This sacred place, an active monastery, includes an astounding 80 caves twisting through a rocky ridge. Within these heavily frescoed caverns, 153 statues of Buddha in various sizes and poses—including a giant sleeping Buddha—share space with countless murals and paintings of Buddha and his bodhisattva followers, depictions of Sri Lankan kings, and even a few statues of popular Hindu gods like Vishnu and Ganesh. The caves were inhabited by the exiled King Valagamba, who hid here for 14 years during the first century B.C.

Indeed, this mysterious cavernous complex dates back over two millennia and is considered integral to the history of Buddhism, namely for its preserved art but also for its role as a pilgrimage site. Five caves are considered most prominent, including the Cave of the Great Kings, Cave of the Divine King, and the Great New Monastery, dating back to the third century B.C., which archaeologists suggest was home to a prehistoric civilization long before the arrival of Buddhism transformed Sri Lanka.

TRAVELER'S NOTEBOOK

＊WHEN TO GO
Sri Lanka's two monsoon seasons (Yala monsoon season, May–Aug., and Maha monsoon season, Oct.–Jan.) make travel to the teardrop-shaped island tricky. High season (Dec.–March) remains the sunniest and best time to visit, with the months of April and Sept. making for a good shoulder season.

＊PLANNING
Sri Lanka's main airport is just outside Colombo. Intracountry flights are expensive and limited, but travel by chauffeured car remains affordable. Sri Lanka's rickety old wooden trains are a charming retro novelty and offer an incredibly scenic ride, but they are slow and seriously lacking in modern comfort. *railway.gov.lk*

＊WEBSITES
srilanka.travel, whc .unesco.org/en/list/561

▶ **UNFORGETTABLE EXPERIENCES**

It's possible to visit the caves on your own, but using a guide gives you access you wouldn't have otherwise. Tour Agency Audley uses local guides who don't shy away from the region's sensitive and complex history. Its 11-day Temples & Islands journey emphasizes Dambulla but also stops in mystical ancient ruins like Polonnaruwa, Kandy's iconic Temple of the Tooth, and Nuwara Eliya's chilly and verdant tea hills for hikes through the terraced plantations. *audleytravel.com*

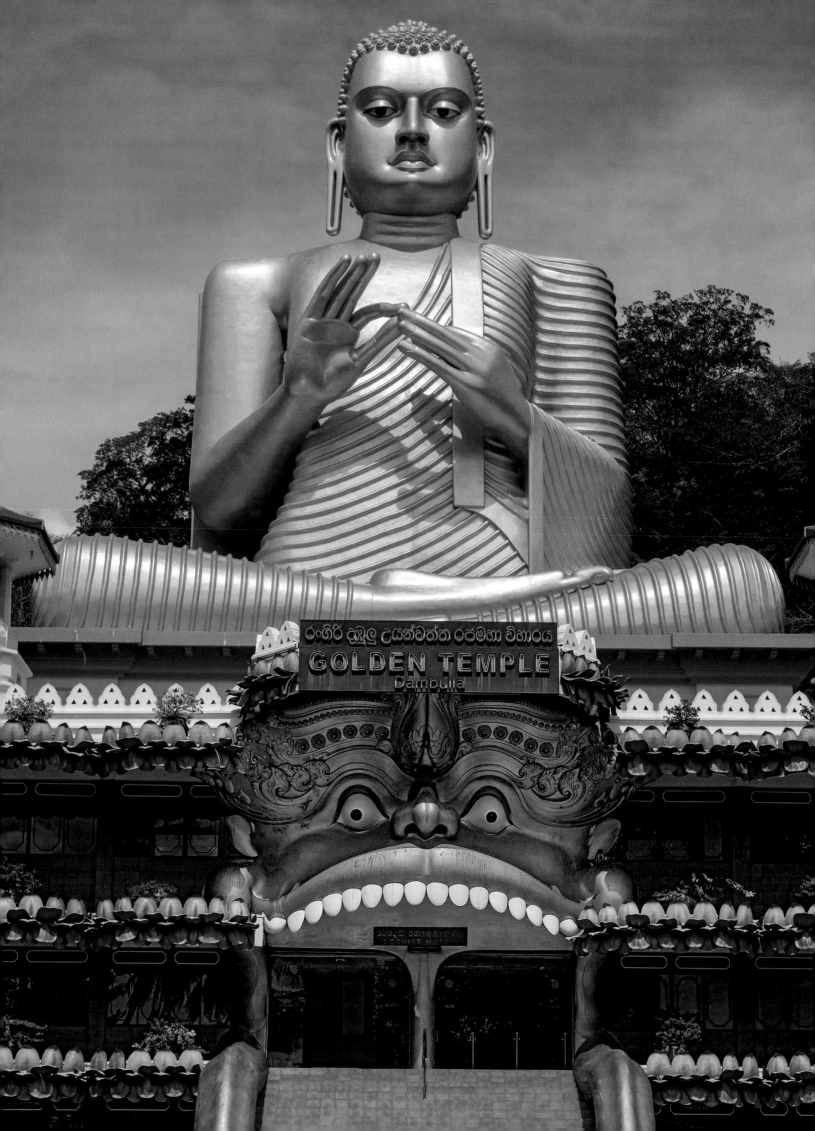

BAGAN
History set in stone along a fabled river

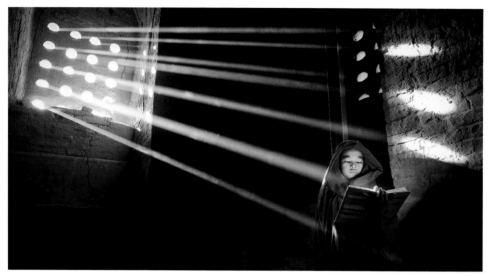

Inside a pagoda in the ancient city of Bagan (above); sunrise brings definition to a few of the city's many temples (opposite).

More than 2,000 temples, monasteries, and pagodas sprawl along the eastern bank of the Irrawaddy River in northern Myanmar (Burma), all that remains of an ancient metropolis that once harbored as many as 200,000 residents. The ancient city of Bagan flourished here between the 11th and 13th centuries A.D. as the capital of the first kingdom to unite most of what now constitutes modern Myanmar. Mongol invasion quashed Bagan's power, and the city slowly faded in both importance and memory, until it was rediscovered by intrepid travelers during the days of the British Empire.

Bagan, along with Angkor in Cambodia, is one of the two most important ancient religious cities in Southeast Asia, with a vast array of sacred antique structures. Among its foremost landmarks are the huge, pyramidlike 12th-century Dhammayangyi Temple; the highly revered Ananda Temple, with its four massive golden Buddhas facing the cardinal directions; and the adjacent, soaring Thatbyinnyu Temple, highest of the shrines and a favorite place to watch the sun rise or set over the riverside plains.

The Bagan Archaeological Museum safeguards sundry treasures recovered from the site, including the "Rosetta stone of Burma"—four languages carved into a stone slab called the Myazedi inscription. The modern-day villages arrayed around Bagan produce a wide variety of traditional handicrafts, in particular the marvelous lacquerware for which the region is known.

▶▶ TRAVELER'S NOTEBOOK

✳ WHEN TO GO
The climate is tropical all year, but the coolest period is Nov.–Feb., when daytime temperatures are warm but comfortable rather than scorching triple digits. Winter is also when some significant Bagan religious celebrations take place, such as the week-long Ananda Temple Festival.

✳ PLANNING
Bagan sits about 111 miles (179 km) southwest of Mandalay in central Myanmar. The ruins can be reached by bus and train from Mandalay, as well as daily flights from Yangon (Rangoon), but one of the more enjoyable ways to arrive is via the daily Malikha riverboat service from Mandalay. Be aware that there is a tourist tax.

✳ WEBSITES
baganmyanmar.com, myanmarrivercruises.com

▶ UNFORGETTABLE EXPERIENCES

Spread across 26 square miles (67 sq km) of predominantly flat plain, Bagan lends itself to exploration by bicycle. Many hotels have their own bike fleets, and there are plenty of places to rent in New Bagan and other villages. Electronic bicycles (e-bikes) have become increasingly popular, allowing riders to explore even more of the ruins in a shorter time span. Family-friendly guided bike tours are available through outfitters like Grasshopper Adventures in New Bagan. *grasshopperadventures.com*

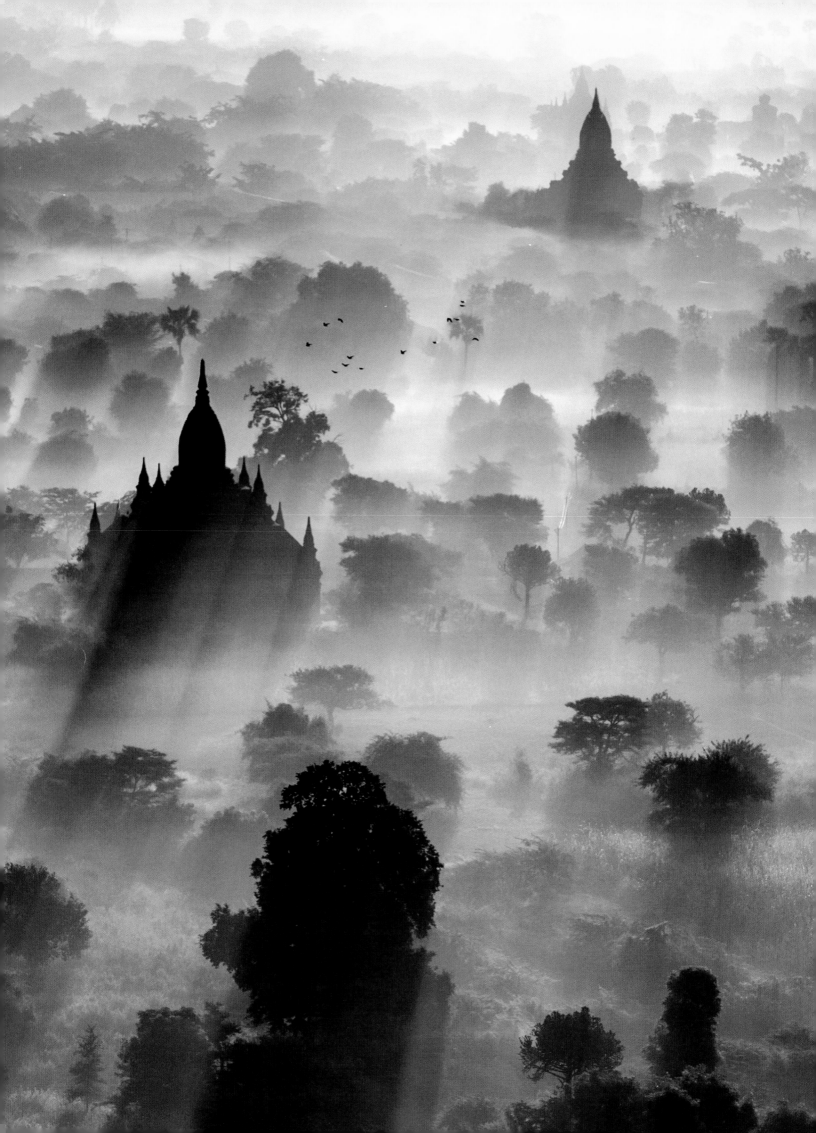

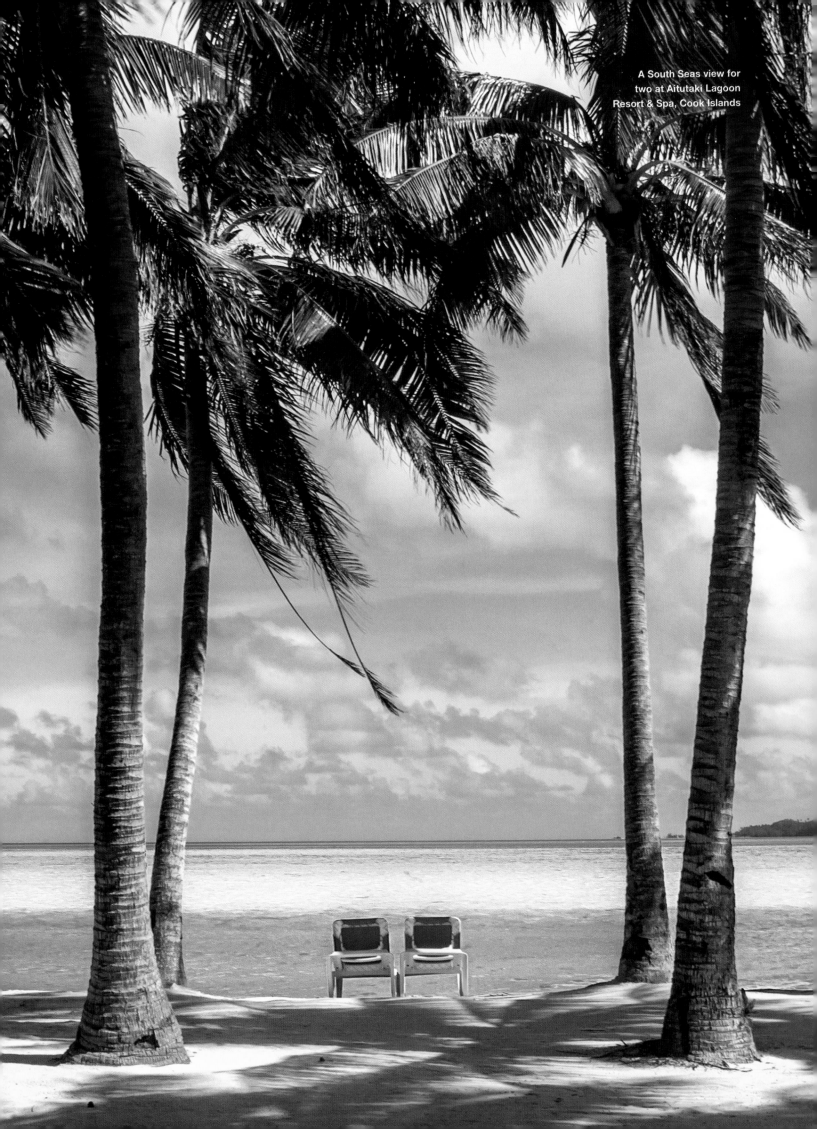

A South Seas view for two at Aitutaki Lagoon Resort & Spa, Cook Islands

SEA&
SHORE

Dip your toe in the water of some of the
planet's most amazing coastlines, bays, islands,
and seashores. Explore the Cook Islands'
sandy islets; Nova Scotia's jagged, lobster-
boat-dotted coastline; and Cambodia's Tonle
Sap river, complete with giant catfish.

PRIBILOF ISLANDS
The bridge between worlds

One can look at the tiny Pribilof Islands, about 300 miles (483 km) off the western edge of Alaska, not as outcrops of land in a stormy sea but as the last tiny bits of the Bering Land Bridge that once connected Asia and North America. They still bridge worlds, mixing the wild and the modern, the traditional and the timeless.

The Pribilofs, home to about 500 people, also host the world's largest population of northern fur seals, with around one million animals, some weighing more than 600 pounds (272 kg). Spots on the otherwise rugged beaches are worn smooth from thousands of years of seals crawling across them.

The Aleut say they first came here to hunt in the 17th century, and they're still on the islands, where their culture blends with the Russian and the American—women with traditional face tattoos drive Fords to the Orthodox Church.

And people still come here to hunt—not seals, now protected by law and left untouched—but rather bird sightings. The islands' position between continents makes them a vital resting place for more than 2.5 million migrating birds. More than 230 species have been spotted here, including the red-legged kittiwake, part of every birder's dream list.

▶ UNFORGETTABLE EXPERIENCES

In summer, birders run the island. But for the less feather obsessed, the best thing is to find a comfortable spot out of the wind and just wait for nature to sink in. With a permit, you can settle into raised observation blinds at the two main seal rookeries; the beaches themselves are off-limits during breeding season (June–mid-Oct.). Adolescent seals will bark at you, puffins will watch from the cliffs, and orca fins may cut the sea as the thick fog comes and goes.

TRAVELER'S NOTEBOOK

✴WHEN TO GO
For avoiding freezing cold and howling wind, and to view the largest diversity of wildlife, May–Aug. is the best time to come to the Pribilofs.

✴PLANNING
St. Paul, the larger of the two towns in the Pribilofs, is easily reached by air via Anchorage. Weather delays are almost a daily occurrence, and the islands can be fogged in for days; any time of year, it's a good idea not to book tight connections back on the mainland.

✴WEBSITES
travelalaska.com

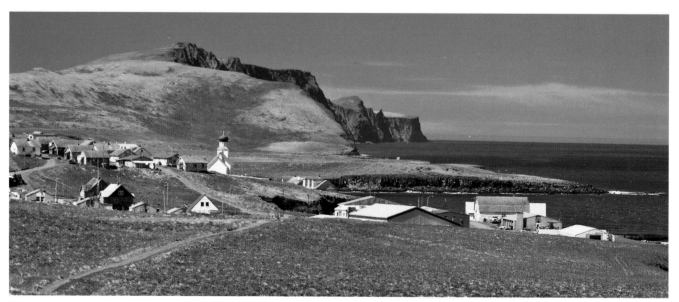

The community of St. George on St. George Island, the Bering Sea (above). The Pribilofs are home to northern fur seals (opposite), once actively hunted for their luxurious pelts and now protected by law.

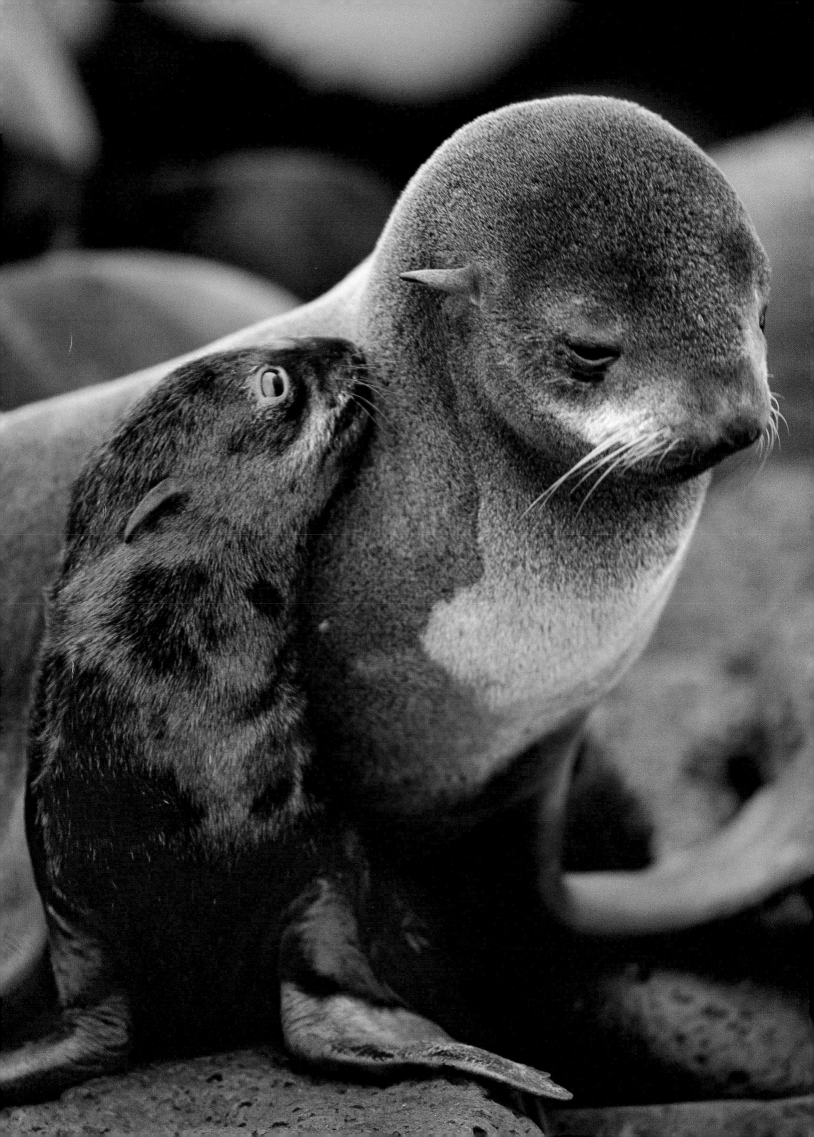

SAN JUAN ISLANDS
A lush archipelago with abundant sea life

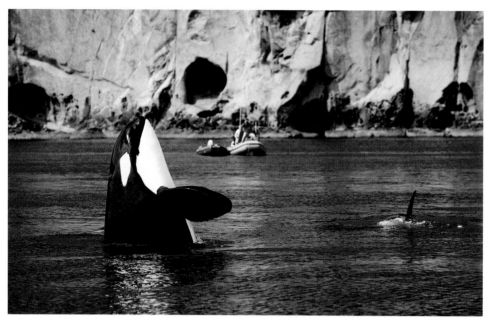

Whale-watching (above) is just one of the watery ways to explore the San Juans, including excursions leaving from charming Friday Harbor, San Juan Island (opposite).

TRAVELER'S NOTEBOOK

＊WHEN TO GO
Visit the San Juan Islands April–Oct., when the weather is at its best. July–Aug. are peak tourism months.

＊PLANNING
San Juan Island, Orcas Island, Lopez Island, and Shaw Island are served by ferries, which depart from the Washington State Ferries Anacortes Terminal, about 80 miles (129 km) northwest of Seattle. Purchasing a ticket online will reserve you a space; otherwise, plan to arrive a few hours before your ferry is scheduled to depart—it's first come, first served. First stop is Lopez Island, and you're charged only for a westward journey, so you don't need a return ticket.

＊WEBSITES
visitsanjuans.com, wsdot.wa.gov/ferries

The more than 400 individual San Juan Islands, part of Washington State, lie between the United States and Vancouver Island, British Columbia. For those without a seaplane, just four of these—Orcas Island, San Juan Island, Lopez Island, and Shaw Island—are accessible by ferry and, at that, only by ferry. This relative disconnection from the mainland contributes to one of the San Juans' greatest assets: a sense of isolation, which brings along with it an unhurried pace and a friendly, in-it-together community atmosphere. This languid feeling and the sense of being pleasantly cut off from the rest of the world—combined with the San Juans' seascapes, wildlife, and opportunities to kayak and bike—make them unforgettable places to visit.

Orcas Island is known as the emerald isle and the gem of the San Juans—and for good reason: It's green and gorgeous, with a beautiful shoreline and hilly terrain. (This makes cycling and hiking on Orcas a wonderful challenge.) The tallest peak on the islands, Mount Constitution, can be ascended by foot, bike, or car. The view from the top is expansive, encompassing sea, islands, and mountains, including Mount Baker on the Washington mainland. Orcas is horseshoe shaped and relatively large, and it has a bit more bustle

▶ UNFORGETTABLE EXPERIENCES

The Pelindaba Lavender Farm *(pelindabalavender.com)*, on San Juan Island, offers a tour through its lavish purple field. Blooms peak July through August, but there is plenty to do here May through October with guided tours of the grounds (July and August), as well as a "Demonstration Garden" featuring more than 50 lavender varieties. The farm distills oil from its flowers on-site—reap the rewards next door at Lavendera Day Spa *(lavenderadayspa.com)*, which uses Pelindaba products in various treatments.

than some of the other San Juans—Eastsound Village offers shops, galleries, a farmers market, and cafés.

From the western coast of San Juan Island, the nearest landmass is far-off Victoria, British Columbia—which means a view that generously gives a sense of limitlessness. The island has miles of farmland, a lavender farm, and orca pods offshore. The peaceful and charming community of Friday Harbor offers a vibrant artistic culture, with murals and mosaics decorating many storefronts.

Lopez Island is the most rural of the San Juans, with large stretches of farmland that also make for relatively easy cycling. It is the most secluded and calmest, and—in an archipelago known for its welcomes—thought to be the friendliest of all, where it's customary to wave at any motorist passing by. And, of course, there is abundant wildlife, from bald eagles taking flight from the treetops above to seals and otters popping up from below the surrounding seas.

The fourth of the ferry-served islands, Shaw Island, is the smallest, at less than 10 square miles (26 sq km), and an easy day trip from the neighboring isles. Stop by its historic general store, one of the oldest businesses in the entire state of Washington, and right on the water. As with all the San Juans, no matter where you wander, wondrous views of the sea are never far away.

> *"Living in the San Juans, you're surrounded by beauty and silence. There is no traffic. People are friendly, civil. It smells good, like the forest: dry and hot like summer vacation or cold and wet with wood smoke."*
>
> – Allison Collins, *painter*

▶ VISIT LIKE A LOCAL

The Fisherman Bay Spit Preserve on Lopez Island—commonly known as "The Spit"—is a local secret, part of the areas protected by the San Juan County Land Bank. It's a delicate landscape, and visitors are asked to stay on the designated trails to protect the plant- and bird-life. The trails lead through an old orchard and a former homestead, and on down to the sand spit, which overlooks the bay, the village beyond, and the channel between Lopez and San Juan.

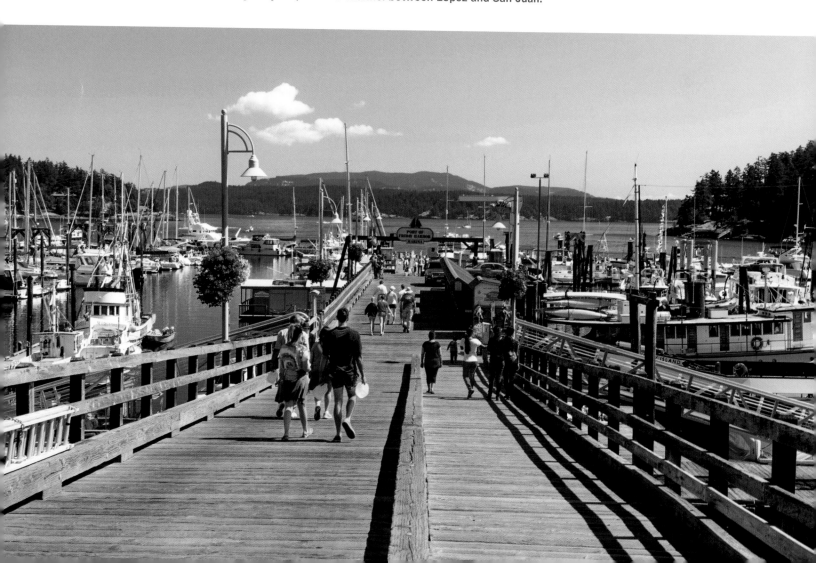

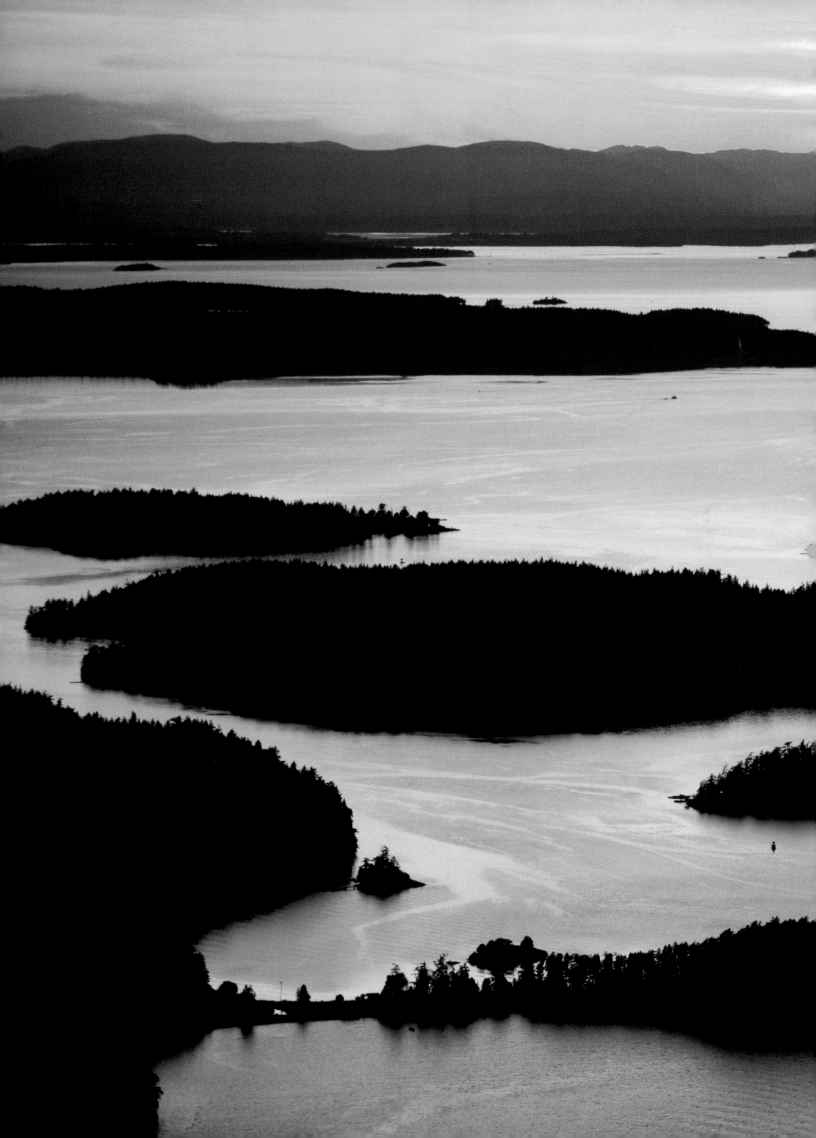

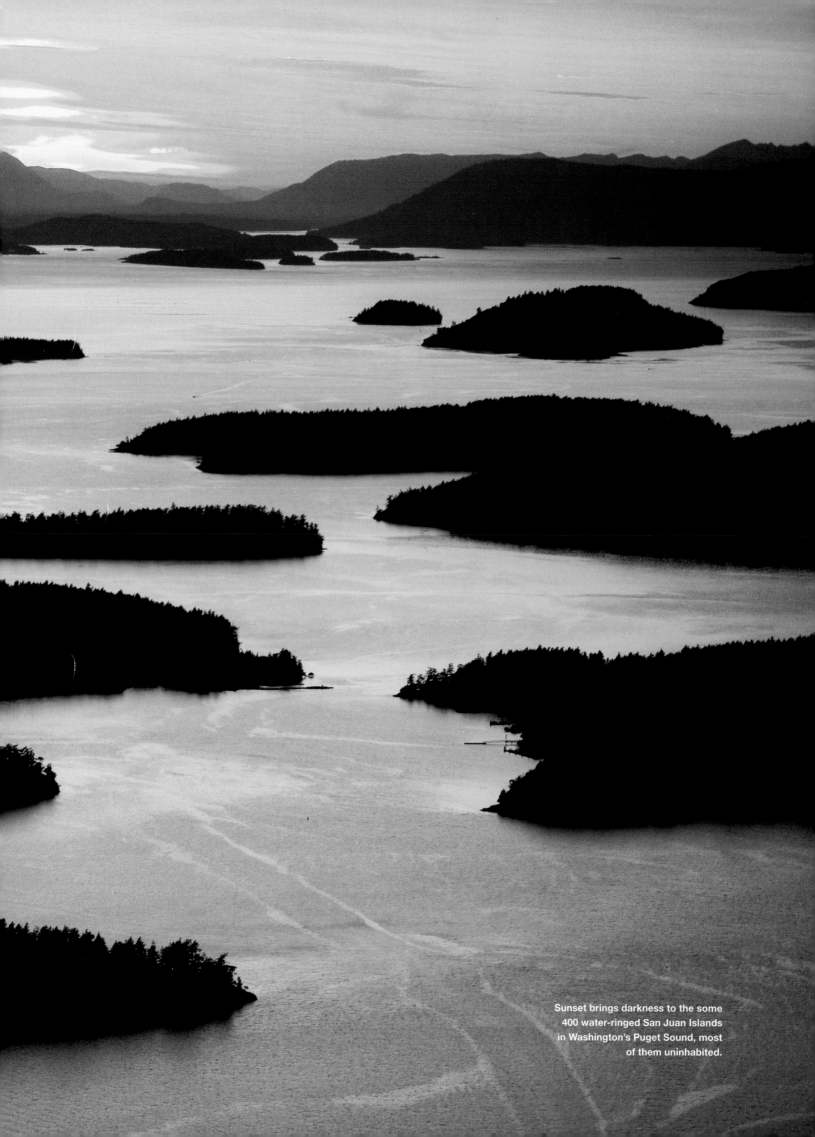

Sunset brings darkness to the some
400 water-ringed San Juan Islands
in Washington's Puget Sound, most
of them uninhabited.

LEGENDARY LIGHTHOUSES

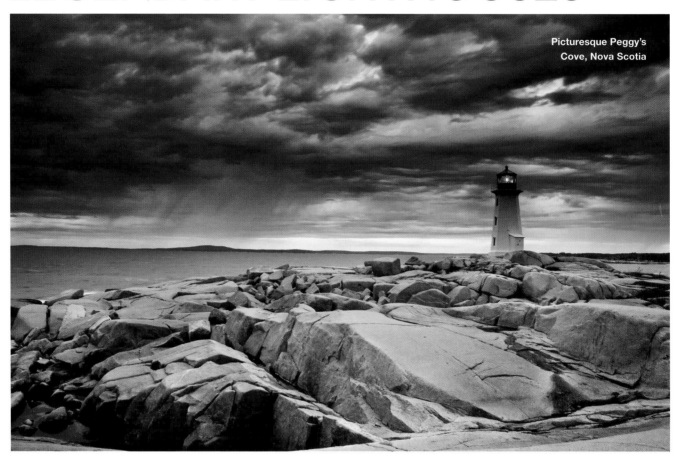

Picturesque Peggy's Cove, Nova Scotia

Peggy's Cove, Canada

It's not hard to understand why this beacon in Nova Scotia has been called the world's most photographed lighthouse. It sits on a rocky outcrop surrounded by surf, overlooking a tiny fishing village scattered with boats painted in primary colors.

Portland Head, Maine

George Washington appointed the first keeper for this Cape Elizabeth beacon, constructed by the Massachusetts Colony and dedicated by the Marquis de Lafayette. The stone lighthouse sits on a rocky ledge, guiding mariners though Casco Bay.

Yokohama, Japan

The ten-sided skeletal steel Yokohama Marine Tower, a latticework structure 348 feet (106 m) in height, rises above one of Asia's most important ports. Take the elevator to the observation deck; on a clear day it's possible to see Mount Fuji some 77 miles (124 km) away.

Cape Hatteras, North Carolina

The tallest United States lighthouse towers 210 feet (64 m) above sea level, reaching the height of a 20-story building. Climb the brick structure's 257 steps and be rewarded with sweeping views of North Carolina's Outer Banks.

Heceta Head, Oregon

This West Coast landmark sits snugly on a cliff above a Pacific cove, shooting a beam of light—first illuminated in 1894—21 miles (34 km) out to sea. The keeper's home, now a bed-and-breakfast, gives overnight visitors a chance to soak up maritime lore.

Split Rock, Minnesota

Although this Lake Superior light station was decommissioned in 1969, its lens shines every November 10 in memory of the Great Lakes freighter *Edmund Fitzgerald*, which sank in 1975, claiming 29 lives.

Ushuaia, Argentina

Les Eclaireurs, the world's southernmost lighthouse, guides shipping through the treacherous Beagle Channel—so named because Darwin's ship passed through here in 1833—in Tierra del Fuego, earning its nickname as el Faro del Fin del Mundo—the Lighthouse at the End of the World.

Les Eclaireurs, Argentina

Bell Rock, Scotland

Robert Stevenson, grandfather of adventure writer Robert Louis Stevenson, constructed this masonry beacon in the early 19th century on a rocky, storm-washed ledge 11 miles (18 km) off the eastern coast of Scotland. Even 200 years later, it remains an astonishing engineering feat.

Jeddah, Saudi Arabia

The world's tallest lighthouse stands 436 feet (133 m) above the Jeddah Islamic Port, marking a break in the coral reef and directing ship traffic at busy Red Sea harbor. The concrete-and-steel tower, painted white, resembles a giant orb and glows green at night.

A Coruña, Spain

The ancient Roman Tower of Hercules remains in use 1,900 years after its construction—according to legend, over the skull of a giant killed by Hercules. It is a UNESCO World Heritage site, and its design may be based on the famed Lighthouse of Alexandria.

A Coruña, the Roman Tower of Hercules, Spain

MARITIME PROVINCES

An enchanting land of misty shores, steep cliffs, and wide bays

The captivating port town of Lunenburg, Nova Scotia (above), known for its shops and galleries. Lobster traps pile high on the dock of the Nova Scotian village of Blue Hills (opposite).

TRAVELER'S NOTEBOOK

✱WHEN TO GO
Summer is the most pleasant season, whereas fall ushers in spectacular foliage. Late June and early September offer smaller crowds. Check the provinces' websites for upcoming events and major cultural festivals.

✱PLANNING
Halifax, the capital of Nova Scotia, is the most popular entry point to the Maritimes, and driving is the easiest way to explore the provinces. Moncton is a good jumping-off point for the best sights in New Brunswick, and Prince Edward Island can be reached via the Confederation Bridge from New Brunswick or the Northumberland Ferry from Nova Scotia.

✱WEBSITES
novascotia.com, tourismnewbrunswick.ca, tourismpei.com, national geographicexpeditions .com

The word "maritime" simply means "of the sea"—the perfect descriptor for Nova Scotia, New Brunswick, and Prince Edward Island, Canada's three small Maritime Provinces. All have been shaped by the Atlantic Ocean, their long, jagged coastlines punctuated by sandy beaches. The fortunes of those who live here likewise rise and fall with the sea, a people who proudly share the cherished traditions of their Scottish Gaelic, Irish Gaelic, French Acadian, or First Nations roots as they continue a rich legacy of fishing and shipbuilding.

Jutting into the North Atlantic, Nova Scotia is bound by a 4,722-mile-long (7,600 km) coastline, connected to mainland Canada by the Isthmus of Chignecto. From its spirited capital of Halifax, you can explore the South Shore's rocky inlets, tranquil harbors, and such engaging fishing villages as picturesque Lunenburg, a UNESCO World Heritage site noted for its colorful wooden 18th-century houses and thriving lobster industry. Those looking for a more adventurous setting head to rugged Cape Breton Island, where brave drivers loop the island via the counterclockwise route along scenic Cabot Trail while enjoying jaw-dropping views of dramatic ocean vistas beyond steep drops. From May to October, fin, pilot, humpback, and minke whales congregate offshore, offering unparalleled whale-watching.

▶ UNFORGETTABLE EXPERIENCES

Prince Edward Island is famed for its oysters and other seafood, including fresh lobster. Join in the feast at one of the island's traditional lobster suppers, frequently served in local churches or community halls. Or try family-run Cardigan Lobster Suppers *(peicardiganlobstersuppers.com)* for a five-course meal of succulent lobster, seafood chowder, mussels, island potatoes, and local vegetables. Fisherman's Wharf restaurant *(fishermanswharf.ca)* selects its catch from its own saltwater pond.

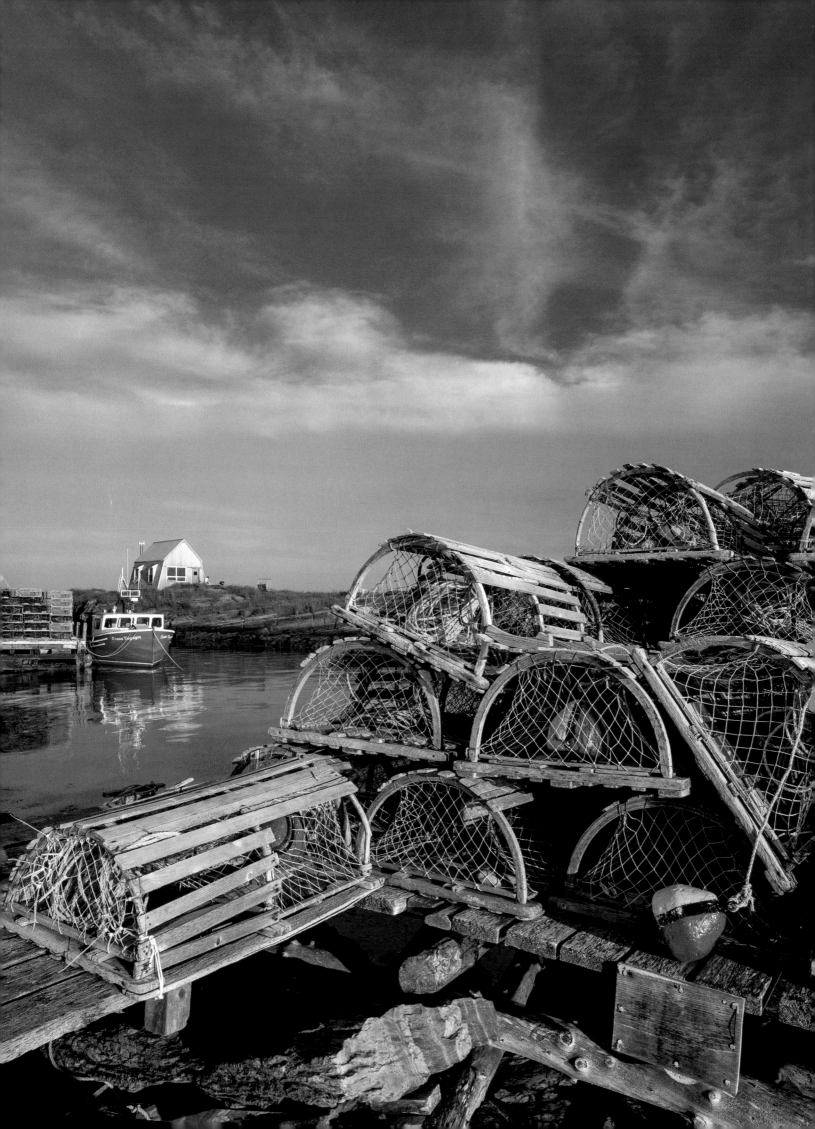

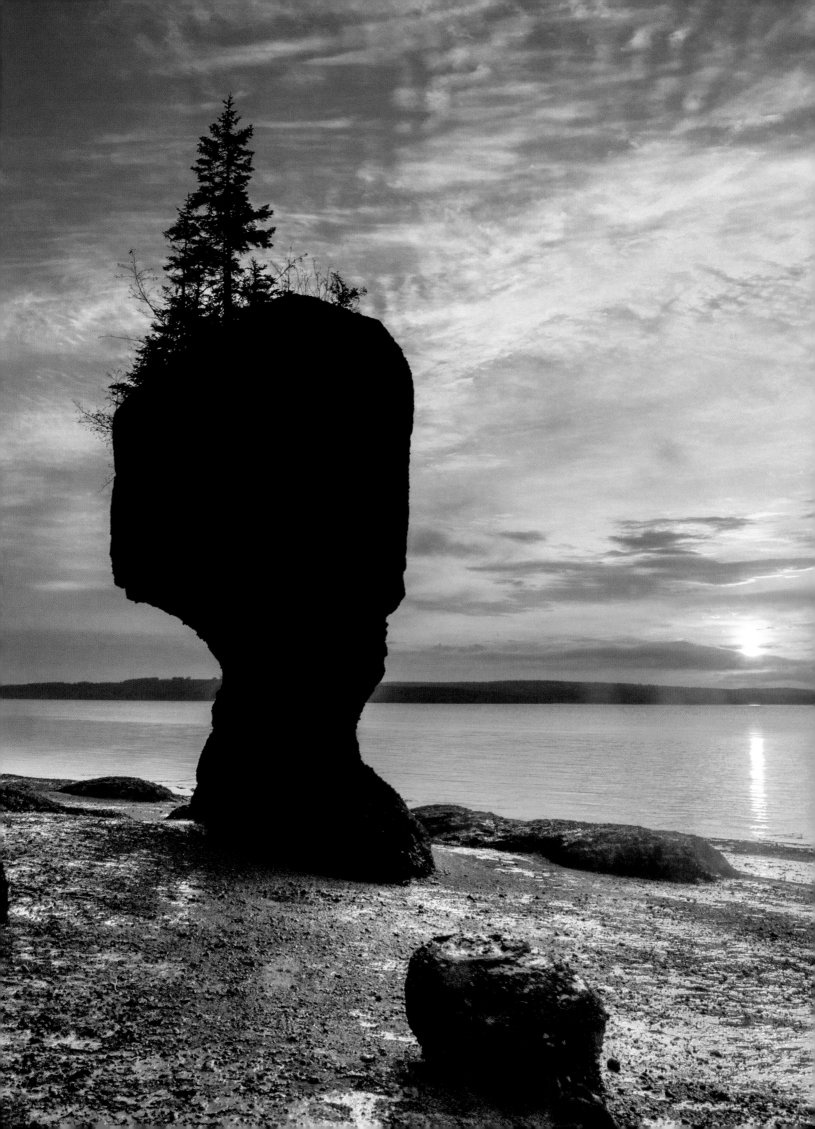

Green Gables farm (above) and its surroundings in Cavendish, Prince Edward Island, are the setting for Lucy Maud Montgomery's beloved *Anne of Green Gables* books. At Hopewell Rocks, New Brunswick, the region's rocky shore showcases nature's imagination (opposite).

Separating Nova Scotia and New Brunswick is the astounding Bay of Fundy, home to the highest tidal range in the world. In a single cycle of about 12 hours, more than 100 billion tons of seawater pass through the bay—equal to the amount that flows daily through all the freshwater rivers on Earth. Here the Fundy Isles form a captivating archipelago of more than two dozen islands that range from genteel Campobello Island, where Franklin D. Roosevelt kept his summer retreat, to wild Grand Manan Island, sporting sharp cliffs, miles of seaside trails, and thousands of Atlantic puffins. Farther north in New Brunswick the native traditions of the Mi'kmaq, active in the Maritimes for 10,000 years, remain vibrant, as evidenced in gatherings such as the Esgenoôpetitj First Nation Powwow each August in the community of Burnt Church.

Cradled above the two provinces, bucolic Prince Edward Island enchants visitors with its rolling red hills, Victorian towns, and windswept dunes. Never far from sight is the sea— "misty and purple, with its haunting, unceasing murmur," wrote local-born novelist Lucy Maud Montgomery, whose beloved heroine Anne Shirley still delights readers across generations. True fans make the pilgrimage to the source of Montgomery's inspiration, the Green Gables farm in Cavendish.

> *"Slower and less aggressive than anywhere else I have lived, Nova Scotia is a naturally contemplative place where people share the values of connecting with, and caring for, nature and each other."*
>
> – Jim Drescher, *co-director, Windhorse Farm*

▶ VISIT LIKE A LOCAL

Few travelers connect surfing with the cold waters of the Maritimes, but Nova Scotia boasts some little-known locales that are prime spots to hang ten. The small town of Lawrencetown Beach, 16 miles (26 km) east of Halifax, has consistently excellent waves, especially at night (although fog may be an issue). Remote Ingonish Beach, located in Cape Breton Highlands National Park, sports miles of sand, scenic views of the Highlands, and gentle swells great for beginner surfers.

MY SHOT

Garrison Savannah, Barbados

While I was on assignment in Barbados, a hotel owner suggested I get up at 3 a.m. to watch the Turf Club horses being bathed in the ocean at sunrise. I drove in the pitch black to the waterfront— there, a parade of grooms- men and their thoroughbreds gradually emerged from the dark street, past the glow of a single streetlamp, and into the ocean. As the sun started to reveal the beautiful blue water, the gorgeous horses, and the Bajan men bathing alongside these incredible animals, everything fell into place.

– Susan Seubert, *National Geographic* **photographer**

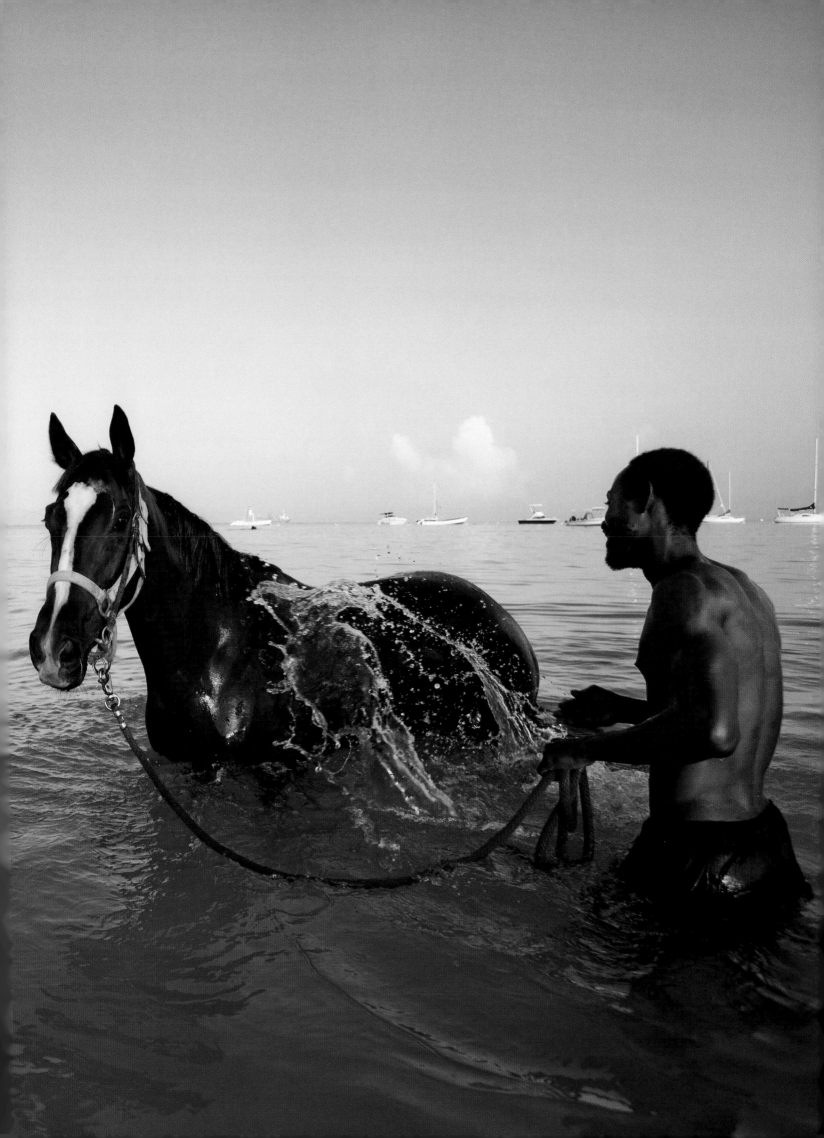

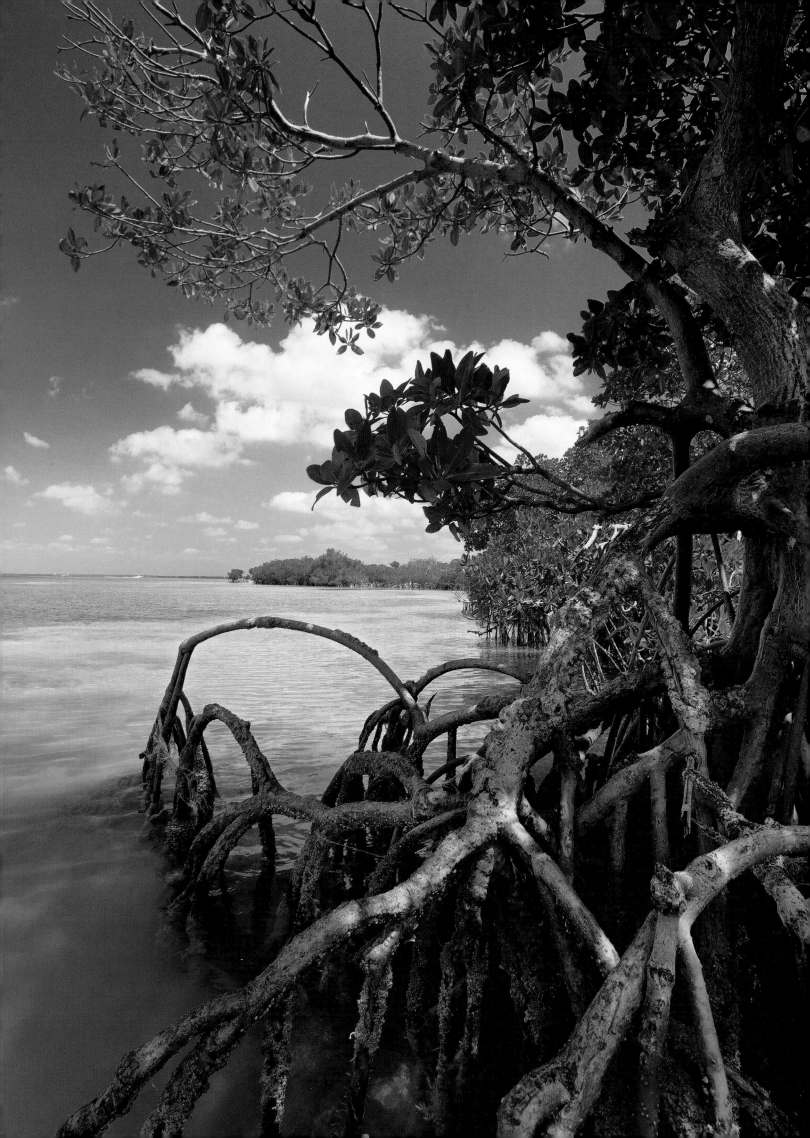

BISCAYNE NATIONAL PARK
Living life on, in, and under the water

Florida cormorants take flight from one of the floating houses of Stiltsville (above), near Key Biscayne, while along the shore mangroves' arched roots shelter an abundance of marine life (opposite).

n February 1878 the iron-hulled *Arratoon Apcar*, en route from Liverpool, was little more than 200 miles (322 km) from its port in Havana when it ran aground at Fowey Rocks on Key Biscayne. The crew was saved, but the 262-foot (80 m) ship sank beneath the waves. Today the shipwreck—and Fowey Rocks Lighthouse, which warns other vessels away from the same fate—is a favorite haunt of schools of colorful tropical fish as well as avid snorkelers visiting Biscayne National Park.

This unique coastal park stretches south from Miami to the Florida Keys—270 square miles (699 sq km), almost all of it underwater. A boat is a must for exploring its rich history and watery wilderness, which includes the northern edge of the Florida Reef, one of the world's largest. Scuba divers and snorkelers join the abundant aquatic life as they follow the Maritime Heritage Trail, featuring six of the region's many shipwrecks among the graceful coral. (The *Mandalay*, which sank in shallow waters at Long Reef in 1966, is another top snorkel and scuba destination.) Along the shore, birders kayak through extensive mangrove swamps in search of the elusive mangrove cuckoo, and sailboats skim across the water between the park's rustic islands, wise to the shallow waters that trapped so many ships before them.

▶ UNFORGETTABLE EXPERIENCES

About 2 miles (3.2 km) off Key Biscayne, seven iconic homes appear to float above the open water. Welcome to Stiltsville. Locals tell of Captain Eddie "Crawfish" Walker, who built the first house on stilts here in the 1930s, and of the town's heyday in the 1940s and '50s, when it was home to wild social clubs for Miami's moneyed set. Today a nonprofit stewards the properties, which are available for event rental *(stiltsvilletrust.org)*. Can't score an invitation? HistoryMiami offers legend-rich tours *(historymiami.org)*.

CABO POLONIO
Where stars and a lighthouse ignite the evening sky

No roads lead to the remote beach community of Cabo Polonio (opposite) along the Atlantic coast; access is by foot or 4x4 (above).

TRAVELER'S NOTEBOOK

***WHEN TO GO**
Best times to visit are during the South American spring and summer, Sept.–March. April is a less crowded time to visit, but the weather can be hit or miss as it cools. La Perla is open all year.

***PLANNING**
Cabo Polonio is about 157 miles (253 km), northeast of Montevideo, following Routes 9 and 10 along the coast, and 93 miles (150 km) from Punta del Este in the same direction. Rent a car or check with Cot bus company, although service is infrequent— once or twice a day even in season. Agencia El Paraíso runs the 4x4 transports that scrape the dunes into Cabo Polonio, and can also arrange individual 4x4 and horseback-riding trips.

***WEBSITES**
cabo-polonio.com, welcomeuruguay.com, cot.com.uy (Spanish only), cabopolonio.com/comollegarx.htm

t takes an effort to get here, walking through the dunes from a distant parking lot cut within a pine forest in Cabo Polonio National Park. It might seem to be faster and easier to take the mechanical shortcut, enormous 4x4 trucks that ride like tanks over the dunes and along the beach, although riders' backs and necks scream for mercy along the way.

Isolated Cabo Polonio is worth the effort, though, a hamlet hidden on one of the most remote beaches on the South American continent. Situated in Uruguay's tiny Rocha department, snug along a peninsula jutting off the Atlantic coast, it's a world away from its famous, celebrity-infested, honky-tonk cousin Punta del Este in the department of Maldonado, 93 miles (150 km) to the northeast. Here in Cabo Polonio there's no source of electrical power at night, save for batteries and solar generators. The roads are paved with nothing more than the sea- and wind-caressed sand; cars are banned, except for emergency and official vehicles. There's no running water system beyond rain or the ocean itself.

Evening in Cabo Polonio is dominated by two things: the endless stars of the Milky Way, incandescent in the black of the night sky and virtually unobstructed by the ambient light of civilization, and the gentle sweep of the light beam emanating from the 1881 lighthouse, designed by British engineers and the sturdiest structure around. Scattered tiny beach

▶ UNFORGETTABLE EXPERIENCES

Experience the region's wide variety of wildlife at Laguna Negra, or the Black Lagoon, a lake sacred to the Indians who once lived here. Now an ecological zone, it lies about 26 miles (42 km) north of Cabo Polonio, with swampy shores teeming with owls, falcons, parrots, and even the giant ostrichlike bird locally called the nandu or the rhea. Brown furry capybara, the world's largest rodents (weighing in between 77 and 145 pounds, or 35 to 66 kg), swim in the mud holes that dot the lakeshore.

houses—many former fishermen's shacks and almost all single story—cluster close, as if seeking shelter or perhaps worshipping the lighthouse's powerful nocturnal beams.

The only reliable year-round hotel is the 15-room La Perla del Cabo, built almost half a century ago by fishermen. Rustic wooden dining tables mingle with hammocks tied to the beams on a front porch, itself sitting on water-lapped rocks on the ocean's edge, offering a view to the surfers in the waves beyond. At night in the darkness the sound of the Atlantic is a constant presence, beckoning you to sleep.

Where humankind leaves very little of an imprint, the variety of animals comes to play, from squawking, mischievous seagulls to curious baby sea lions that squeal with delight at the small human presence in their midst.

If even this is not lonely enough for you, walk north along the peninsula toward Cerro Buena Vista, the seaside cliff visible from town. It looks close, but is more than 7 miles (11 km) away, overlooking the park's immense Sahara-like sand dunes, which glow gilded at sunset. After darkness falls, the eternal rhythm of the ocean and the sweeping beam of the lighthouse will guide you back to Cabo.

> *"I work in a paradise and I live in a place that is mythical and magical. We are in touch with nature all the time. There are no people. It is a place far from Maldonado, and closer to God. I am full of pride to be here."*
>
> – Leonardo Da Costa, *lighthouse keeper*

▶ VISIT LIKE A LOCAL

To live off the land, or rather the ocean, as Uruguayan vacationers do, go fishing as has been done along the beach for well over a century. At low tide, simply use a small stone to chip off the abundant mussels clinging to the boulders along the beach, or walk to the edge of the stone piles that jut into the ocean to cast your rod, if you've been smart enough to bring one ahead of time. With a late-night oceanside campfire and a beer, dinner is served.

The ever shifting sand dunes of
Uruguay's Cabo Polonio change
shape with the wind.

ECUADOR

GALÁPAGOS ISLANDS
Darwin's eternal and spectacular living laboratory

Flung far into the Pacific Ocean, well away from the nearest civilization, the Ecuadorian Galápagos archipelago has preserved its unique, primeval ecosystem against all odds, making this a must visit for ecologically minded tourists.

The raw, open ocean and uninhabited volcanic islands provide a spectacular canvas upon which evolution is leaving its whimsical marks. Here guests find iguanas that venture underwater to feed on algae, distinct giant tortoises that helped Darwin articulate evolution, and birds so unaccustomed to human presence that they don't feel threatened or budge an inch when travelers venture near them. On the islands of Fernandina and Isabela, cormorants have simply stopped bothering to fly, using their webbed feet to swim for food instead.

Taking to the water, visitors might swim along playful sea lions or be swarmed by a school of colorful burrito grunt fish; a giant tortoise, which can live well over a hundred years old, might casually glide by. Deeper still, graceful manta rays and gentle hammerhead sharks bathe quietly as colorful coral, sea anemone, and huge octopuses lurk in crags and nooks. High above, kitelike black frigatebirds flutter their long scimitar wings while surveying the water surface for fish to catch. Blue-footed boobies, known for their stomping courtship

▶ **VISIT LIKE A LOCAL**

Island hopping shows firsthand how different Galápagos ecosystems evolved in isolation from one another. Naturalists accompany passengers on board National Geographic cruises *(nationalgeographicexpeditions.com)* to islands like snorkeler's delight Floreana and bird-watcher's paradise Genovesa. Finch Bay Hotel *(finchbayhotel.com),* on Santa Cruz Island, runs yacht excursions to sites like North Seymour, abundant with eagle rays and sea turtles.

》》 TRAVELER'S NOTEBOOK 《《

＊WHEN TO GO
Mid-May–mid-June and mid-Nov.–mid-Dec. are shoulder seasons between wet and dry periods when the water is warm, the weather balmy, and the crowd thinner.

＊PLANNING
Flights arrive in Santa Cruz from mainland Ecuador's Guayaquil and Quito. You may visit the uninhabited islands only as part of a licensed group tour, so your best bet is to join a cruise, which ranges from spartan to posh.

＊WEBSITES
visit.ecuador.travel/ galapagos

The Galápagos giant tortoise, *Chelonoidis nigra* (above), may live to be more than 100 years old. The volcanic craters of Isabela Island (opposite) attest to the forces that originally created the Galápagos.

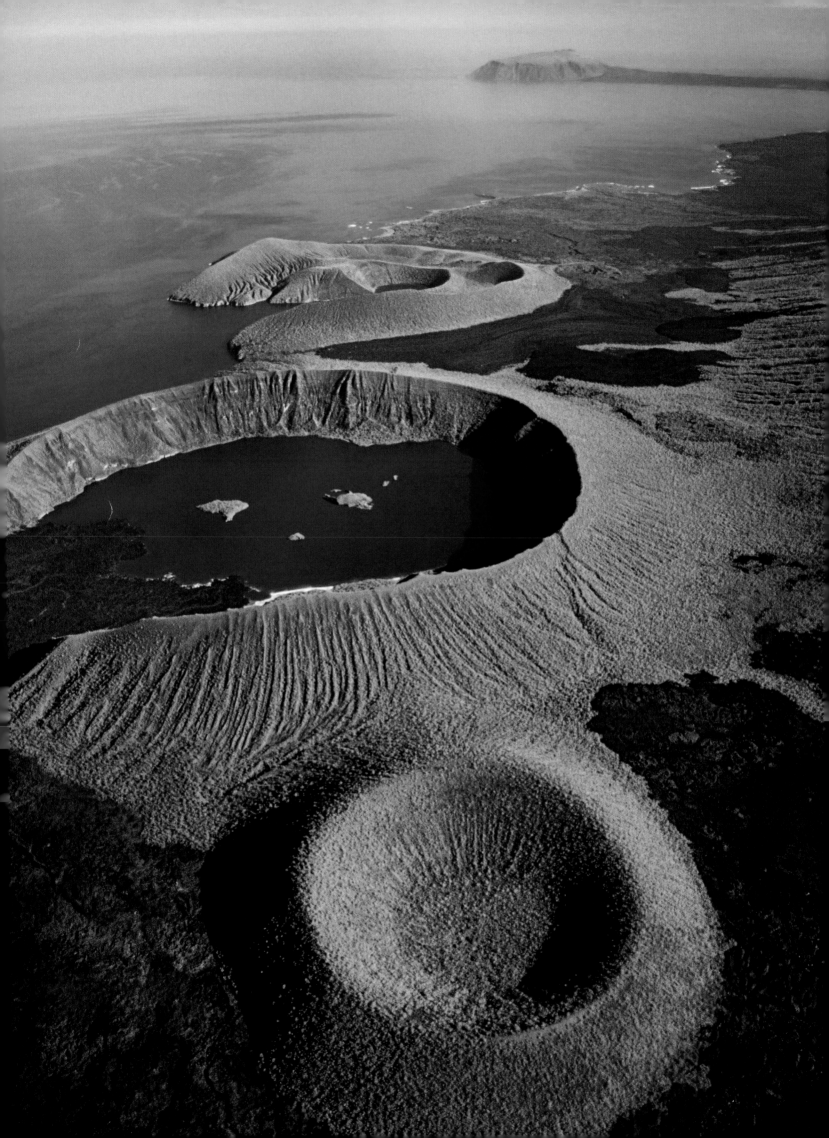

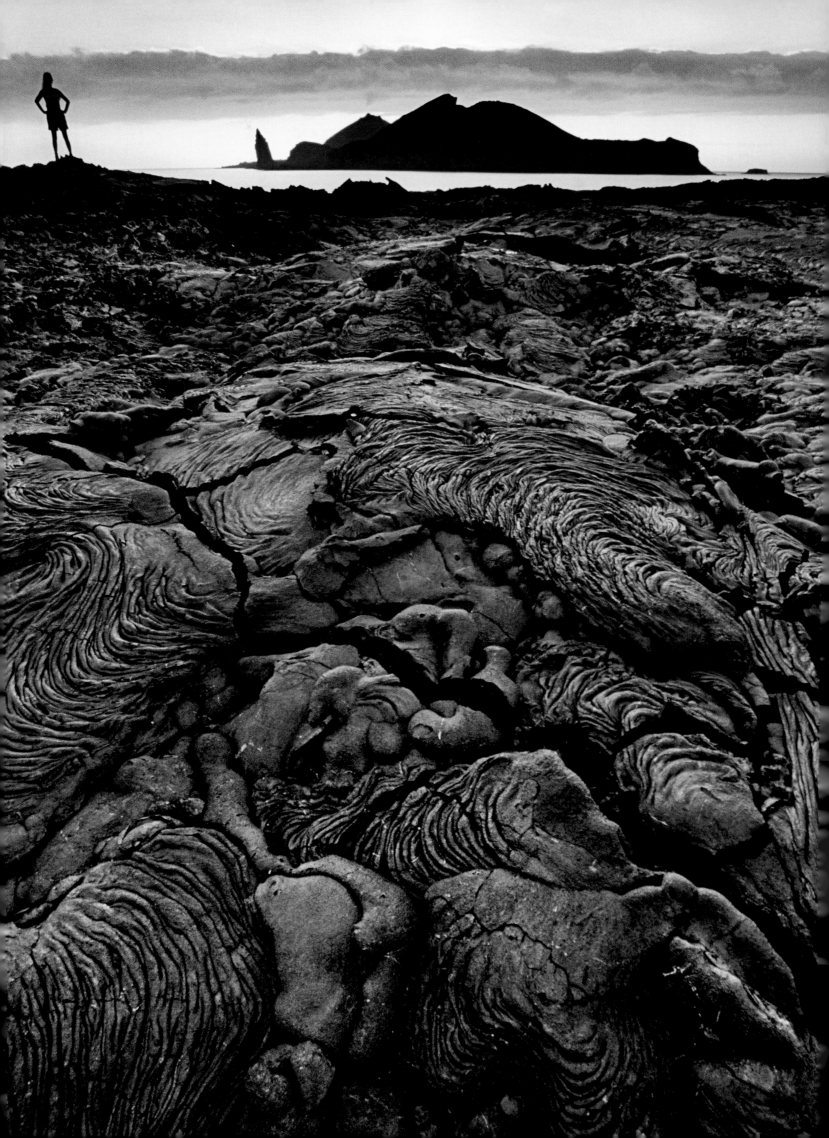

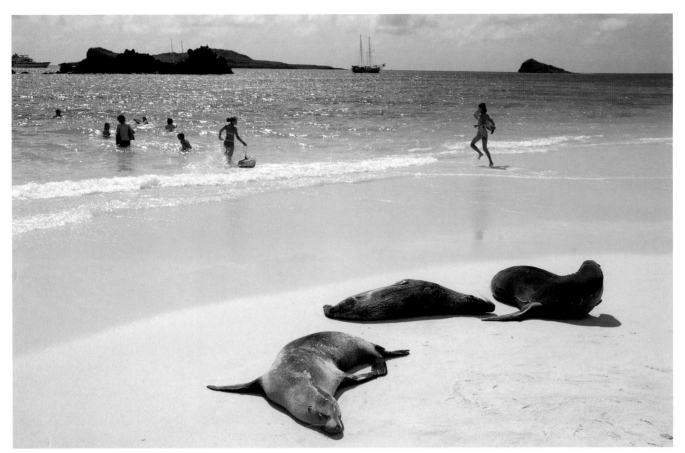

Remarkably tame sea lions (above) can be seen in the waters and on the beaches of nearly all of the Galápagos Islands. Hardened lava flow stretches to the sea at Sullivan Bay (opposite), Santiago Island, formed of two overlapping volcanoes.

dance, dive-bomb into the ocean to come up with fresh catch. The so-called Darwin finches chatter while the teeny Galápagos penguins, the northernmost of the tuxedoed species, waddle about coves and caves.

With distinct ecosystems, the more than 20 islands and a multitude of rocks, most of which are protected and closed to human settlement, are proving how nature transforms itself over time. Visiting the Galápagos gives us a glimpse at how this planet might have looked in a different time. Not all is well, however. Global climate changes continue to threaten these idyllic isles. Rising ocean temperature and irregular rainfalls have altered the archipelago's delicate food chain, proving detrimental to the marine iguanas, seabirds, sea lions, and sharks. In addition, introduced and stowaway species like mice, cats, and goats have wreaked havoc on the ecosystem that was previously devoid of predators. But conservationists are trying their hardest to reverse the adverse effects of past human visitation, with some success. In addition, expanding wind turbine projects aim to replace diesel-generated electricity with renewable energy, proving perhaps we can get along nicely with nature.

> *"I love meeting people from all over the world who come in search of silence and pure nature on my island, surrounded by sea lions, pelicans, turtles, penguins, sharks, all of them completely fearless and harmless."*
>
> – Xavier Burbano de Lara, *Finch Bay Hotel manager*

▶ VISIT LIKE A LOCAL

While the Galápagos Islands' status as a protected national park makes independent travel without a licensed guide nearly impossible, a few inhabited islands can be visited without joining a group. Consider volunteering for an animal conservancy or for sustainable development organizations: The Charles Darwin Foundation recruits skilled volunteers with scientific knowledge, and Hacienda Tranquila offers participants a chance to help reforestation efforts. *galapagos.org*

LAKE DISTRICT
Glistening tableaus of blue water

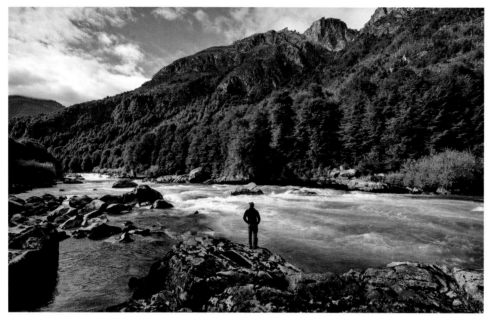

Landmarks of Chile's Lake District include the Terminator Rapid of the Río Futaleufú (above) and Osorno Volcano (opposite), noted for its similarity to Mount Fuji.

TRAVELER'S NOTEBOOK

***WHEN TO GO**
Nov.–April, spring and summer in Chile, is the best time to go to the Lake District. January can bring crowds, especially Chilean vacationers. The ski season falls during the South American winter (June–Sept.), but hiking trails can become impassible in the snow.

***PLANNING**
Puerto Montt is one of the main gateways to the Lake District region, about 635 miles (1,022 km) south of Santiago. Check for flights on LAN Airlines, Chile's main international airline, or Sky Airline.

***WEBSITES**
chile.travel (Spanish only), *lan.com, www.sky airline.cl*

Those who wind along the twisting roads and mountain passes of Chile's Lake District—a sometimes difficult journey—are inevitably rewarded by breathtaking views of vibrant blue lakes and snow-shouldered volcanoes. This majestic place is one of the world's most rugged and geographically diverse areas, and still among the least explored. The vast expanse is home to many national parks and even more reserved land that straddles mountains, rivers, and lakes throughout the region. Intrepid adventure seekers find myriad ways to explore the untamed wilderness, from boating the waters and fjords to hiking through snowy mountains, zipping on canopy trails strung along the forested volcanic base, or bathing in thermal springs along the rivers flowing by.

The Lake District may seem remote, stretching out at the southern end of Chile, but the area is surprisingly accessible, its northern regions about 600 miles (966 km) south of Chile's capital, Santiago. These hinterlands were among the last strongholds of the proud Mapuche, known as the tribe that resisted the Spaniards. Alpine architecture hints at later German, Austrian, and Swiss immigrants, but more compelling is the presence of some of the world's oldest and grandest flora, such as the slow-growing sequoia-like alerce, with some trees more than 3,000 years old.

▶ UNFORGETTABLE EXPERIENCES

Whitewater rapids enthusiasts in the know flock to the Lake District's Río Futaleufú, a river whose name means "grand waters" in the Mapuche language. Fed by glacier melt from the earthly warmth of the constant volcanic activity, it's one of the world's best whitewater zones. More than 40 miles (64 km) of rapids are found here, divided into four major areas, including a wild upper region considered dangerous even by experts. Bio Bio Expeditions leads kayaking tours for every level. *bbxrafting.com*

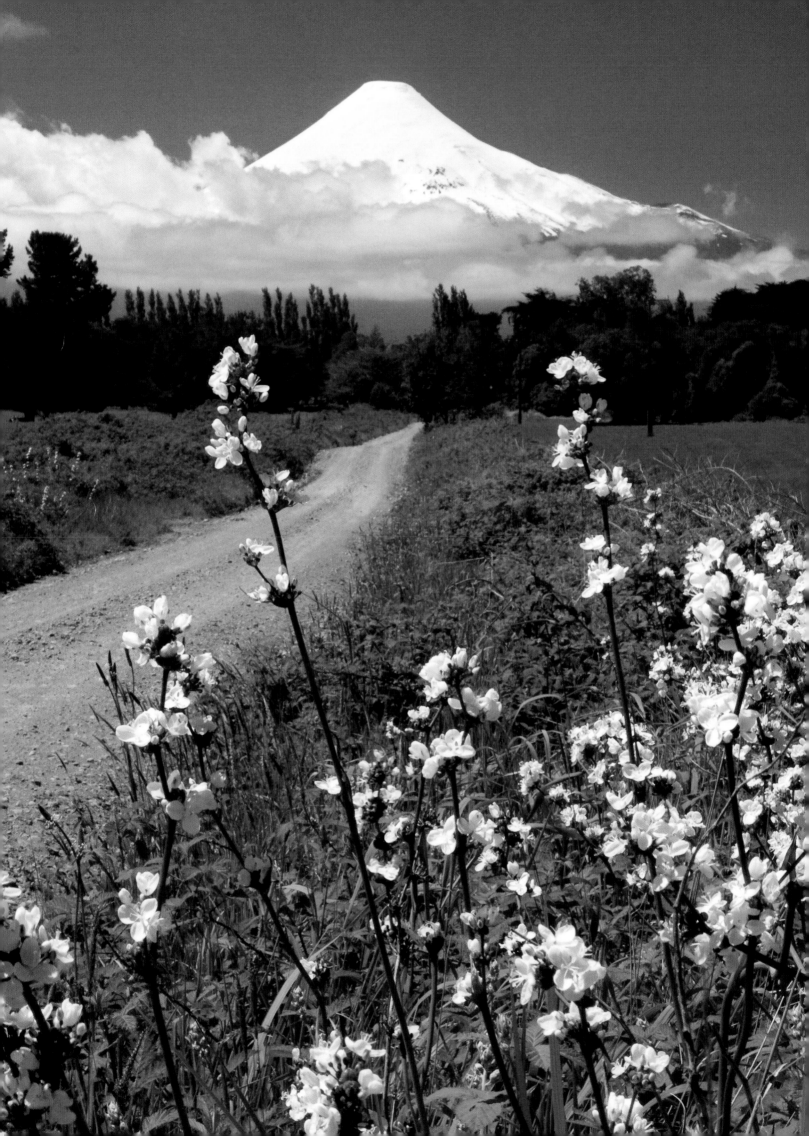

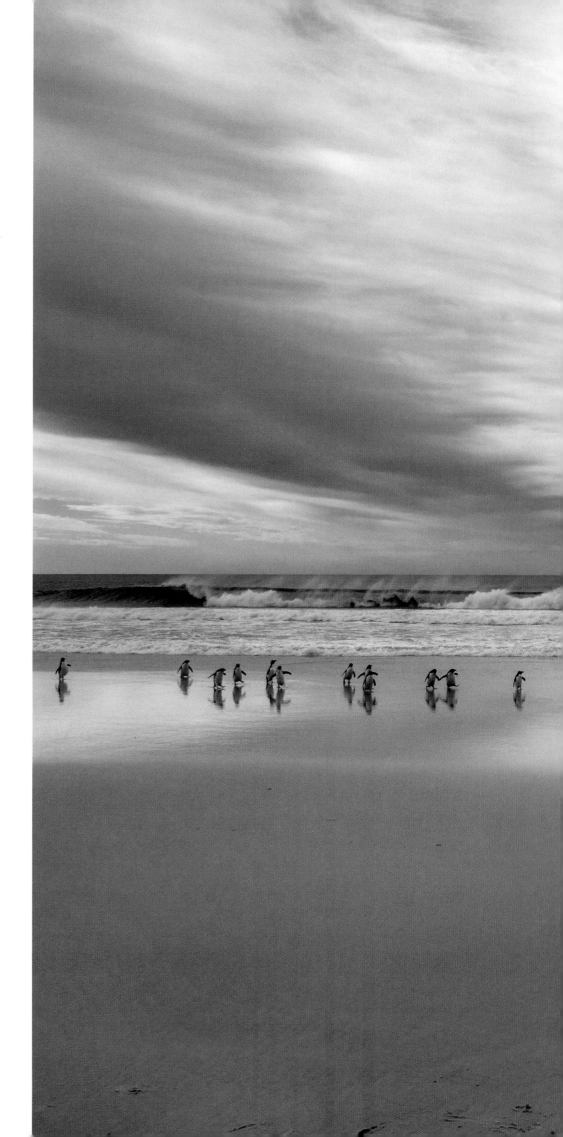

MY SHOT

Saunders Island, Falkland Islands

This particular afternoon on Saunders Island was quite beautiful, with the lowering sun providing a warm light that washed the wildlife and landscape. As I watched, cycles of waves pounding the shoreline would reveal groups of penguins making their transition from the surf of the South Atlantic Ocean to the sandy shore. This set of southern rockhopper penguins looked to me to be a perfectly formed brigade (in proper ranks, it seemed), marching to their terra firma nests.

– Jay Dickman, *National Geographic* photographer

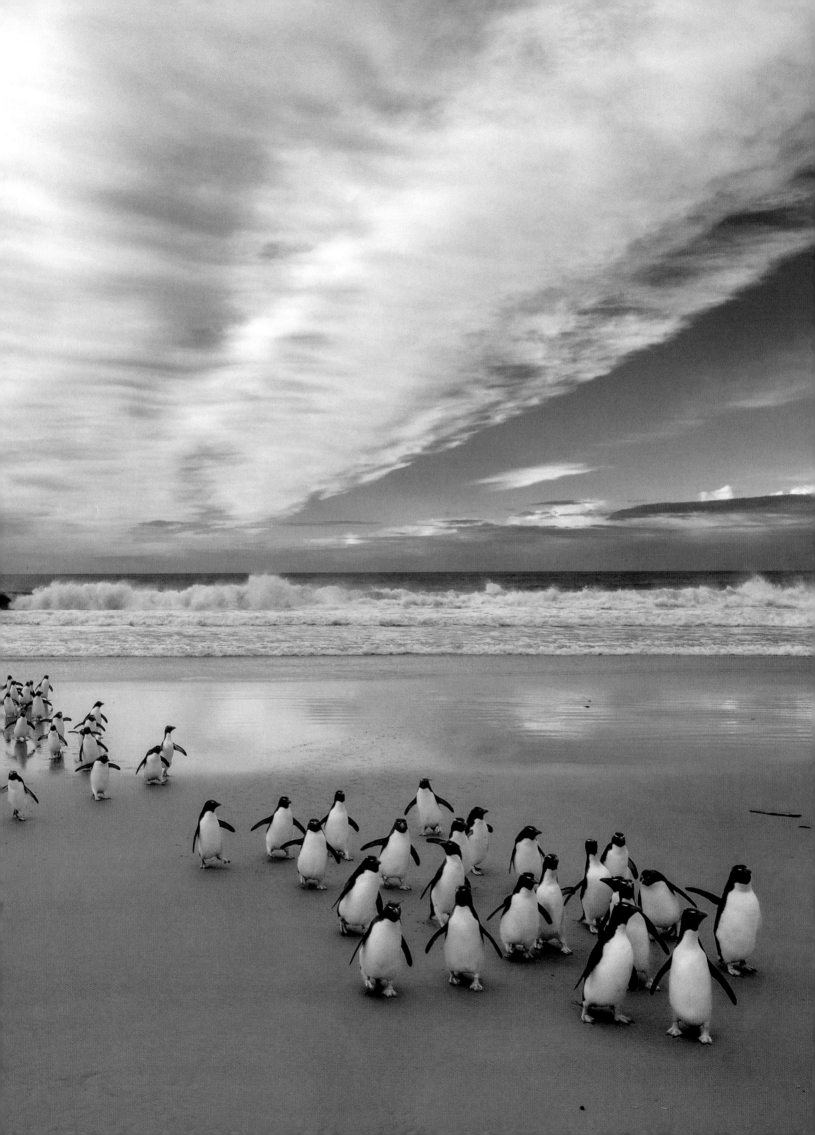

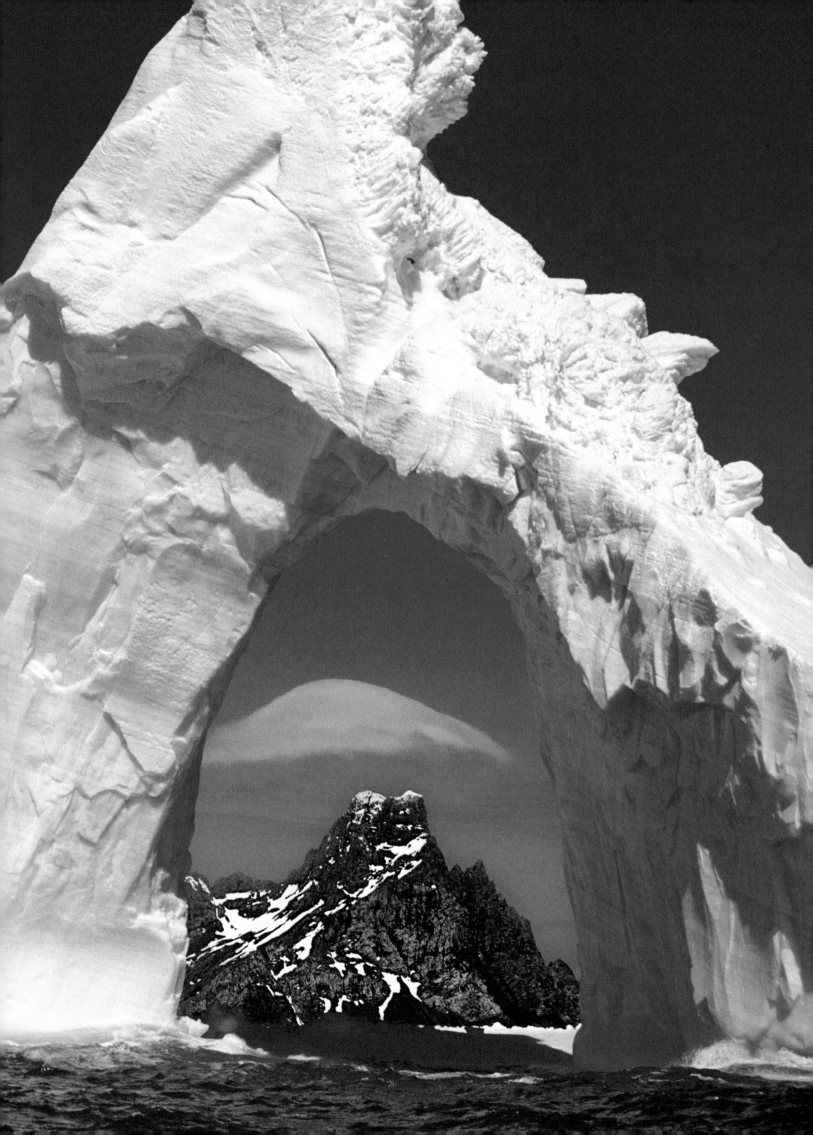

SOUTH GEORGIA ISLAND
A cold oasis in the frozen South

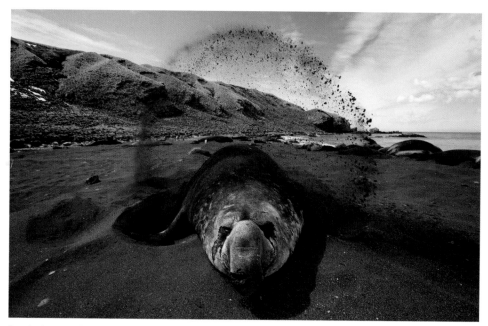

An elephant seal works to keep cool under a flipperful of sand (above) on remote South Georgia Island (opposite), a welcome migration stop for birds and animals crossing the South Atlantic.

TRAVELER'S NOTEBOOK

***WHEN TO GO**
South Georgia is accessible only during the Antarctic summer. Most people visit Jan.–March, generally as part of longer Antarctica cruise trips, which come here and to the Falklands. Be prepared for rough seas.

***PLANNING**
Beyond booking passage on a cruise that includes a stop at South Georgia, you can't really plan a trip here; your ship will determine the sites. The South Georgia website lists some good suggested reading for specific interests. For the general history, Ernest Shackleton's *South: The Endurance Expedition* is as good as it gets.

***WEBSITES**
sgisland.gs

South Georgia Island pulls like a magnet for a very simple reason: It's the only dry land in a very empty part of the ocean. This makes it a natural—and necessary—stopping point for migrating animals, and the beaches are covered with seals, sea lions, penguins, and more. Although cruising Antarctica has become almost common, South Georgia is still off the edge of the map.

This island of gray rocks and blue glaciers was also once the center of the southern whale migration, and thus the perfect spot for a whaling station. Here the factory town of Stromness worked the winter months at full speed from 1912 to 1931. Whales still swim past, but all that remains are bones, ghosts, and impossibly large hoist chains mixing with rusting hulks from the second life of Stromness, as a shipyard, active into the 1960s.

Today, fur seals and elephant seals drape themselves over the small graveyard and skua spread their wings, looking for any unprotected penguin chicks. Like their Galápagos cousins, the animals have no reason to fear people, allowing incredibly close encounters; it may be your only chance ever to know that elephant seal breath smells just like perfume—if your idea of perfume is rotted fish. For the visitor, South Georgia is a remote Eden; for the animals, it's a safe haven in the middle of a sea of huge waves.

▶ UNFORGETTABLE EXPERIENCES

Most people go to South Georgia to visit the grave of Ernest Shackleton, perhaps the greatest Antarctic explorer ever: In 1916, after his ship was crushed in the ice, he led a crew of men more than 800 miles (1,287 km) through the wildest seas in the world, keeping everyone safe. The grave marker is on the edge of Stromness Bay, among whalebones and the hulks of ships. A small museum reflects on the heyday of the station, and a rare breed of scavenging ducks likes to hang out near the chapel.

GREENLAND'S EAST COAST
The frozen edge of the world

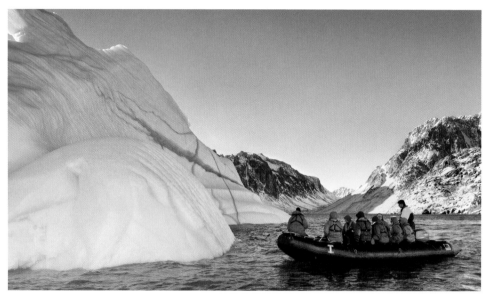

Eastern Greenland offers icebergs up close and personal (above), sperm whales rising above the waves, and remote communities such as Isortoq (opposite), population 64.

T he edges of the world change in East Greenland, altering day by day and season by season as the ice edge advances and retreats. The actual Sermersuaq, the enormous ice cap, isn't often visible, but sea ice grinds against ship hulls, gives a solid place for polar bears to hunt, and beyond that, settles into a landscape of tundra, scattered with bone.

Most people who go to Greenland go to the west side of the island, but to truly see one of the most remote corners of the world, to see a landscape that defeated Vikings and where musk oxen still stand, their long guard hairs waving in the breeze, East Greenland is the place to go. Traces of humans are few and far between: the occasional ruins of a weather station left over from the Second World War and moss-covered stones in a suspiciously straight line, dating back to when the Vikings tried to make this wild place home.

The land is further dotted with ghosts of the grand age of exploration, echoed in place-names: Scoresby Sound, Peary Land—the most northerly ice-free piece of rock on Earth. The entire northeast corner of Greenland, Kalaallit Nunaanni nuna eqqissisimatitaq, is a protected wilderness, at nearly 375,000 square miles (971,250 sq km), the largest national park in the world. Here sperm whales and walrus work the waters and herds of musk oxen sweep down hillsides, their long guard hairs waving. A world of its own.

TRAVELER'S NOTEBOOK

✴WHEN TO GO
Unless you're very good with sled dogs, July–Aug. are the best months to visit Eastern Greenland. To go into the park requires entry with a guide or a permit from the Ministry of Nature and Environment.

✴PLANNING
Most people come to East Greenland as part of an Arctic cruise. The hardy, though, head to the village of Tasiilaq (formerly Ammassalik), reachable by helicopter or boat from Kulusuk (itself accessed by air from Reykjavík). Once there, some charter services and very expensive helicopters are usually available. As far as supplies go, what the store stocks depends entirely on the last time a supply ship made it to town, and locals might not be thrilled with your buying it.

✴WEBSITES
eastgreenland.com

▶ **UNFORGETTABLE EXPERIENCES**

The near continental scale of Greenland keeps most people looking up at the wide horizon, the glacial glints of blue. But to see how the landscape really works, look down, into the tundra and into the ice-ground beaches, where garnet chips look like rubies in cold sand. The tundra itself holds more than 500 species of plants, their growth stunted by the harsh environment, so hundred-year-old willow trees may grow only an inch (2.5 cm) tall.

CURONIAN SPIT
Solitude and majestic sand dunes along the Baltic Sea

The Curonian Spit town of Nida's colorful gardens and picturesque cottages (above) are a contrast in hue to the region's undulating golden sand dunes (opposite).

The Curonian Spit, a narrow 61-mile (98 km) jut of land lining Lithuania's Baltic Sea coastline and extending south into the Russian province of Kaliningrad, is a unique, protected ecosystem of giant sand dunes surrounded by pines and low-growth deciduous forest. Artists and writers such as Nobel Prize–winner Thomas Mann visited here in the early 20th century, lured by the spit's remote feel and natural beauty. These days, tiny fishing villages like Nida, with their pretty, crimson cottages lined in blue trim, retain much of this "lost world" atmosphere, while the dunes—some as tall as a 15-story building—lend an air of dignity and solemnity.

In summer, the spit draws bikers and bathers in equal measure to try out the miles of cycling paths or to enjoy the long stretches of sandy beach. But even during the most popular months of July and August, the spit rarely feels overrun. Out of season, in spring or autumn, the pulse here slows to barely detectable, though the heady Baltic Sea mist, usually carrying the slight scent of smoked fish, is just as refreshing, and the paths up to the tops of the dunes remain accessible year-round.

TRAVELER'S NOTEBOOK

＊WHEN TO GO
The dunes can be hiked year-round, but some hotels and restaurants shut down from Oct.–mid-May.

＊PLANNING
The Curonian Spit is accessible via ferryboat from the Lithuanian seaport of Klaipėda, 186 miles (299 km) northwest of the capital, Vilnius. Buses and trains make the run from Vilnius in about four hours. Once on the spit, the main resort of Nida is 30 miles (48 km) south of the ferry landing.

＊WEBSITES
nerija.lt, visitneringa.com

▶ UNFORGETTABLE EXPERIENCES

The grandest of the dunes, the Parnidis dune, rises some 170 feet (52 m) and calls out to be climbed. Pack a thermos with something hot and follow the coastline of Curonian Lagoon, separating the spit from the Lithuanian mainland, south of Nida for half a mile (1 km) before seeing the wooden steps that lead to the summit. On top, find a suitably mystical sundial bearing runic inscriptions and a Sahara-like view into the void.

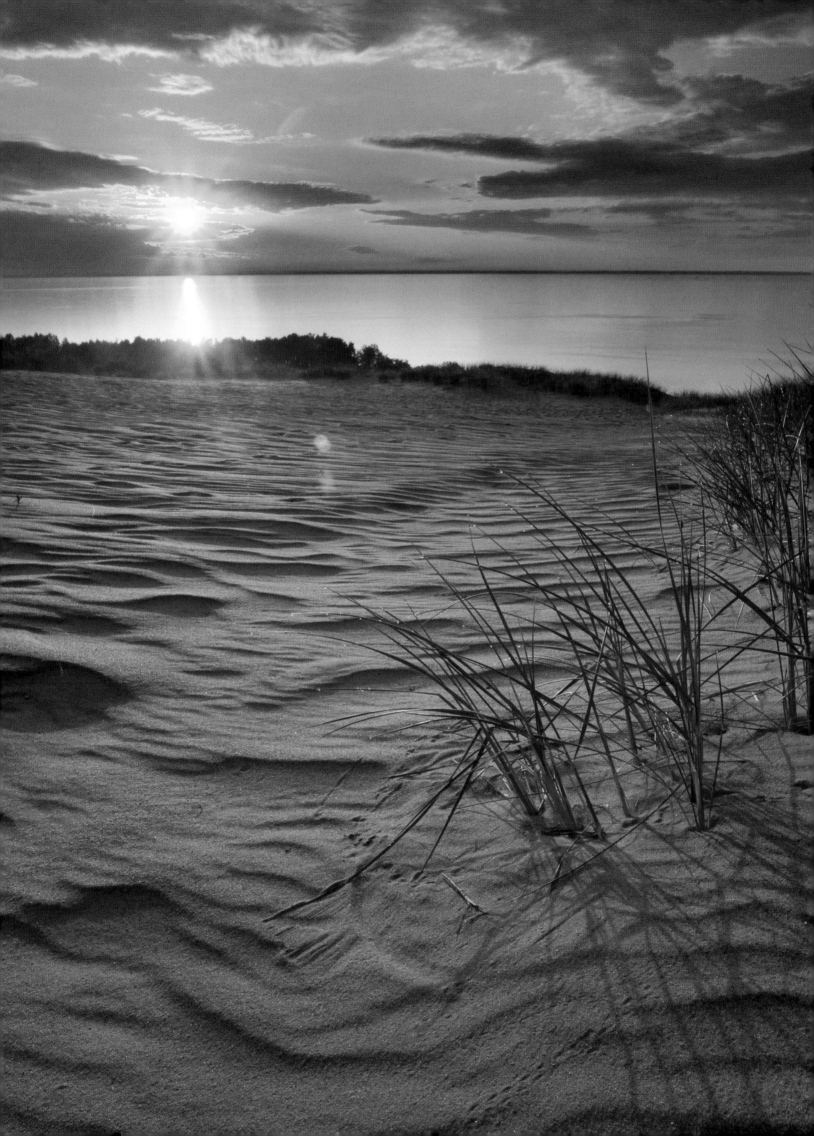

MY SHOT

Lake Hallstattersee, Austria

We were on assignment in the Austrian Lake District and made arrangements to go with the fishermen early one morning. When they picked us up around 4 a.m., first light could just be seen behind the mountains. In this image, the fisherman's young helper is set off from the background by the boat's wake, and you have a sense of motion. We love the photo because it does such a great job of expressing what it felt like to be there that early, foggy morning.

– Sisse Brimberg and Cotton Coulson, *National Geographic* **photographers**

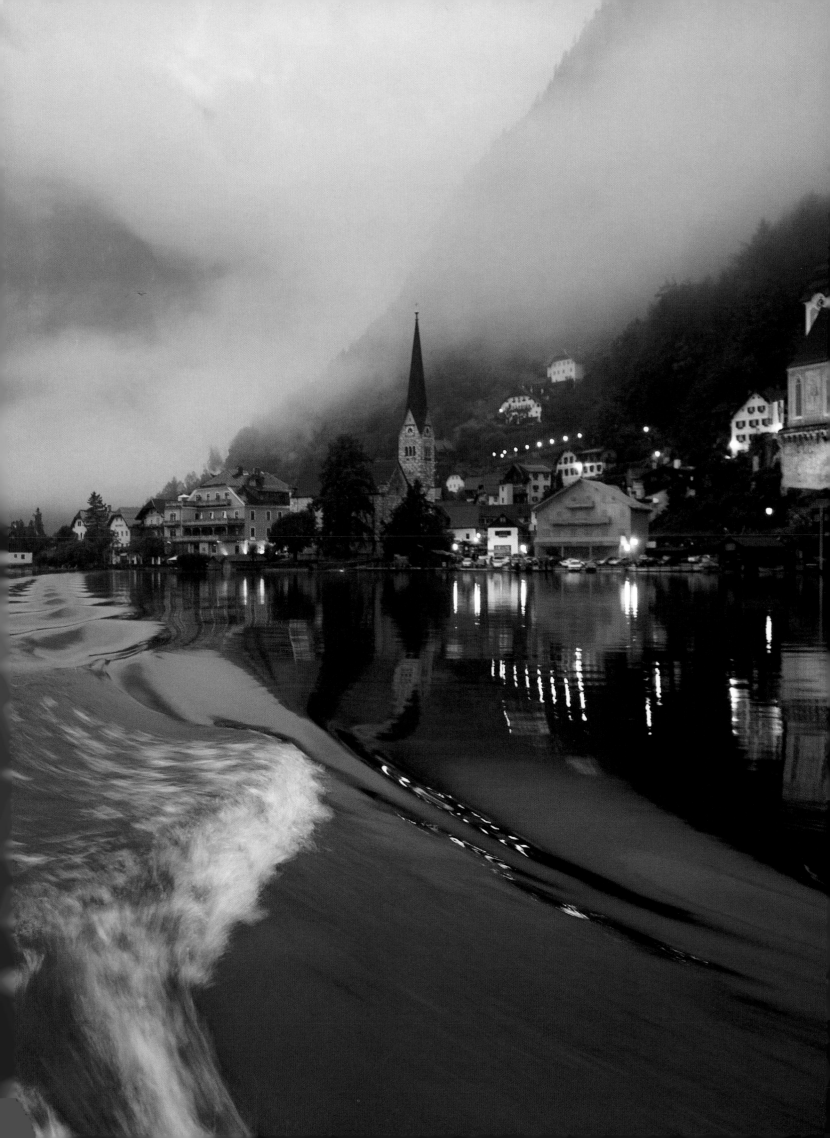

CAPE VERDE

The archipelago of harmonies and hurricanes

Music is a way of life on Cape Verde (above), ten volcanic islands washed by the Atlantic Ocean (opposite).

TRAVELER'S NOTEBOOK

＊WHEN TO GO
Almost always warm and dry, Cape Verde's climate is moderated by the trade winds and the Guinea Current. A short rainy season *(tempo das chuvas)* can bring downpours in Aug.–Sept., but the precipitation does little to affect an archipelago average of 350 sunny days each year.

＊PLANNING
International airports on Sal and Praia islands receive direct flights from such locations as Lisbon, Dakar, and Boston. Domestic flights serve seven of the islands, and modern ferries ply between five of the scattered landfalls (including two that don't have airports).

＊WEBSITES
turismo.cv (Spanish only), *capeverde.com, flytacv.com*

A loose assemblage of ten volcanic islands, Cape Verde floats about 350 miles (563 km) off the western coast of Africa in a part of the ocean where many of the hurricanes that ravage the other side of the Atlantic first take shape.

But even more than a beach destination or a cradle of ferocious storms, the islands are renowned as a hotbed of world beat music. Influenced by 500 years of Portuguese colonial rule, an ebb and flow of maritime traffic from Brazil, and proximity to the rich civilizations of West Africa, the archipelago has developed a musical heritage that blends all three of its mother cultures. There's a good argument to be made that Cape Verde has produced more recording artists per capita than any other nation, among them legendary crooners like Cesária Évora and Ildo Lobo. The islands have begotten at least five unique musical genres, foremost among them *morna*—folk tunes sung in the local Crioulo dialect to the sound of guitars, violins, accordions, and other instruments.

Despite their shared culture and common history, the islands have developed very distinct personalities. São Vicente is the archipelago's cultural hub, an island of artists, writers, and musicians living in pastel-colored houses. Boa Vista is closest to the Sahara, and by

▶ UNFORGETTABLE EXPERIENCES

All of the islands host music clubs where locals and tourists alike can catch Cape Verde tunes, and many stage music festivals that showcase island song. Among the largest is the Festival de Música da Baía das Gatas, which takes over an entire beach on São Vicente during the August full moon. Stay another week and catch the Praia de Santa Cruz music festival on Boa Vista island. Other melodious shindigs include the Santa Maria music festival on Isla de Sal in September, and Praia's Gamboa festival in May.

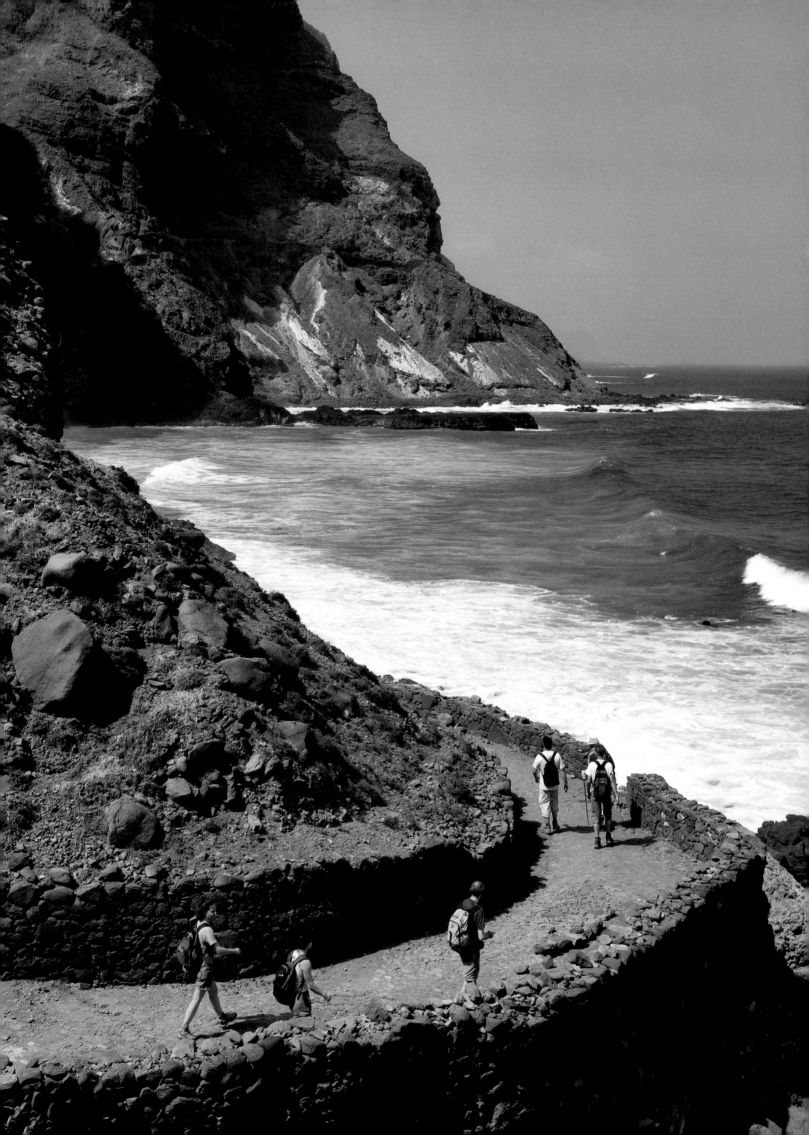

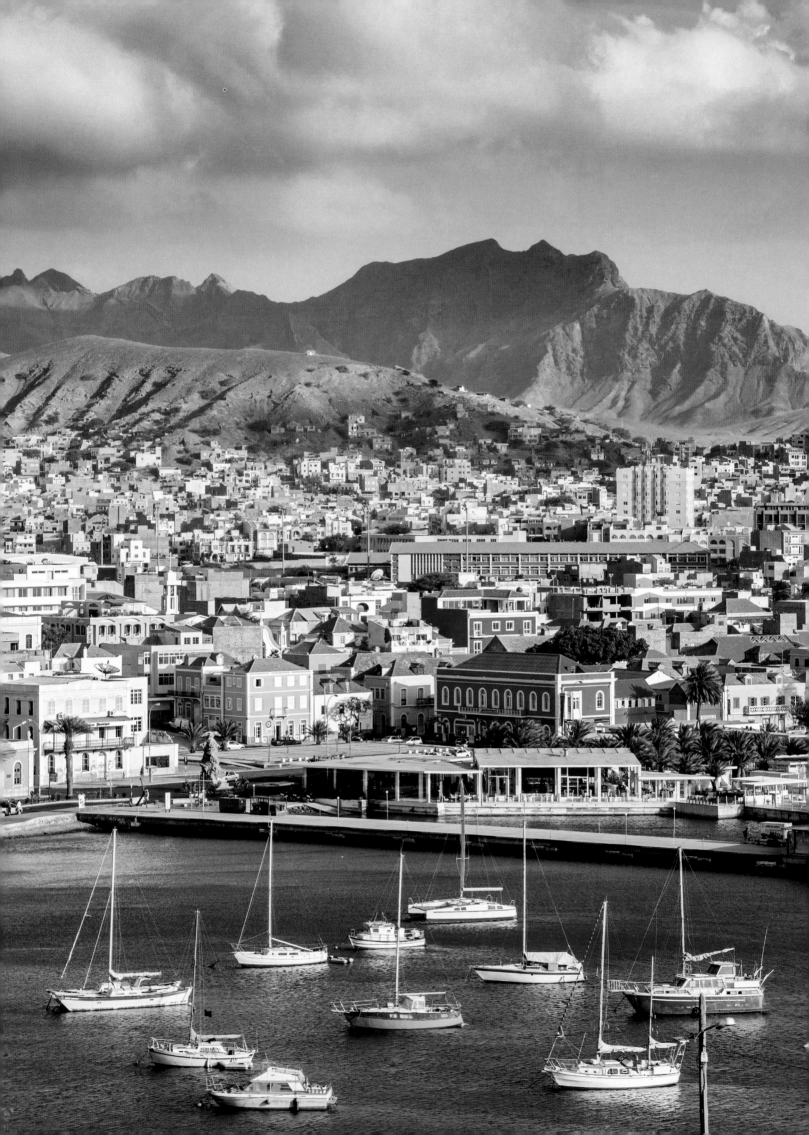

Santa Maria's fishing pier (above) on Isla de Sal and the port city of Mindelo on São Vicente (opposite)—two of the Cape Verde islands that reside hundreds of miles off the western coast of Africa.

consequence a place of dunes and desert shores—as well as where morna was born during the 18th century. Santiago was a bastion of Portuguese power for five centuries, a heritage that produced the energetic national capital, Praia, and the World Heritage site of Cidade Velha, where both Christopher Columbus and Vasco da Gama sojourned on their voyages of discovery. Tiny Brava was once a home-away-from-home for New England whalers and homeland to many of the Cape Verdeans who live in Massachusetts and Rhode Island today.

Named after the salt mines that once flourished there, Isla de Sal now makes its living from tourism, with resorts spread along its stark white sands. True to its name, Fogo is the island of fire, dominated by a 9,281-foot (2,829 m) volcano that last erupted in November 2014. Rugged and largely wild Santo Antão is the best place to hike, trails winding through deep ravines and lush woodland to secluded bays and beaches. São Nicolau nurtures the rare and endangered dragon tree *(dragoeiro)* as well as distilleries that produce a popular rumlike beverage called *grogue*. Renowned in the past for both its goats and salt mines, tiny Maio is now a haven for those who cherish secluded beaches. Uninhabited Santa Luzia is a maritime and terrestrial nature preserve that protects typical Cape Verde flora and fauna.

> *"Maio is our best-kept secret. Unbelievable beaches and friendly people. This is where locals from the big island come for weekend getaways. Not a lot of tourists, great music, and very talented guitar players."*
>
> – Fantcha Mendes, *singer*

▶ VISIT LIKE A LOCAL

Even though pre-Lent celebrations take place on all the islands, the Carnaval de São Vicente is the most renowned, a mini Rio de Janeiro flowing through the cobblestone streets of the island's main town, Mindelo, leading up to Ash Wednesday. The grogue (rum) flows freely; carnival parades blend flamboyant costumes; and over-the-top floats, dance troupes, and music groups playing morna, samba, and other Afro-Iberian styles form a rowdy mélange of Cape Verde's multicultural heritage.

KERALA
Meandering backwaters bursting with life

A wide variety of birds, including the great egret (above), flock to feed on Kerala's abundant waterways. The marshy lowlands make living on a houseboat (opposite) a logical choice.

TRAVELER'S NOTEBOOK

＊WHEN TO GO
Brilliant skies and low humidity make travel a delight in Kerala in Dec.–Feb. Kochi's Shiva Temple festival, with music, fireworks, and colorful parades, takes place over eight days in Jan. or Feb.

＊PLANNING
Kozhikode, Kochi, and Thiruvananthapuram have airports served by domestic and international flights. Kerala is a vast state with 360 miles (579 km) of coastline, so plan to use overnight boats and trains to get around. Kollam and Alappuzha are other popular gateways.

＊WEBSITES
keralatourism.org

A self-sustained ecosystem brimming with plant and animal life, the Kerala backwaters are a dazzling maze of interlocking rivulets, fresh lakes, saltwater lagoons, and man-made canals—hundreds of miles of waterways seeping through this southwestern Indian state. Along the way, majestic herons, graceful egrets, flamboyant Great Indian Hornbills, and cunning kingfishers will swoop about, diving into the water to fish.

It's not only the birds that benefit from the area's rich aquatic life. Locals paddle alongside the houseboats, hauling the day's catch in cantilevered fishing nets. Long before the arrival of roads, these winding waterways provided not only means of transport but also the very source of life—the so-called rice bowl of Kerala fed by the crisscrossing waterways that shimmer throughout the low-lying inland before flowing out to the Arabian Sea.

The backwaters' abundance enabled Kerala to develop one of India's most varied and rich culinary traditions. Fresh fish, coconuts, and spices meld into dishes such as *meen vattichathu,* a fiery stew, and *meen moilee,* a fish curry. The Nasrani, or Syrian Christians who trace their heritage back to the first century, make up about 20 percent of Kerala's population and put a decidedly carnivorous accent on the food in a country where beef and pork remain for the most part taboo.

▶ UNFORGETTABLE EXPERIENCES

Akkara House *(akkara.in)* is a breezy, intimate mansion on a secluded riverside property outside Kottayam town center. Terracotta–tiled rooms are filled with heirloom furniture, and the family matriarch feeds guests traditional dishes like dosa made with fresh coconut chutney from the garden. For aquatic accommodations, the exclusive Oberoi Motor Vessel *Vrinda,* with a gourmet restaurant and eight timber-floored deluxe cabins, glides the tranquil waterways over four days. *oberoihotels.com/kerala-backwaters*

With such a nourishing backdrop, perhaps it's fitting that Ayurveda, a holistic medical system, is at its most popular and well developed here. The waterways also provide rich grounds for medicinal herbs and plants to flourish, enabling a sophisticated tradition of folk medicine.

The immense region nurtures several other forms of inimitable cultural heritage. Colorfully painted and masked dancers and drummers perform Theyyam, a religious ritual whose roots date back to the Neolithic period, which is said to channel spirits to bless those in attendance. Kalaripayattu, considered the world's oldest martial arts still in practice, combines aggressive attack movements and weaponry with healing modalities.

A trip to Kerala is not about particular attractions, performances, or destinations, but rather the journey itself. The emerald water, dotted with floating water lilies and lotuses, gleams as it passes by wide fields and tiny hamlets languishing under the mighty South Indian sun. While sandy beaches beckon along the Arabian Sea, those seeking a more meditative experience will hop on a ferry or rent a houseboat and drift down the palm-fringed canals and lakes. So fold away the map and see why Kerala is nicknamed "God's own country."

"I love the migratory birds, and the fishing and farming villages. The toddy shops serving the most delicious, spicy local food fare are a true treat to the foodie in me."

– Kurien C. Kurien, *education industry executive*

▶ **VISIT LIKE A LOCAL**

To explore the backwaters like a local, forgo the touristy cruises and hop on the State Water Transport public ferry. Five daily services traverse the waterways between Alappuzha (Alleppey), a busy transit hub, and Kottayam, a city known for achieving 100 percent literacy. For a handful of rupees you'll be treated to a 2.5-hour journey, during which the boat calls on several villages untouched by mass tourism. The best part will be sharing stories—and snacks—with fellow passengers.

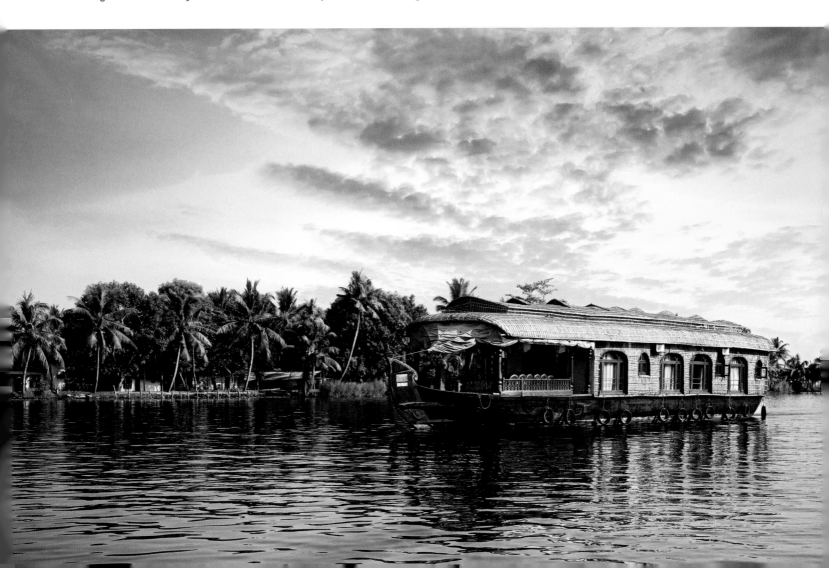

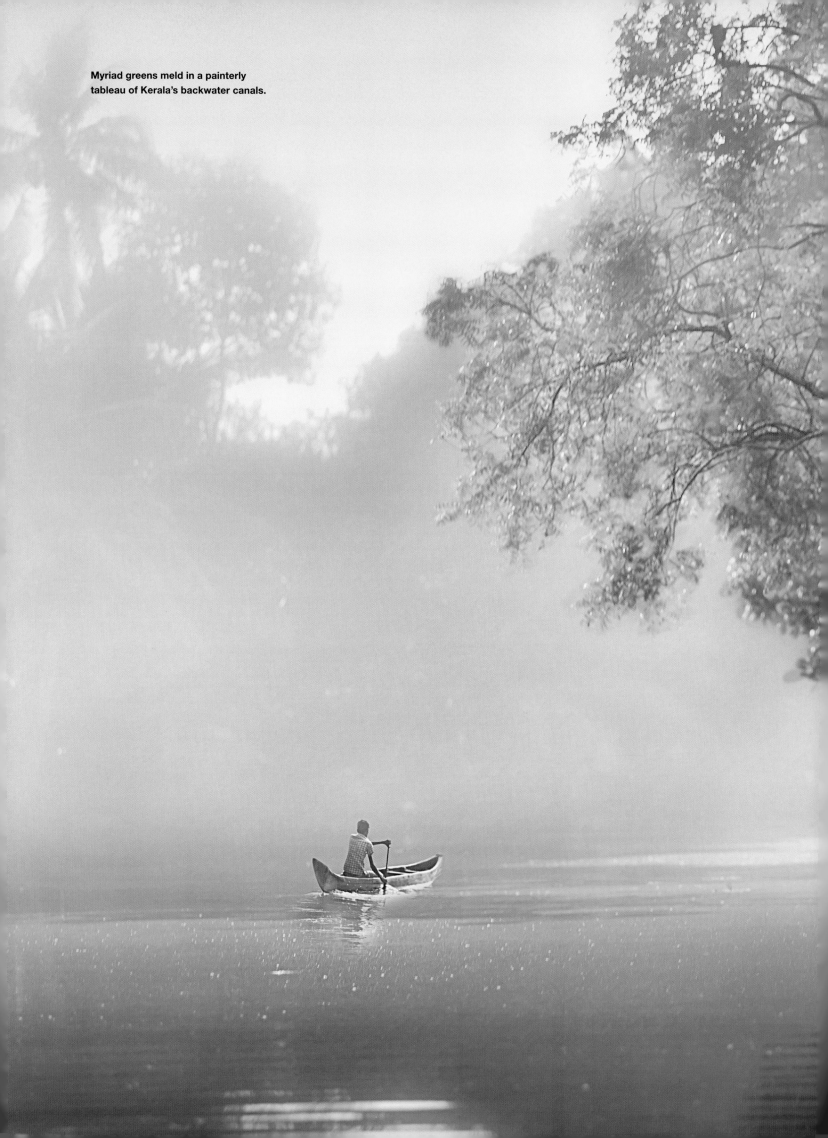

Myriad greens meld in a painterly
tableau of Kerala's backwater canals.

SANDS OF THE SILVER SCREEN

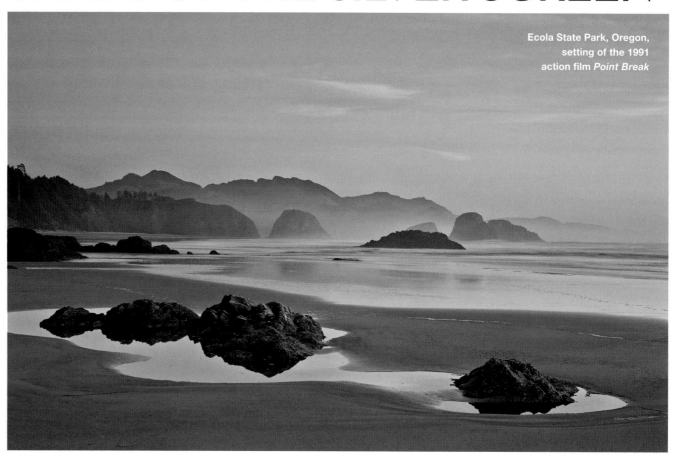

Ecola State Park, Oregon, setting of the 1991 action film *Point Break*

Ecola State Park, Oregon

Surprise! That wasn't an Australian beach in *Point Break*. Instead, Keanu and company were hanging in Oregon. With Sitka spruce, sea stacks aplenty, and area farmer's markets supplying picnic supplies, this will become a fast favorite.

Devil's Beach, Fiji

There's nothing wrong with falling in love on these white Turtle Island sands—where *The Blue Lagoon*'s teen characters (and stars Brooke Shields and Christopher Atkins) got . . . close. Now a private resort, there's still plenty of privacy for paying visitors.

Lumahai Beach, Hawaii

Wash that man, that job, or whatever else you're hoping to forget out of your hair with a walk and photo session on Kauai's Lumahai Beach, which took a star turn in 1958's *South Pacific*. (But stay out of the water—the beach is famous for its strong tides.)

Joseph Sylvia State Beach, Massachusetts

Rent a bike in town for an easy ride along a bike path out to this 2-mile-long (3.2 km) beach where a very nervous Martha's Vineyard first encountered *Jaws* in 1975. It's actually a nearly perfect lazy-day destination for families.

Hanauma Bay Nature Preserve, Hawaii

One of the key locations in *Blue Hawaii*, the first of three movies that Elvis Presley filmed in the state, Hanauma Bay on the Big Island deserves even more attention as one of the best spots for snorkeling in the United States. It takes just a moment or two of swimming near a sea turtle or some neon parrotfish to feel in harmony.

Cape St. Francis, South Africa

The classic surfer film *The Endless Summer*, released in 1966, turned this beach from a locals-only surf spot into an instant legend. Not up for paddling out? There's plenty of fun in just watching experienced surfers wait for the perfect wave. Seal Point Lighthouse provides good photo fodder when the surf dies down.

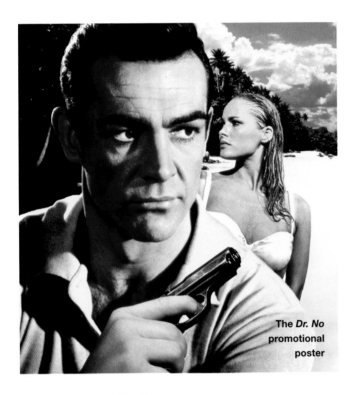

The *Dr. No* promotional poster

James Bond Beach, Jamaica

It took some kind of special to hold attention up against Ursula Andress in the first Bond film, *Dr. No*—but this beach on Oracabessa Bay, with mountains at its back, held its own. Charter a boat for a ride past author Ian Fleming's estate, now part of the GoldenEye resort.

Malibu Lagoon State Beach, California

Surfboards may be a bit more high tech than they were back when Frankie Avalon and Annette Funicello filmed *Beach Blanket Bingo* here in the early 1960s at what locals call Surfrider Beach. There's also good bird-watching and fishing from the historic pier.

East Beach, Texas

Though the trick moves Jack Nicholson and Shirley MacLaine (or their stunt doubles) did in *Terms of Endearment* aren't recommended, driving right onto the wide sands of this Galveston beach is just fine. Early June brings a huge sand castle competition.

Kastani Beach, Greece

Even the threat of an ABBA earworm (and, at times, lots of other people) shouldn't put you off from this beach on the Greek island of Skopelos, where Meryl Streep and company sang away in *Mamma Mia!* Snag a seat in the sand—the sunsets here deserve a musical all their own.

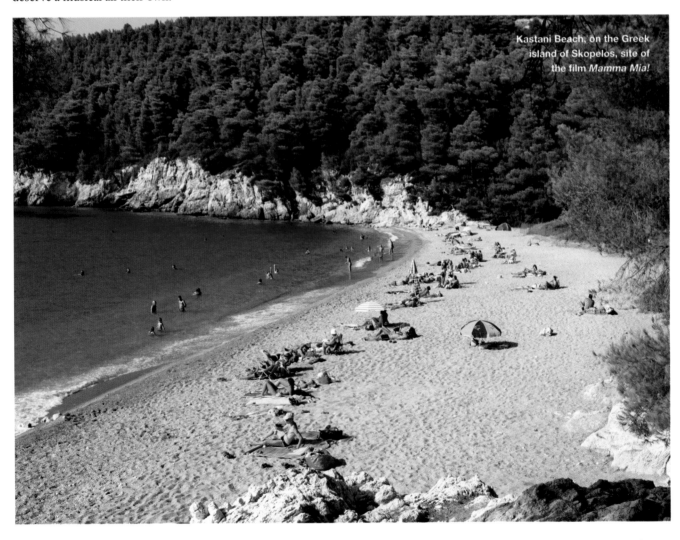

Kastani Beach, on the Greek island of Skopelos, site of the film *Mamma Mia!*

CAMBODIA

TONLE SAP

The rhythms of a bountiful river nourish the soul of Southeast Asia

Below the waters of Cambodia's Tonle Sap dwells Naga, the legendary snake master of the depths. The many-headed Hindu deity is said to have sheltered the Buddha during a storm. The confluence of the two great faiths is celebrated in the elaborate ornamentation of the temples of nearby Angkor Wat. Naga relinquishes his grasp as the rainy season ends, making way for the sun god.

Tonle Sap is a river with a split personality. From November through May, its freshwater is a shallow 74-mile (119 km) stream that drains south, meeting the mighty Mekong at Phnom Penh. When the monsoon arrives in June, the Mekong pushes the river to reverse its course, forming an enormous lake that eddies to the stone thresholds of Angkor Wat. Teeming with life, it is both symbol and sustenance for the Khmer people.

The largest freshwater lake in Southeast Asia, the Tonle Sap was designated a UNESCO Biosphere Reserve in 1997. Its annual transformation nourishes emerald rice paddies that stretch for miles along the riverbank; it also sustains enormous stocks of fish. The Mekong giant catfish that lurks in its waters can reach lengths up to 10 feet (3 m). Perhaps not

▶ VISIT LIKE A LOCAL

Cambodians celebrate the reversal of the river's flow each fall with Bon Om Touk, the annual three-day water festival. In preparation, crews gather in riverbank pagodas, refurbishing sacred canoes for the traditional races in Phnom Penh. To be chosen as a crew member is a lifetime honor, and victory is said to bless the coming fishing season for the entire village. Illuminated boats, hundreds of races, and open-air concerts attract thousands to Sisowath Quay near the Royal Palace in Phnom Penh. As fireworks explode, rural celebrators crowd into the capital city, cheering their hometown heroes and the end of the rains.

》》TRAVELER'S NOTEBOOK 《《

＊WHEN TO GO
The date of the Cambodian annual water festival, generally set for November, is determined by the date of the full moon in the lunar calendar. Many visitors prefer the drier, cooler winter months.

＊PLANNING
During the high-water season (June–Nov.) riverboats run frequently from the Phnom Penh waterfront to Siem Reap, a half-day journey. Bus and minivan services also connect the cities. Angkor Wat is 4.5 miles (7.2 km) from Siem Reap.

＊WEBSITES
tourismcambodia.com

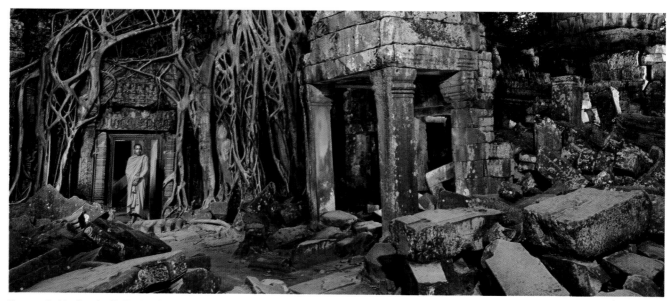

Surrounded by jungle, Ta Prohm (above) is one of the hundreds of temples of the Angkor region, home to the Tonle Sap. The largest freshwater lake in Southeast Asia, its waters also serve as a commercial thoroughfare for merchants large and small (opposite).

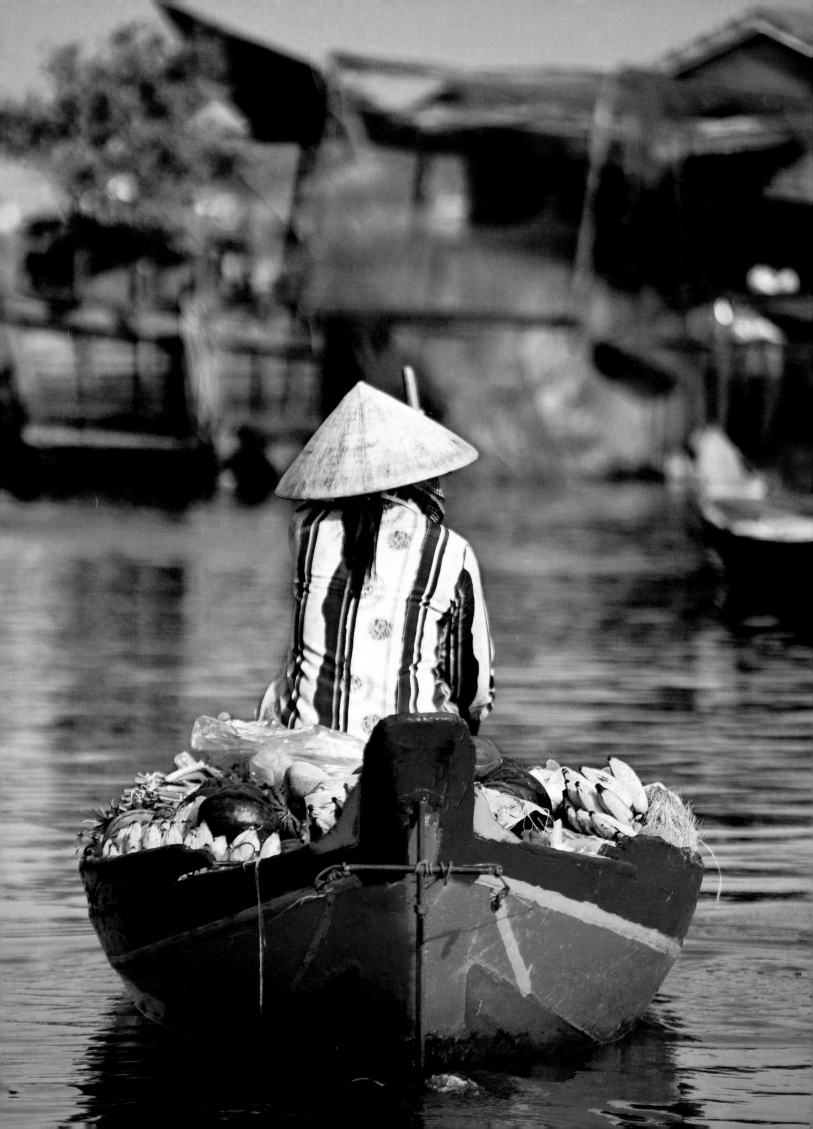

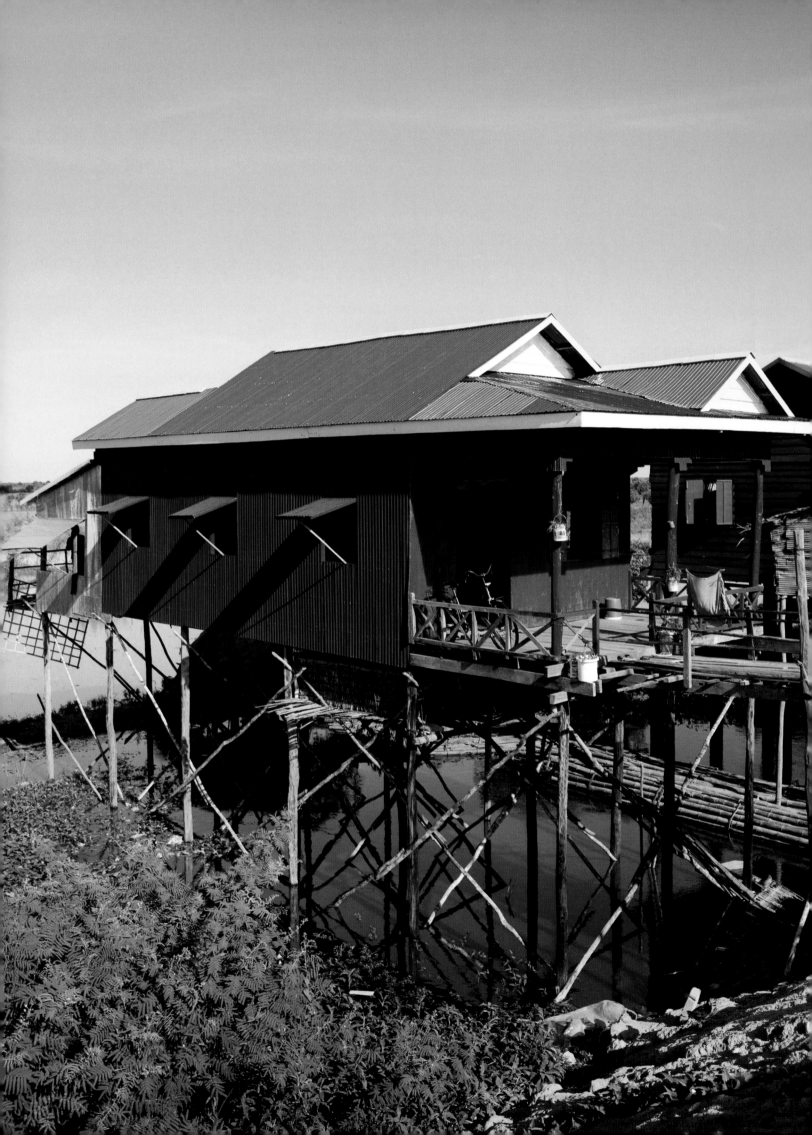

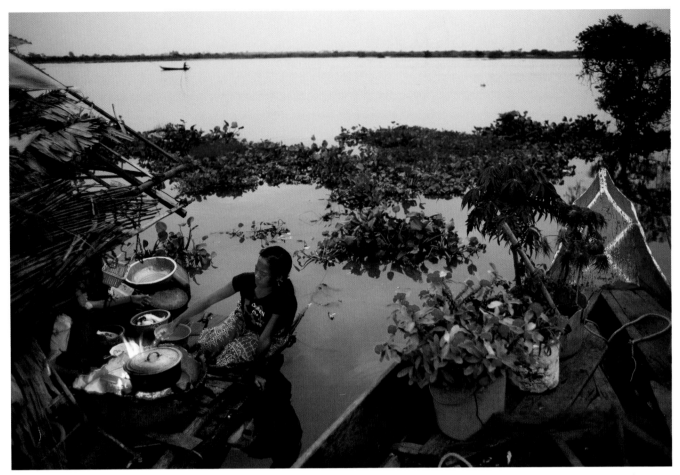

Thousands of people live on Cambodia's Tonle Sap, surviving the change in water level in floating villages of tethered houseboats (above) and homes on stilts (opposite).

surprisingly, thousand-year-old images of fish adorn the sacred temples of Angkor Wat. Even the national currency, the riel, is popularly believed to be named for the small silver carp that is a Cambodian daily meal.

Small wonder, then, that most rural Cambodians are fishermen. Their floating bamboo villages rise from a surface teeming with water lilies. En route to Siem Reap, the small city adjacent to Angkor Wat, crowded motorboats thread their way along a thoroughfare that is a confluence of ancient and modern activity. Schools, gas stations, karaoke bars, and even alligator farms bob with the water level. Exuberant children delight in the Tonle Sap, treating it as their personal playground, entered by plunging off piers and doorways.

Monsoon season often causes the Tonle Sap to crest its banks in Siem Reap. Visit here at dawn or dusk, when the lagoons eddying from the river provide the most spectacular reflections of its many temples. Angkor Wat is easily reached by bicycle or the traditional open-air *tuk-tuks* from town, and many Siem Reap operators offer river tours to the floating villages.

> *"The river is hemmed by rice fields so green they hurt your eyes. Then it yields in one breathtaking moment to a vast lake."*
>
> – James O'Toole, *journalist for the* Phnom Penh Post

▶ **UNFORGETTABLE EXPERIENCES**

Siem Reap hotels accommodate visitors from hundred-person tour groups to bare-bones backpackers. An agreeable alternative to megahotels or hostels is the Steung Siem Reap, a 76-room guesthouse in the French Quarter that dates from the 1920s. Recently refurbished and slightly removed from the late-night party scene of Pub Street, the Cambodian-owned property— actually two colonial buildings that face each other across the street—includes a pleasant outdoor pool. *steungsiemreaphotel.com*

AITUTAKI LAGOON
An ideal atoll crowns the Cook Islands

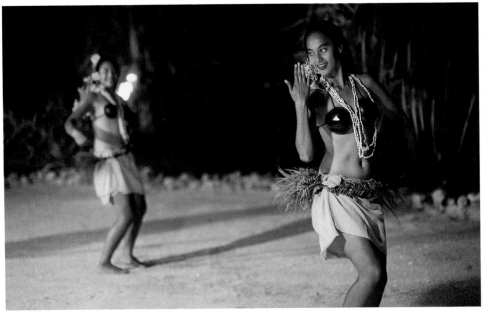

Pristine white sand, clear turquoise waters, prime snorkeling, and a welcoming culture make the remote Aitutaki atoll (above and opposite) a storybook destination.

>> TRAVELER'S NOTEBOOK <<

✳WHEN TO GO
Although it's warm here year-round, the best time to snorkel, kayak, or swim is Oct.–Feb., when the lagoon is clear and warm, with the water temperature hovering around 86°F (30°C). Be prepared for the possibility of rain.

✳PLANNING
Daily flights link Aitutaki with Rarotonga, the Cook Islands capital, 164 miles (264 km) to the south. The atoll can be visited as a long day trip from Rarotonga, but that means limited time to explore the lagoon.

✳WEBSITES
cookislands.travel, aitutaki.com

Discovered by Captain Bligh and the *Bounty* crew just before the famous mutiny, Aitutaki is one of the world's most stunning islands, the epitome of a palm-shaded South Pacific paradise. Rather than being amoeba shaped like so many coral atolls, the island is roughly triangular, like an arrowhead, with a reef that wraps around a vast lagoon renowned for its "coat of many colors." Depending on the light and bottom topography, the lagoon water reflects myriad shades of blue and green, from turquoise and indigo to malachite and milky jade.

The marine life is equally chromatic, a menagerie of tropical fish, sea turtles, hard and soft corals, giant clams, moray eels, and the occasional reef shark. Much of the lagoon is protected by traditional *raui* ("not to be touched") marine sanctuaries where fishing and shellfish collection are forbidden. Talcum-powder-fine beaches ring 15 *motus* (sandy islets) scattered around the lagoon. The largest one—relic of an ancient volcano—is home to nearly all of the 2,000 islanders, most of the resorts, and an airfield built by American GIs during World War II. Arutanga, the only real town, retains a bygone Polynesian vibe of coral block churches and zinc-roofed homes shaded by coconut palms and giant banyan trees, with

▶ **UNFORGETTABLE EXPERIENCES**

There's nothing that channels old-school Polynesia like the traditional dance of Aitutaki and other Cook Islands. In this mélange of swaying hips, flexing muscles, and fierce drum beats, even the simplest steps exude an atavistic sensuality. Troupes make the rounds of the atoll's beach hotels, with the fire knife dance a crowd favorite. Aitutaki Gospel Day at the end of October and the nationwide Te Maeva Nui cultural festival in August offer two great chances to view local dance.

bikes and boats more evident than motor vehicles. Tapuaetai (One Foot Island), at the atoll's southeastern corner, is renowned for its splendid strand and funky beach bar, where you can get your passports franked with a barefoot stamp. Other motus have hosted a leper colony and the *Survivor* TV series, as well as nesting areas for a variety of birds, including the rare blue lorikeet.

Aitutaki was first settled around a thousand years ago by migrants arriving in long-distance outrigger canoes from nearby French Polynesia. Legend holds that the atoll was first colonized by a powerful chief and 20 virgins. The remains of a stone *marae* (shrine) near Arutanga attest to early occupation, but a combination of chance and geographical isolation kept the atoll out of the path of European navigators until 1789, when H.M.S. *Bounty* came across the island on a passage between Tahiti and Tonga. Missionaries soon followed, along with a conversion from cannibalism to Christianity that continues to reverberate among the island's deeply devout residents. By the end of the 19th century, the atoll and the rest of the Cook Islands were part of the British Empire, a distinction that lingers in the archipelago's status as a semi-independent territory aligned with New Zealand.

> *"I like to take people to the top of Maunga Pu Hill, highest vantage point on the island, with its 360° view of the lagoon, the uninhabited islands inside the lagoon, the reef, and the Pacific Ocean."*
>
> – Bill Tschan, *longtime resident and botanist*

▶ VISIT LIKE A LOCAL

Aitutaki is an excellent place to sample traditional Polynesian cuisine, including island favorites *remu* (sea grapes), lagoon-harvested *ariri* (turban snails), and *paua* (giant clams). *Ika mata* is a raw seafood dish similar to ceviche—flying fish marinated with lemon or lime and then served with coconut cream; the Boat Shed Bar & Grill on Popoara Beach serves it in a coconut shell. Other local delights include breadfruit stew, steamed or creamed taro leaves, and baked *kumara* (sweet potatoes).

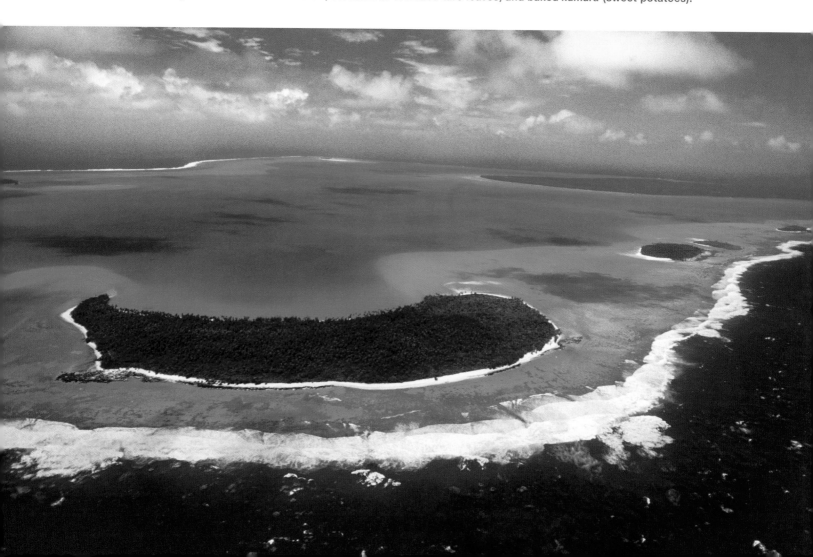

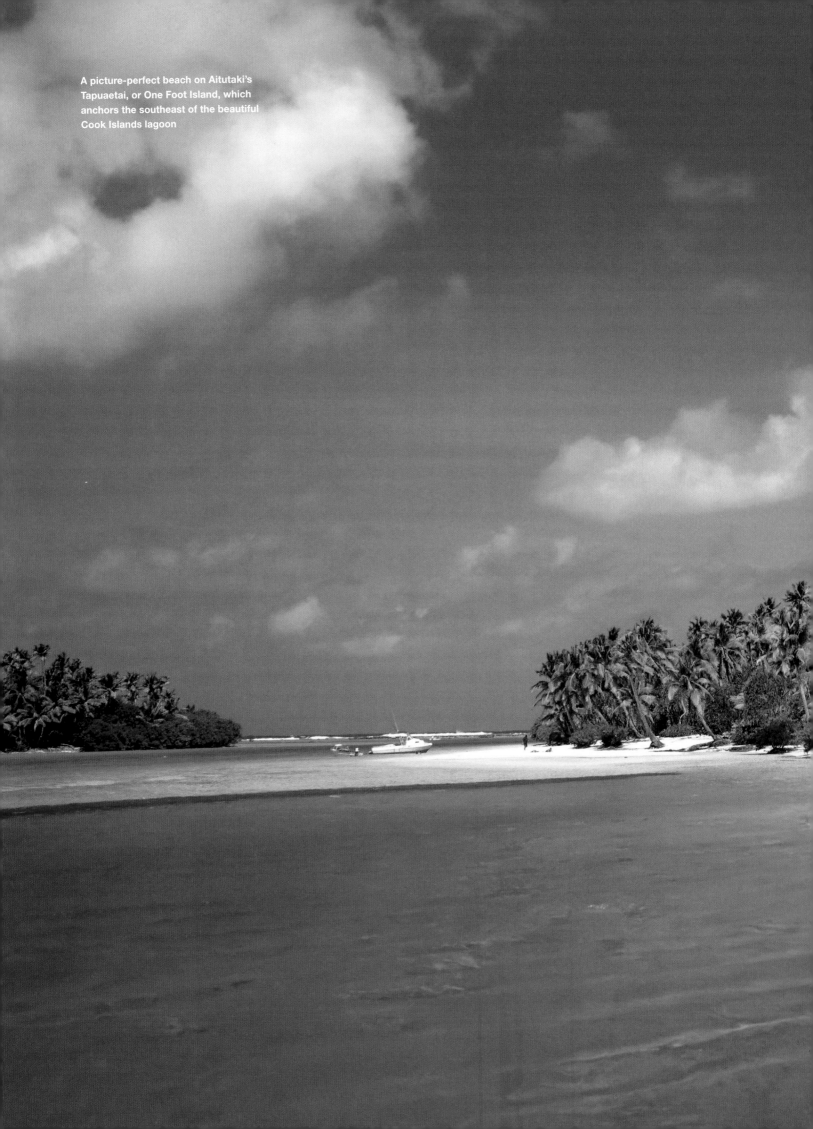

A picture-perfect beach on Aitutaki's Tapuaetai, or One Foot Island, which anchors the southeast of the beautiful Cook Islands lagoon

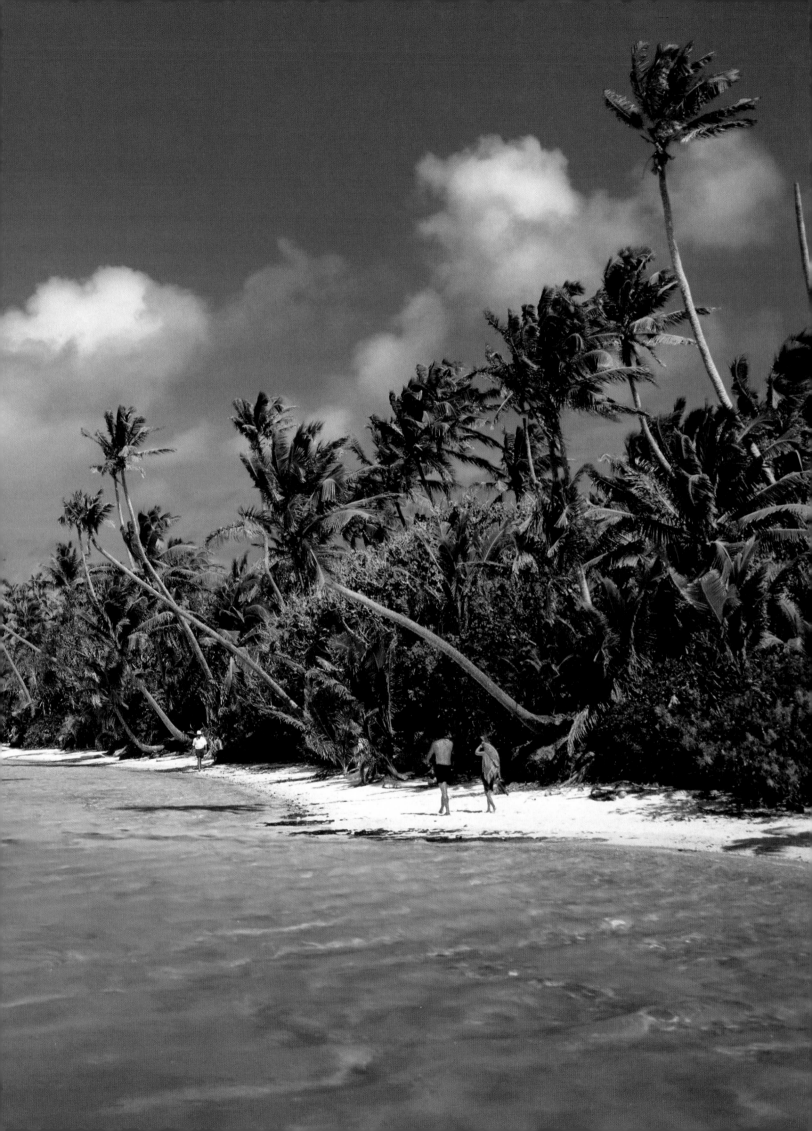

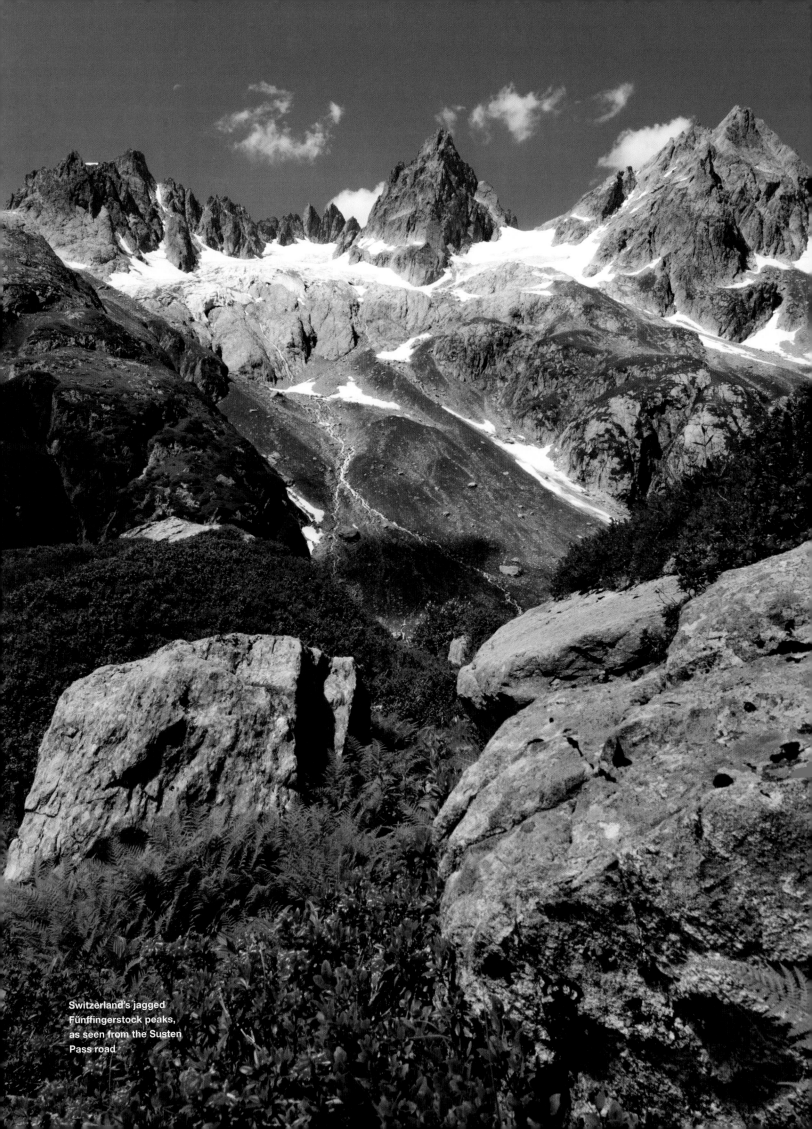

Switzerland's jagged
Fünffingerstock peaks,
as seen from the Susten
Pass road

MOUNTAIN MAJESTY

Take a high-altitude tour of the world's highest places, from Switzerland's vertiginous Axenstrasse highway and Honshu's towering Japanese Alps to cascading Angel Falls in Venezuela.

ALASKA

WRANGELL-ST. ELIAS NATIONAL PARK
Summits and solitude in outback Alaska

Take the old riddle about that lonely tree falling in the forest, magnify it a million times, and the end result would be something close to Wrangell-St. Elias. Every day in this vast chunk of Alaska wilderness, nature thrives beyond the sight and sound of human incursion.

In and around the huge park, North America's largest glaciers moan, groan, and calve giant chunks of ice. Grizzlies and black bears fish for salmon and scrounge for berries. White water gushes down hundreds of pristine rivers and streams. And countless trees sprout, soar, sway, and yes, even fall, with no one around to witness the splendor. America's single largest national park sprawls across 20,625 square miles (53,419 sq km) of southeastern Alaska—an area 13 times the state of Rhode Island. From white-sand strands and iceberg-choked bays along the Gulf of Alaska, the park works its way inland through boreal forest, snowcapped peaks, glacial valleys, rocky floodplains, alpine meadows, and a massive volcanic field to the tundra and permafrost of the Yukon River Basin.

Nearly everything about Wrangell-St. Elias is awesome and overwhelming, in particular its namesake mountains. Named after an early 19th-century governor of Russian America,

> ## ▶ VISIT LIKE A LOCAL
>
> They start drifting into the Golden Saloon around sundown, the bush pilots, guides, rangers, and other rugged Alaskans who call McCarthy home. The only bar for 50 miles (80 km) around is open only between spring and fall, but during those months the rustic pub is the hub of Wrangell-St. Elias social life. It has live music on weekends and open mic on Thursday for anyone who wants to tell a joke, spin a tale, or strum a song. *mccarthylodge.com*

▶▶ TRAVELER'S NOTEBOOK ◀◀

✳WHEN TO GO
Early June–mid-Sept. is the best time to visit; many park facilities are open only between Memorial Day and Labor Day. Snow is normally falling by the end of September, making roads impassible.

✳PLANNING
The main park entrance at Chitina is about 250 miles (402 km) east of Anchorage. From there it's a 60-mile (97 km) drive along an unpaved road to the town of McCarthy. Yakutat is the gateway to the park's coastal sections, and Nabesna Road the only way to reach the remote northern sector.

✳WEBSITES
nps.gov/wrst

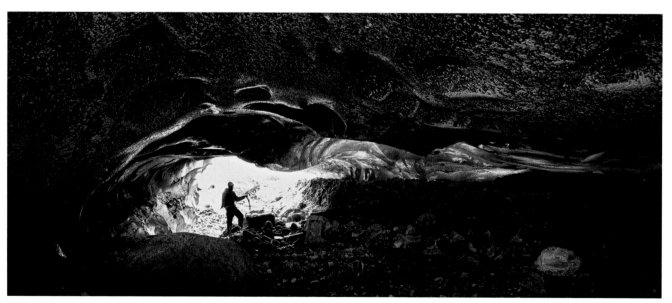

Enormous Wrangell-St. Elias National Park is a glacial showroom, from the subterranean glow inside Kennicott Glacier (above) to the mighty sweep of the Barnard Glacier (opposite).

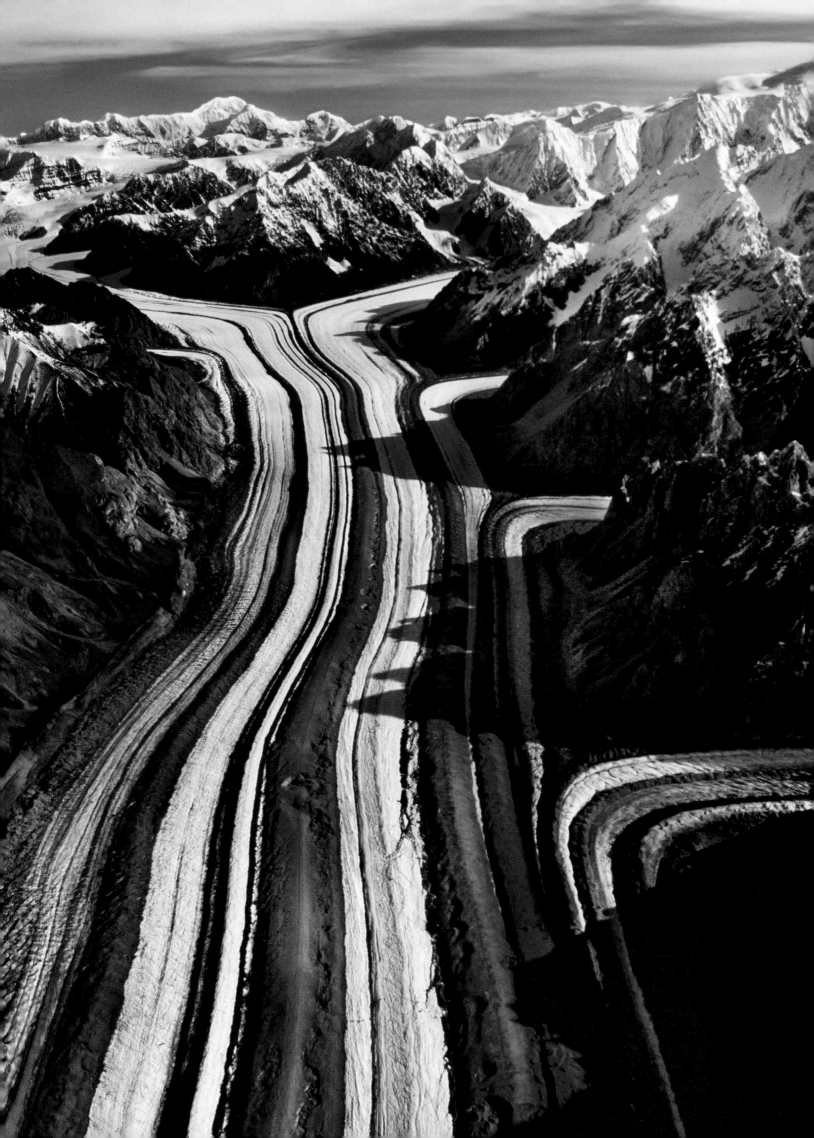

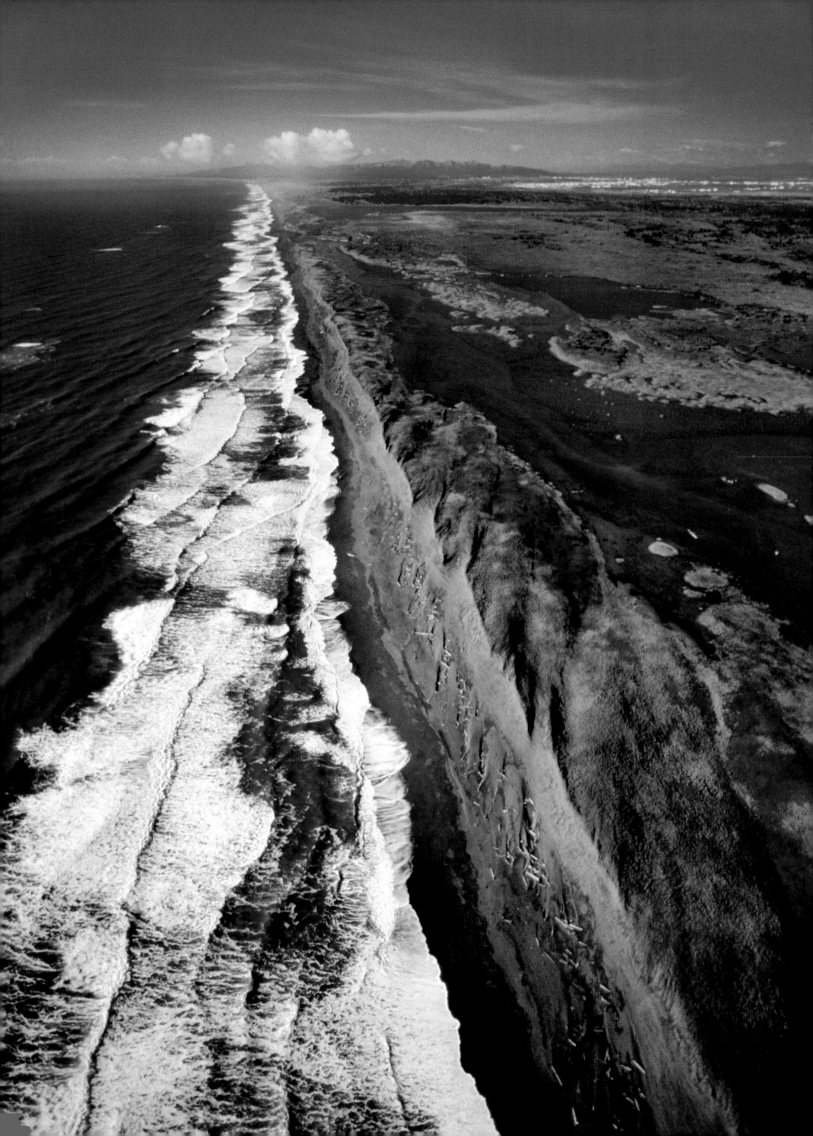

Wrangell-St. Elias stretches over an area more than twice the size of Massachusetts and features snowy mountain peaks (above), slow-moving glaciers, and wave-pounded coastlines like those of Yakutat Bay (opposite).

Mount Wrangell is a massive shield volcano. The St. Elias Mountains—which stretch across the international border into Canada—is one of the world's highest coastal ranges, rising from sea level to 18,000 feet (5,486 m) in a mere 15 miles (24 km).

Roughly a quarter of the park is covered by glaciers, including several record holders. Nabesna, stretching more than 75 miles (121 km), is the world's longest interior valley glacier. The gargantuan Bagley Icefield is 127 miles (204 km) long and up to 3,000 feet (914 m) thick. The continent's largest piedmont glacier, Malaspina is more than 60 times bigger than Manhattan Island.

Wrangell-St. Elias also hosts large and diverse animal populations—grizzly bears and humpback whales, moose and trumpeter swans, Dall sheep and timber wolves, lynx and salmon—in numbers not found anywhere else on the planet. Indigenous Alaskans hunted and fished the region for thousands of years before the arrival of European explorers and fur trappers. Later came gold miners and copper barons. But humans made little impact on such an immense and forbidding landscape, and today only about 50 people reside year-round inside the park, most of them in tiny McCarthy, once a hotbed of vice for the nearby (and now defunct) Kennecott copper mine and nowadays a mild-mannered hub of hiking, fishing, and hunting.

> *"Ninety-nine percent of this park is inaccessible by road. But with an aircraft you can touch down just about anyplace."*
>
> – Paul Claus, *bush pilot*

▶ UNFORGETTABLE EXPERIENCES

Wrangell-St. Elias is true wilderness: few trails, even fewer campgrounds, and an almost complete divorce from civilization. Backpackers can set off from McCarthy or hop an air taxi to remote hiking locations like Skolai Pass and Iceberg Lake. Adrenaline junkies hire bush pilots to land them on mountain aeries or frozen glacier tops. Paddlers run the Chitina River or glide across Icy Bay. Newcomers to the park should enlist the service of St. Elias Alpine Guides in McCarthy. *steliasguides.com*

MY SHOT

Wood-Tikchik State Park, Alaska

I've done a lot of flying around Alaska, and on this mid-September day I was high above the string of clearwater lakes that make up the enormous Wood-Tikchik State Park, where more than a million sockeye salmon return to spawn each year. We circled the plane around a few times—with the window open—and this scene with Chikuminuk Lake jumped out at me. I knew it was a good shot right when I took it, which is not always the case!

– Michael Melford,
National Geographic
photographer

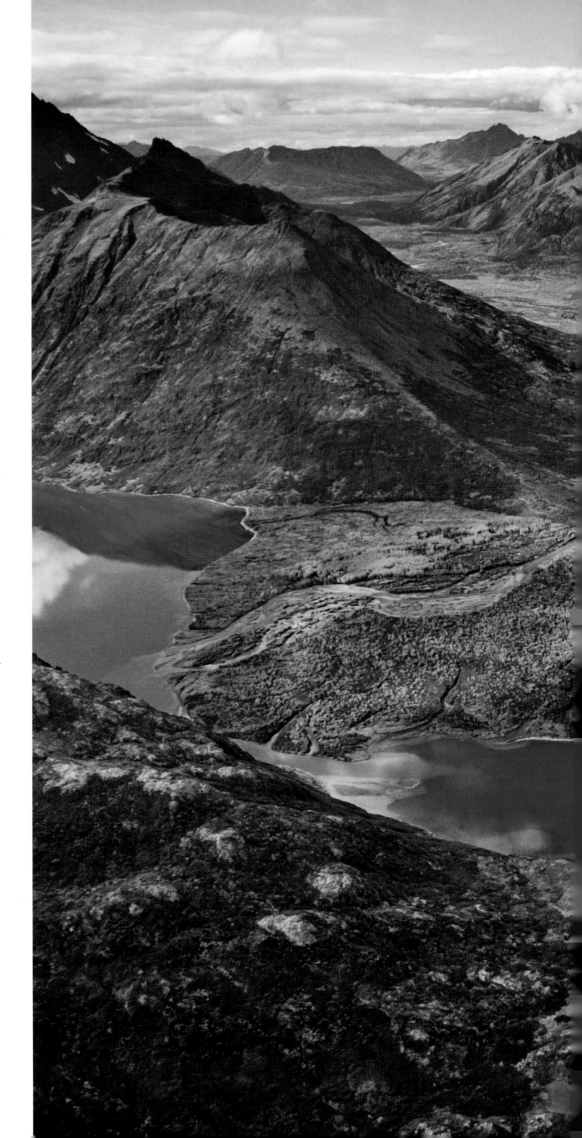

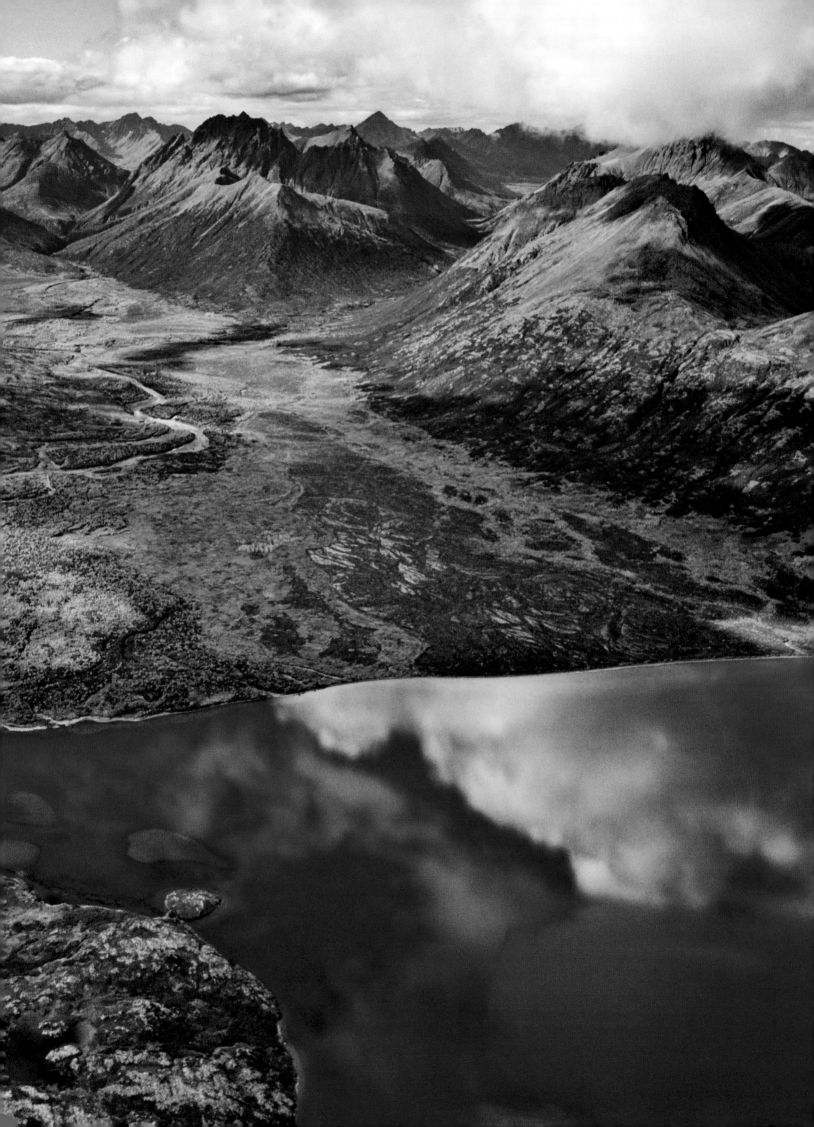

IDAHO
SAWTOOTH MOUNTAINS
Razor-edged peaks and high alpine lakes

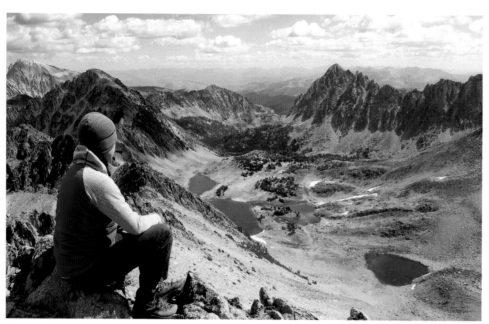

Views of alpine lakes and the surrounding Sawtooth range reward hikers on Patterson Peak (above). The jagged mountains form a scenic backdrop to the verdant Idaho valley below (opposite).

TRAVELER'S NOTEBOOK

＊WHEN TO GO
It's best to visit the Sawtooth mountains (located within the Sawtooth National Recreation Area) from late spring until early autumn; if you want to hike and climb at high elevations, go during July and August.

＊PLANNING
You'll need a car—and if you're going to venture off highways and onto mountain roads, it should be a high-clearance 4x4. Call ahead to the Stanley Ranger Station (208-774-3000), 3 miles (4.8 km) south of Stanley at the base of the Sawtooths, to get up-to-date information on weather and trail conditions.

＊WEBSITES
discoversawtooth.org, fs.fed.us

"You'd have to come from a test tube and think like a machine not to engrave all this in your head so you'd never lose it." So said Ernest Hemingway, facing the profile of the Sawtooth mountains in south-central Idaho. As you round a bend on Route 21, the range suddenly dominates the southern horizon in a series of forbidding, knife-sharp ridges that cut the sky like shark teeth. The Sawtooths are one of the most spectacular ranges in the American West, more remote and wild than Wyoming's Tetons or Colorado's Front Range, with a profile of angry serrations that resemble a coarse saw blade. They don't rise to the heights of the southern Rockies, but dozens of these pinnacles are more than 10,000 feet (3,048 m) in elevation, their steep, splintered walls the result of rapid geologic uplift and distinct patterns of weathering. Hundreds of icy alpine lakes spot the high mountain terrain, and the long Salmon River flows through picturesque Sawtooth Valley at its base, dropping more than 7,000 feet (2,134 m) in elevation as it winds southwest toward its confluence with the Snake River.

Grassy meadows, lodgepole pines, and alpine fir trees climb the lower slopes of the Sawtooths before the granite walls rear up into bare, ragged crests. In spring and summer the

▶ UNFORGETTABLE EXPERIENCES

If you're looking for creature comforts on your visit to the Sawtooth Range, book a cabin at the Idaho Rocky Mountain Ranch *(idahorocky.com)*, about 10 miles (16 km) south of Stanley. It has been operating as a guest ranch since the 1930s, and the rustic, cozy log cabins and lodge are on the National Register of Historic Places. Begin your day with a cup of coffee on the front porch of the lodge, which has a stunning vista of the mountains, and end it with a hearty supper from the ranch kitchen.

high meadows bloom with lupine, lilies, scarlet gilias, and columbine; in winter, the spiny ridges emerge from deep snowfields that keep the high slopes under cover well into the summer. Most of the wildlife that roamed the mountains a couple of centuries ago are still there today. Grizzly bears have migrated north, but black bears, wolves, elks, cougars, moose, and even the elusive wolverine still live in the Sawtooth Wilderness. The streams and lakes are full of chinook and sockeye salmon, and osprey and bald eagles are spotted often.

The ridges that give the range its name are no less dramatic close up. The Monte Verita Ridge complex, a subrange composed of towering granite spires, epitomizes the distinctive Sawtooth profile. Luckily, the spectacle of its peaks can be appreciated from below—climbing them takes considerable technical skill. Louis Stur, a 1960s mountaineering pioneer in the Sawtooth Range (who later died from a fall there), ascended to the summit of the most daunting peak, Warbonnet, and wrote of the dizzying exposure at the top, "A stone dropped from this point will fall for nine seconds before disintegrating on the boulder fields below." *Fair warning:* Don't lose your footing while admiring the awesome mountain panorama surrounding you.

> *"An unusual spot in the Sawtooths is Thompson Peak. It's the highest and has a rounded profile that contrasts with its sharpened neighbors. Not a hike to be taken lightly, but from the summit, mountain ranges unfold in all directions."*
> – Bill Leavell, *guide*

▶ VISIT LIKE A LOCAL

For a hike into the heart of the magnificent Sawtooth Wilderness, strike out from the Iron Creek trailhead on the 10-mile (16 km) out-and-back trek to the high alpine Sawtooth Lake. The path traverses forests and alpine meadow before ascending steeply on switchbacks to the pristine lake, flanked by 10,190-foot (3,106 m) Mount Regan. For a slightly less strenuous day hike, the very pretty lower Alpine Lake is about a mile shy of Sawtooth Lake, off the same trail and back a half-mile spur.

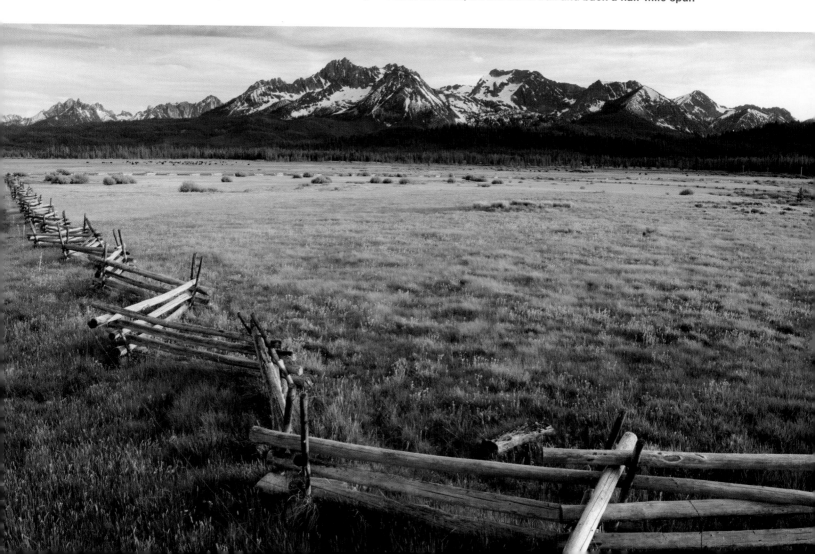

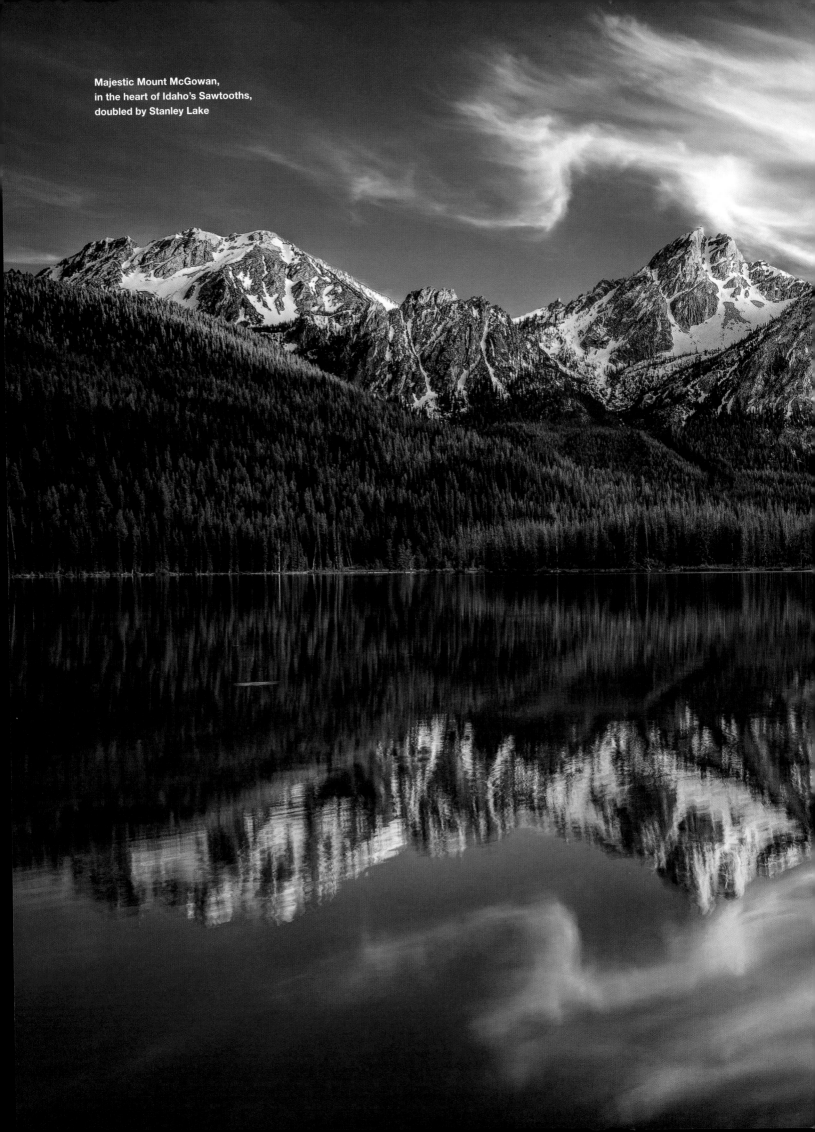

Majestic Mount McGowan,
in the heart of Idaho's Sawtooths,
doubled by Stanley Lake

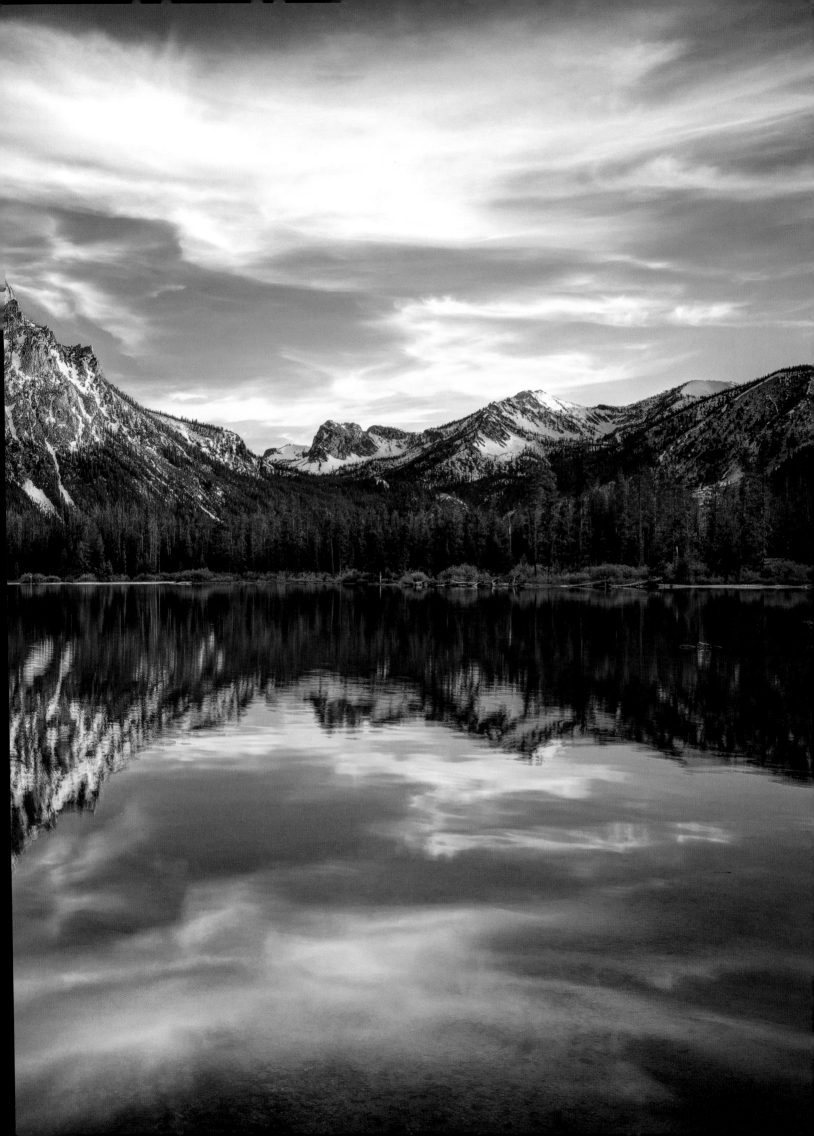

MOUNT WASHINGTON
Weathering New England's ceiling

The weather station at Mount Washington Observatory (above) has recorded weather conditions since 1932. In warmer months, hiking trails offer views of the surrounding White Mountains (opposite).

On a clear day from the summit of Mount Washington you can see 130 miles (209 km), from Canada clear to the Atlantic Ocean. But clear days aren't the norm at the top of the Northeast's highest peak (6,288 ft/1,917 m), known for its extreme and erratic weather. In winter, when this bare White Mountain is all but abandoned, weather conditions rival those of Everest and the polar regions. In the summer, visitors come for the surreal experience of walking among the clouds, where snow in May is normal, June temperatures can dip to near freezing, and on some days visibility is just a few hundred feet.

The summit continues to attract the adventurous as a peak accessible to any fitness level. Today, guests arrive via a narrow, twisting 8-mile (12.9 km) road (a "This Car Climbed Mount Washington" bumper sticker is an American icon); historic cog railroad (a favorite with families); or challenging 4-mile (6.4 km) hike—all beautiful options with plenty of scenery along the way. The visitor center at the top was designed to withstand winds in excess of 200 miles an hour (322 kph); nearby are the Mount Washington Observatory (reservations required), and Tip Top House, one of two hotels built here in the 1850s, when access to this dramatic and forbidding site was possible only by foot or horseback.

▶ UNFORGETTABLE EXPERIENCES

When it opened in 1902 in the mountain's shadow, the Omni Mount Washington Resort was considered one of the most elegant hostelries of its day. In its 110-plus-year history, the majestic hotel has hosted a who's who of area visitors, including Thomas Edison, Babe Ruth, and Princess Margaret. Today's guests can relive a more elegant era with a four-course dinner in the chandeliered dining room—complete with orchestra—or relax posthike in the thoroughly modern spa. *omnihotels.com/MountWashington*

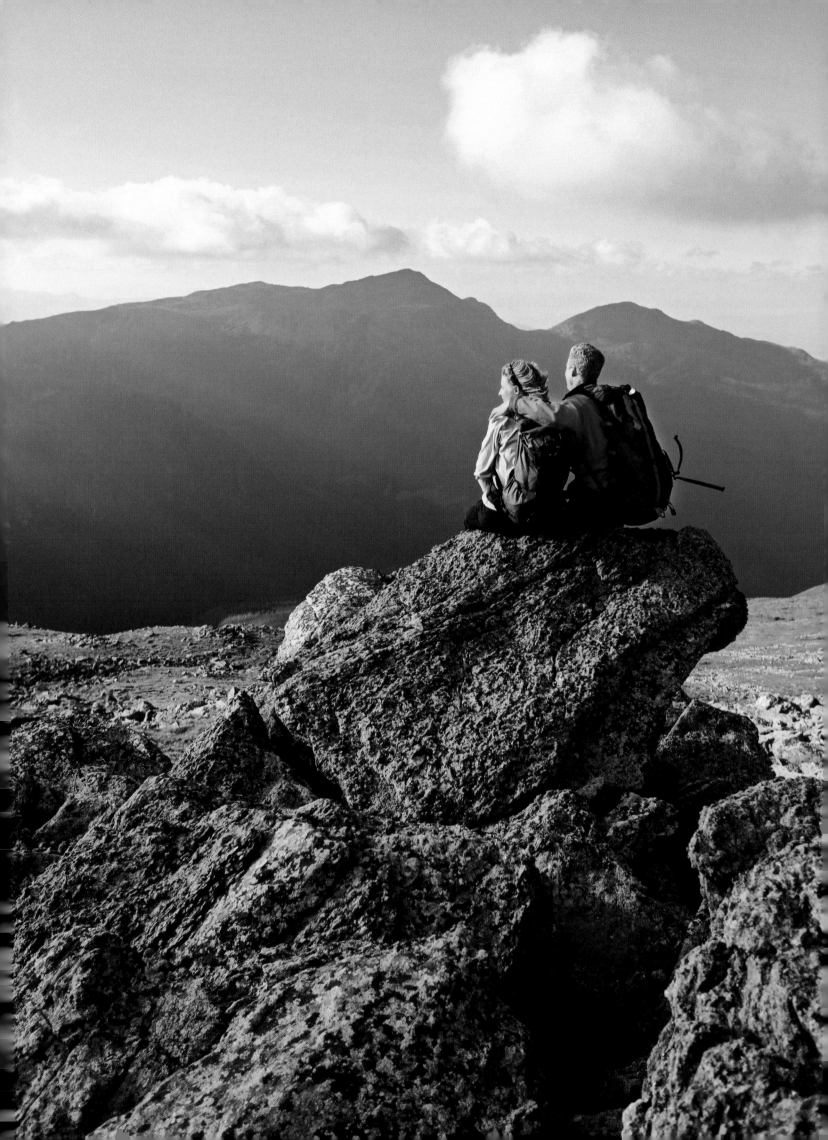

VENEZUELA

AUYÁN TEPUÍ & ANGEL FALLS
A lost world of cloud-shrouded mesas and Earth's highest cascade

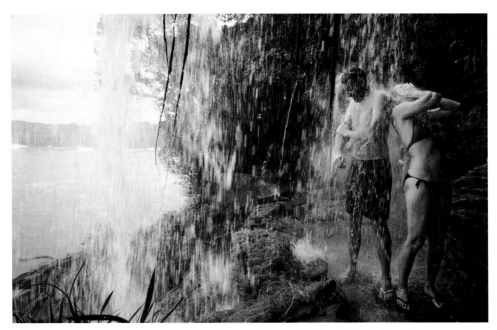

Hundreds of waterfalls beckon visitors to southeastern Venezuela (above); the highest, the spectacular Angel Falls, spill from Auyán Tepuí (opposite).

I n a remote corner of southeastern Venezuela lies a prehistoric land of mile-high table-top mountains, misty jungles, and hundreds of waterfalls. The Pemon Indians termed these ancient mesas piercing the clouds *tepui,* or house of the spirits. Awed reports of the primeval terrain sent back by Victorian explorers inspired Sir Arthur Conan Doyle to write his 1912 fantasy novel *The Lost World,* about a forgotten land where dinosaurs still roamed.

Travelers today may not encounter dinosaurs, but the soaring tepuis—typically 5,000 to 10,000 feet (1,524 to 3,048 m) high—are truly islands in the sky, their steep walls cutting them off from the surrounding rain forest. Their lush habitats host unusual geological formations and creatures, and they are rife with orchids, bromeliads, and carnivorous plants. Some tepuis are almost two billion years old, believed by geographers to be the remnants of a plateau from the ancient supercontinent of Gondwana.

The largest tepui, Auyán Tepuí, has a surface area of 270 square miles (699 sq km), and the world's highest waterfall, the spectacular Angel Falls, drops from a cleft in its summit. Plunging 3,212 feet (979 m) into the Gauja River, the cascade was named for U.S. pilot Jimmy Angel, who crash-landed his plane here in 1937 while looking for gold.

TRAVELER'S NOTEBOOK

＊WHEN TO GO
Rivers run low in the dry season. Come during the rainy season, May–Nov., for the best access to Angel Falls and to view the cascade at its greatest glory.

＊PLANNING
Trips to Angel Falls start in the village of Canaima, in Canaima National Park. The village is accessible only by air; visitors can fly in from Caracas, Venezuela's capital. Several tour companies offer multiday guided hikes and river trips; those willing to splurge can even charter a helicopter to fly above the tepuis.

＊WEBSITES
eeuu.embajada.gob.ve,
backpacker-tours.com,
abenteuer-venezuela.de

▶ UNFORGETTABLE EXPERIENCES

Their sheer vertical flanks render many of the tepuis utterly inaccessible, but travelers willing to make the tough trek can reach the summit of Mount Roraima. Unexplored until 1884, the 7,152-foot (2,180 m) Roraima juts above the clouds in the Gran Sabana region. Six-day guided trips from the town of Santa Elena de Uairén lead hikers to its plateaued summit, a wonderland of waterfalls, natural quartz-lined pools, and Punto Triple, where the borders of Venezuela, Brazil, and Guyana meet.

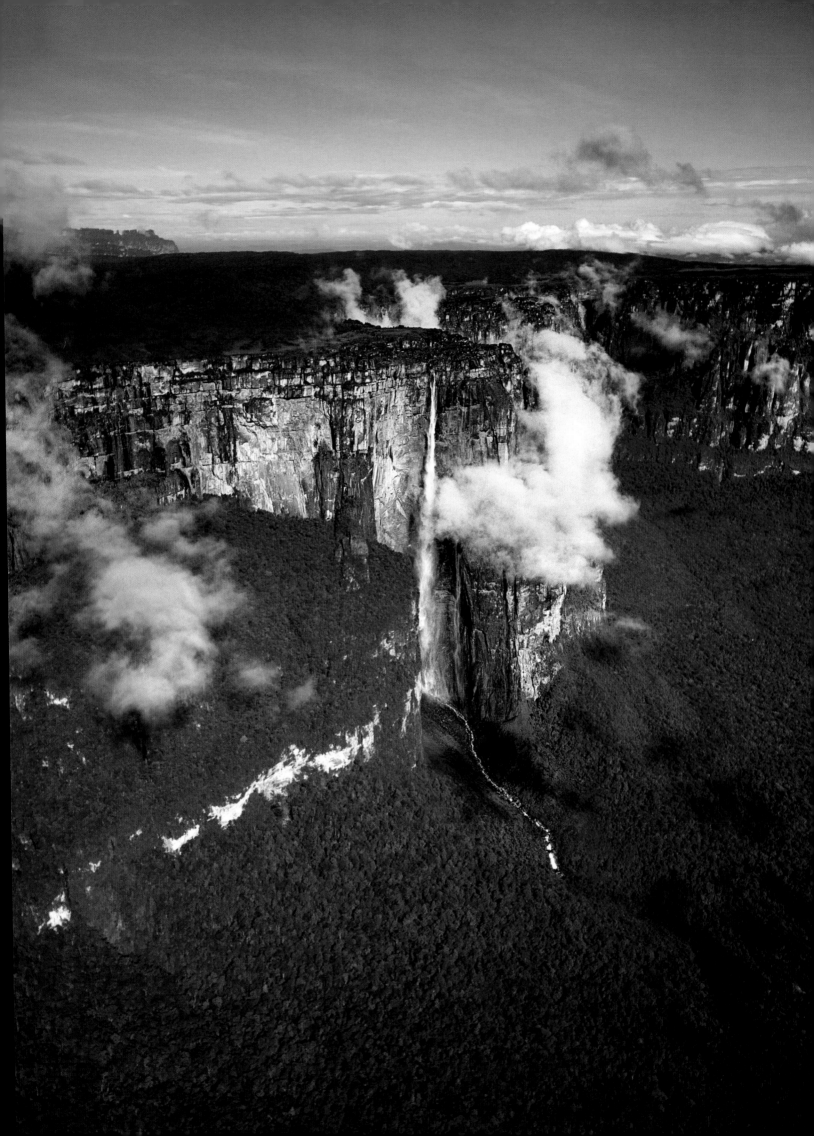

NAHUEL HUAPI NATIONAL PARK
The glacier-carved gateway to Patagonia

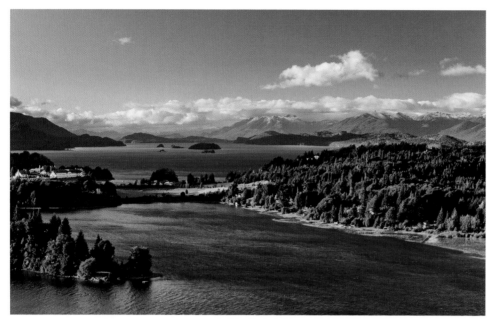

The mountains surrounding glacier-fed Lake Nahuel Huapi (above) provide fantastic skiing (opposite) during the South American winter months of May to September.

TRAVELER'S NOTEBOOK

***WHEN TO GO**
Visit year-round, depending on interest: Winter in this hemisphere means skiing in mid-May–early Sept., with summer water activities in mid-Dec.–early March. Fishing season opens in Nov.

***PLANNING**
Nahuel Huapi is located in western Argentina on the Chilean border, about 1,000 miles (1,600 km) from Buenos Aires. Aerolineas Argentinas and LAN Airlines fly frequently from Buenos Aires to San Carlos de Bariloche, about two hours.

***WEBSITES**
bariloche.com, patagonia-argentina.com/en, trekbariloche.com

Nature clamors for attention in the immense Nahuel Huapi National Park in western Argentina, where Patagonian cypress trees, their bark ribbed and knotted, tower 200 feet (61 m) into the air. Peer through their thin foliage and you may catch a glimpse of an Andean condor gliding on its 10-foot (3 m) wingspan toward a perch in the region's rocky cliffs. Here, too, shine the vibrant blue waters of Nahuel Huapi Lake, which stretch for 200-plus square miles (518 sq km). The massive lake is home to trophy-worthy trout and, just maybe, Nahuelito, Nahuel Huapi's mythical lake monster. Surrounding all, the crisp blue-and-white backdrop of the snowcapped Andes mountains rises in full splendor.

This region is known as the Gateway to Patagonia—Argentina's sparsely populated southern tip—but the stunning scenery of this glacier-carved valley can stop you in your tracks. In winter, these peaks are a skier's delight and the valley a slightly warmer respite. In spring, hikers seek out the spectacular seasonal waterfalls. And in summer, the lake beckons, for fishing, water sports, or a leisurely cruise, one of the best ways to see all this national park has to offer.

▶ UNFORGETTABLE EXPERIENCES

There's a moment of surprise when you first spot San Carlos de Bariloche, a South American resort town that looks transported from the Alps to the Andes and is an ideal base for exploring Nahuel Huapi. The town's German and Austrian settlers left their mark not only on its architecture but also on its chocolate. A tour of the Museo del Chocolate Fenoglio *(Av. Bustillo 1200)* is best followed by sampling the wares of the chocolate boutiques of Mitre Street.

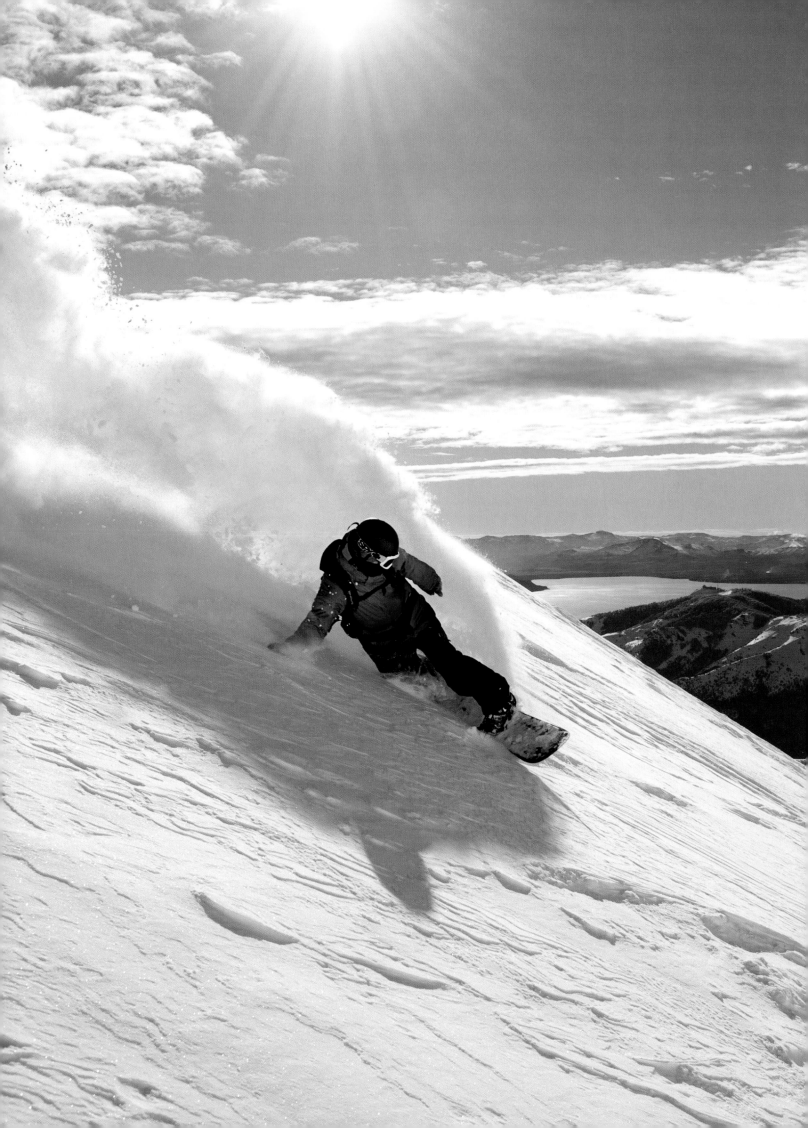

AZORES

Bubbling geysers, steaming volcanoes, and an ocean teeming with life

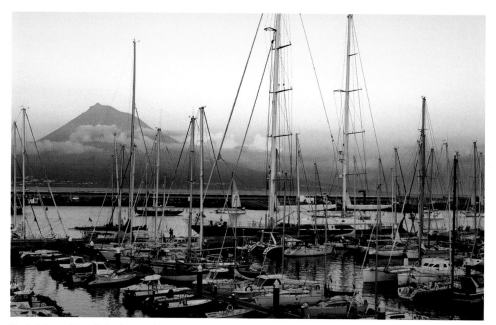

Dusk falls on Horta's harbor and Mount Pico (above). By day, the Azores' volcanic origins are evident in dramatic coastal cliffs and bluffs like those of São Miguel (opposite).

TRAVELER'S NOTEBOOK

✱WHEN TO GO
The Azores often experience four seasons in a day, but for the best chance of good weather, aim to visit in May–Sept. Though the Azores are never crowded, August is the busiest month, as the Azorean diaspora return home for summer vacation. Most whales travel through the area in April–Oct.

✱PLANNING
There are direct flights to the islands from mainland Europe and limited direct charter routes operate from Boston, Oakland, Montreal, and Toronto, especially during the summer months.

✱WEBSITES
visitazores.com, sata.pt, azores.com

It would be difficult to visit the Azores and not feel that you're experiencing the planet at its unadulterated best. Whether hiking around a crater lake, soaking in bubbling hot springs, gasping at a sperm whale, or simply watching the sunset behind Mount Pico's majestic cone, this is a place where people have learned to live in a delicate yet harmonious balance with the awesome power of nature.

Scattered in the North Atlantic, the nine volcanic islands that make up the Azores are in fact the peaks of some of the world's tallest mountains (measuring from the bottom of the ocean). Their location, on the junction of three major tectonic plates, has endowed them with a history of violent eruptions, earthquakes, and tremors, molding and shaping the archipelago into a place of exceptional beauty.

São Miguel, the largest of the islands, is known for its jaw-dropping scenery. In the east, fumaroles of the Furnas crater hiss steam and scalding water through fissures in the earth, and locals cook lunch in underground geothermal ovens. The island's center offers more serene views of Lagoa do Fogo (Lake of Fire). Look to the west, where, should the mist rise, you'll enjoy vistas of the stunning Sete Cidades crater, with its blue and green lakes and hydrangea-trimmed rim.

▶ UNFORGETTABLE EXPERIENCES

For many, the sole purpose of a visit to the Azores is to encounter some of the Earth's largest living creatures. Scanning the horizon for that elusive blow, waiting patiently for the picture-perfect whale fluke, or zooming along with schools of dolphins, the Azorean waters, home to sperm whales and more than 20 other resident and migrant cetacean species, offer an exhilarating experience. Be sure to choose a reputable operator that respects the animals, such as Espaço Talassa. *espacotalassa.com*

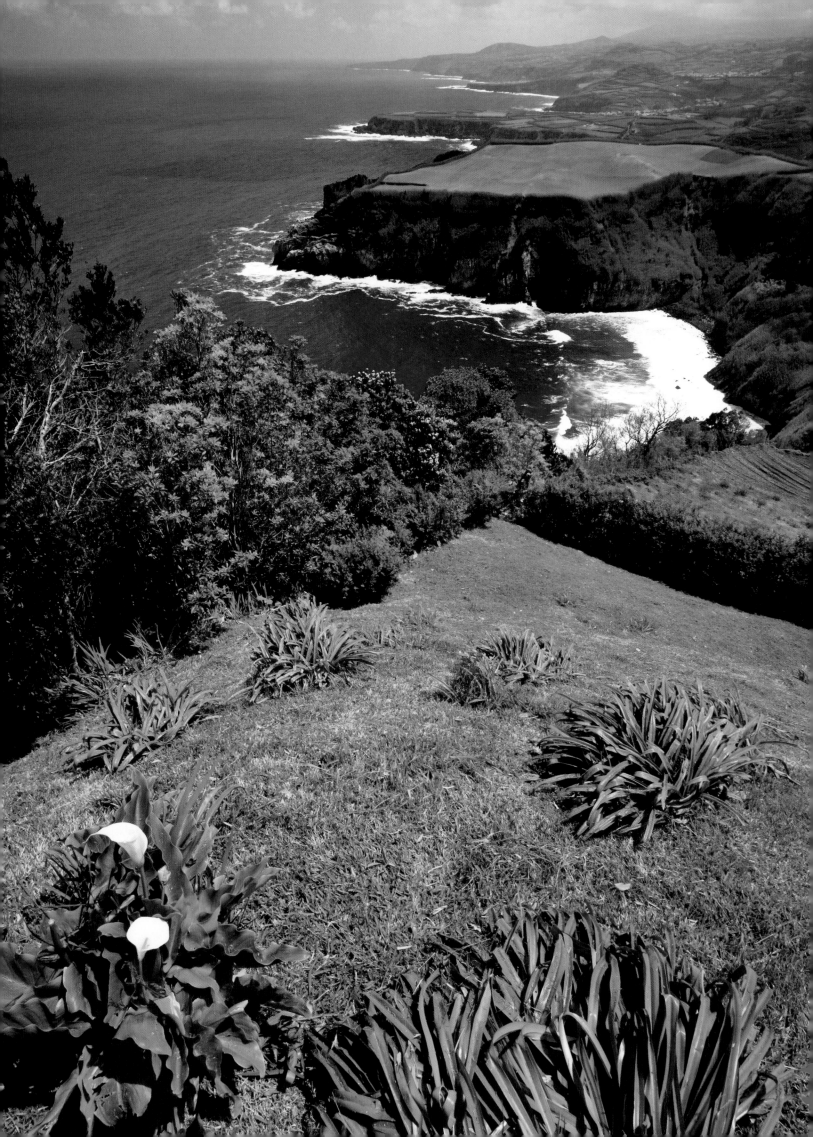

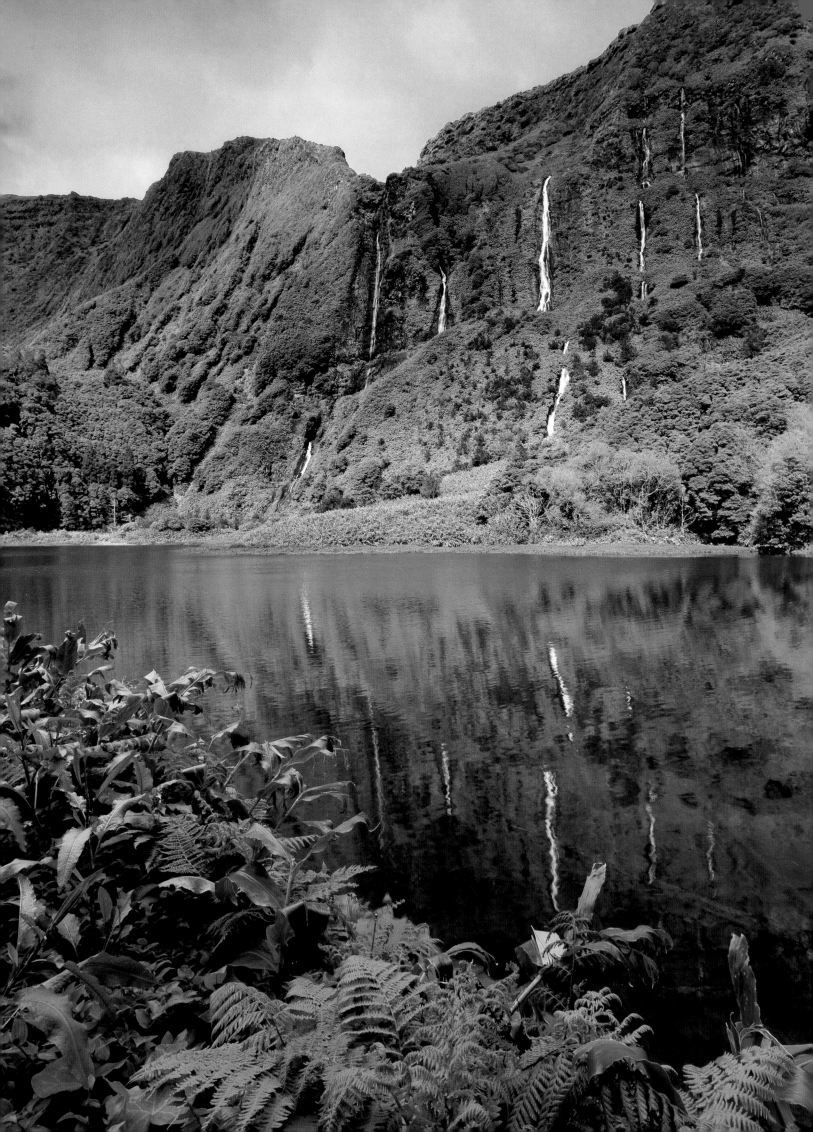

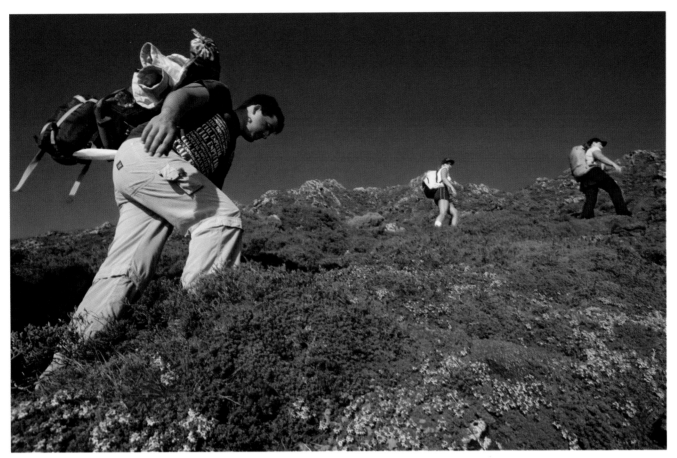

Hikers in the Azores are rewarded by the island group's varied offerings, including wildflower fields (above) and views of waterfalls, such as those dripping down the emerald green slopes of Flowers Island (opposite).

Northwest from São Miguel lies the Central Group of islands; all are unique, but there are undoubtedly some not-to-be-missed highlights. Terceira's capital, the UNESCO Heritage site of Angra do Heroísmo, is the oldest city in the Azores and a port of call for all voyages to the New World between the 15th and 19th centuries.

On the island of Faial, the Horta marina is an obligatory stop on any transatlantic yachting route. Here you can join sailors as they hop ashore for a gin and tonic and stroll the quay where crews paint their boat's name and emblem to bring good luck and fair winds for the remainder of their voyage. Across the narrow straights is the island of Pico, its almost perfect conical peak rising more than 7,700 feet (2,347 m) above the Atlantic. The view of Mount Pico is constantly changing as clouds and sunlight pass across its steep slopes, evoking a different mood every hour. Finally, in the west lie the least populated—and thus very peaceful—islands of Corvo and Flores, the latter named for its abundance of flowers and declared a UNESCO Biosphere Reserve.

It's true that a little effort is required to reach the Azores, 850 miles (1,368 km) from continental Portugal. But it is this remote location that has preserved them as one of Europe's few remaining traditional island communities, a treasure to be protected for future generations.

"June to September are the ideal months for watching whales and dolphins and offer the best climatic conditions, but for the highest chance of seeing the great whales (blue, fin, humpback, etc.), come in April or May."

– Serge Vialelle, *tour company owner*

▶ **UNFORGETTABLE EXPERIENCES**

For the ultimate Azorean hike, lace up some boots and head to Portugal's highest peak. Rising 7,713 feet (2,351 m) above sea level, Mount Pico rewards climbers with outstanding views, which on a clear day can include all five of the Central islands. Several companies offer guided hikes up the stony trail, which from base camp climbs 3,600 feet (1,097 m) steeply uphill for 2.5 miles (4 km). Stay overnight for a memorable sunset and sunrise.

MOUNTAIN MONASTERIES

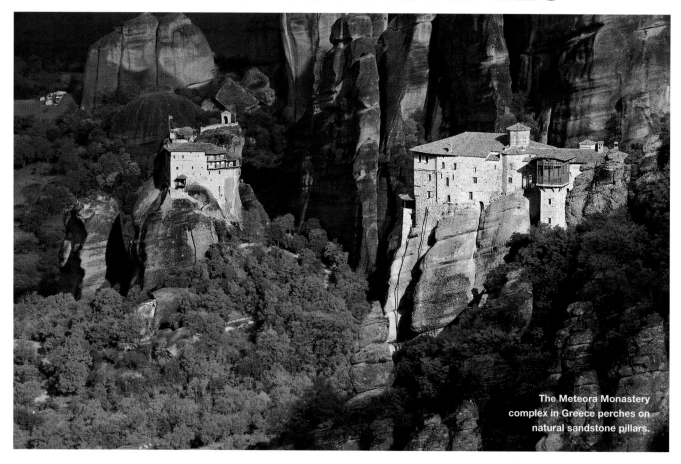

The Meteora Monastery complex in Greece perches on natural sandstone pillars.

Meteora Monastery, Thessaly, Greece

This complex of six Greek Orthodox monasteries stands about 1,000 feet (305 m) over the surrounding Thessaly plains. Originally settled by hermits, pilgrims now climb the steps cut into the bizarre sandstone formations. Later visitors include James Bond in the film *For Your Eyes Only*.

Abbey of Saint-Martin of Canigou, France

Home to the Catholic Community of the Beatitudes, this cliff-top Pyrenees abbey opened in 1009. After a half-hour climb, you can take a silent tour past cloisters, a garden representing Eden, and magnificent carved marble columns.

Santa Maria de Montserrat Monastery, Barcelona, Spain

At 3,937 feet (1,200 m), this Benedictine abbey in Barcelona offers sweeping views as far as the Mediterranean island of Majorca. Gregorian chants are sung daily to honor the Black Madonna, patron saint of Catalonia.

Shambhala Mountain Center, Red Feather Lakes, Colorado

A towering gold stupa, one of the most significant Buddhist landmarks in North America, somehow doesn't feel out of place at this Rockies sanctuary and retreat center at Red Feather Lakes, about 50 miles (80 km) from Fort Collins, Colorado.

Sumela Monastery, Trabzon Province, Turkey

This Greek Orthodox refuge clings to a rock cliff far above the Black Sea coast in Trabzon Province. It was originally constructed in the fourth century and dedicated to the Virgin Mary; today visitors come to see its rock church and medieval frescoes.

Key Monastery, India

At nearly 14,000 feet (4,267 m), this Tibetan Buddhist monastery in the Spiti valley of Himachal Pradesh—a training center for high priests—resembles a fortress. Visitors find prayer wheels, images of Buddha, and ancient manuscripts.

Taung Kalat, Myanmar (Burma)

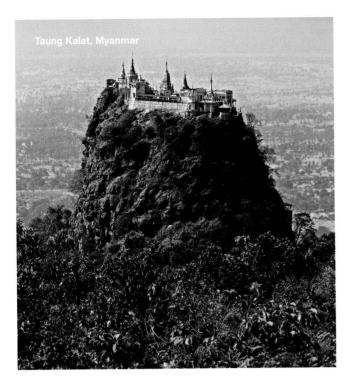

Taung Kalat, Myanmar

Monkeys seem to rule this Buddhist monastery, perched atop Mount Popa, a dramatic pedestal-shaped volcanic plug in central Myanmar (Burma). But it's the 37 resident spirits, or *nats,* that attract pilgrims, who climb the 777 steps to the summit and its fantastic views.

Ling Jiou Mountain Monastery, Fulong, Taiwan

A forest of pagodas mark this Buddhist monastery, built in the 1980s in Fulong, above Taiwan's northeast Pacific coast. Pass under the Buddha Eye Gate to view the commanding 39-foot (12 m) golden bodhisattva and a rare left-reclining Buddha.

Trongsa Dzong Monastery, Bhutan

This *dzong,* or fortresslike complex, is the country's largest, housing several hundred monks. It is the ancestral home of the country's royal family; its stunning location over a river gorge led to its nickname "door to heaven."

Xuan Kong Si Hanging Temple, China

This cliff-side monastery perches on crossbeams about 246 feet (75 m) above a valley floor, protecting it from floods. The 1,500-year-old site, near Datong City, contains 40 halls and includes elements honoring the country's three main religions: Confucianism, Buddhism, and Taoism.

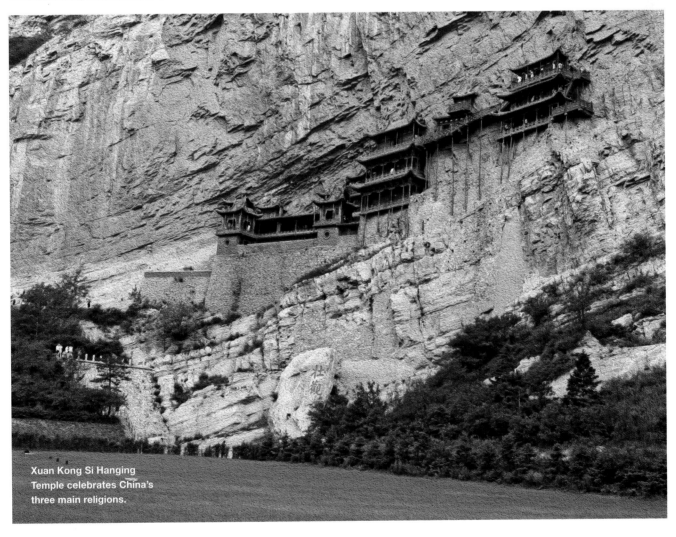

Xuan Kong Si Hanging Temple celebrates China's three main religions.

AXENSTRASSE

An ancient byway snaking through Switzerland's snowy peaks

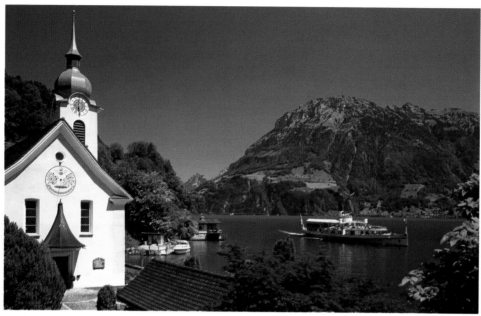

The scenic Axenstrasse stretches along beautiful Lake Lucerne (above), leading ramblers to Alpine hikes (opposite).

Vertigo sufferers, beware. Just 40 miles (64 km) from Zürich is central Switzerland's jaw-droppingly scenic Axenstrasse, an ancient mountain ridge route that evolved into a corkscrew motorway over the centuries. After exiting the dark Mosi Tunnel, drivers are catapulted onto the historic road that winds some 7 glorious miles (11 km) around the breathtaking Urner Alps. Occasionally plunging through century-old mountain tunnels, the road dangles precipitously above the shimmering turquoise waters and steep-cliffed perimeter of Urnersee, a branch of the four-fingered Vierwaldstättersee (Four Forested Cantons Lake), also known as Lake Lucerne.

This road leads visitors into the rarely seen heartland of Switzerland. It might lack the polish of glittery ski resorts like Gstaad and St. Moritz, but it certainly doesn't miss out on magnificent natural scenery. Nor does the area lack history, dating back to 2200 B.C., when Bronze Age and La Tène–era Celts forged intricate metalware and torques from these rugged Alps and traded them alongside quartz and copper pottery with neighboring Ticino tribes. The route was subsequently used by Romans, Franks, and Swabians, and eventually the Habsburgs. Most important, it played witness to Switzerland's formation (then called

▶ UNFORGETTABLE EXPERIENCES

Nature lovers flock to the Axenstrasse, where hikers often spot ibex, fox, and chamois, as well as rare wildflowers such as mottled Alpine orchids, purple enzian, yellow globeflowers, and cobalt gentian. Birders are equally rewarded with a variety of feathered species, including the furtive black grouse, acrobatic alpine choughs, colorful tits and chattering treecreepers, and the occasional accidental southern varieties riding the thermals of the warm *föhn* winds, said by locals to cause madness.

Confoederatio Helvetica) in 1291 by an alliance of cantons against the Habsburg dynasty in the oath sworn at the historic Rütli Meadow, just across the lake from one of the Axenstrasse's many photogenic viewing areas (and still reachable by steamship today). It also bypasses the picturesque hamlet of Bürglen, alleged birthplace of iconic William Tell (who some argue was mythical), one of the country's founding oath swearers, as well as the neighboring village of Altdorf, where the famously precise marksman purportedly split an apple on his son's head with his crossbow to grant their freedom from the Habsburg tyrant Albrecht Gessler.

But the Axenstrasse offers more than nice Alps views and myth-steeped patriotism. The scenic stretch is also noted for its much praised *Alpenglühen,* the reddish glow atop the mountains in spring and winter, and *nebelmeer,* seas of fog that fill the valleys in spring and autumn. It's no surprise that hiking remains especially popular here. A toothy wall rising 650 feet (198 m) shelters this part of Canton Uri from the neighboring Urner Alps. Protected within lie a smorgasbord of Alpine treasures—rare violet orchids, swimmable cobalt lakes, snow-frosted peaks, bell-clad cows, and a plethora of open-air cable cars to reach the mountaintops. This is the Switzerland free from tourism pretension, served up with a hefty side dish of peace and quiet.

"The Axenstrasse is especially beautiful during the full moon, and even more beautiful during a full moon and a föhn, when the southerly winds are warm and the mountains are bathed in moonlight."

– Hansruedi Herger, *photographer*

▶ **VISIT LIKE A LOCAL**

The Axenstrasse's most spectacular viewpoint can be reached only when driving southbound. After passing the Tellsplatte tunnel, drive to just beyond a slightly curving bridge; immediately turn right into a short cul-de-sac and park. This is one of the oldest segments of the cliff-hanging road, and from it you can witness dizzying heights, gnarly trees, wildflowers, and the turquoise fjordlike Lake Uri. A parade of mountains lines the opposite bank, crowned by glacier-topped Uri-Rotstock (9,606 ft/2,928 m).

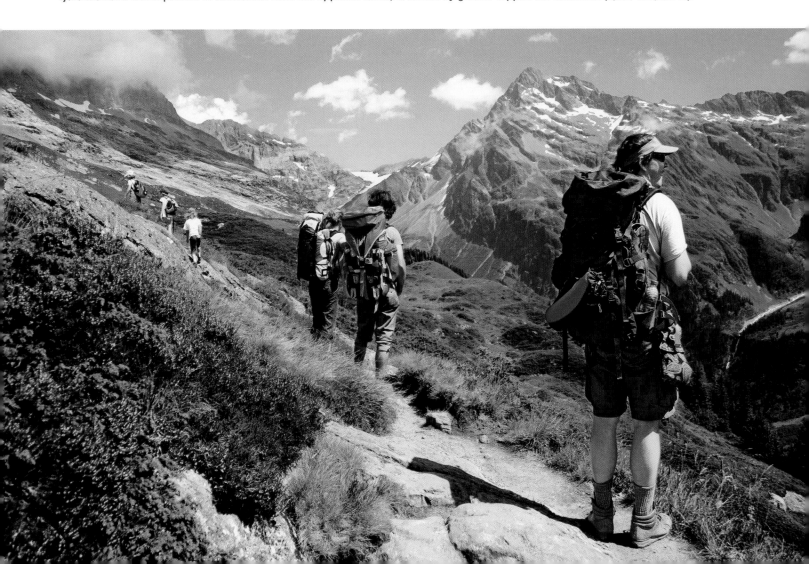

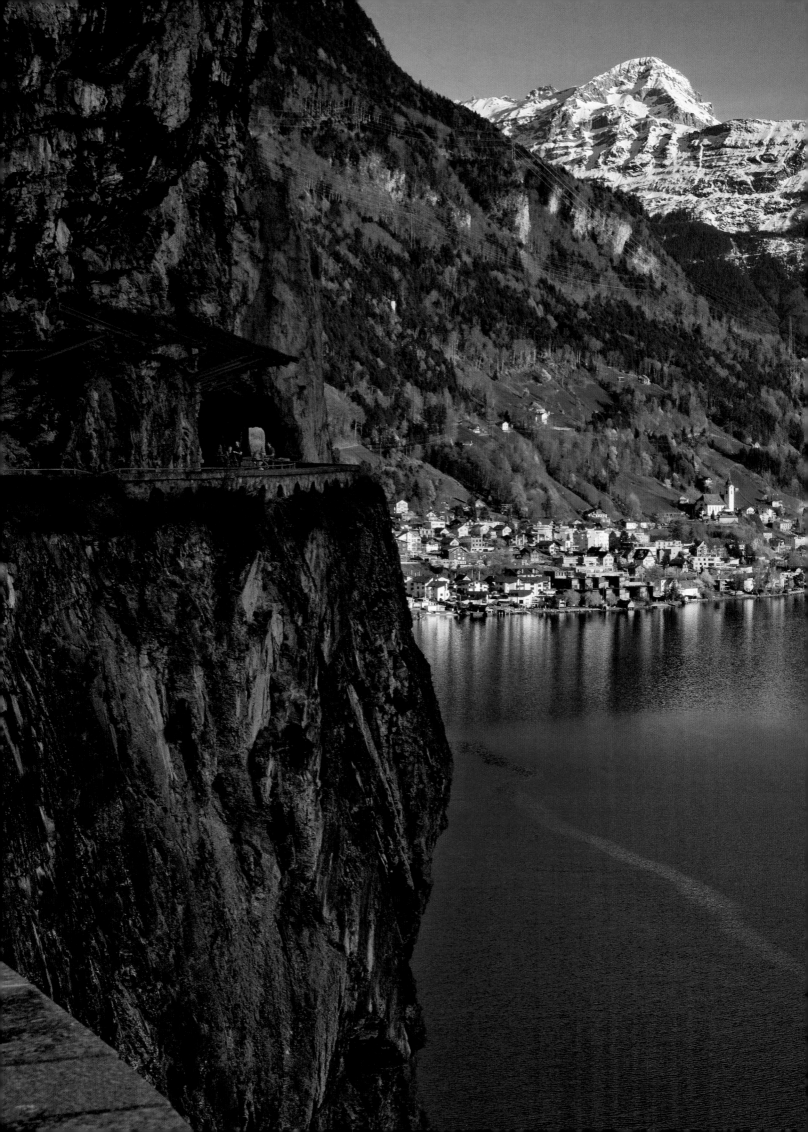

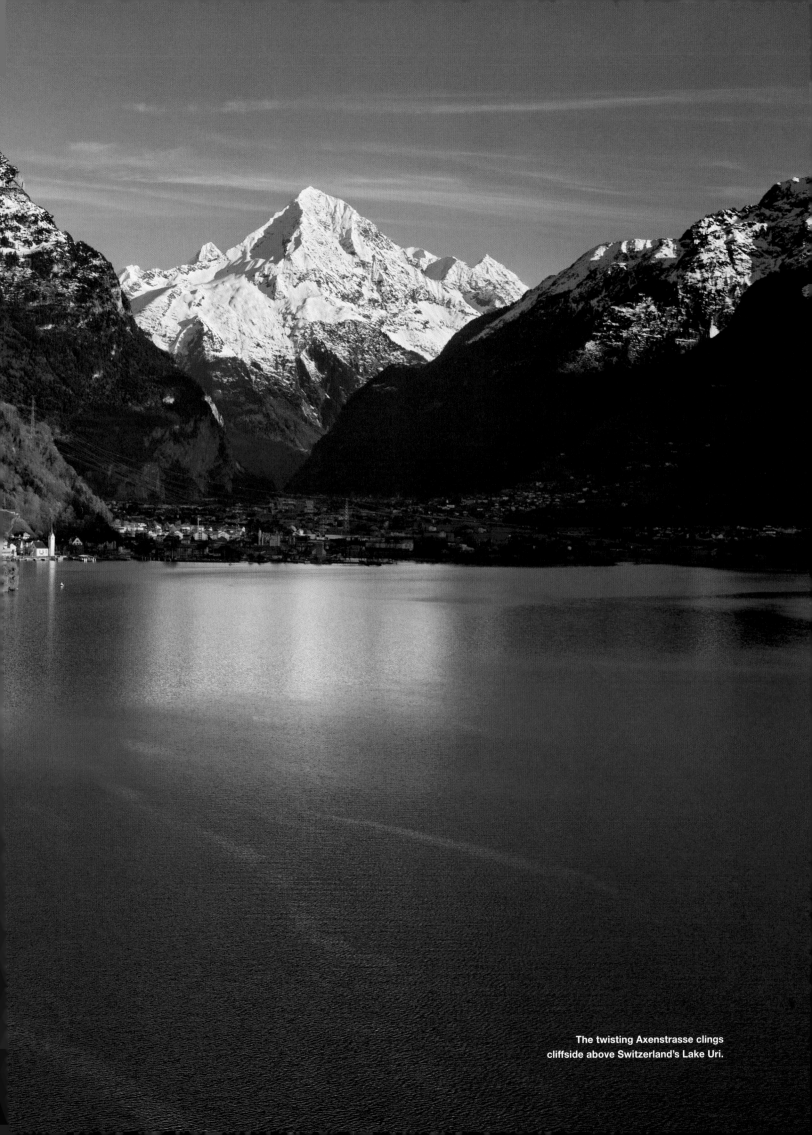

The twisting Axenstrasse clings
cliffside above Switzerland's Lake Uri.

SOCHI
From seaside spas to spectacular skiing

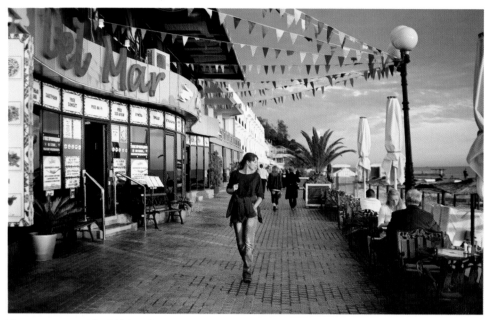

The resort town of Sochi (above), on the shores of the Black Sea, owes its subtropical climate to the nearby Caucasus Mountains (opposite), which block out cold northern air.

Located about a thousand miles (1,609 km) south of Moscow at the foot of the towering Caucasus Mountains, and stretching for 90 miles (145 km) along the beckoning Black Sea, Sochi is a subtropical resort town with a twist.

Palm trees and warm summer waters are only part of the city's charm. The majestic Caucasus block the cold air rushing in from the north, so that the city is bathed in the warm, moist air from the sea to the south. And, yes, in this subtropical city—whose climate resembles that of Portland, Oregon—you can head straight from the beaches to the ski slopes.

Thanks to the 2014 Winter Olympics, several of the area's ski resorts have been rebuilt to world-class stature. Krasnaya Polyana, for example, was expanded to ten times its previous size, and Rosa Khutor, which hosted alpine ski events in 2014, was equipped with an artificial-snow system that allows for skiing a third of the year. The mountains, of course, are good for far more than winter sports: In the off-season, hikes—such as up Mount Akhun, which offers a viewing tower—are a great option. In the distance Mount Elbrus, technically an inactive volcano, rises 18,510 feet (5,642 m) up into the air, making it the highest mountain in all of Europe.

▶ UNFORGETTABLE EXPERIENCES

Sochi is the only place in Russia where tea is produced, and it is home to one of the world's most northern tea plantations. Learn the science and history of growing tea at the Dagomys Tea Plantation *(302 Zaporozhskaya St.)*, where you can also enjoy a traditional tea ceremony, with tea poured from a samovar; cakes, jams, nuts, and fruit; and a folk performance given in full costume.

The 2014 Winter Olympics in Sochi, Russia, where gold medal winner Sage Kostenburg of the United States (opposite) and others competed, revitalized the region's ski resorts (above).

Sochi also boasts a car-free embankment facing the Black Sea and, farther inland, an array of parks bursting with magnolia and cypress trees. The world-renowned Sochi Arboretum is home to more than 1,500 exotic and rare plants native to areas around the globe, with stunning displays of color in glossy leaves and exuberant blooms of all shades and sizes. An on-site cable car brings more views of the mountains and sea as you soar.

Sochi is also an ideal place to rejuvenate, heal, or simply reprioritize one's health. The area was historically renowned for its sanatoriums, where Soviet workers took annual respites. Although many were torn down or renovated in the run-up to the Olympics, the legacy lives on in the form of the luxury hotels and spas that replaced them.

Of course, the beaches themselves offer the best respite. Sochi, fondly referred to as the "Russian Riviera," is sunny for the majority of the year, and the Black Sea is fit for swimming from April all the way through October. The beaches—lined with pebbles, not sand—can get very crowded during the summer months, so in-the-know travelers visit during the fall, when the water is still warm. Certain hotels also reserve specific beach areas for their guests alone.

> *"When you visit Sochi and Krasnaya Polyana, you have to visit a Russian bath. The experience really will stay with you for a long time."*
>
> – Tatyana Larkin, *Sochi resident*

▶ VISIT LIKE A LOCAL

For a pleasant day out, visit Riviera Park *(1 Yegorova St.)*, designed in 1898 and one of the oldest parks in Sochi. Locals flock here in droves, especially for a sweet stroll on a summertime evening. Wander the "Glade of Friendship"—an explosion of magnolia trees planted by Soviet cosmonauts—then enjoy some amusement park rides, games, and the aquarium. A small botanical garden, which blooms with exotic flora, is right next door.

MOUNTAIN RETREATS, REFUGES & GETAWAYS

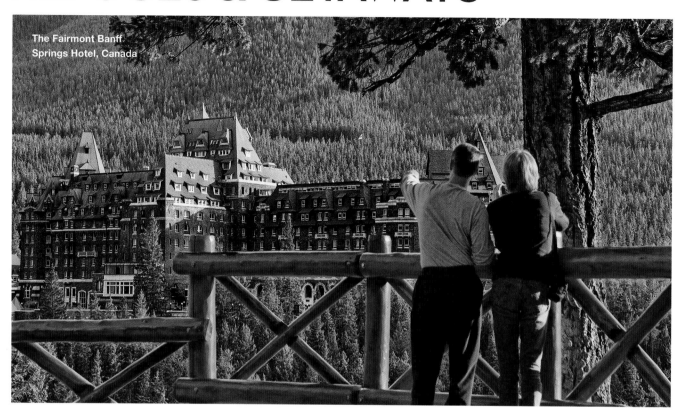

The Fairmont Banff Springs Hotel, Canada

Fairmont Banff Springs, Canada

One of the great Canadian railway hotels built in Scottish Baronial style, this castle in the Rockies rises within the conifer forests of Banff National Park in Alberta. Up above, turrets and dormers reach into the sky, while crackling fireplaces and a grandiose lobby keep things warm and cozy.

Kimamaya, Japan

This luminous barnlike hotel is located in the ski region of Niseko-Hirafu on Japan's northernmost island of Hokkaido. Its stone-and-oak *onsen* (thermal bath inn) is the ideal après-ski spot to soak and relax after a day swooshing down the powdery slopes.

Grand Hotel Tremezzo, Italy

This century-old charmer on the hydrangea-lined banks of Lake Como remains one of the best examples of Italian Liberty-style architecture, and a new spa and floating pool have added some contemporary luxury to this grand old hotel.

Oberoi Wildflower Hall, India

Nestled high above Shimla in the Indian Himalaya amid virgin cedar and pine forests, this former palace of Lord Kitchener has been transformed into a grand English colonial resort, with horseback riding and rafting over the heaving Sutlej River.

Juvet Landscape Hotel, Norway

The mountain chalet gets an übermod update in these seven carefully designed rectangular modules, each fronted with a glass wall overlooking a mountainous Nordic landscape of birch, moss, and the tinkling turquoise water of the Valldøla River. Visitors are urged to disconnect (digitally) during their stay.

Berggasthaus Aescher-Wildkirchli, Switzerland

This rustic mountain lodge, built directly into a cliff face in the Appenzell Alpstein, is reached only via footpath through caves where bears and hermits lived 500 years ago. Shared rooms are rugged, but the view bathed in the golden morning light is memorable.

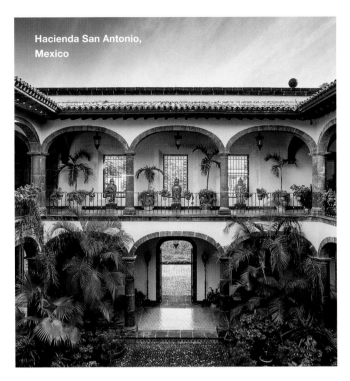
Hacienda San Antonio, Mexico

Hacienda San Antonio, Mexico

Deep in the central Mexican mountains, this remote 19th-century coffee plantation turned hotel awaits guests. The pink *casa grande* is made of volcanic stone from nearby (and active) Mount Colima, set among fountains and shaded trails.

Inkaterra Machu Picchu Pueblo Hotel, Peru

Throw back a Pisco Sour (Peru's classic drink, starring the namesake brandy) while gazing at the lush cloud forest from one of 85 private casitas at this luxurious eco-resort, complete with on-property musicians and nightly nature shows.

Hotel Salto Chico, Chile

This contemporary hotel sits within yards of Patagonia's Salto Chico waterfall in southern Chile, while the peaks of the Paine massif loom behind it like a gigantic spectral ghost. But the majesty of nearby Lago Pehoé and Torres del Paine National Park are the real stars.

Gstaad Palace, Switzerland

A Gilded Age hotel that lords over the tiny alpine village of Gstaad like a giant chess rook, this is Switzerland's definitive party palace, home to the infamous GreenGo Club, a swank disco with its own sprawling indoor pool. Oversize terraces abound.

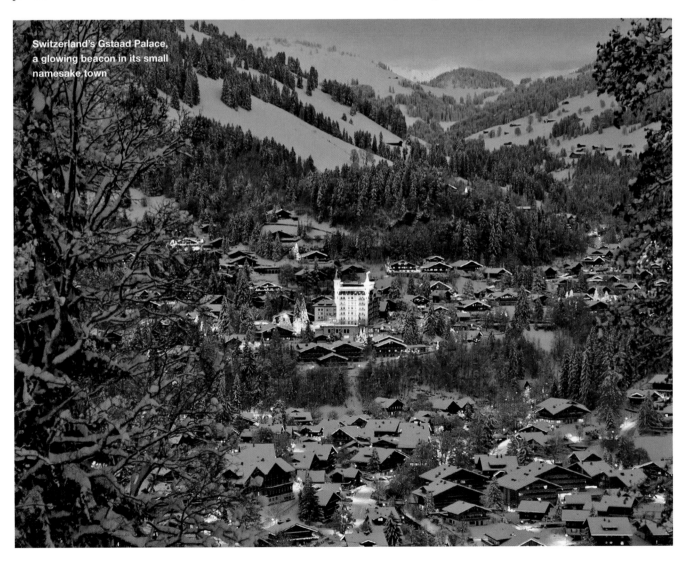
Switzerland's Gstaad Palace, a glowing beacon in its small namesake town

MY SHOT

Caucasus Mountains, Georgia

Walking through isolated Ushguli, at some 7,000 feet (2,134 m) considered the highest inhabited settlement in Europe, is like visiting frozen history, untouched by centuries of wars and invasions happening elsewhere. At this altitude, light can change in a heartbeat. Often I see something, I set the tripod, and it's already gone. Here the light became smooth and gentle on the village, making the grass around even greener as the mountains far behind showed their beauty for a moment. I'm watching all these changes through my lens, so I'm ready to press the shutter.

– Massimo Bassano,
National Geographic
photographer

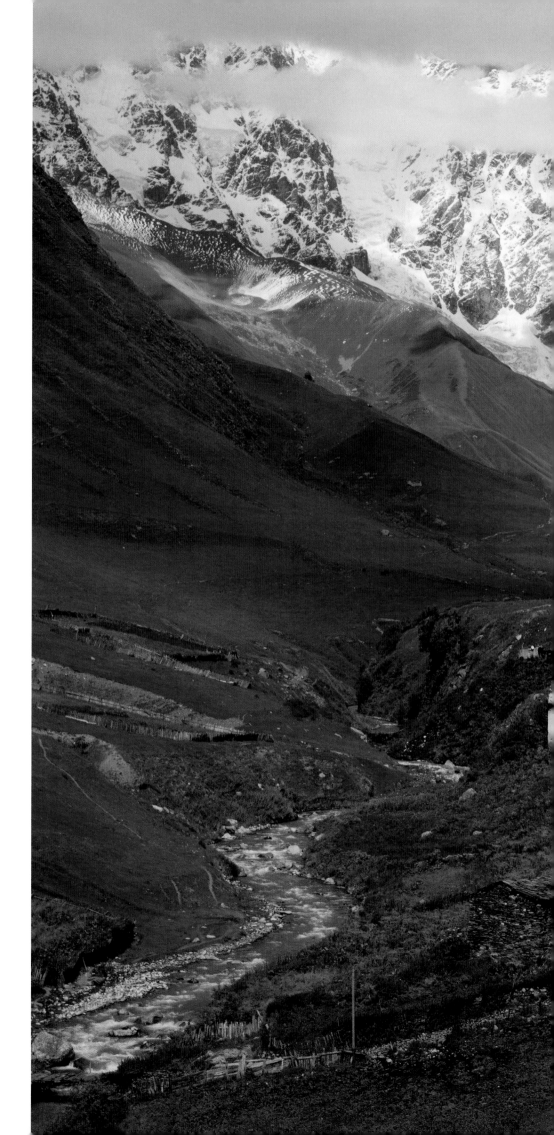

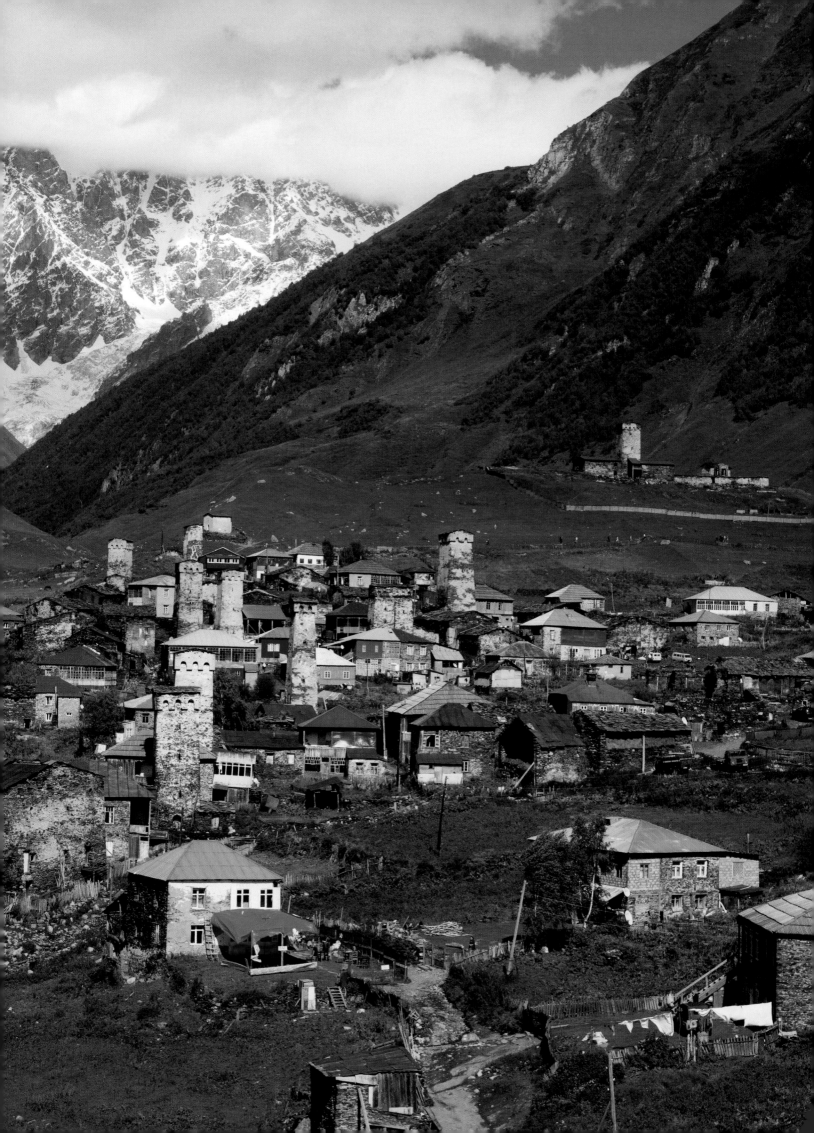

RWANDA

NYUNGWE FOREST NATIONAL PARK
Unspoiled mountain rain forest flush with primates and birds

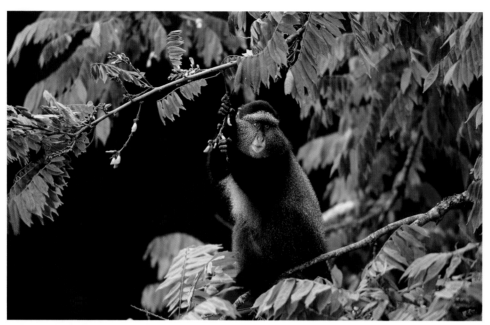

A blue monkey (above) is one of the many species of primates found in the misty folds of the Nyungwe rain forest (opposite).

TRAVELER'S NOTEBOOK

＊WHEN TO GO
July–Oct. is dry and ideal for seeing primates, watching the tea harvest, and hiking mountain trails. Birdwatchers should visit in Dec.–March to spot the widest variety, although this corresponds with the wet season.

＊PLANNING
Fly in to Kigali International Airport, some 140 miles (225 km) northeast and about a four-hour 4x4 drive from Nyungwe Forest National Park. Booking with a tour operator such as Rwanda Eco Tours or Rwanda Gorilla Tours is often the easiest logistically.

＊WEBSITES
rwandaecotours.com,
rwandagorilla.com

For many, Rwanda still calls to mind the brutal genocide of the 1990s between the Tutsi and Hutu tribes. Two decades later, the country is fast rebuilding, with tourism taking a central role. One of the nation's most precious travel gems is Nyungwe Forest National Park, offering fantastic wildlife viewing—everything from large, curious primates to colorful birds—set amid picturesque waterfalls and lush green mountain peaks.

A protected wild mountain rain forest reserve near the Burundi border, among the largest remaining in Africa, Nyungwe covers more than 375 square miles (971 sq km), with the soaring Mount Bigugu (9,596 ft/2,925 m) a defining feature very popular for hiking. The reserve is rightly famed for its broad range of primates, including chimpanzees, olive baboons, red-tailed monkeys, and many others. More than 100 forms of orchids and lobelias blossom here, providing vibrant accents of color set within the lush forest canopy, itself home to hundreds of species of birds, making the rain forest one of the best birding sites in the world. For a stunning view of both waterfalls and wildlife, many visitors forgo their fear of vertigo and trek the Nyungwe canopy walk, strung 164 feet (50 m) through the highest branches of the trees above the forest floor.

▶ **UNFORGETTABLE EXPERIENCES**

After a long day hiking the park's extensive 81 miles (130 km) of trails, relax at the Nyungwe Forest Lodge, the most luxurious resort inside the forest. Set on the mist-shrouded grounds of a tea plantation, the lodge is comfortable and romantic, with large, air-conditioned rooms, fireplaces, and even a whirlpool set on an open-air balcony. The outdoor pool and spa, complete with massage therapists, offer a way to find additional respite in the midst of the jungle. *newmarkhotels.com*

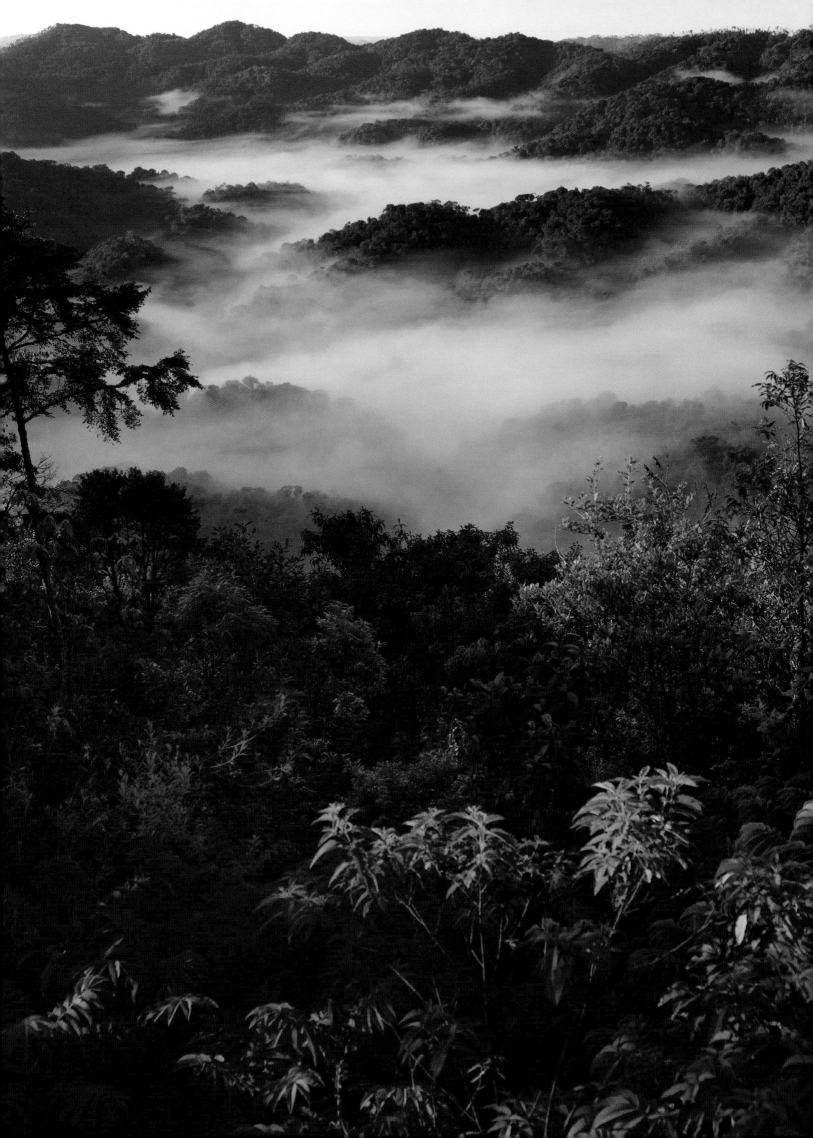

TANZANIA

NGORONGORO CRATER
Warriors and wildlife in East Africa's enormous bowl

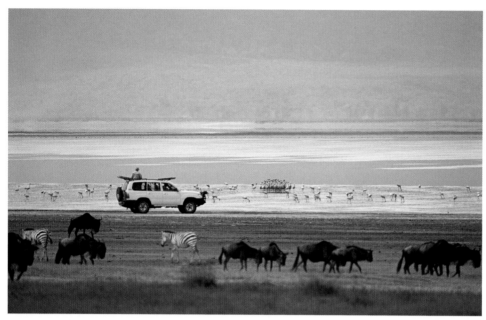

Ngorongoro Conservation Area (above and opposite) protects an amazing array of wildlife on 3,200 square miles (8,288 sq km) of prime African savanna.

The world's largest inactive, unbroken, unflooded volcanic caldera, Ngorongoro would be one of Africa's great natural wonders even without its incredible wildlife. But it's the number and variety of animals here that makes experiencing this place so extraordinary.

Formed by a massive volcano that blew itself apart roughly three million years ago, the crater stretches 12 miles (19 km) from rim to rim and dips some 2,001 feet (610 m) deep. Although the wildlife aren't completely trapped inside, most of the larger creatures choose to stay within the steep volcanic walls. The short-grass plains and acacia woodlands of the crater floor are home to a wide variety of African species, including all of the "big five"—elephant, rhino, buffalo, leopard, and a very dense concentration of lion. The shallow crater lake is often tinged pink with thousands of flamingos, one of around 500 bird species spotted in the area.

The crater is part of the much larger Ngorongoro Conservation Area (NCA), a highly protected region that blends wildlife and the traditional lifestyle of the local Maasai people. It's not unusual to see Maasai warriors herding their long-horned cattle across the crater floor. With digs such as Olduvai Gorge, the NCA is also renowned for its early human history.

TRAVELER'S NOTEBOOK

***WHEN TO GO**
During the dry season, May–Oct., the wildlife tends to congregate around permanent water holes, making them easier to observe and photograph.

***PLANNING**
Ngorongoro Crater rises around 118 miles (190 km) west of Arusha in northern Tanzania. You can obtain a permit to explore the crater floor in your own 4x4 vehicle or join a private or group tour. Either way, all vehicles must be accompanied by a licensed guide. Overnight camping and walking safaris are not permitted inside the crater, only on the rim and elsewhere in the NCA.

***WEBSITES**
ngorongorocrater.org,
ngorongorotanzania.com

▶ **UNFORGETTABLE EXPERIENCES**

Perched on the crater's southeast side, Gibb's Farm offers a bygone African overnight experience with an emphasis on local traditions. Founded in the 1920s as a coffee farm, it has 17 cottages that sprawl through lush gardens with views across the Great Rift Valley and Ngorongoro Forest. Much found on the restaurant menu is farm grown, including the wondrous Arabica coffee. In addition to wildlife drives, Gibb's organizes crater walks, village and school visits, and volunteer opportunities. *gibbsfarm.com*

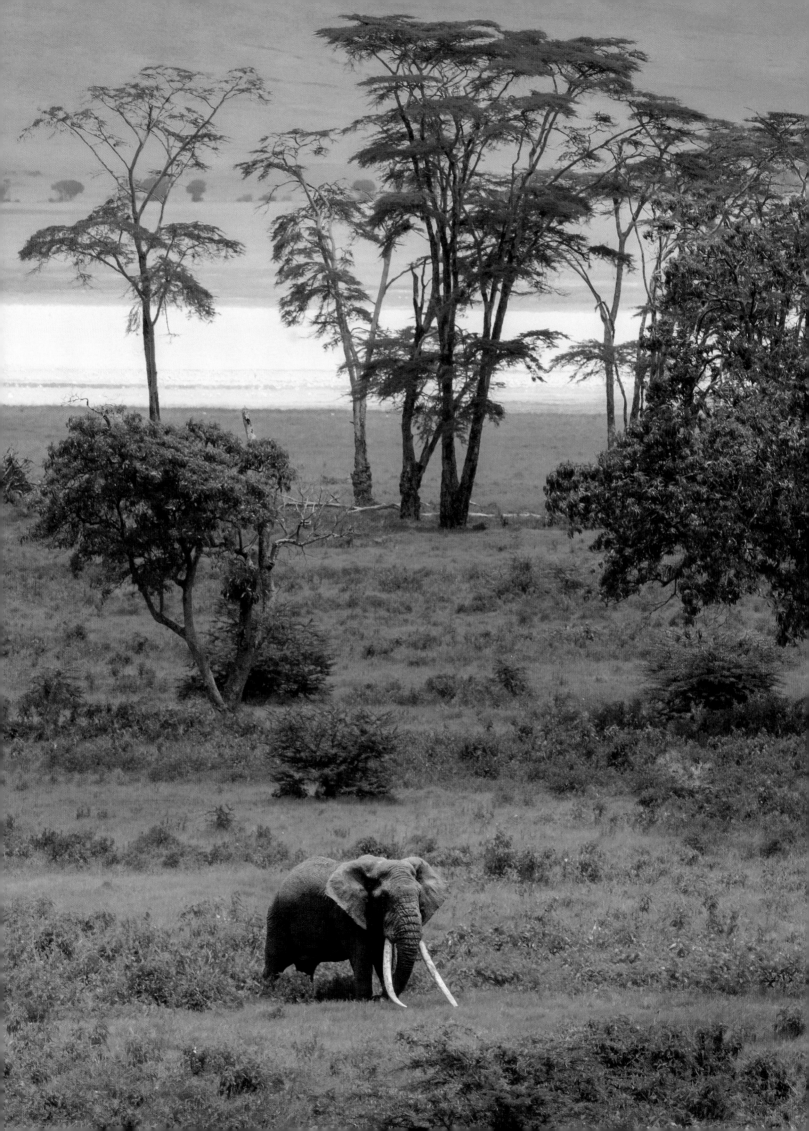

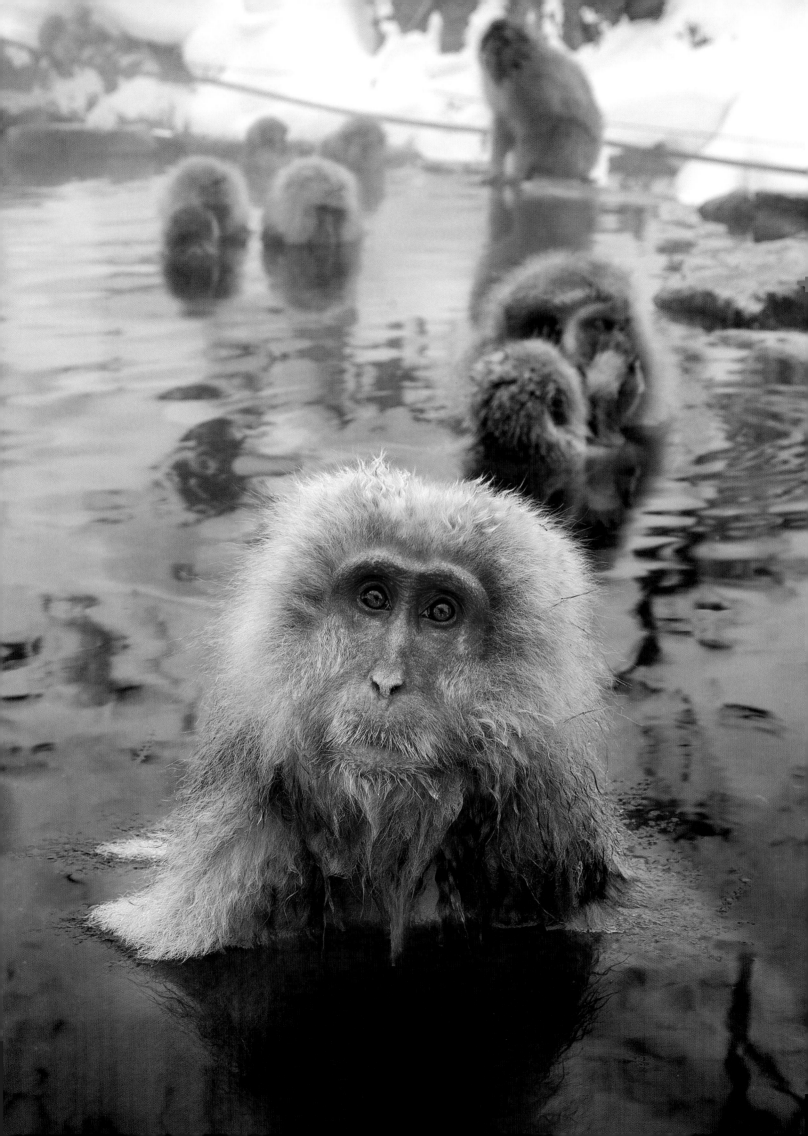

JIGOKUDANI MONKEY PARK
Primate-beloved hot springs deep within the Japanese Alps

The appeal of a long soak in hot water is shared at both the Hoshinoya Karuizawa luxury resort (above) and the pools of the Jigokudani Monkey Park (opposite).

<div style="float:right;border:1px solid black;padding:5px;">

▶▶ TRAVELER'S NOTEBOOK ◀◀

❋WHEN TO GO
It's possible to visit Jigokudani Monkey Park year-round, but winter months (Dec.–March) are best to see the macaques' bright red faces and fur dusted in snow.

❋PLANNING
There is no nearby airport, so many international visitors arrive by bullet train via Nagano or Tokyo. The park's small information center is mostly in Japanese, with a live camera feed from the monkey pool. Two foot trails access the park's hot springs: One involves taking a bus from Yudanaka Station and a 40-minute walk through the forest. The other is a 10- to 15-minute walk from a paid parking lot just west of the park.

❋WEBSITES
jigokudani-yaenkoen .co.jp, japan-railpass.ch, www.jnto.go.jp

</div>

Deep within a tranquil forest in the Japanese Alps curves a volcanic, bowl-shaped valley where the world's northernmost primates—the Japanese macaques, also known as snow monkeys—soak in steamy hot-water springs. Watching them reminds us both of our close connection to our ancient cousins and the universally relaxing appeal of hot water.

Jigokudani Monkey Park in Yamanouchi includes part of the monkey's natural habitat—the mixed forests of the Jigokudani—and is close to the *onsen* (hot springs) towns of Shibu and Yudanaka. Jigokudani, which means "hell valley," is veined with hundreds of geysers that draw the snow monkeys year-round. But winter remains the best time to see the snow settle on their scarlet faces, red as ripe apples. The macaques have been bathing in the springs here only since the 1960s, and the park remains the only place in the world to witness such a phenomenon.

The monkeys have many natural pools to choose from, but the park's main man-made pool is the best place to get close to large social groups, including playful baby monkeys and adults grooming one another in the bath. It's a short walk from the park entrance; no fence stands between you and the monkeys, and monkeys are often seen on the trails to the bath.

▶ UNFORGETTABLE EXPERIENCES

Soak in your own hot water at Hoshinoya Karuizawa's ultramod onsen, divided into three chambers. Each has less light than the last, with the third chamber serving as a thermal sensory deprivation tank. The refined and tranquil *ryokan* (inn) offers an excellent example of Japanese *omotenashi* (wellness hospitality), emphasizing a balance between human and nature. Guided nature hikes and light Japanese mountain cuisine bring an even deeper understanding of Japanese onsen culture. *global.hoshinoresort.com*

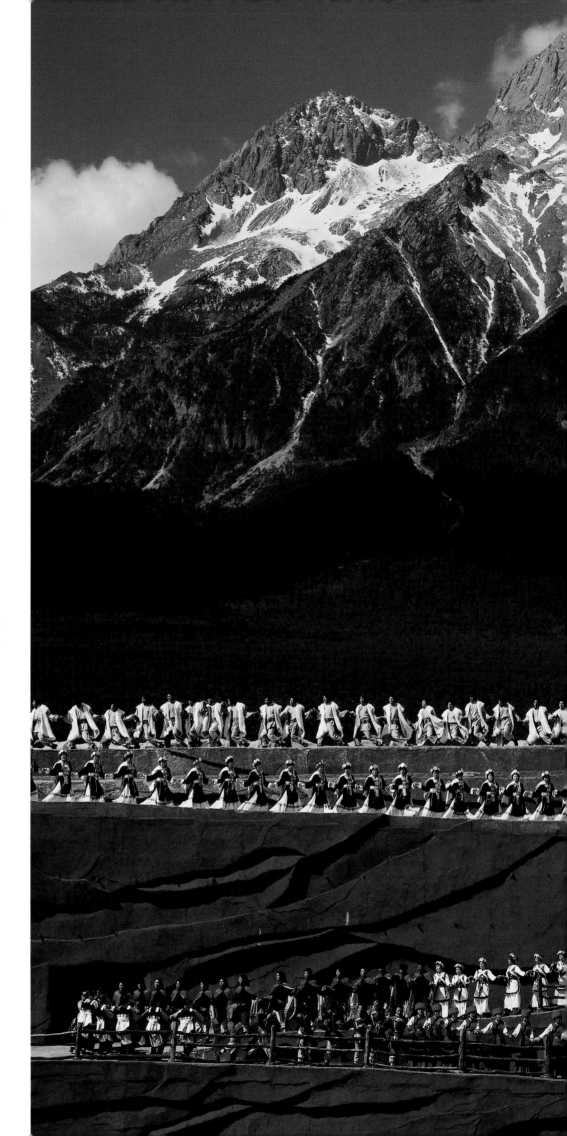

MY SHOT

Lijiang, China

I'm not a huge fan of photographing performances, but I have to say this one blew me away visually. There were around 400 performers gathered from ten different Chinese ethnic groups, and many times, as in this image, it appeared they were all onstage together, dancing, singing, and playing instruments. The show takes place at about 10,000 feet (3,048 m), with the 18,360-foot (5,596 m) Jade Dragon Snow Mountain (Yulongxue Shan) as a stunning backdrop.

– Amy Toensing, *National Geographic* **photographer**

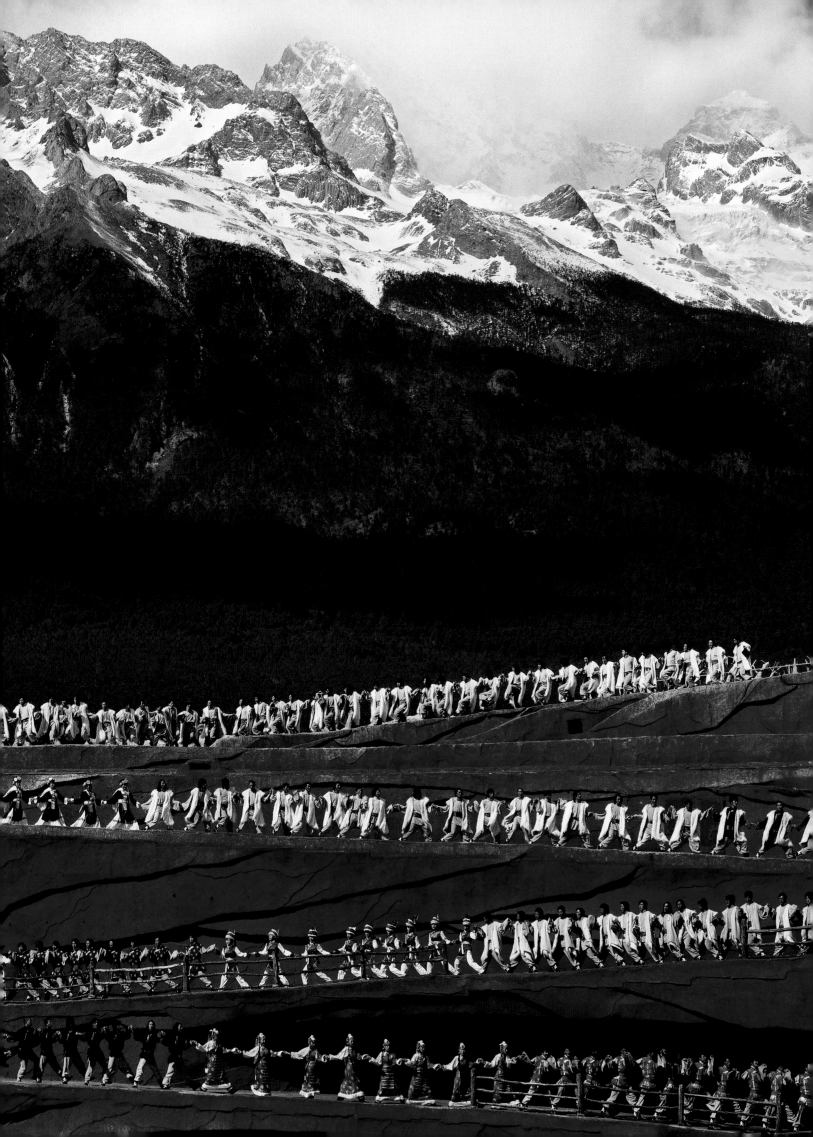

PAHIA & OTEMANU
Gin-clear waters, iconic peaks, and emerald-hued volcanoes

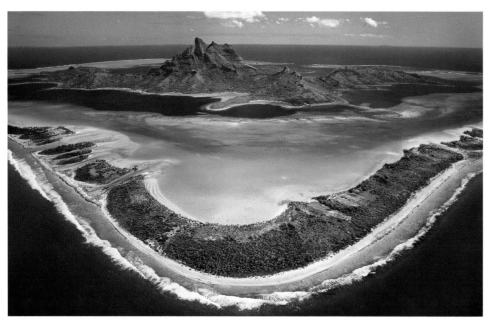

A barrier reef protects the shallow turquoise lagoon surrounding the Pacific islands of Bora Bora (above), where the extinct volcanic peak of Mount Otemanu juts into the sky (opposite).

TRAVELER'S NOTEBOOK

＊WHEN TO GO
High season in Bora Bora lasts May–Oct., when conditions are sunniest for diving visibility at its clearest. The rest of the year is low season, which can bring rain showers and clouds but has three times fewer tourists and lower hotel rates.

＊PLANNING
International visitors will arrive in Tahiti's Fa'a'ā International Airport in capital Papeete (a flight of 8 hours and 20 minutes from Los Angeles), where they can transit to Bora Bora via a 45-minute connecting flight on Air Tahiti.

＊WEBSITES
tahiti-tourisme.com,
airtahitinui.com

You haven't seen color until you've seen French Polynesia. The chain of 118 islands that scatter from Manuae to Mangareva offers a kaleidoscope not found anywhere else on Earth. The archipelagos that make up the region span a width the geographic equivalent of Europe, but two standouts among the islands are the 2,169-foot-high (661 m) Pahia and the 2,385-foot-high (727 m) Otemanu in Bora Bora. These verdant, velvet-green conjoined twin peaks are more than just a honeymooner's backdrop. They are weathered and worn-down extinct volcanoes lording over the lagoon's sapphire waters like a pair of spectral Polynesian gods, and they remain a mesmerizing and primordial sight to behold.

Each inch of the twin peaks seems to be illuminated by the reflection of the surrounding luminous waters, and lush green vertical flora delivers on the promise of a South Seas landscape befitting a Gauguin masterpiece. Polynesians, however, credit the scene to the ancient god Ta'aroa, who according to Polynesian myth made the rocks and sand from the shell he was born from, filled the rivers and oceans with his tears, used his backbone to create the mountains, and painted the rainbows in the sky with his own blood.

▶ UNFORGETTABLE EXPERIENCES

Bora Bora is honeymoon ground zero, and French Polynesia's soft white-sand beaches, vanilla plantations, coconut groves, and ultraclear waters help make some of the world's sexiest accommodations. This includes Bora Bora's Le Meridien overwater bungalows, featuring glass floors to see the whitetip sharks and rays below, as well as breathtaking up close views of Pahia and Otemanu. *starwoodhotels.com/lemeridien*

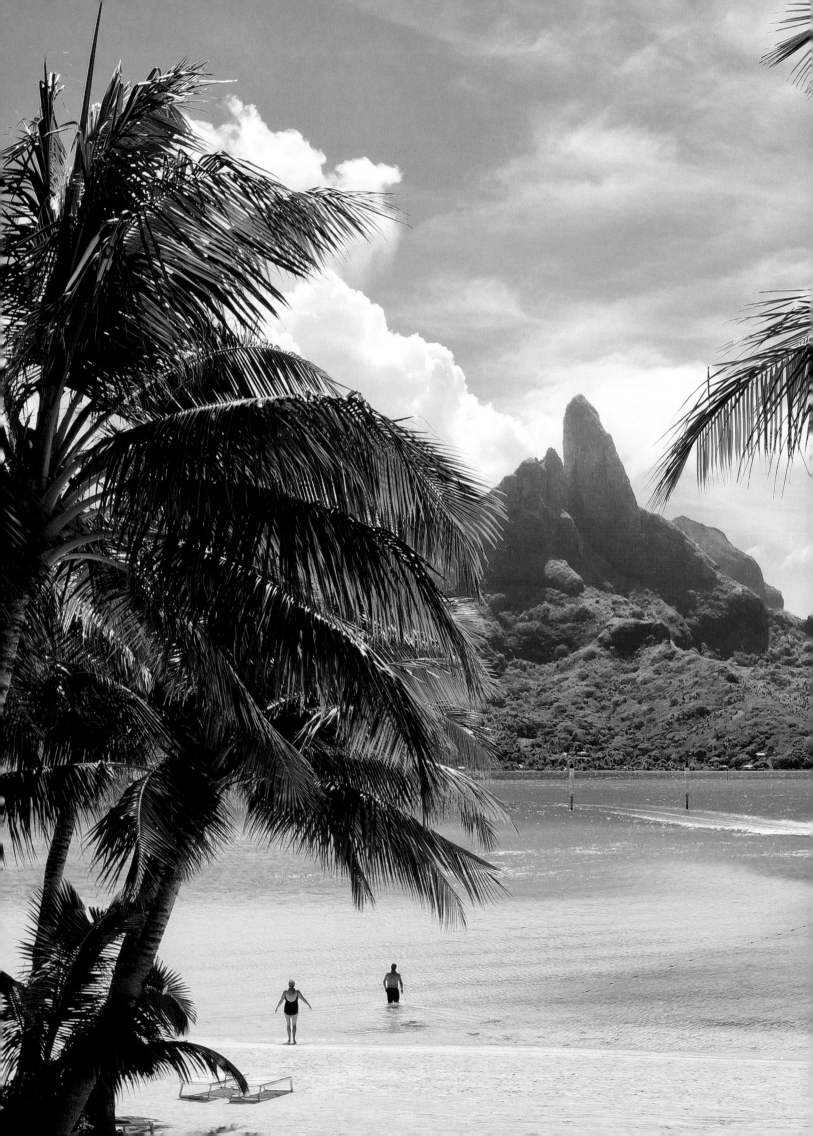

ULURU-KATA TJUTA NATIONAL PARK
Ancient red monoliths sacred to the Aboriginal people

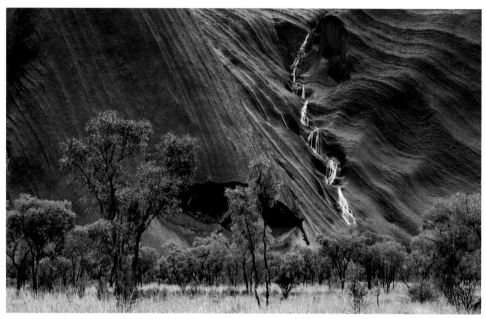

A rare waterfall along the rippling slopes of Uluru (above). To the east, hikers explore the folds of Walpa Gorge, part of Kata Tjuta (opposite).

TRAVELER'S NOTEBOOK

＊WHEN TO GO
The best time to visit Uluru is May–Sept., when the outback's weather is cooler and it's easier to hike around the sites. The colors of the rocks are also more vibrant, and you are more likely to see waterfalls, plants, and animals.

＊PLANNING
Uluru is located in the Northern Territory about 280 miles (451 km) from Alice Springs. Driving from Alice Springs takes about 4.5 hours, or you can fly to Ayers Rock Airport in the nearby resort town of Yulara.

＊WEBSITES
parksaustralia.gov.au /uluru

At sunrise, golden light floods the vast sandy plain of central Australia. When it strikes Uluru, the immense monolith that rises abruptly from the desert, the red rock glows with brilliant color. This breathtaking sight, which continues to awe thousands of visitors each year, makes clear why this ancient mount, along with the nearby Kata Tjuta rock formations, remains sacred to the Anangu Aboriginal people.

Uluru towers nearly 1,142 feet (348 m) above the plain in Australia's Northern Territory, with a base circumference of 5.8 miles (9.3 km). Some 16 miles (26 km) to the east clusters Kata Tjuta, also known as the Olgas, a group of 36 domed rocks, the highest of which, Mount Olga, rises 1,791 feet (546 m) from the plain. With virtually nothing around them but flat, sandy scrub, the two landmarks can appear on the horizon as a hazy, dreamlike mirage in the desert heat. Up close, the formations—hundreds of millions of years old—hold a more tangible presence. The hard, iron-rich sandstone of Uluru, vibrantly red from rust, features a highly textured surface. Deep fissures run down its sides, and caves and overhangs punctuate the base. The narrow chasms and valleys dividing Kata Tjuta's steep-sided domes form a stunning arid maze, perfect to explore during an early morning hike where sharp-eyed walkers might spot rock wallabies.

▶ UNFORGETTABLE EXPERIENCES

Skip the controversial climb of Uluru—it can be dangerous, and the Anangu request that visitors stay off the mount out of respect for the rock's sacredness—and bike around the mountain instead. The flat, 9-mile (15 km) ride circles the entire mountain at the base, getting you right up close to the monolith's fascinating details; bicycles are available for rent at the park's Cultural Centre. Take the circuit on your own or with a guide provided by the local outfitter. *outbackcycling.com*

Formerly known as Ayers Rock, Uluru was returned to the stewardship of the Aboriginal people in the famed "handback" of 1985, when the Anangu agreed to jointly manage Uluru-Kata Tjuta National Park with the Australian government. The handback recognized Uluru's deep spiritual significance to the Aboriginal people. According to their traditional religious philosophy, the Tjukuritja are ancestral beings who created Uluru, Kata Tjuta, and the surrounding world and left their mark in the form of trees, rocks, caves, and water holes. They believe these ancestors and their spirits still inhabit the land, binding their living descendants to these sacred landmarks.

Aboriginal people have lived in central Australia for at least 30,000 years, and their historic rock art, dating back 5,000 years, can be found all around Uluru. Shallow caves along the Mala Walk and Kuniya Walk to Mutitjulu Waterhole, for example, display the swirls, circles, and dots painted to represent people, animals, boomerangs, and places. The delicate traditional paint in hues of red, yellow, orange, white, and black is made from natural minerals and mixed with water or animal fat. The symbolism and techniques seen at Uluru are still used in sand painting, wooden crafts, and modern artworks created by the Anangu today.

"It's a fantastic place—you never get sick of looking at Uluru. I don't, anyway. It's a place of incredible stories that contribute to the mystique of the rock."

– Erwin Chlanda, *editor of* Alice Springs News Online

▶ **VISIT LIKE A LOCAL**

After viewing Uluru, rent a 4x4 vehicle and strike out for some of the other sites of Australia's Red Centre. About 90 miles (145 km) southwest of Alice Springs, Uluru's closest city, a walking path winds through 12 craters at the Henbury Meteorites Conservation Reserve, formed by a disintegrating meteor 4,700 years ago. For more spectacular red-rock formation, head to the Rainbow Valley Conservation Reserve, about 60 miles (97 km) south of Alice Springs. *parksaustralia.gov.au*

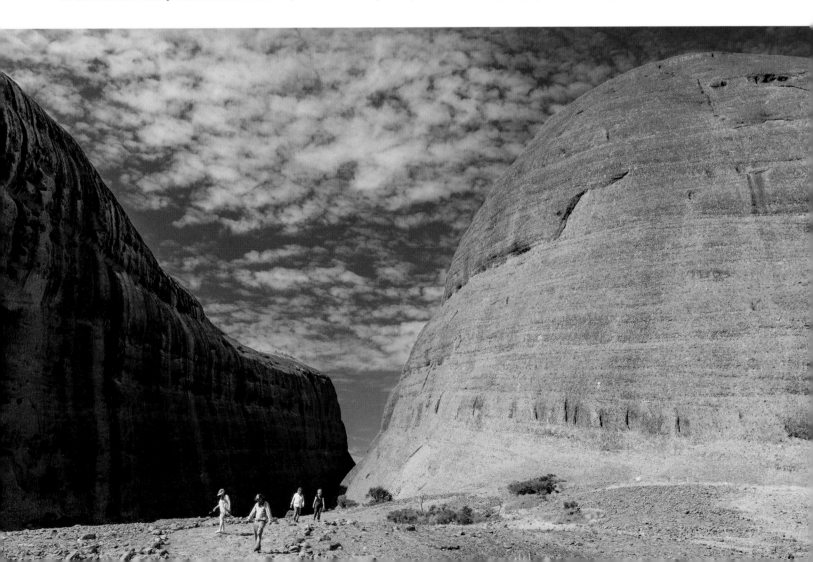

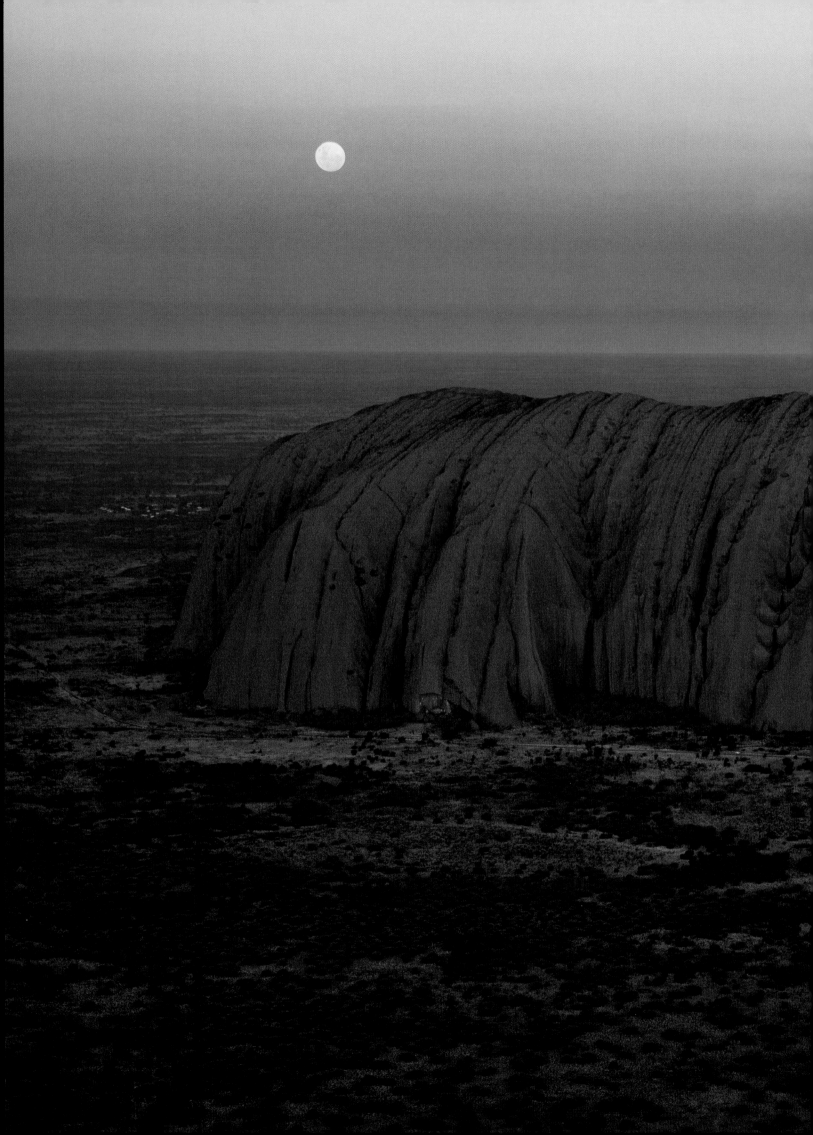

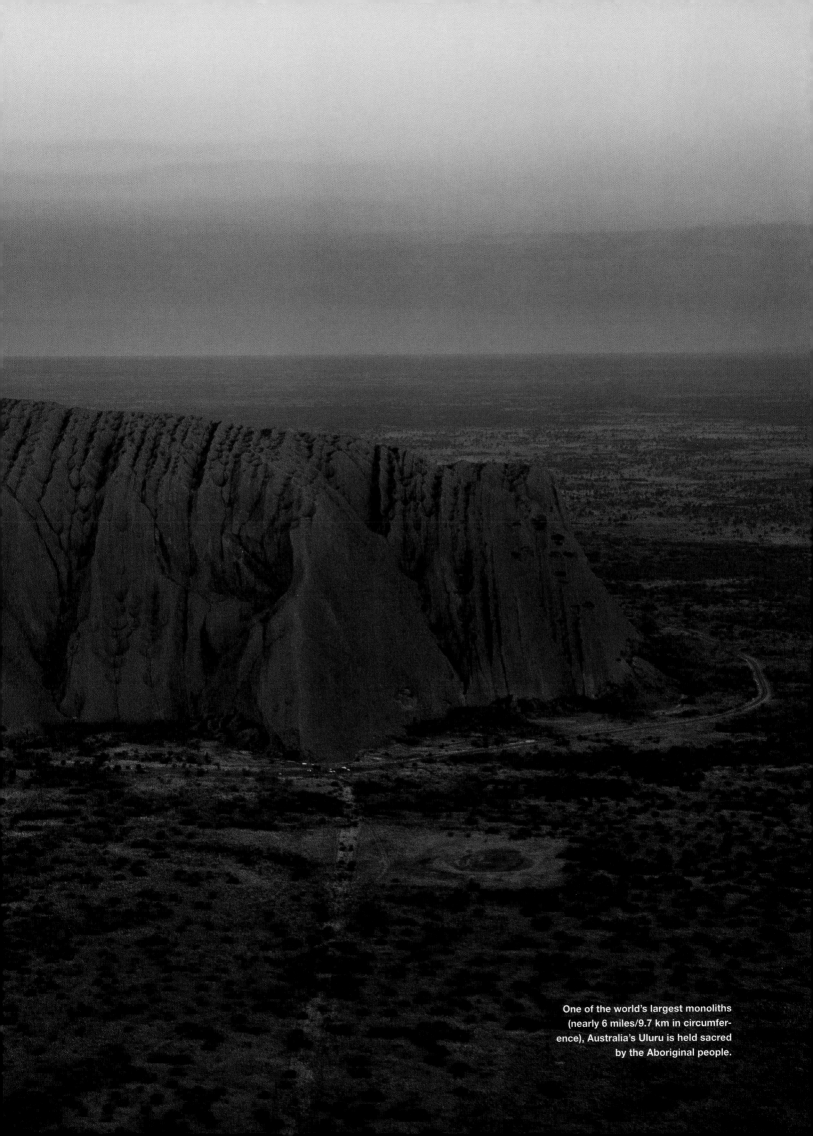

One of the world's largest monoliths (nearly 6 miles/9.7 km in circumference), Australia's Uluru is held sacred by the Aboriginal people.

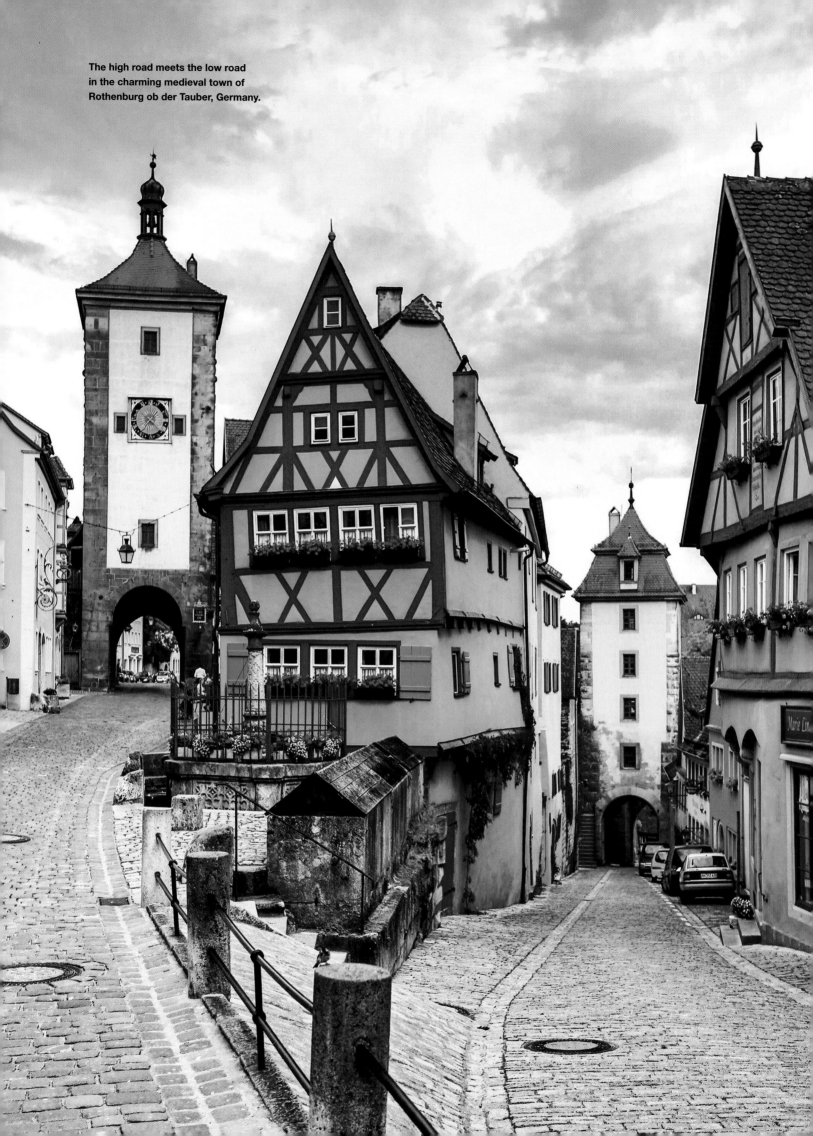

The high road meets the low road in the charming medieval town of Rothenburg ob der Tauber, Germany.

TOWN & COUNTRY

The world happily is still full of surprising mixes of culture and country. Discover Gullah tradition in the Atlantic seaboard's Sea Islands, and shop for truffles and wine in the winding back lanes of Rovinj, Croatia's medieval Old City.

WAIPI'O VALLEY
An otherworldly mix of black sand and waterfalls

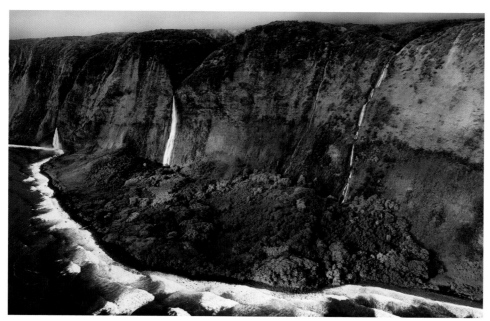

Delicate waterfalls, pounding surf, lush green countryside, and black-sand beaches grace Hawaii's Waipi'o Valley (above and opposite).

The closest many people get to the Waipi'o Valley is its eastern overlook, at the end of the Hamakua Heritage Corridor—a spectacular 50-mile (80 km) drive from Hilo, the Big Island's largest city. The valley, whose name means "curved waters," lies more than 5 miles (8 km) below, down one of the world's steepest roads. From the overlook, the valley's lush greenery, crescent-shaped black-sand beach, and crashing surf appear ethereal, even on an island renowned for its tropical beauty.

Venture farther into the Valley of the Kings, once home to island royalty and still considered to be imbued with their mana, or power, and you might feel like a castaway on a deserted island. Fewer than 100 people live among the valley's taro fields, which were devastated by a 1946 tsunami. And the difficult descent, lack of services, swaths of private property, and strong rip currents of the picturesque beach discourage all but the most intrepid visitors—and adventurous surfers. The rest will miss absorbing the quiet magic of this seemingly forgotten land and witnessing the power of the island's celebrated Hi'ilawe waterfall, which free-falls into the valley from more than 1,200 feet (366 m) above, along with its companion Hakalaoa Falls, which magically appears only after a drenching rain.

▶ **VISIT LIKE A LOCAL**

Forget the overlook: The best view of the valley and Hi'ilawe is reserved for serious hikers (just be sure to stay on public property). Descend into the valley by foot; then turn right toward the beach. Follow the shoreline to the left, fording Wailoa Stream, to the opposite side of the valley. There you'll see signs for the extremely difficult, 8-mile (13 km) Muliwai Trail to the adjacent valley. Just three steep switchbacks up the slope and you will be rewarded with a breathtaking view of the Waipi'o.

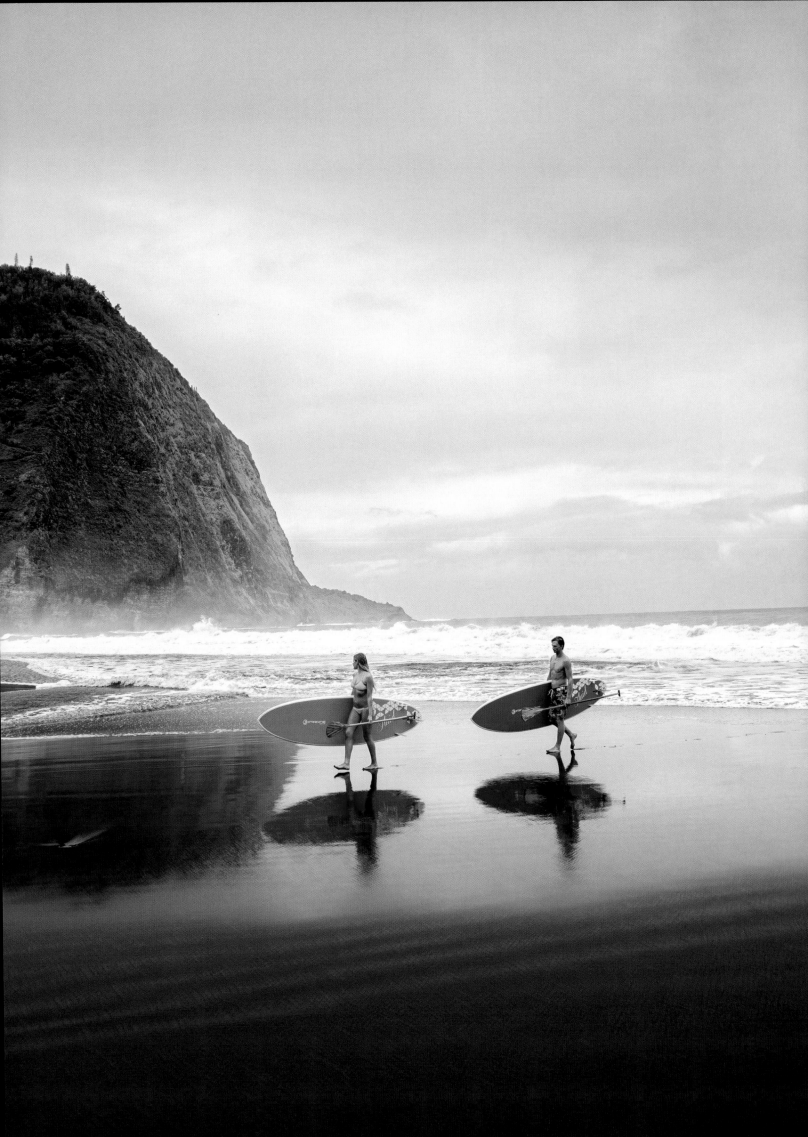

CANADA

VANCOUVER
Crunchy, diverse, stunning

Skyscrapers happily coexist with plentiful parklands in Vancouver (above), consistently named one of the world's top ten most livable cities. A popular public market (opposite) resides on Granville Island.

Set against the crystalline waters of the Strait of Georgia and the snow-dusted North Shore Mountains, Vancouver is easily one of the most scenic metropolises in the world. But this urban area hasn't relied on its pretty face. With a dynamic population hailing from every corner of the globe, Canada's largest city on the west coast has become a true microcosm of the whole world.

Perhaps Stanley Park encapsulates how Vancouver brings together its nature with the diversity of its population. Once a 19th-century military reserve, this natural entrance to Vancouver Harbor features 1,000 acres (405 ha) of temperate rain forest and 17 miles (27 km) of tranquil trails, right in the city's heart. You can admire flower gardens bursting with color while spotting 200-some bird species, take in a variety of performing arts at the open-air summer theater, or lounge on one of the two swimmable beaches. The park brings Vancouverites together to take in British Columbia's fresh air and water.

To complement this appreciation, Vancouver is in the midst of an ambitious Greenest City Action Plan, which aims to claim the title of "world's greenest city" by 2020. New bike lanes, car-share co-ops, additional wind turbines, and curbside compost collection are among some of the ideas in the works.

TRAVELER'S NOTEBOOK

***WHEN TO GO**
Summer is the best time to visit Vancouver, with warm weather and continuous festivals to keep everyone entertained. Winter is ideal for skiers heading out to the slopes nearby.

***PLANNING**
Vancouver is 140 miles (225 km) north of Seattle, and 74 miles (119 km) south of Whistler. A major international hub, Vancouver's airport has direct services to most major Canadian and American cities as well as such international destinations as Amsterdam, Auckland, Hong Kong, Paris, Seoul, Shanghai, and Tokyo.

***WEBSITES**
tourismvancouver.com, hellobc.com

► UNFORGETTABLE EXPERIENCES

Visitors interested in Canada's original culture should check in at Skwachàys Lodge, a renovated Victorian in an area known as the Downtown Eastside. Each of the 18 rooms in the boutique hotel cum art gallery is individually decorated by First Nation artists. Guests will also appreciate its sweat lodge, traditional smudge room, and rooftop totem pole proudly rising above Vancouver's skyline. The socially conscious enterprise also supports 24 on-site live-work art studios. *skwachays.com*

On the cultural front, Vancouver is made of distinct, vibrant neighborhoods. Commercial Drive, the traditional Italian enclave, has an endless supply of espresso bars to keep the city on high drive. Railtown, just across hipster-packed Main Street from cobblestoned Gastown, is emerging as a new creative hub with studios and young entrepreneurs. Near the historic Chinatown, noteworthy for its tranquil Dr. Sun Yat-Sen Classical Chinese Garden, is Strathcona, one of the city's most diverse zones, where designers and artists open their doors for the annual Eastside Culture Crawl. South Asian flavors rule the so-called Punjabi Market, and Kitsilano, where old-time hippies mix with Greek *yayas,* provides an easy gateway to Granville Island, a gentrified district famous for its foodie public market offering the freshest seafood, produce, and more.

Vancouver's youthful population has recently given birth to a thriving craft beer scene, with upwards of 40 craft breweries popping up in a matter of years. In addition, a dozen craft distillers now make small-batch gin, vodka, whisky, and even sake. But you won't need to sip anything to feel intoxicated by all the exhilarating changes that keep this Pacific jewel alluring.

> *"We had many reasons for choosing Vancouver as our home: the people, the politics, and the general vibe. Then we fell in love with the mountains. But most of all, it was about the lifestyle . . . don't get me started on the food!"*
>
> – Aoife Dowling,
> *executive assistant*

▶ VISIT LIKE A LOCAL

Don't be afraid of the suburbs. Vancouver's Chinatown is a fascinating destination, but the locals in the know hop on the SkyTrain's Canada Line to dine in neighboring Richmond, which boasts more than 400 Asian restaurants. Alexandra Road, hailed as British Columbia's "Food Street," has hundreds of vendors competing with one another to sate gourmands with genuine *bibimbap,* ramen, *som tum,* congee, dim sum, and other authentic fare from across Asia.

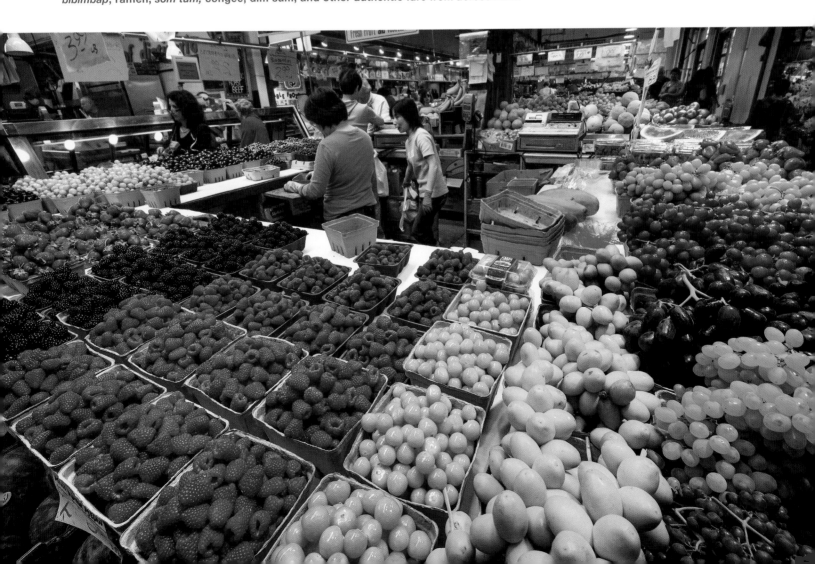

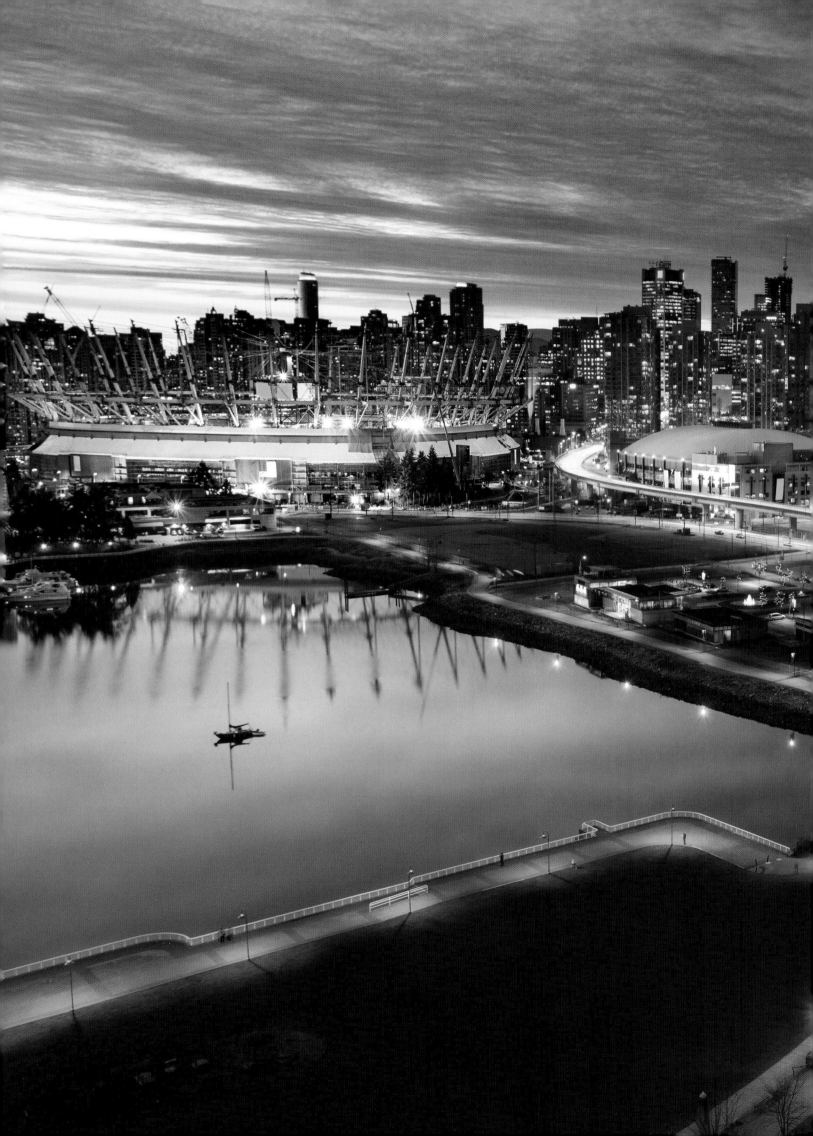

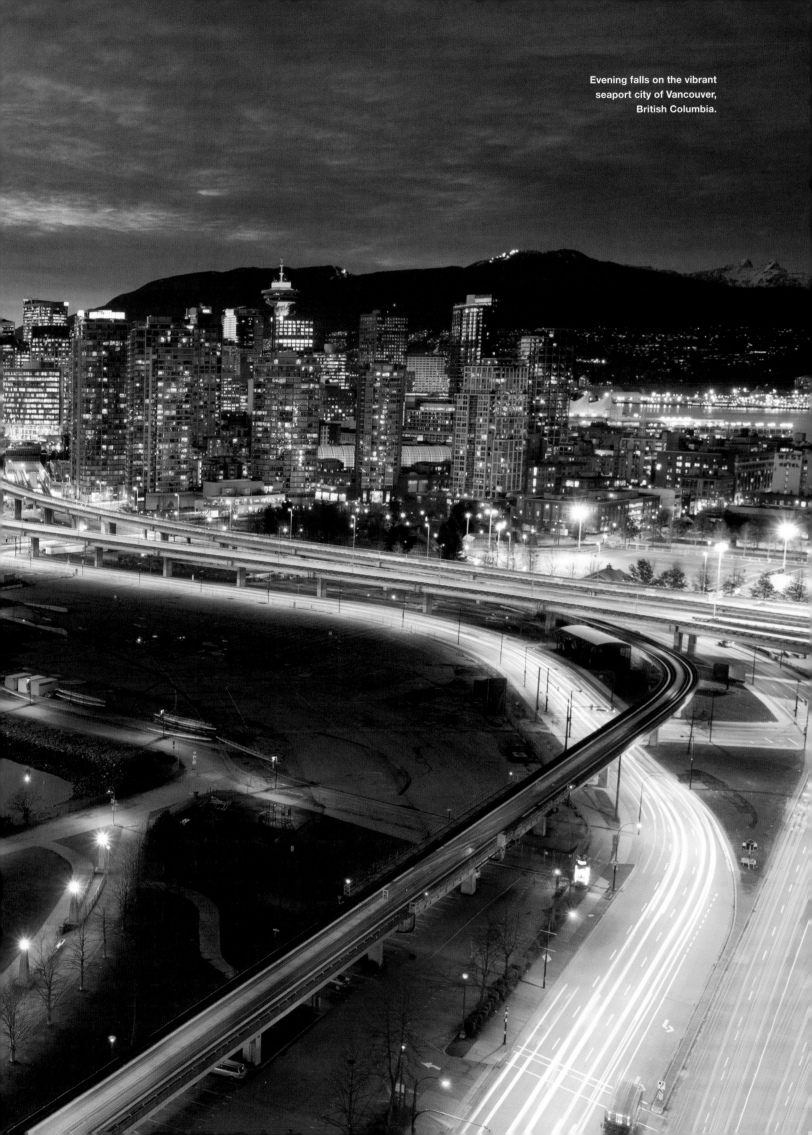

Evening falls on the vibrant seaport city of Vancouver, British Columbia.

MAGNIFICENT HOTELS

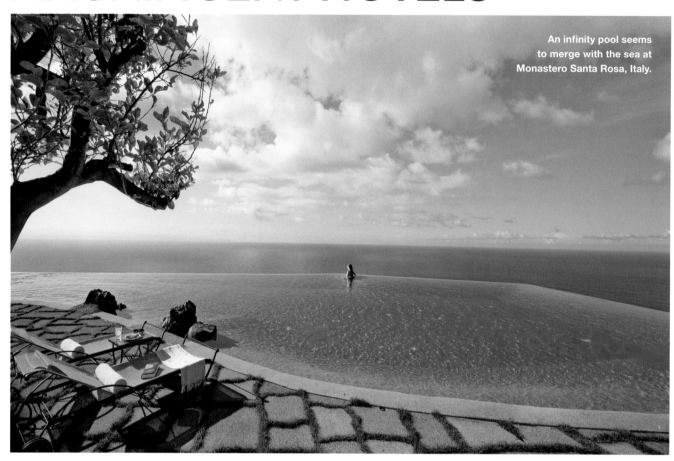

An infinity pool seems to merge with the sea at Monastero Santa Rosa, Italy.

Monastero Santa Rosa, Conca dei Marini, Italy

Looming above the port town of Amalfi and the turquoise Tyrrhenian Sea, this scrupulously renovated 17th-century monastery turned hotel sits quietly and dramatically atop a sea cliff that's been carved into a leafy tiered garden.

Amangiri, Canyon Point, Utah

This modernist desert bunker set among 5,000-year-old petroglyphs and the stratified canyons and plateaus overlooking Utah's Grand Staircase is especially remote and understated, with paths lit with flickering hurricane lanterns.

Loews Don CeSar, St. Pete Beach, Florida

An iconic Jazz Age hotel on the white sands of Florida's St. Pete Beach, the pink palace is festooned with Moorish chimneys and dramatic double-arched windows. It once hosted the likes of F. Scott Fitzgerald and FDR.

Park Hyatt, Tokyo, Japan

Housed on the upper floors of Tokyo's landmark Shinjuku Park Tower, this plush hotel offers lush turquoise interiors, meticulously trained staff, a spacious penthouse spa, and views of the neon canyon of Shinjuku below.

Aman at Summer Palace, Beijing, China

The former quarters of Empress Dowager Cixi remains the only hotel built inside the Summer Palace, an extensive complex of 18th-century temples and gardens designed as a royal urban retreat from Beijing complete with lion-perched gates, tranquil reflecting pools, and a secret entrance.

Heritance Kandalama, Dambulla, Sri Lanka

At first glance, it looks like a Bauhaus structure sinking into a steamy swamp. But closer study reveals an ingeniously landscaped eco-resort with dripping indigenous foliage festooned to resemble a long-forgotten ruin.

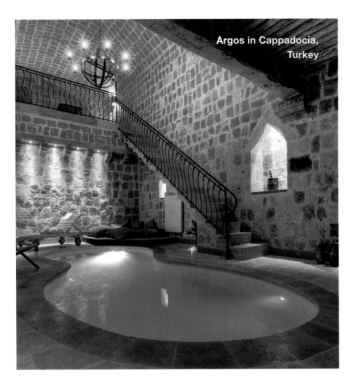

Argos in Cappadocia, Turkey

Argos in Cappadocia, Uchisar, Turkey

The guest rooms in this converted, thousand-year-old monastery—some embedded in Cappadocia's iconic troglodyte caves—feature dramatic arched ceilings, alcove plunge pools, colorful textiles, antique furnishings, and stunning views of Mount Erciyes.

Amankora Bumthang, Jakar, Bhutan

Set in Bhutan's remote and pristine Choekhor Valley, adjacent to the 19th-century Wangdichholing Palace and its active Buddhist monastery, Amankora Bumthang offers awe-inspiring views, oversize tubs, and crackling woodstoves.

Xaranna Okavango Delta Camp, Botswana

Plunge pools and open-air rooftops overlook a hippo-filled lagoon at this African wilderness camp. Amphibious safaris through the Okavango Delta and an exceptional staff who sing, drum, and dance traditional songs make this property a standout.

Four Seasons Tented Camp Golden Triangle, Thailand

Perched in a bamboo forest on the banks of the Ruak River at the seams of Thailand, Myanmar (Burma), and Laos, this resort of luxuriously outfitted tents is an integral part of an elephant shelter.

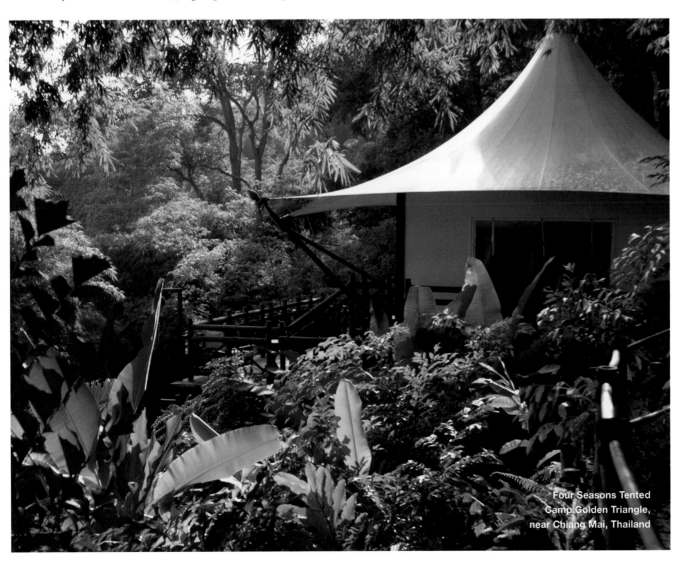

Four Seasons Tented Camp Golden Triangle, near Chiang Mai, Thailand

251

HUDSON RIVER VALLEY
Artistic heritage along the banks of a mighty river

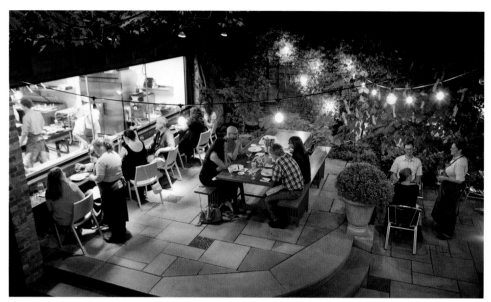

Fresh, local ingredients and innovative chefs have sparked a thriving food scene in Hudson (above) and neighboring towns in New York's scenic Hudson Valley (opposite).

The Hudson Valley's inviting landscape of mountains, valleys, and rivers framed by lush foliage is a site of rich artistic history. The region is known to museumgoers around the globe via the paintings of America's first true artistic fraternity, the Hudson River school, in the mid-1800s. This was the era of grand estates, with Rockefellers, Vanderbilts, and their peers constructing imposing "cottages" along the banks of this important thoroughfare to escape the bustle of New York City. The Hudson Valley, which stretches from Westchester County north to Albany, is also home to the United States Military Academy at West Point; Hyde Park, FDR's home; and "the other" CIA, the Culinary Institute of America, which trains top chefs and welcomes discerning diners.

The historical sites would be reason enough to visit the area, but a recent influx of young residents has brought a vibrant, fashionable new culture to fading industrial towns like Cold Spring, Hudson, and Kingston (the name "the new Brooklyn" is frequently invoked). The thriving locavore food scene is complemented by world-class microbreweries and vineyards.

But the valley's real lure remains nature herself, enjoyed in every season by hiking or camping within the 7,000 acres (2,833 ha) of Catskill Park, skiing the family-friendly mountains, fishing or tubing the many rushing creeks, or simply enjoying the views.

TRAVELER'S NOTEBOOK

＊WHEN TO GO
The Hudson Valley and Catskill Mountains have something to offer in every season, from hiking and biking in summer to apple picking and dining in fall to skiing in winter.

＊PLANNING
The Hudson Valley stretches 150 miles (241 km) north of Manhattan to Albany, New York, on both sides of the Hudson River. The Catskill Mountains are about 50 miles (80 km) west of the Hudson River and 135 miles (217 km) north of midtown Manhattan. Both are reachable by train or bus, but private car is the easiest way to get around.

＊WEBSITES
travelhudsonvalley.com,
visitthecatskills.com

▶ VISIT LIKE A LOCAL

Woodstock, New York, is not actually where the Woodstock Festival took place—that was in Bethel—but it's a quirky, cozy arts town well worth a visit. There are art galleries and antique shops, recital halls and playhouses, and hiking trails for wooded walks. For a particularly pleasant visit, stay at the Woodstock Inn on the Millstream, a series of cottages with a main house where a leisurely complimentary breakfast buffet is served. *woodstock-inn-ny.com*

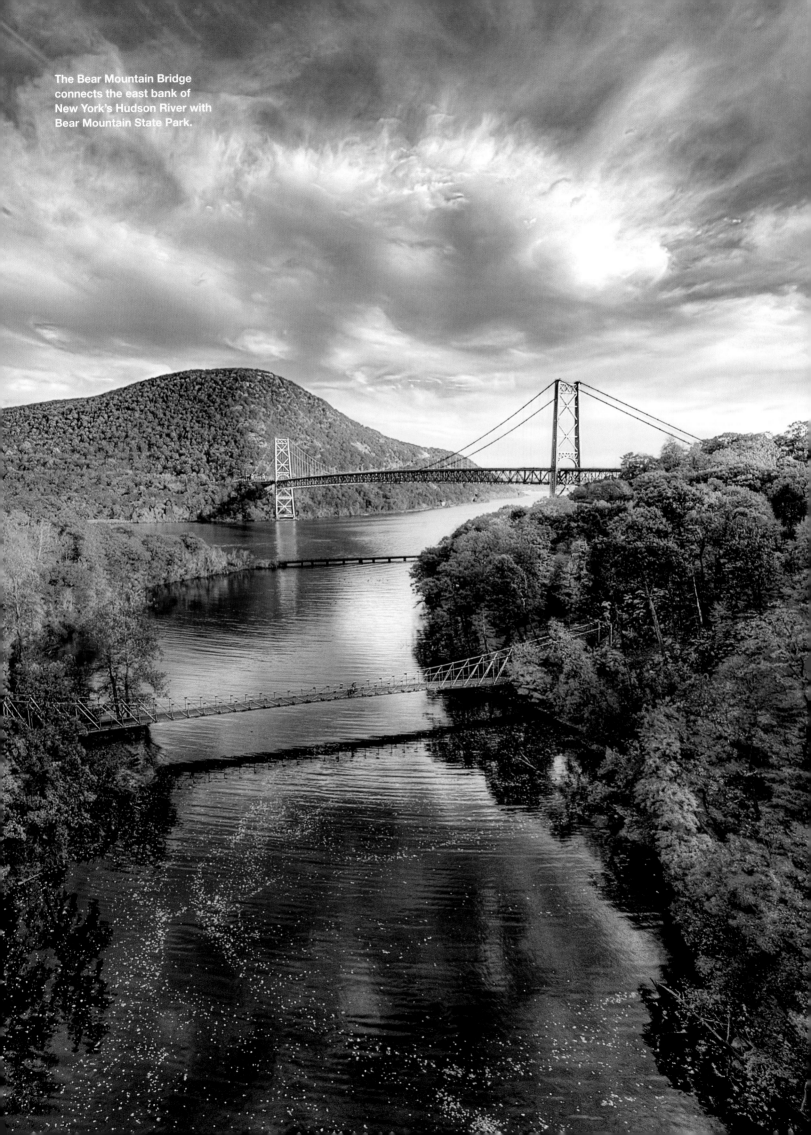

The Bear Mountain Bridge
connects the east bank of
New York's Hudson River with
Bear Mountain State Park.

SEA ISLANDS
Unique ways survive along America's Southeast coast

Cumberland Island National Seashore (above) protects an extensive area of Sea Islands' wetlands. To the north, Harbour Town Lighthouse at Blue Hour (opposite) marks Hilton Head Island.

> **TRAVELER'S NOTEBOOK**
>
> ✳ **WHEN TO GO**
> The islands are pleasant at just about any time of year, even during the deep summer, when a steady sea breeze takes the edge off the southern heat. Among special events are the Original Gullah Festival in Beaufort, Port Royal Island (May), and the Gullah Celebration on Hilton Head Island (February), both in South Carolina.
>
> ✳ **PLANNING**
> Airports in Savannah, Georgia; Charleston, South Carolina; and Jacksonville, Florida, are closest to the Sea Islands. Some of the most intriguing landfalls—like Cumberland, Sapelo, and Fort Sumter—are accessible only via ferry.
>
> ✳ **WEBSITES**
> *exploregeorgia.org, southcarolinalowcountry .com*

The untamed islands off the coasts of Georgia and South Carolina are home to one of America's most distinct regional cultures. Collectively called the Sea Islands, the archipelago has developed its own unique cuisine and clothing styles, art and music forms, language patterns and superstitions, thanks in large part to an African-American population isolated from the mainland South for more than a hundred years.

Called the Gullah people in the Carolinas and the Geechee in Georgia, they are the descendants of slaves brought from West Africa to work the rice, indigo, and long-staple cotton plantations that once spangled these marshy isles. When many of the plantation owners failed to return after the Civil War, the recently freed blacks settled the abandoned lands in small communities of self-sufficient farmers and fishermen.

Some of the Gullah/Geechee customs have spilled over racial lines, seeping into local white society and creating the cultural gumbo that makes these islands more like a foreign country than the United States. Several isles are now connected to the mainland by bridges, but others are reachable only by ferry or small planes that can land on grassy airstrips. Nature has reclaimed many of the old plantations, a devolution into forest, marsh, and

► **UNFORGETTABLE EXPERIENCES**

The main option for overnight visitors on secluded Sapelo, The Wallow is a rustic six-room B&B in the middle of Hog Hammock, the island's only settlement. Proprietor Cornelia Walker Bailey is the island's renaissance woman—hotelier, political activist, homemade-jelly maker, and author of a book on growing up on Sapelo. Guests can prepare their own grub or preorder Geechee meals home-cooked in Cornelia's kitchen. She can also arrange private guided tours of the island. *gacoast.com/geecheetours.html*

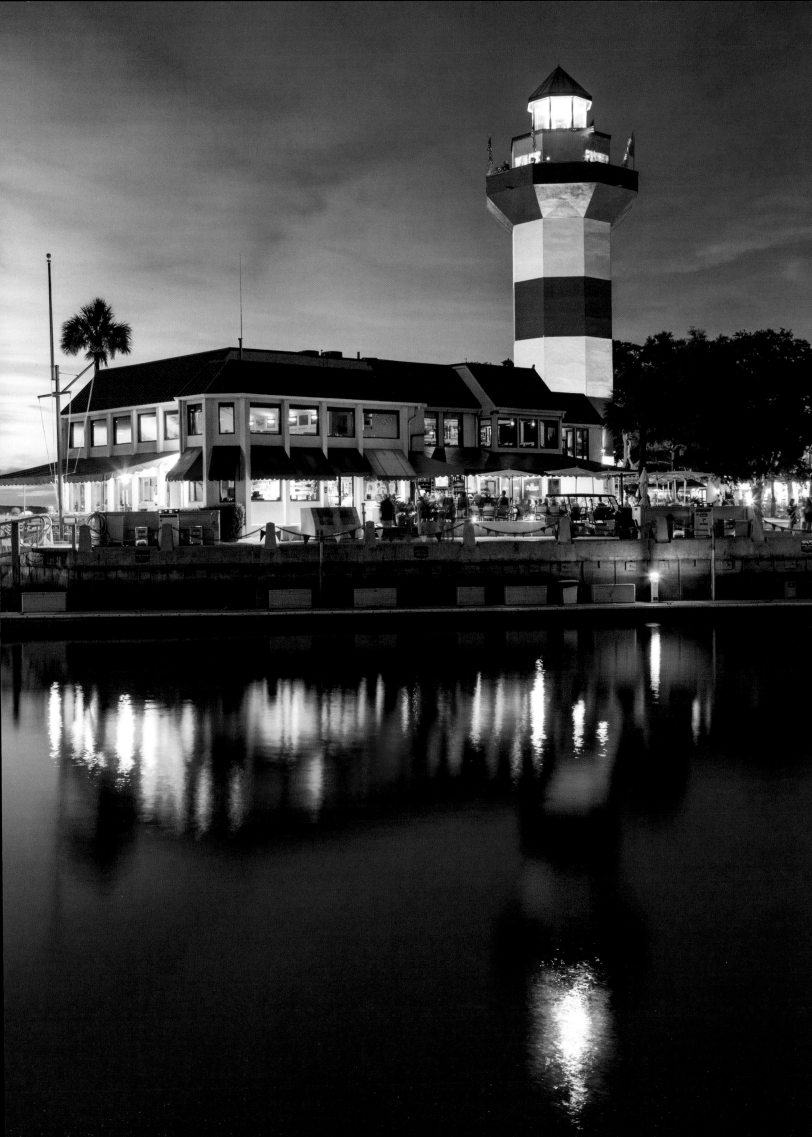

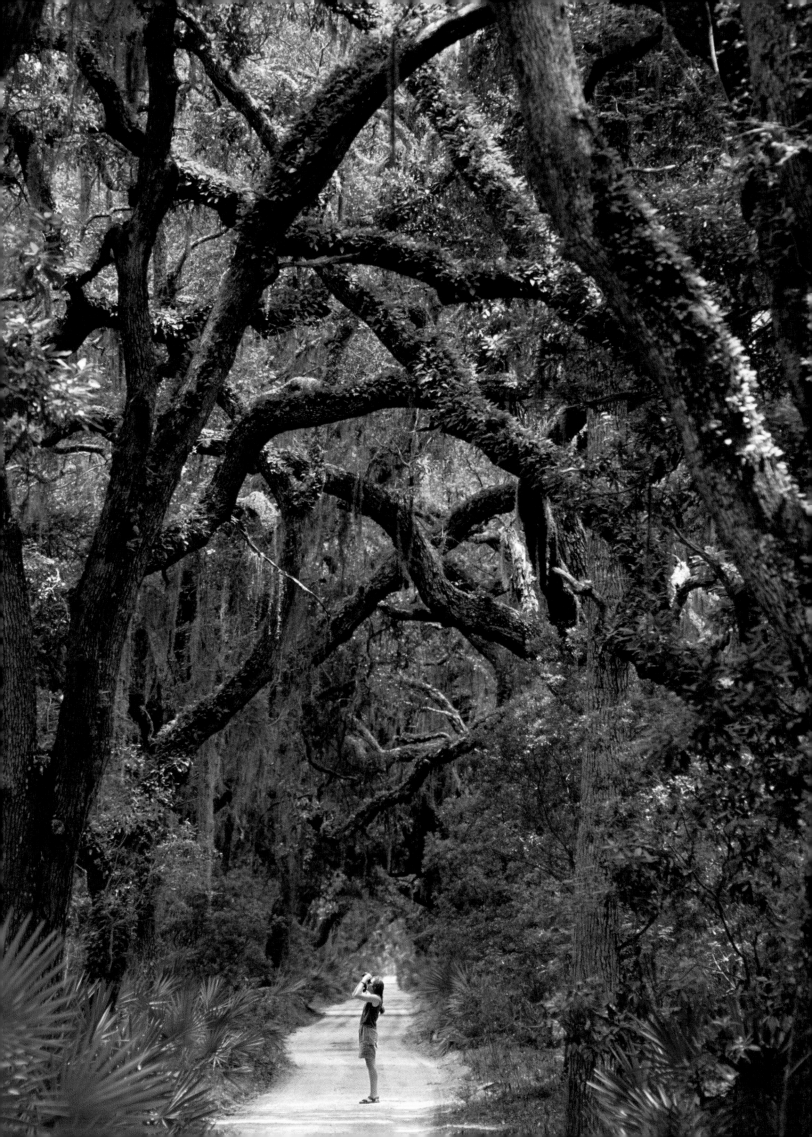

Multitalented Cornelia Walker Bailey and the Sapelo Island Cultural and Revitalization Society (above) are both working to preserve the Gullah/ Geechee heritage in the Sea Islands. Towering trees draped with Spanish moss form a canopy on Cumberland Island (opposite).

meadows inhabited by white-tailed deer, nesting sea turtles, myriad shorebirds, wild hogs, and even the occasional alligator.

Hilton Head is the largest and best known of the Sea Islands, and probably the most modern, an upscale blend of beach resorts and country clubs. At the other end of the spectrum is Sapelo, an off-the-grid Georgia island with a single village (Hog Hammock) and a population comprising mostly Geechee people. Tiny Daufuskie Island is renowned as the place where Sea Islands author Pat Conroy once taught school, an experience described in his memoir, *The Water Is Wide* (and the movie *Conrack*). Cumberland, wildest of the islands, is now a national seashore where wild horses frolic on a wide white-sand strand that runs 17 miles (27 km) down its windward shore. Martin Luther King, Jr., chose secluded St. Helena Island as a venue for clandestine meetings with the Southern Christian Leadership Conference, gatherings that shaped the direction of the civil rights movement.

A sandbar perched near the entrance of Charleston Harbor was one of the smallest and least significant Sea Islands until 1829, when the U.S. Army began construction of a brick bastion. Later named after Revolutionary War hero Thomas Sumter, the island fortress would witness the first shots of the Civil War.

> *"Voodoo on these islands is still incredibly strong. I get requests all the time from people who want me to work spells. But I don't do root for others—you might get charged with practicing medicine without a license. Naw, man. Only for myself."*
>
> – Roger Pinckney, *author*

▶ VISIT LIKE A LOCAL

From collard greens with cabbage to she-crab soup and fried shark strips, food has long been one of the most distinct features of Sea Island culture. Sea Island gumbo is especially tasty, flavored with ham hocks, bacon grease, and bone marrow as well as locally gathered herbs and spices. Restaurants specializing in local cuisine include Gullah Grub on St. Helena Island, Dye's Gullah Fixins on Hilton Head, and Hannibal's Soul Kitchen in Charleston. *gullahgrubs.com, dyesgullahfixins.com, hannibalkitchen.com*

MY SHOT

Guanajuato, Mexico

I visited Guanajuato to do a story about Josefa Ortiz Dominguez, a Mexican heroine—and possible distant relative—who helped start the revolution against the Spanish in 1810. This was a key location on the Ruta de la Independencia—the main path of fighting that led to Mexico's independence. I shot the image at the overlook of this historic, festive town at dusk on the evening of November first, Day of the Dead, symbolic timing when chasing the ghosts of my family history.

– Pete McBride, *National Geographic* photographer

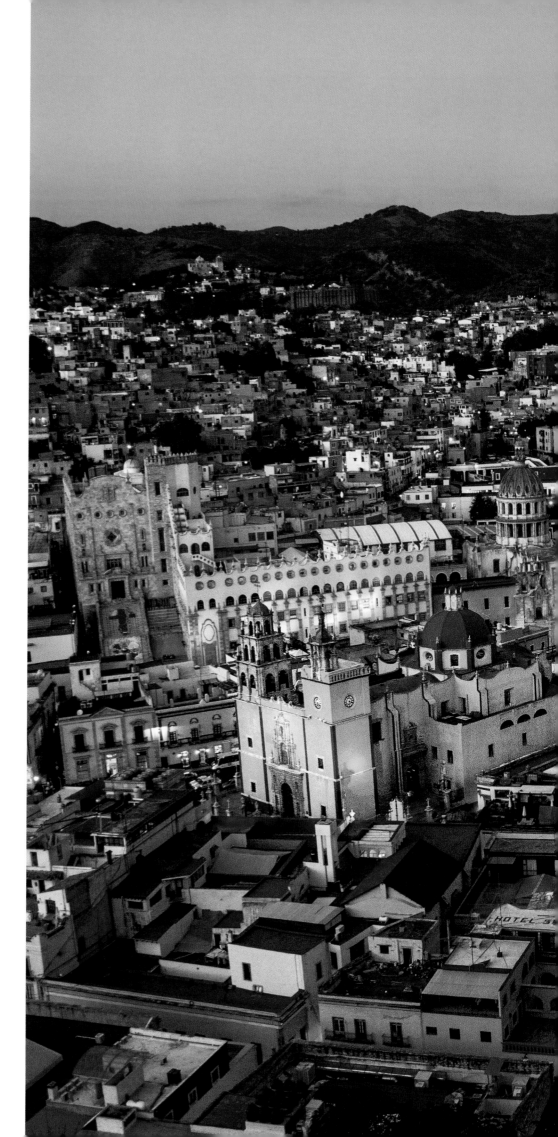

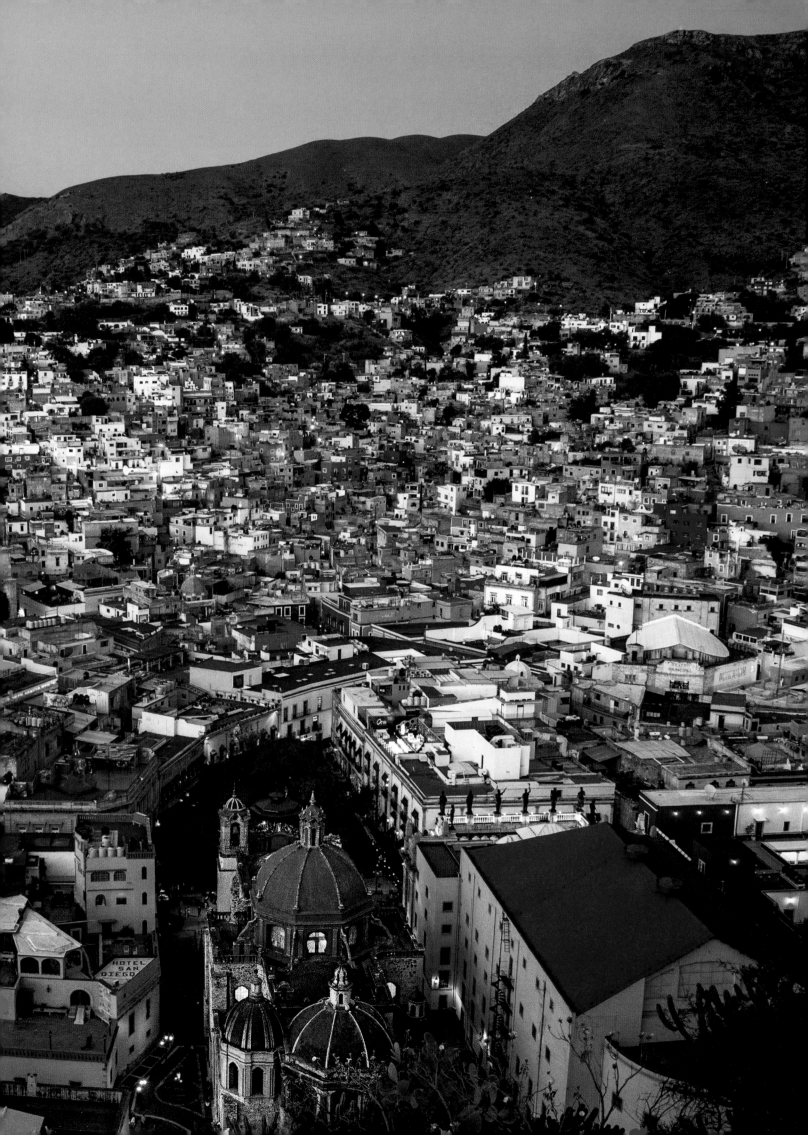

BARACOA
Cuba's intoxicating charm, history, and natural splendor—distilled

The unspoiled town of Baracoa (above and opposite), isolated at Cuba's eastern tip

yths run thick through the streets of Baracoa, Cuba's first settlement and most captivating town. According to local lore, Christopher Columbus transported a giant crucifix from Spain and planted it here upon arrival (he did bring a cross, but carbon dating reveals the wood is of Cuban, not European, origin). You may also hear how the town was incommunicado from the outside world until the revolution—partially true, as there was only boat or very difficult dirt track access until 1964, when the famous La Farola road was completed. Legend goes on to say that those who swim in Baracoa's Río Miel will never leave—it is indeed difficult to tear away from this town's unique mix of hospitality, laid-back pace, and exquisite coastal and montane beauty. Throw in the remote location and delicious, regional cuisine, and it's a recipe for lifelong travel memories.

Baracoa's magic and magnetism start with something as mundane as geography. Nestled between sea and verdant mountains running with rivers, it's an enclave to about 48,000 souls who gossip in the plaza, with its requisite colonial church, and stroll hand in hand along the sea promenade. Founded in 1511 but inhabited by native Taíno long before, it makes an

TRAVELER'S NOTEBOOK

＊WHEN TO GO
Baracoa is year-round beautiful, but it can get battered when hurricanes blow (June–Nov.). Keep abreast of weather developments before traveling.

＊PLANNING
Baracoa is 90 miles (145 km) northeast of Guantánamo. The airport is 2.5 miles (4 km) outside of town; owing to its popularity, make sure to arrange ongoing transport beforehand, especially if timing is tight (unless, like most visitors from the United States, you're on a tour, in which case all transport will be prearranged). Although much has been made about renewed relations between Cuba and the United States, travel for Americans is still limited by the U.S. government to people falling into one of a dozen categories, and it carries a host of limitations *(see treasury .gov/ofac)*.

＊WEBSITES
baracoa.org

▶ **UNFORGETTABLE EXPERIENCES**

Baracoa is literally a mouthwatering place, famous for its coconut and chocolate—the air in these parts is fairly laced with intoxicating aroma. Learn how cacao is grown and harvested at Finca Duaba and how it's transformed into chocolate at the Fábrica de Chocolate, about 4 and 3 miles (6.4 and 4.8 km) northwest of town, respectively—the perfect excuse for hiring a *bici-taxi*. Then taste the results at the Casa del Chocolate *(Antonio Maceo No. 123)*, including coco choco, bars of grated coconut covered in a slab of chocolate.

enchanting place to soak up contemporary, colonial, and indigenous culture—from the pre-Columbian artifacts housed in the Museo Matachín (one of Baracoa's three forts) to the hopping Casa de la Trova with live music nightly.

The town is located at Cuba's extreme eastern knob and is a joy (and trial) to reach via one of the country's engineering marvels, La Farola. Candidate for Cuba's most picturesque road, La Farola climbs quickly as an idyllic stretch of Caribbean coast—where José Martí and company kicked off the war of independence—before beginning a long, serpentine ascent through mountainous jungle. It's a tough road to maneuver, as much for the jaw-dropping views as the hairpin turns, blind switchbacks, and precipitous ascents. (Not everyone is up for this kind of perilous ride; luckily, several flights a week connect Baracoa and Havana.)

A few days spent in and around Baracoa hiking up El Yunque mountain or through a rare area of virgin Caribbean rain forest in Alejandro de Humboldt National Park (a UNESCO World Heritage site), swimming, and slowing down are sure to cure what ails you.

> *"Baracoa feels isolated, but when I was young, boats zipped between here and the USA, Jamaica, Hispaniola, so we were more connected to the outside world than to Cuba. It's a sui generis place. I'm very proud to be Baracuense."*
>
> – Ana María Navarro, *guesthouse owner*

▶ VISIT LIKE A LOCAL

Cubans know how to throw a party. Every Saturday night, that party takes to the streets when Baracoa's main road, Calle Antonio Maceo, is closed off for Noche Baracuensa. During this weekly cultural extravaganza, locals eat, drink, and make merry with live music and dancing. Find *cucurúchu* (a toothsome coconut snack sold in palm husk cones), *tetí* (a thumbnail-size fish marinated in coconut milk and spices), and other local fare at the food kiosks lining the route.

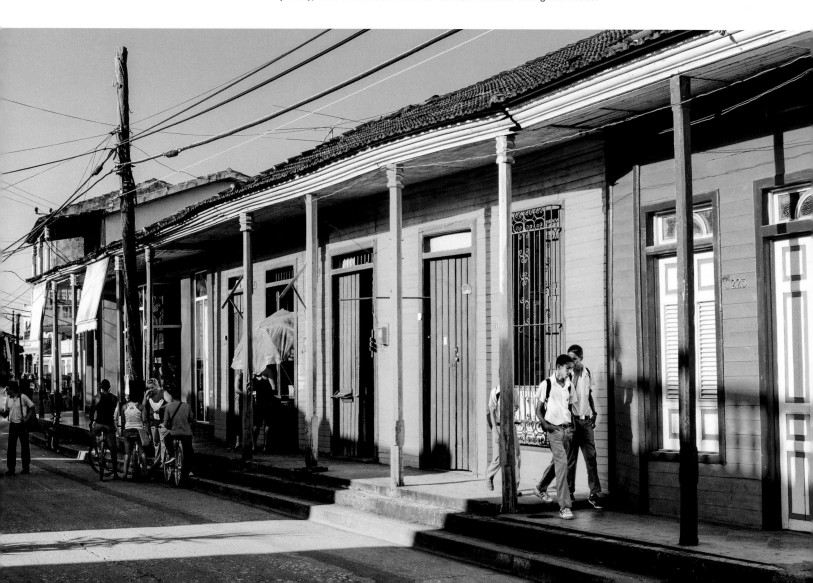

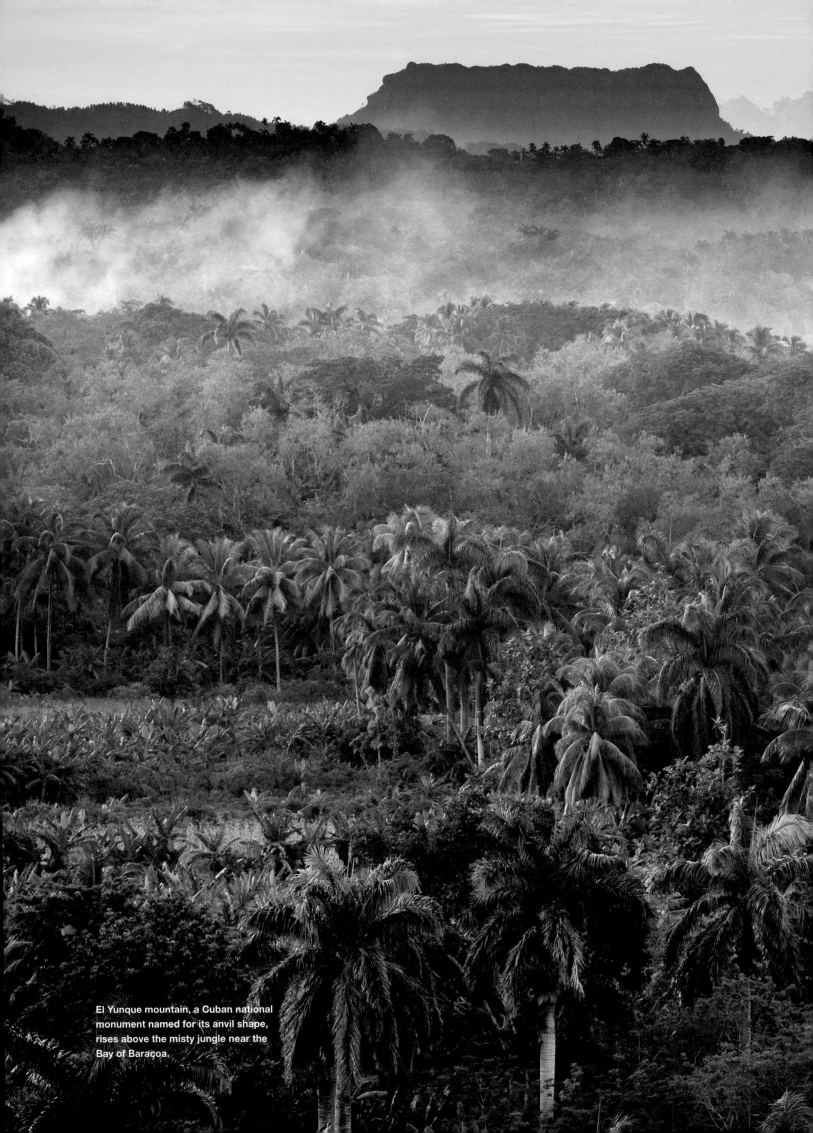

El Yunque mountain, a Cuban national monument named for its anvil shape, rises above the misty jungle near the Bay of Baracoa.

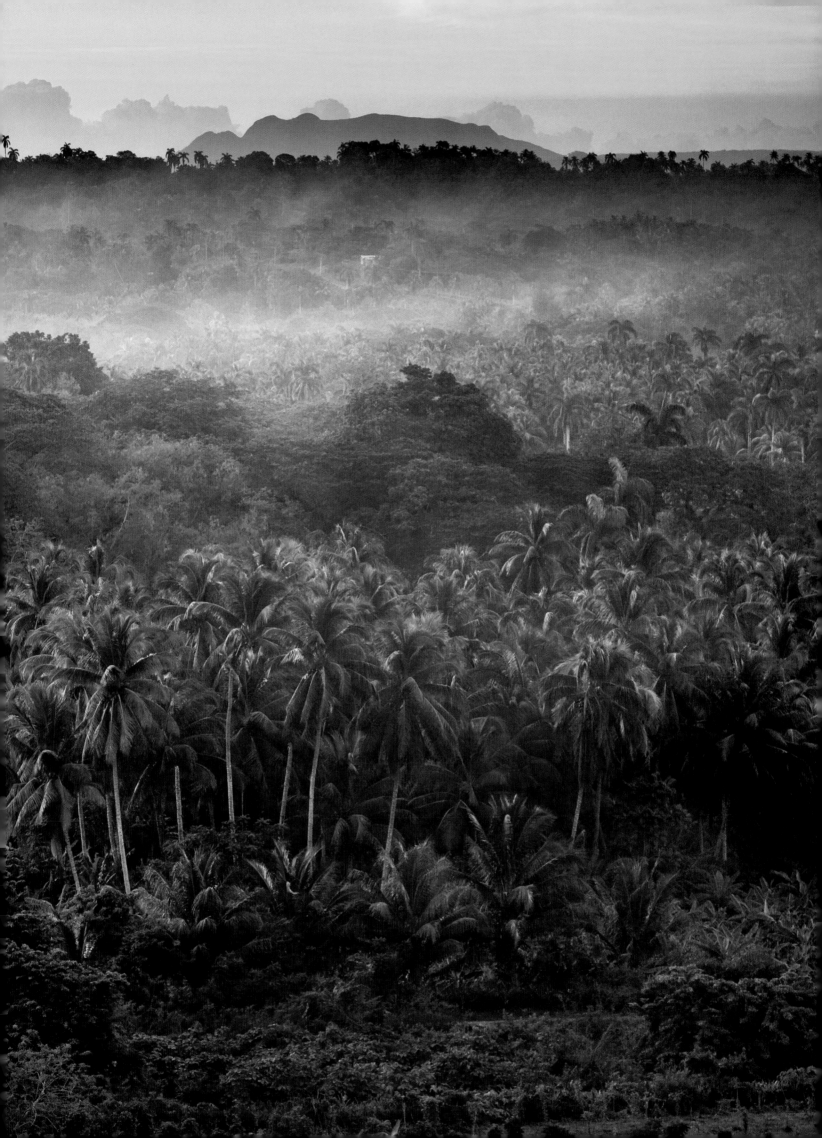

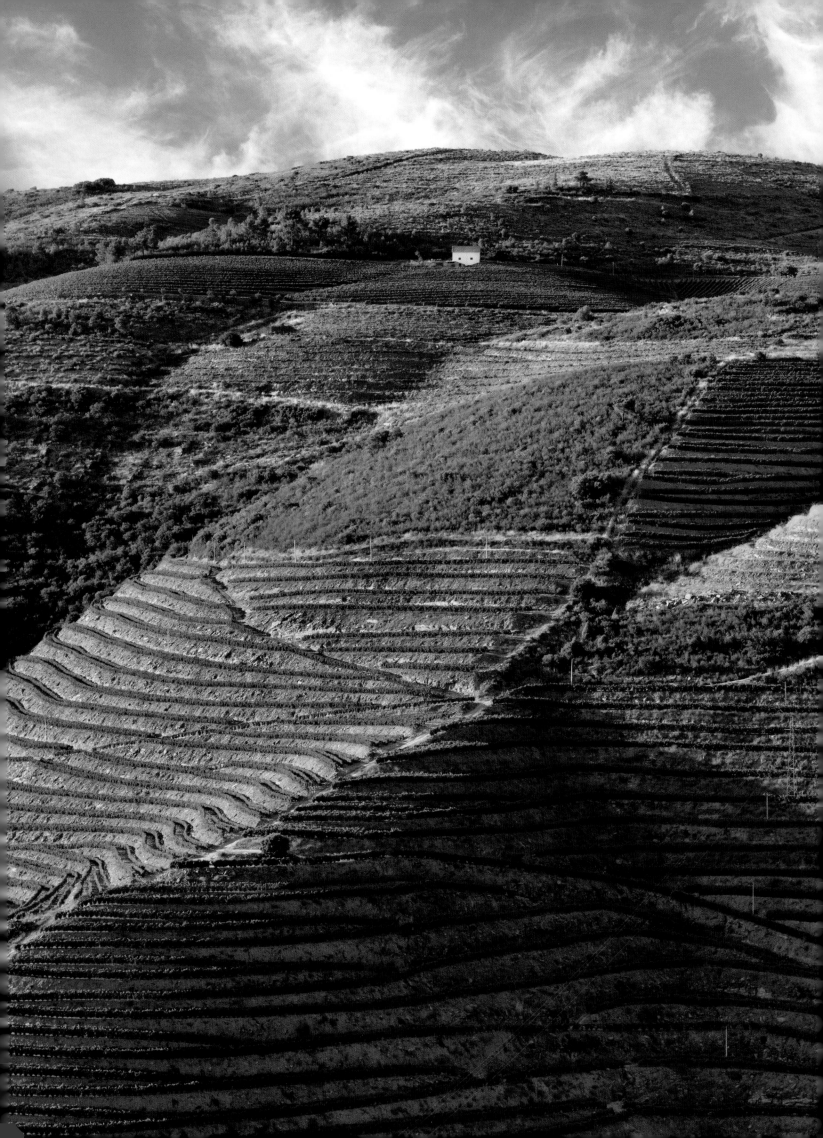

DOURO VALLEY
Spectacular mountains and vine-clad river valleys

Iconic flat-bottomed *rabelos* ply the Douro River (above). Centuries of winemaking earned the Douro Valley (opposite) the designation of world's first wine region in 1756.

One of the world's most stunning and revered wine regions, the Douro Valley cuts a swath across northern Portugal from the borderland canyons in the east to Porto on the Atlantic.

Since its introduction by third-century Roman settlers, viticulture has been pivotal to every aspect of Douro life, molding its economy, culture, and history. Most evident is the indelible mark that winemaking has left on the valley landscape: immaculate schist terraces raked deep into the steep hillsides above the meandering river that draw visitors from around the globe.

These waters, however, were not always placid. Until its damming, in the mid-20th century, the Douro comprised a series of treacherous rapids that claimed countless lives (and barrels of wine). The country's iconic flat-bottomed *rabelo* boat was designed specifically to navigate these waters, and until the end of the 19th century it was the only means of transport to and from the wine-growing regions upstream.

Douro was demarcated in 1756 as the world's first wine region, and it is the quality of its port and table wines and its unique cultural heritage that led to the whole valley being declared a UNESCO World Heritage site in 2001.

▶ UNFORGETTABLE EXPERIENCES

A great way to experience the Douro valley is to ride the river-hugging Linha do Douro train line, a magnificent feat of 19th-century engineering that covers some 100 miles (161 km) from Porto upstream to Pocinho. Trains depart several times a day from São Bento or Campanhã stations, and the whole route takes around four hours. Or, to catch the most dramatic scenery, take the train from Régua, where the line clings precipitously to the rocky gorge through Pinhão, with its pretty tile-clad station, and on to Pocinho.

MY SHOT

Flatey Island, Iceland

Flatey is the largest of Iceland's western islands, believed to have been forged under the weight of a great glacier during the last ice age. Most houses there are occupied only during the summer season. We ran into these two brothers, wearing their Icelandic sweaters that their grandmother has knitted for them, selling little painted pebbles to visitors from a small road stand on the island's only street. They looked right at the camera, making this a particularly powerful portrait.

– Sisse Brimberg and Cotton Coulson, *National Geographic* **photographers**

MARSEILLE
France's new capital of culture

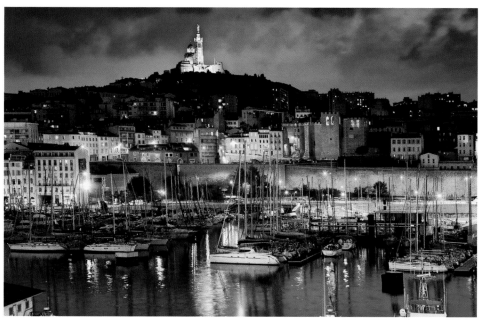

The beacon of Bonne Mère shines above Marseille (above). Along the Vieux-Port, the striped Cathédrale de la Major is doubled by the glass walls of the MuCEM (opposite).

High on a hill overlooking Marseille, Bonne Mère—a neo-Byzantine church officially called Notre-Dame de la Garde—has stood tall for eight centuries (in one form or another), protecting the Marseillais below. And what a proud "Good Mother" she must be. The city began as a seafaring star of the Greek Empire around 600 B.C. and blossomed as a trading and intellectual center during the Roman Empire. After centuries of plague and nefarious, port-related activities, France's second city is reclaiming its status as a world-class destination.

The best place to take it all in is along the Vieux-Port, where fishing boats putter among glistening yachts. From here you can admire the stunning new architecture rising from its dramatically renovated waterfront. Dominating the far end, the stone ramparts of 17th-century Fort St.-Jean have been interwoven with the glass and steel of the MuCEM, a bold symbol heralding the city's status as a flourishing pan-Mediterranean hub.

There's more. The once sketchy Panier neighborhood is now a trendy quarter of cafés and art galleries. Decrepit buildings have become glitzy shopping arcades. Sculpture exhibitions are a regular occurrence. Sandy beaches await nearby.

This is a city whose time has come—and come again. Just ask Bonne Mère.

▶ VISIT LIKE A LOCAL

A seashell's toss from Marseille's busy core awaits the lavender-scented landscape of Provence—easily accessible via the extensive SNCF rail network. The charming town of Aix-en-Provence, just 30 minutes north, is a popular destination, with its elegant Cours Mirabeau (considered by some the most beautiful street in all of France) and a lane-laced old town to get lost in. The best time to go is Tuesday, Thursday, or Saturday morning, when an extensive flower and produce market unfurls on Place de l'Hôtel de Ville.

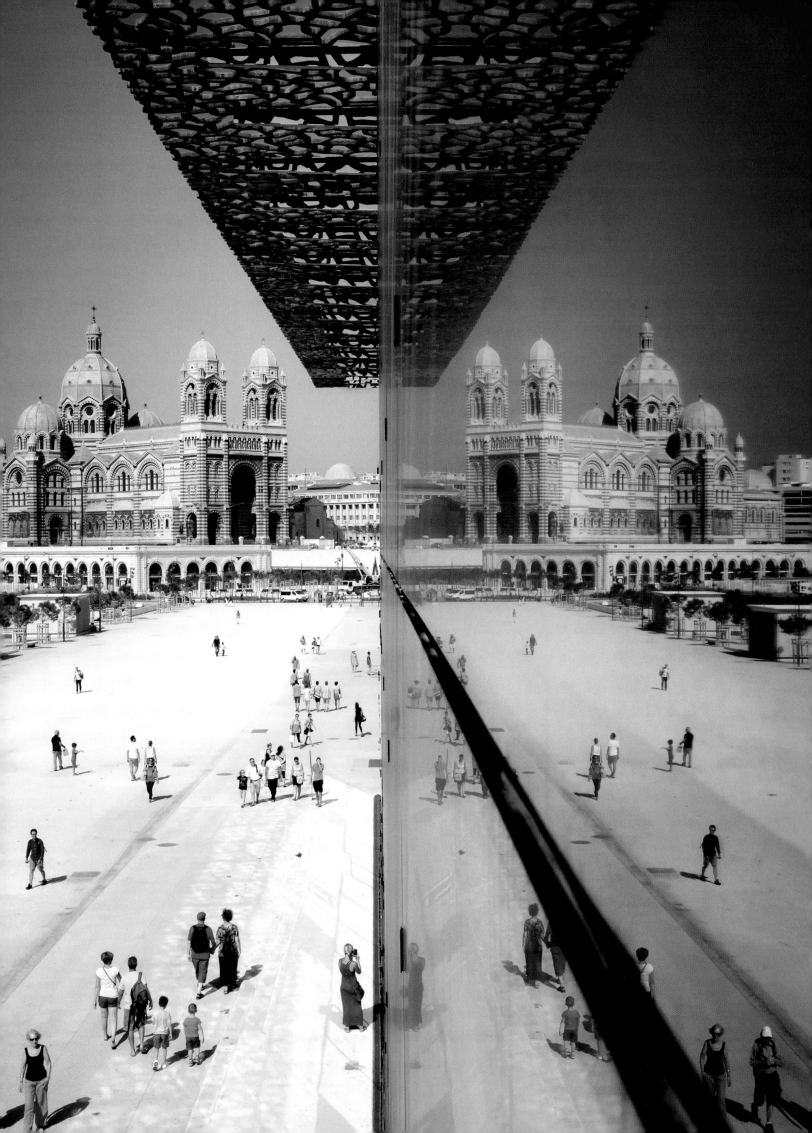

THE ROMANTIC ROAD
Falling in love with Germany's historic heartland

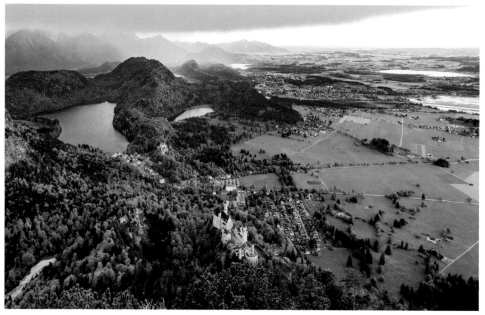

The scenic byway known as the Romantic Road wanders from Bavaria's castle-studded valleys (above) to the cobblestoned streets of storybook old-town Rothenburg ob der Tauber (opposite).

There's a reason why the byway from Würzburg to Füssen through southern Germany is called *the* Romantic Road. All along its 220 miles (354 km), flowers spill from the balconies of timbered homes, rolling vineyards bask in the sun, and lake-studded countryside sparkles against the grand Alps. To travel these winding lanes is to experience a manifestation of sentimental scenery.

Start in Würzburg, a stately baroque town of 124,000 that stays youthful thanks to its large university population. Stop in at the 350-room Würzburg Residence, a UNESCO World Heritage site and one of Germany's grandest palaces, a harmonious symphony of formal gardens and opulent structures like the famous staircase painted with frescoes by Tiepolo. About an hour's drive brings you to Rothenburg ob der Tauber, possibly Europe's best example of medieval glory, with charming fairy-tale spires, ingenious fountains, and neo-Gothic churches. In winter this town's quaint Christmas markets light up the cobblestoned town center. Farther south, revisit life in medieval Germany in orange-roofed Nördlingen, which has seemingly kept the past few centuries outside its circular city walls. One of Europe's most stunning medieval castles soars above Harburg, a village of 6,000 farmers and craftsmen. In Steingaden,

TRAVELER'S NOTEBOOK

＊WHEN TO GO
A year-round destination, with summer seeing the most visitors to the Romantic Road, but weather is pleasant in spring and fall, and Christmas lights enchant the area in winter.

＊PLANNING
Würzburg, at the northern tip of the Romantic Road, lies 75 miles (121 km) southeast of the Frankfurt International Airport. Füssen, the southern end, is 100 miles (161 km) southwest of Munich International Airport. Between Füssen and Frankfurt the Romantic Road bus runs daily in both directions, May–Oct., calling at various villages. The 273-mile (439 km) bicycle route, slightly longer than the automobile lane and flat for the most part, is well marked.

＊WEBSITES
romantic-road.com

▶ UNFORGETTABLE EXPERIENCES

The Romantic Road is a sybarite's dream come true, cutting through Franconia's wine country and Bavaria's beer territory with southern Germany's hearty cuisine served along the way. In Rothenburg, indulge in staples like pot roast, pork shoulder, and *knödel* (potato or bread dumplings) at the family-run Gasthof Goldener Greifen *(gasthof-greifen-rothenburg.de)*. Swabian roast beef accompanies excellent local wine at Riesling Nördlingen *(riesling-noerdlingen.de),* and in Füssen, gateway to Neuschwanstein, try mushroom-filled ravioli and Bavarian pork roast at Hotel Hirsch's beer garden *(hotelfuessen.de).*

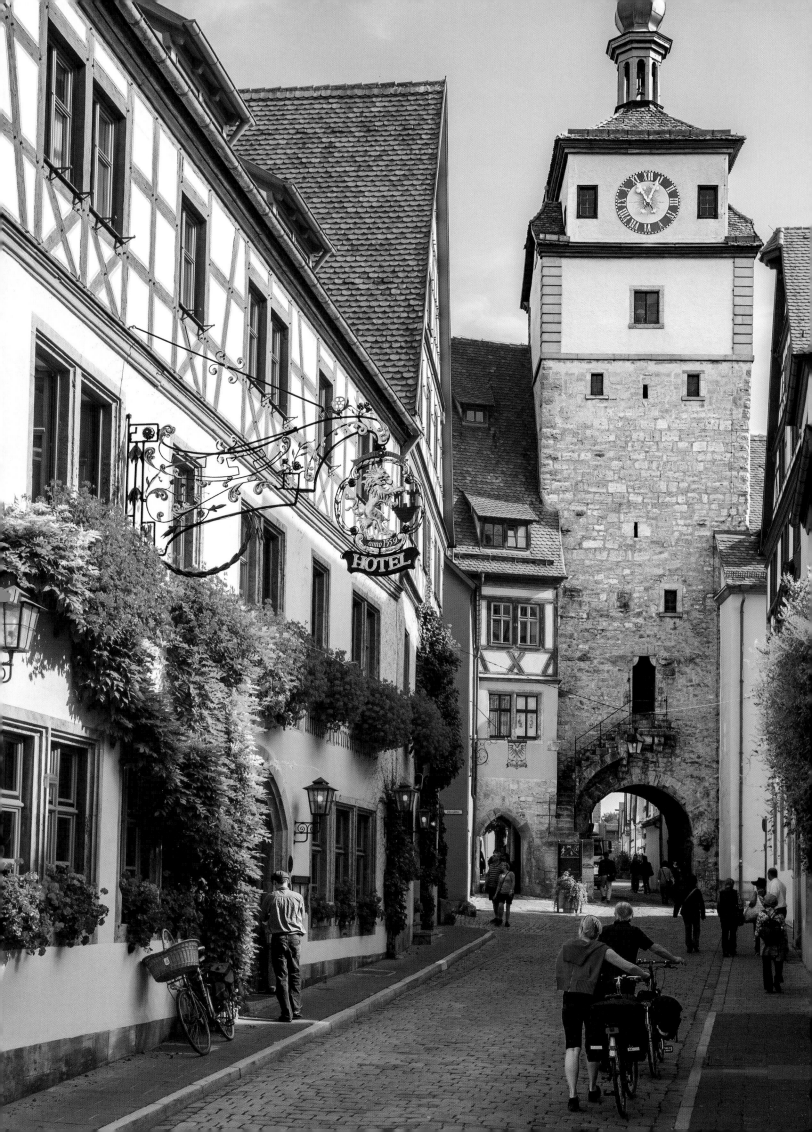

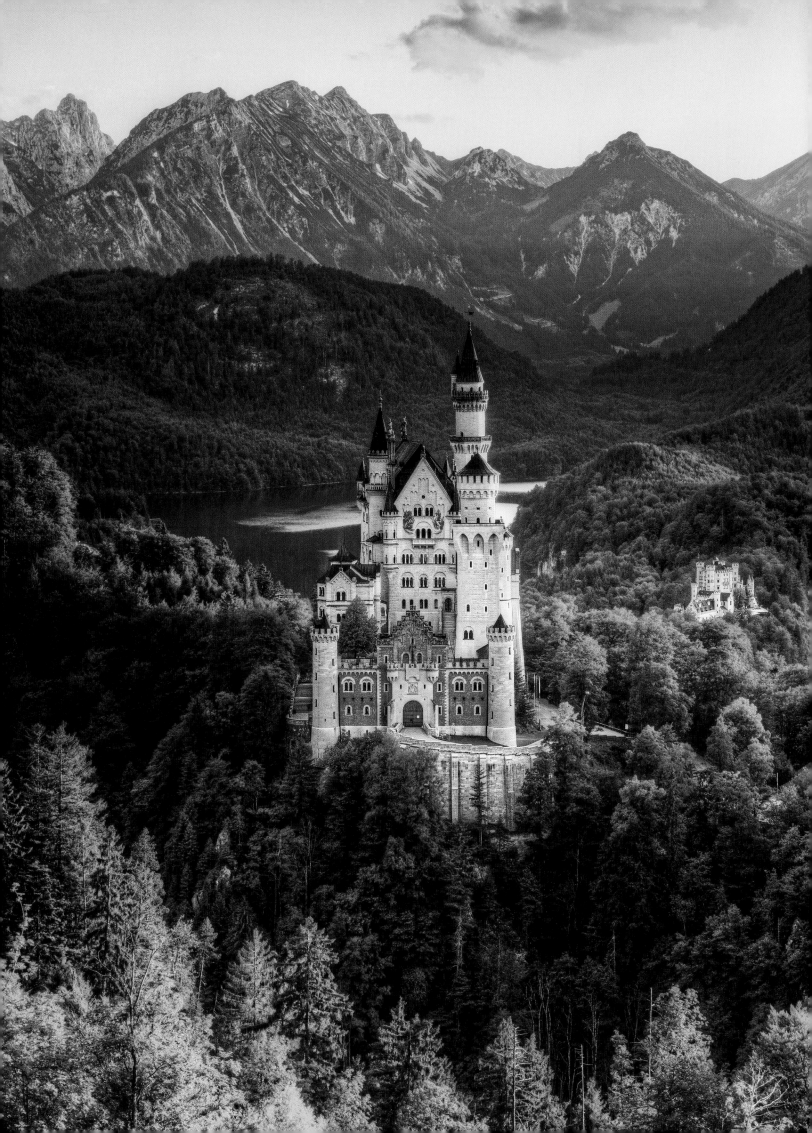

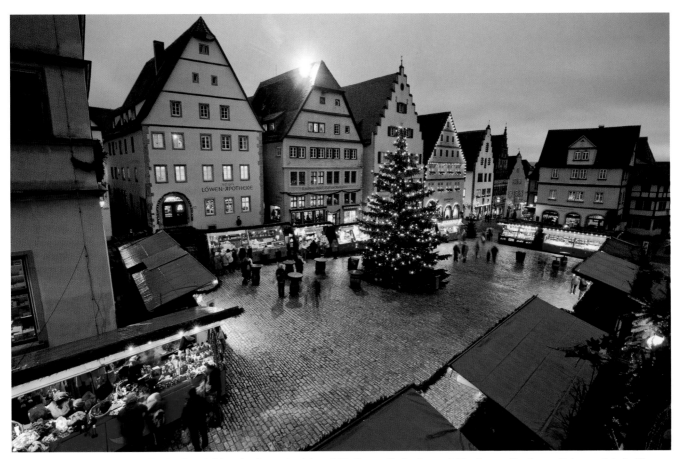

A Christmas market brightens Rothenburg's historic city center (above). To the south rise two neighboring castles (opposite) associated with "mad" King Ludwig II, his turreted Neuschwanstein and the crenelated Hohenschwangau, his childhood summer home.

the bucolic meadow and plain facade of Wieskirche belie the rococo church's glorious cupola, gilded stucco, and marble balustrades, all mystically illuminated by the large windows.

Perhaps the one singular showstopper on the Romantic Road is Neuschwanstein, a dramatic castle floating against an equally theatrical landscape of craggy mountains and piercingly blue lake. Drawing from various European architectural styles, King Ludwig II devoted the last 17 years of his life to building this 19th-century edifice, so fantastical that Disney modeled Cinderella's castle after it. Rebuilt to honor its original medieval footprint, this neo-Gothic–style complex brings together magnificence with gemütlichkeit, a feeling of cheer and belonging. Purist historians favor the neighboring Hohenschwangau, a castle built on the ruins of a 12th-century fortress from where you can, like Ludwig II, admire the neighboring Neuschwanstein above.

These marvelous sights are connected by a two-lane road that is a pure joy for a drive or, better yet, a bicycle ride, much of it on designated bike paths. Recognizing that their greatest asset is their historic heritage, the proud residents of the Romantic Road continue to invest in preserving these centuries-old monuments and homes, not only keeping up appearance for the sake of tourism but also honoring the region's legacy by living alongside these special places.

> "For me, the Romantic Road isn't just a road for tourists, but an amalgam of wonderful destinations, beautiful landscapes, and culinary specialties, with a touch of nostalgia."
>
> – Katherina Pfitzinger, *city manager for the town of Feuchtwangen*

▶ VISIT LIKE A LOCAL

Spend a night in one of the tiny, lesser known villages instead of the famous destinations along the Romantic Road. Thürnhofen, for instance, a hamlet of a few hundred people in the Feuchtwangen region, sits on the edge of a tranquil forest and affords a glimpse at ordinary life in southern Germany. At the humble Zum Grünen Wald pension *(braeutigam-pension.de)*, mingle with the locals over regional beer and fresh carp.

OLOMOUC
This former Catholic bastion dazzles with baroque beauty

After experiencing Prague, the Czech Republic is something of terra incognita for visitors. There's natural beauty aplenty, and smaller UNESCO-protected towns like Český Krumlov or Kutná Hora often make it onto travelers' itineraries, but few cities spring easily to mind. Olomouc, a former medieval capital of the eastern province of Moravia, is one to put on the list.

Visiting Poles from across the border call Olomouc Little Kraków—and it's not hard to see why. The graciously proportioned central square, built around a Gothic Town Hall and surrounded by big baroque churches and statues, lends it an unmistakable aesthetic and spiritual dimension.

Olomouc's pride and joy is the 115-foot-high (35 m), UNESCO-protected Holy Trinity Column, which stands near the center of the upper square. It's a late baroque tour de force, topped by a massive gilded sculpture with representations of the Father, Son, and Holy Spirit. Follow the column downward to find the Virgin Mary, more saints than one can count, and a small chapel.

The sheer scale of the column is balanced by the girth of the 15th-century Town Hall, with its own massive tower rising some 250 feet (76 m). Note the surreal "Astronomical Clock" on the northern face. The original medieval clock face was ruined in World War II; this modern-day

★WHEN TO GO
This city is an all-year destination. Summer, with warm days and cool nights, is the most popular. Spring and fall are the prettiest seasons but chillier with some rainy days.

★PLANNING
Olomouc is 173 miles (278 km) east of Prague. Czech Rail's *(cd.cz)* three-hour express Pendolino service, privately operated Student Agency (which also has buses, *studentagency.eu*), and LEO Express *(le.cz)* trains also serve Olomouc.

★WEBSITES
tourism.olomouc.eu, czechtourism.com

▶ VISIT LIKE A LOCAL

Although Moravia is generally known for its wine, Olomouc has a terrific beer culture to rival any Czech city. In addition to the popular pub Drápal *(restauracedrapal.cz)*, where Pilsner Urquell is hauled in fresh in big tankers, the city is home to two noteworthy and inventive microbreweries. Moritz *(hostinec-moritz.cz)* is the smaller and homier of the pair, whereas Svatováclavský pivovar *(svatovaclavsky-pivovar.cz)* is reminiscent of a German-style beer hall.

The church-filled town of Olomouc (above) boasts the elaborate, baroque Holy Trinity Column and 15th-century Town Hall (opposite) at its center.

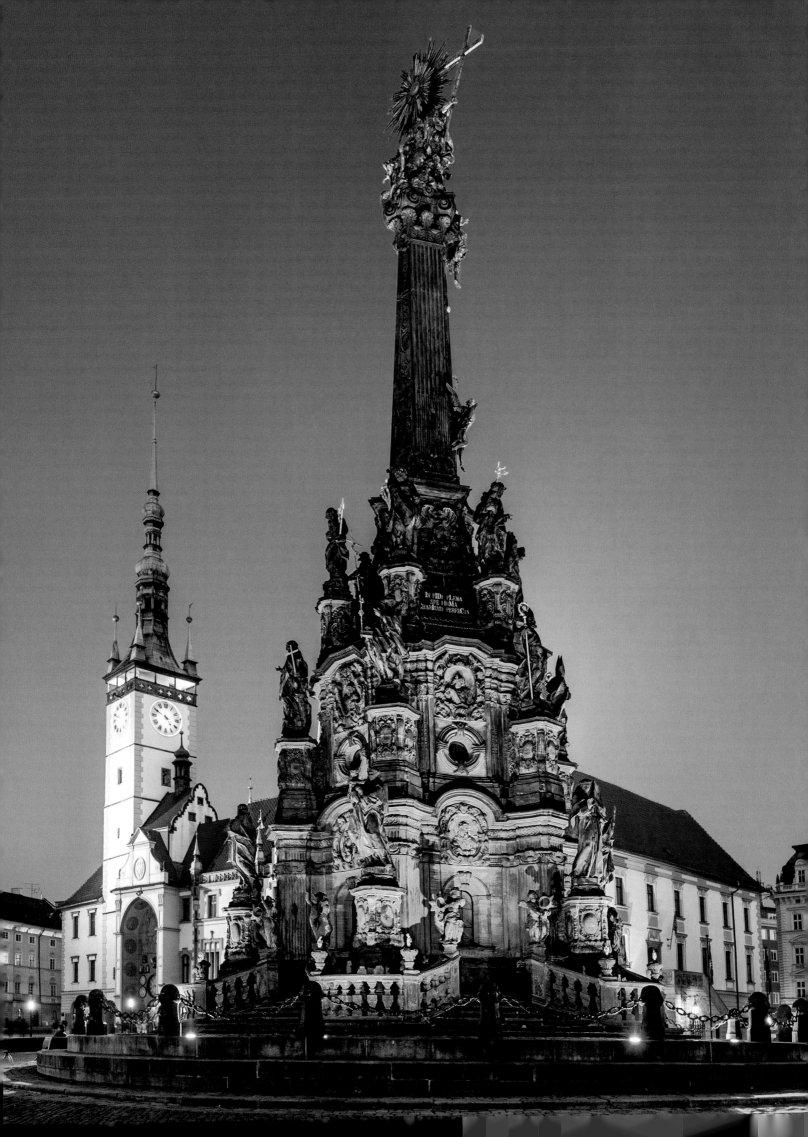

The picture galleries of Olomouc, Moravia's Archdiocesan Museum (above). Outdoors, the Czech town's cobblestoned streets and multicolored houses form a timeless image (opposite).

wonder features workers, athletes, scientists, and others instead of more standard images of saints, bishops, and kings.

The true beauty of Olomouc is found in its churches. The number and scale of the houses of worship attest to the city's importance as a Catholic bastion when large swaths of territory were enthralled with Protestantism. St. Moritz, which rises northwest of the upper square, retains its Gothic dignity, while boasting Moravia's biggest organ. St. Michael's, northeast of the Town Hall, hides an exuberant baroque interior. Farther north, the gracious St. Wenceslas Cathedral dates back to the 12th century.

Alas, the bulk of ancient Olomouc Castle didn't survive into modern times, though portions of the old Romanesque foundation can still be seen at the Archdiocesan Museum, next to the cathedral. The exhibits, more historical than sacral, tell the city's story over the course of a millennium. The high (or low) point came in 1306, when the visiting Czech king, Wenceslas III, was assassinated here. That murder ended the Přemyslid dynasty and handed the Czech lands to the House of Luxembourg and eventually to the Habsburgs. They would rule into the 20th century.

"Definitely try Olomoucké tvarůžky, a soft, ripened cheese with a strong smell and incredible taste, served in pubs as is or fried."

– Tereza Tichá,
Olomouc native

▶ UNFORGETTABLE EXPERIENCES

Olomouc's historic center is ringed by beautifully manicured parks and gardens that come into their own in April and May, when trees blossom and flowers bloom. But beneath this natural beauty hides a less bucolic human-made secret: a nuclear bunker built in the 1950s to protect the communist party bosses in the event the Cold War went white-hot. The tourist office *(tourism.olomouc.eu)* offers guided tours of the Civil Defense Shelter and other sites from mid-June to mid-September.

GRAND MARKETS

Central Market Hall, Budapest, Hungary

Central Market Hall, Budapest, Hungary

The stunning architecture of Budapest's largest market hall is no rival for its selection of Hungarian classics—sausages, Tokaj wine, and paprika. On the second floor: handcrafted souvenirs and a popular *lángos* (savory fried dough) stand.

St. Lawrence Market, Toronto, Canada

Saturday is farmer's market day in downtown Toronto, a tradition dating back to 1803, held alongside 120 specialty food and craft vendors. Save room for a peameal bacon sandwich, a local specialty.

Ferry Building, San Francisco, California

You can make an amazing meal grazing through the restaurants and gourmet food vendors of the Ferry Building every day of the week, but Saturdays, when the building is surrounded by the Ferry Plaza Farmer's Market, is the real feast.

Mercado de la Merced, Mexico City, Mexico

The first thing you notice at Mercado de la Merced in Mexico City is its size: the equivalent of about eight city blocks filled with chilies, cactus fruit, *chapulines* (grasshoppers), and innumerable other Mexican ingredients.

Borough Market, London, England

London's Borough Market traces its history back to the 13th century. Modern-day shoppers come for high-end produce and meats, storied producers like Neal's Yard Dairy, and lunch options that range from Scotch eggs to paella to *boureka* (baked stuffed pastry).

Tsukiji Fish Market, Tokyo, Japan

The day starts well before dawn at the world's largest wholesale fish market, which opens at 3 a.m. in Tokyo. Later sleepers can still enjoy a sushi breakfast in the bustling market.

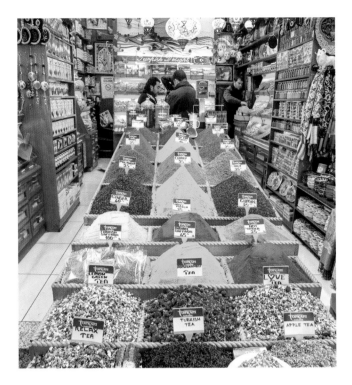

Spice Bazaar, Istanbul, Turkey

Officially known as the Egyptian Bazaar, this centuries-old Istanbul market is home to dozens of enthusiastic vendors selling exotic spices. Bring home lemony sumac and spicy *urfa biber,* as well as other tasty souvenirs from tea to Turkish delight *(lokum).*

Old Market Hall and Kauppatori Market Square, Helsinki, Finland

The vendors of Helsinki's iconic Kauppatori Market Square serve up herring seaside as they hawk Finnish meat pastries. Nearby, inside the newly renovated Old Market Hall, artisan breads, smoked meats, and classic sweets are on offer.

Donghuamen Night Market, Beijing, China

This Beijing destination for daring foodies—fried scorpion, anyone?—is also a favorite of the less adventurous, who might be persuaded to try a Xinjiang-style lamb skewer or some stinky tofu. Bonus: Stalls often advertise in English.

Castries Market, Castries City, St. Lucia

This colorful Caribbean market is filled with tropical fruits and vegetables, including breadfruit, *jambu,* and soursop, as well as island-grown spices. Coconut water straight from a young coconut opened with a machete is a particular treat.

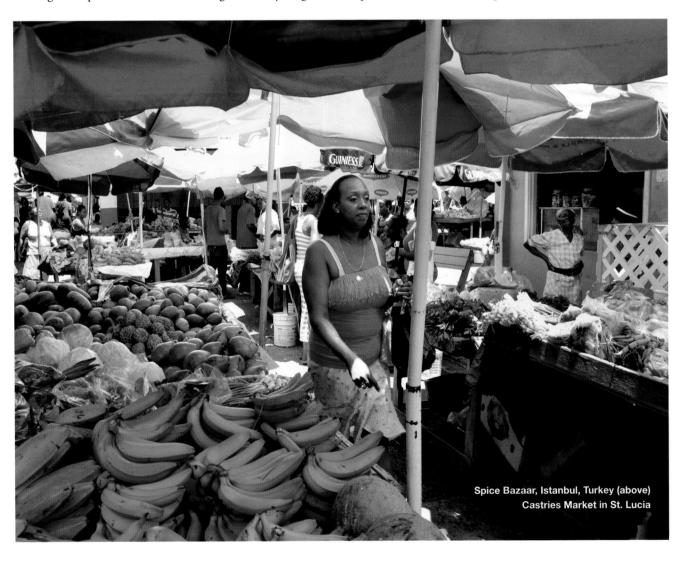

Spice Bazaar, Istanbul, Turkey (above)
Castries Market in St. Lucia

ROVINJ
Echoes of Venice surrounded by the shimmering Adriatic

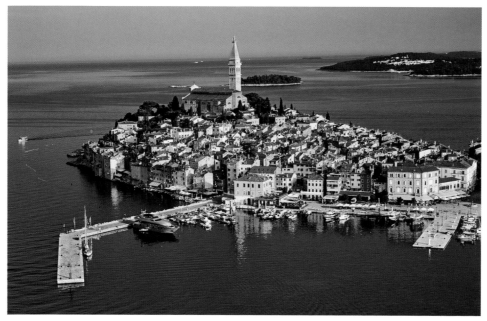

Encircled by the Adriatic Sea, Rovinj's old town (above) dates from medieval times. Its winding streets and alleys (opposite) are steeped in tradition.

Seen from afar or experienced from within, the romantic and timeless old town of Rovinj has all the charm of Venice with a fraction of the tourists. The medieval Croatian city rises from the Adriatic with a Gothic effect that gives Normandy's Mont Saint-Michel a run for its money. In its crumbling cobblestoned heart, studded with centuries-old churches and glass-windowed *gelatarias,* streets that hum with activity by day quiet down to mellow evenings marked by clear, starry skies and the happy clink of Malvasia-filled glasses from waterside bars.

Indeed, walking the crooked streets of the Old City is the best way to understand Rovinj's deep connection to Istria, the Italy-adjacent region it is located in, known for its truffles and wines. These local products, alongside earthy honeys, zingy olive oils, and bottles of *biska rakija* (mistletoe grappa), can be found for sale in numerous shops and farmer's markets peppered throughout the city and serve as a tasty reminder of its 500-year status as a Venetian vassal state.

The turquoise waters of the Adriatic surround Rovinj's old town, encased within its egg-shaped peninsula like a long-forgotten Mediterranean kingdom. At its center rises the

▶ **UNFORGETTABLE EXPERIENCES**

Hotel Monte Mulini is arguably the best hotel in Rovinj, tucked quietly into a private cove of the Adriatic, an ideal spot for a dip yet only a ten-minute walk into the heart of the old town. The spacious rooms feature balconies and a tasteful modern decor. The hotel's Wine Vault Restaurant is a highlight, with a chef's table inside the kitchen and a cellar stocked with more than 550 Croatian wines, many available by the glass. *montemulinihotel.com*

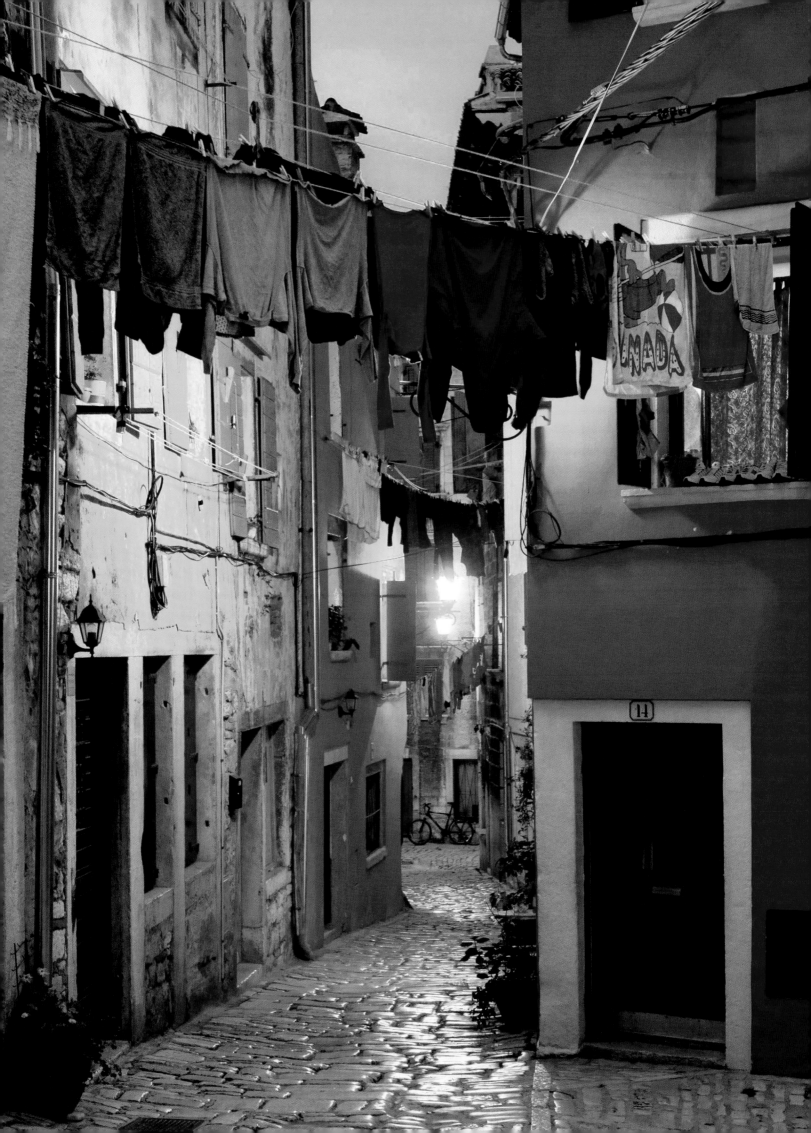

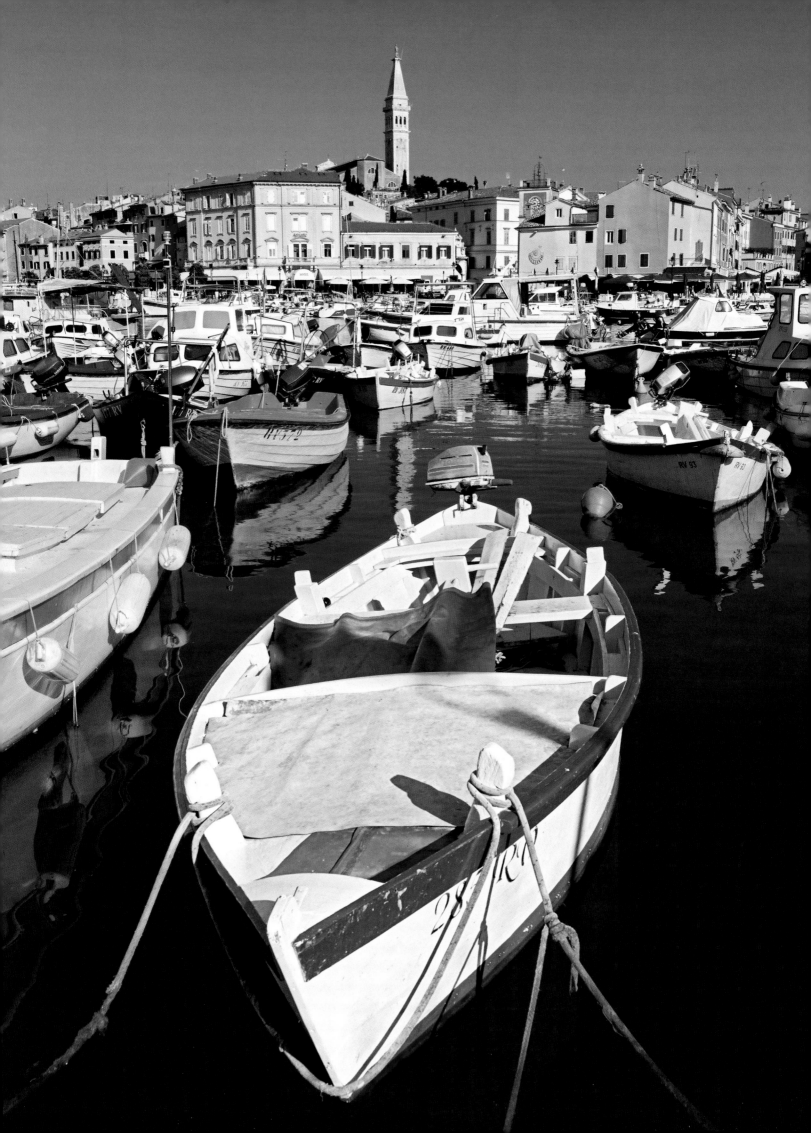

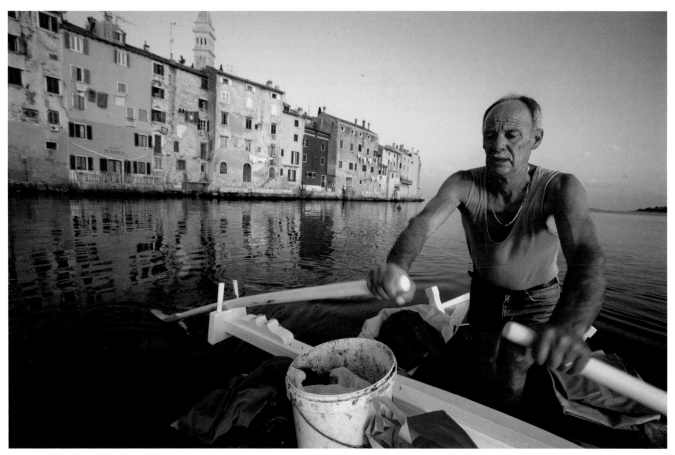

Although tourism is a strong support in modern times, the waters surrounding Rovinj (opposite and above) have provided for its resident fishermen for hundreds of years.

18th-century Church of St. Euphemia—modeled after St. Mark's in Venice—the tallest point in Rovinj and the largest baroque building in Istria. Its belfry is capped with a copper weathervane of St. Euphemia, Rovinj's patron saint, who is said to have been fed to lions because of her Christian faith; her marble tomb rests inside. Climb up the narrow stairs of the sturdy old tower, nearly 200 feet (61 m) tall, to see the town spread below, rimmed by several pine-shaded coves that entice swimmers with the promise of a refreshing plunge.

Rovinj is surrounded by islands, each with its own gems to see, but for a beautiful view of the city, walk south along the harbor to the leafy and fragrant Punta Corrente Forest Park, a peninsula that stretches along the waterfront past fishing docks and picnic and swimming areas. This groomed stretch of woods, established in 1890, when the city was part of the sprawling Austrian Empire, remains thick with oak trees and pine groves and no fewer than ten cypress species. No trip to Rovinj is complete without a dip in its crystalline waters, and this is one of the city's best places to get wet and still be in view of the rising cathedrals and belfries. As a bonus, it is frequented by old Yugoslavs bearing bathing caps and circling the cove in slow breaststrokes.

"The best way to experience Rovinj is from the sea, in the early morning or evening. Just hop on one of the taxi boats. For me, it's the perfect blend of nature and culture—the sea and the sight of Rovinj."

– Ognjen Maravić,
photographer

▶ VISIT LIKE A LOCAL

Istria, Croatia's northern, arrowhead-shaped peninsula that encompasses Rovinj, is known for its Malvasia wines, which are delicious and available everywhere. But for a taste of something slightly more offbeat, try wine aged the ancient way, underground in amphorae (terra-cotta pots) or in acacia wood. Sample either at Restaurant Monte near the steps of St. Euphemia, along with inventive fare such as algae omelets, monkfish poached in olive oil, and cherry tomatoes stuffed with soft creamy *skuta* cheese. *monte.hr*

ALBANIA
The Balkans' enigmatic Adriatic enclave

Ksamil attracts bathers to the tip of the Albanian Riviera (above), across from the Greek island of Corfu. Far to the north rises the imposing castle at Krujë (opposite), now a museum.

TRAVELER'S NOTEBOOK

*WHEN TO GO
Albania's classic Mediterranean climate revolves around hot, dry summers and refreshingly mild winters. Mountain areas get a sprinkling of snow each winter. The back-to-back celebrations of Independence Day and Liberation Day come at the end of Nov., while Gjirokastra Castle hosts the Albanian National Folklore Festival every five years.

*PLANNING
Once cut off from the outside world, Albania is now easily reached overland from Greece, Montenegro, or Macedonia; by ferry from Bari and Brindisi in southern Italy; or via direct flights from more than a dozen major European cities.

*WEBSITES
albania.al

ne of Europe's most inscrutable nations, Albania floats at the bottom of the Adriatic Sea, part of the flock of Eastern bloc countries that flew the communist coop in the early 1990s. Its cultural roots are deep and varied, as it was a fringe player of both the Greek and Roman civilizations that had a brief golden age in the Middle Ages before the Ottoman Turks invaded in the early 15th century.

Islam and Ottoman culture endured until the early 20th century, when Albanian independence sparked dereligionization and a westward cultural drift. After World War II, strongman Enver Hoxha transformed the tiny nation into a communist enclave and declared it the world's only atheist state. This cultural stew is what makes Albania so fascinating today, as a blend of East and West, old and new, Marxist relics and newfangled capitalism. The mosaic is most evident in Tirana, the thriving little national capital, where flashy luxury cars swirl around horse carts and glistening skyscrapers loom above grim communist-era blocks. Sprawling Skanderbeg Square is engulfed by a hodgepodge of buildings reflecting more than 200 years of Albanian architecture, from the 18th-century Et'hem Bey Mosque and the gingerbread mansions of the Italian colonial period to the recently restored National History

▶ UNFORGETTABLE EXPERIENCES

A savory blend of Turkish, Balkan, and Italian culinary roots, Albanian food is a tasty surprise that combines exotic spices, rich sauces, and ingredients straight from farm and sea. One national dish is *tavë kosi*, a casserole comprising lamb, rice, and yogurt sauce. *Qofte të fërguara* (fried meatballs) and *mish qingjji me barbunja* (veal with lima beans) are also popular fare. Authentic Albanian cuisine can be found in Tirana's ERA and Oda, with its Ottoman-style dining room.

Museum and its archaeological treasures. With fewer than half a million residents, the city has a cozy, approachable feel compared with larger European capitals. The same could be said for Albania as a whole, a compact nation that measures roughly 50 miles (80 km) from east to west and around 225 miles (362 km) from north to south. Despite the capital's rapid modernization, much of the Albanian countryside remains quaintly archaic, strewn with medieval towns and tiny farms that still seem far removed from the 21st century.

Perched on a strategic mountainside less than an hour's drive north of Tirana, Krujë is where Albanian national hero Skanderbeg made his stand against the invading Turks. His restored castle is now a museum dedicated to his knightly heroics; the village below offering a labyrinth of cobblestoned streets flanked by traditional shops and cafés. In the country's deep south, the UNESCO World Heritage site at Butrint protects the nation's significant Greek and Roman ruins amid a region rich in olive groves and citrus trees. In the far north, the rugged Albanian Alps are home to rare wildlife, remote hiking trails, and some of Europe's southernmost glaciers. Nearby Lake Shkodër, which Albania shares with Montenegro, attracts as both a fishing haven and a site of protected wetlands, where more than 280 bird species have been spotted.

> *"In the summer much of Tirana empties as people head for the coast, primarily in the southern riviera. Durrës is a popular destination for day trips, as is the Dajti Mountain or the surrounding hills for those looking for fresh air."*
>
> – Andi Balla, *Tirana native*

▶ VISIT LIKE A LOCAL

The Albanian Riviera between Vlorë and the Greek border offers a glimpse of what the Aegean isles must have been like before the advent of mass tourism. The region is renowned for twisting coastal roads, secluded beaches, and dreamy Mediterranean vistas, especially places like Dhërmi and Ksamil. Warm waters are ripe for swimming or snorkeling, and divers can explore wrecks that range from ancient Roman cargo vessel to a World War II hospital ship. *albanian-riviera.net*

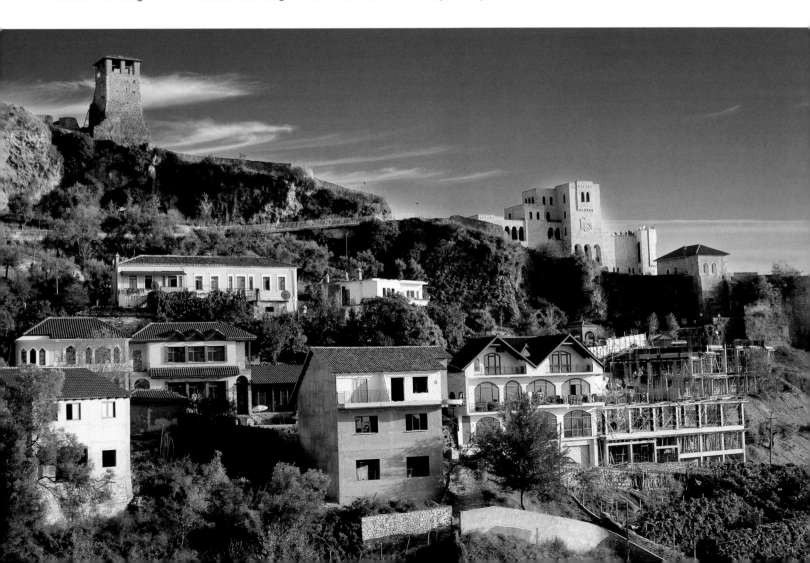

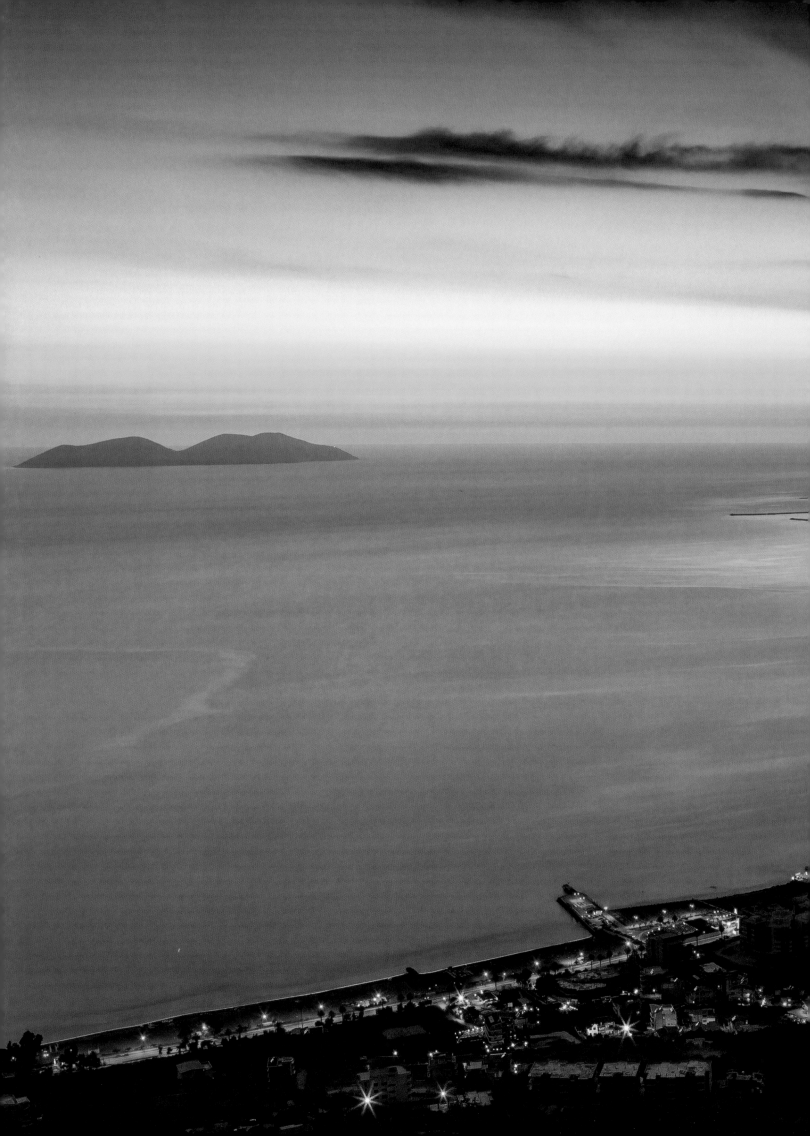

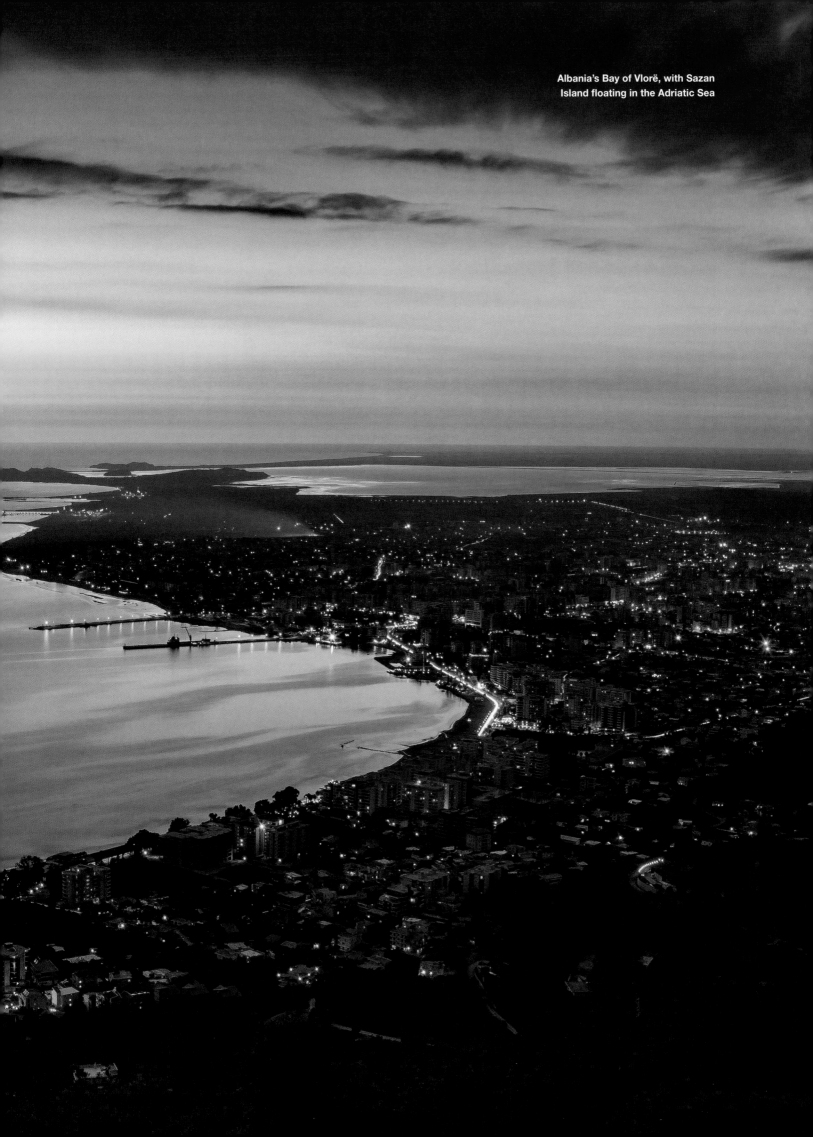

Albania's Bay of Vlorë, with Sazan
Island floating in the Adriatic Sea

SARAJEVO
The Balkans' urban phoenix

In Bosnia and Herzegovina, Sarajevo's old marketplace (above) pulses with life. The rebuilt City Hall (opposite) reopened in 2014 on May 9, officially the Day of Victory over fascism.

TRAVELER'S NOTEBOOK

＊WHEN TO GO
Spring, summer, and fall (April–Oct.) are generally clear and comfortable. The lime trees blossom in June, a splendid sight. Downhill skiing is available in winter at Jahorina Olympic Ski Resort, which hosted the 1984 Winter Olympic events.

＊PLANNING
Public transportation (tram, trolleybus, and bus), taxis, and walking are the most convenient ways to navigate the city. Bus and train routes connect Sarajevo to other destinations in Bosnia and Herzegovina. During ski season, buses link Sarajevo to Mount Jahorina.

＊WEBSITES
sarajevo-tourism.com

A t first blush, Sarajevo appears to remain entrenched in the devastation of war, though decades have passed since the last Serbian bomb fell and this resolute town reigned as the "world's most dangerous city." War-year reminders are everywhere, but mostly in its neoclassical buildings, once the darlings of a world-class destination, today still blighted with shrapnel pockmarks, graffiti, and intrusive weeds.

But stroll into the old city's pedestrian Stari Grad, or Old Town, with parts dating back to its Ottoman heyday, and you'll feel the buzz of something new and exciting. Trolleys clickety-clack past café-going coffee drinkers and hookah smokers. Bustling stalls purvey copper pots and Bosnian carpets. Visitors are everywhere—and not just postwar gawkers. And at midday, in this city where three religions coexist side by side, muezzins cry from minarets and rabbis call *minchah* as the ringing bells of neighboring churches echo through the surrounding Dinaric Alps.

There's something truly mesmerizing about Bosnia and Herzegovina's capital. This majestic city traces its roots back to the 15th century, when the Ottoman Empire united a cluster of villages and established a closed market, public bath, hostel, and castle around a central mosque, called the Tsar's Mosque in honor of the sultan Mehmed II. By the end of

▶ VISIT LIKE A LOCAL

Seek out a *kafić* (café) in Sarajevo's Baščaršija, the old Ottoman bazaar, where traditional Bosnian coffee, or *kafa*, is cooked in a copper pot called a *džezva* (pronounced JEZ-vah) and served with Turkish delight. Take your time to enjoy, but be sure to ask your waiter how to properly spoon the froth and when to dip the sugar cube. Take home a bit of the coffee experience with you: You'll find traditionally handmade coffee sets throughout Baščaršija.

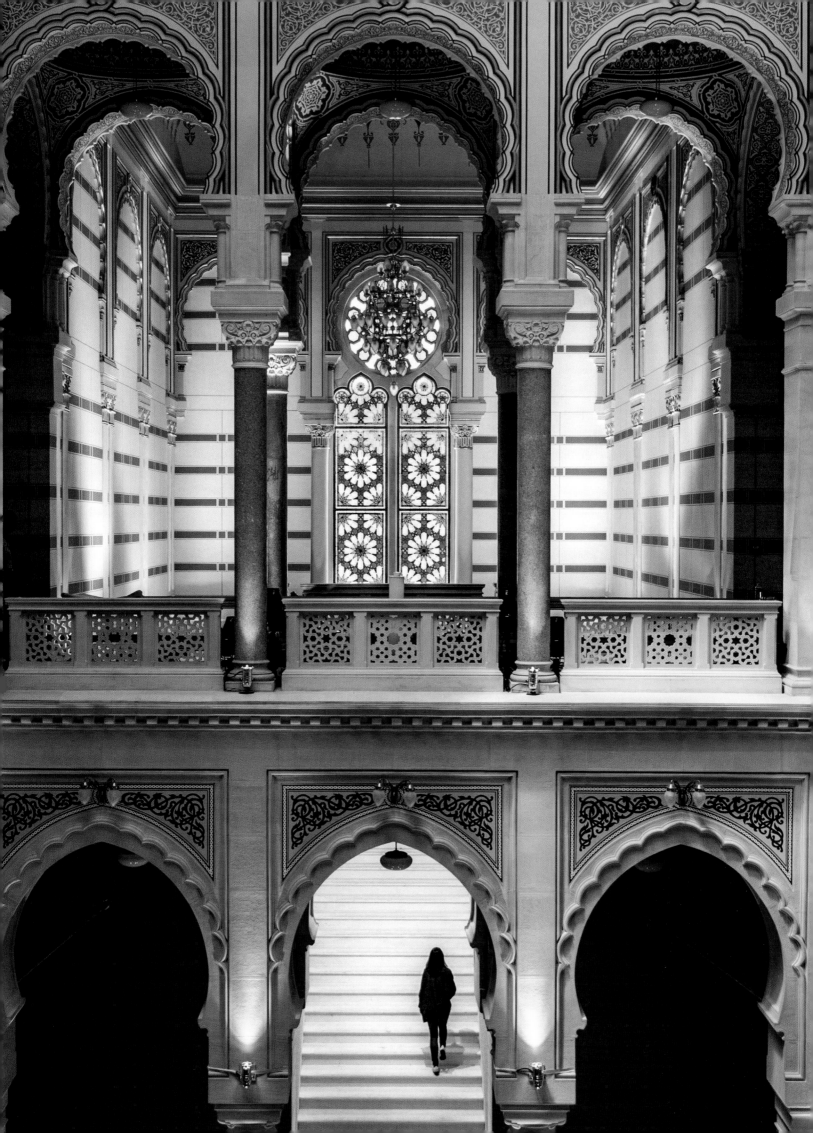

A relaxed café scene (opposite) reflects Sarajevo's postwar rejuvenation. The mountains that surround the city (above) lure hikers to their trails.

the 16th century, Sarajevo had bloomed into the most important Balkan Ottoman city after Istanbul, with more than a hundred mosques and a famous marketplace.

Since then, history has dragged it through three devastating wars—including, as every student knows, its starring role as ground zero for World War I, when Austro-Hungarian archduke Franz Ferdinand's 1914 assassination here triggered a whole chain of pent-up events.

After a brief global spotlight as the host of the 1984 Winter Olympics, disaster struck again in 1992 with the arrival of the Bosnian wars. For the next four years, Sarajevo's population of just over 500,000 withstood shelling, tank fire, and sniper attacks by 18,000 Serbian soldiers staked out in the surrounding hills. More than 11,000 people lost their lives, and large swaths of the city were destroyed. Yet the Sarajevans—Christians, Muslims, and Jews united in a single cause—refused to be defeated.

There's a famous photograph of musician Vedran Smajlović, playing his cello in tie and tails amid the City Hall's rubble in 1992, just days after the beautiful, neo-Moorish building was destroyed. His goal: keep making music even in the midst of a four-year siege. No doubt, it's fortitude like this that underlies Sarajevo's ever generating renewal.

"In Sarajevo I enjoy having coffee, hearing distant sounds coming from the city center, and being surrounded with mountains with snowy peaks— which are as cliché as it gets. But cliché sometimes means simple happiness."

– Amra Baksic Camo, *film producer*

▶ VISIT LIKE A LOCAL

Sarajevo snuggles in the rugged embrace of the Dinaric Alps, beckoning hikers into one of Europe's last remaining virgin forests. Head into its untrammeled beauty along the Via Dinarica *(via-dinarica.org),* a trail that cuts through seven countries (Slovenia, Croatia, Bosnia and Herzegovina, Montenegro, Albania, Kosovo, and Serbia). *But beware:* Live land mines remain from the 1990s war. Be sure to hire an in-the-know guide; Green Visions *(greenvisions.ba)* organizes trips for every level of traveler.

MARDIN
Orthodox monasteries and Artuqid legacy

The minaret of Zinciriye Madrassa (above), built in 1385, surveys the Mesopotamian plains. Ancient artifacts from the region's rich past are shared at the Mardin Museum (opposite).

TRAVELER'S NOTEBOOK

***WHEN TO GO**
The best months to visit Mardin are April–June and Sept.–Oct., when days are mild and sunny.

***PLANNING**
Mardin lies 922 miles (1,484 km) southeast of Istanbul, from where there are direct flights. Minibuses also travel frequently from the nearby cities of Urfa, Midyat, and Diyarbakir. Check your government's travel advisory service before planning any trips to volatile areas. American citizens should see *travel.state.gov.*

***WEBSITES**
goturkey.com/en/pages/ read/mardin

The dazzling city of Mardin sits atop a dramatic crag like a shiny crown overlooking the Syrian Desert. This tawny citadel town in southeastern Turkey is a labyrinth of winding roads and terraces, studded with ancient stone homes, Orthodox churches, and modest mosques. Once an important resting stop on Anatolian and Mesopotamian trading routes, Mardin also occupies a vital spiritual place among the hearts of Syrian Christians, who have occupied the vast plains that surround the town.

Its coveted, strategic location has meant turbulent history for Mardin, which was claimed by several empires, including the 11th-century Artuqid dynasty that stretched from eastern Anatolia and northern Syria to northern Iraq and left brilliant architectural and engineering marvels, many still in use. Recent unrest in the nearby Kurdish zone has kept tourists away, but with peace comes visitors. An outpouring of support from expatriated locals who send money to keep their ancestral Syrian Christian churches in top shape has also helped revitalize the area.

For a city of its modest size, Mardin has an impressive number of sacred places. The elaborate minaret of Ulu Camii, a charming 12th-century mosque, soars above the town's varied skyline. The tranquil courtyard of Kasimiye Madrassa, a 15th-century religious school, is an

▶ UNFORGETTABLE EXPERIENCES

The traditional hammam, or Turkish bath, is a cleansing social ritual. Strip down to a thin *peştamal* towel and lie on a hot marble platform. Once the skin is properly softened from the steam, an attendant scrubs every surface and nook of the body with *kese*, a loofah-like sponge, and envelopes the guest in a mound of hot, pampering soapsuds. Mardin's bath traces its origins to Roman times and offers a wide-open panorama from its terrace to boot. Separate hours for men and women.

impressive play of light and shadow that exemplifies the glory of Artuqid architecture, characterized by highly figurative decorations, soaring columns, and angular arches. The medieval Syriac Orthodox Church of Forty Martyrs, its high walls dating back to A.D. 569, carries on the town's Christian heritage with a growing congregation gathering in the sun-soaked courtyard. Also of note, the intimate Mardin Museum, formerly home to a Syriac patriarch, contains a fascinating archaeological collection with artifacts as old as 4000 B.C.

Mardin is the gateway to the surrounding Tur Abdin plateau where Aramaic, the language of Jesus, has survived against odds. Some 3 miles (5 km) outside town, Syriac Orthodox priests continue to use the 365 rooms, one for each day of the year, of the fifth-century Deyrulzafaran, or Saffron Monastery. A tour to the lowest level reveals evidence of a stone temple dedicated to the sun dating from about 1000 B.C. The town of Midyat, 40 miles (64 km) east of Mardin, with even more ornate stone homes, is another place where you will hear an imam's call of prayer alongside church bells. Mor Gabriel Monastery, 16 miles (26 km) southeast of Midyat, is the oldest surviving Syriac Orthodox monastery in the world, dating back to A.D. 397 and still active with monks, nuns, and a bishop.

"I was shocked when I returned to Mardin after working three years in Germany. It's so much cleaner now, and people care more about our cultural heritage. At the same time, there's less stress here, and life is easy like the old days."

– Sabri Bastog, *waiter*

> ### ▶ VISIT LIKE A LOCAL

Just one block down the hill from the town's main street, Cumhuriyet Caddesi, Mardin's bazaar is a refreshing antidote to the touristy markets of other destinations. Rub shoulders with local folks who come out to buy fresh fruits, veggies, and spices (sidestepping the donkeys that transport the goods). Artisans carry on centuries-long know-how by making silverware, copper cookware, lace embroidery, leather saddles, and carpets in the small family workshops that have been there for generations.

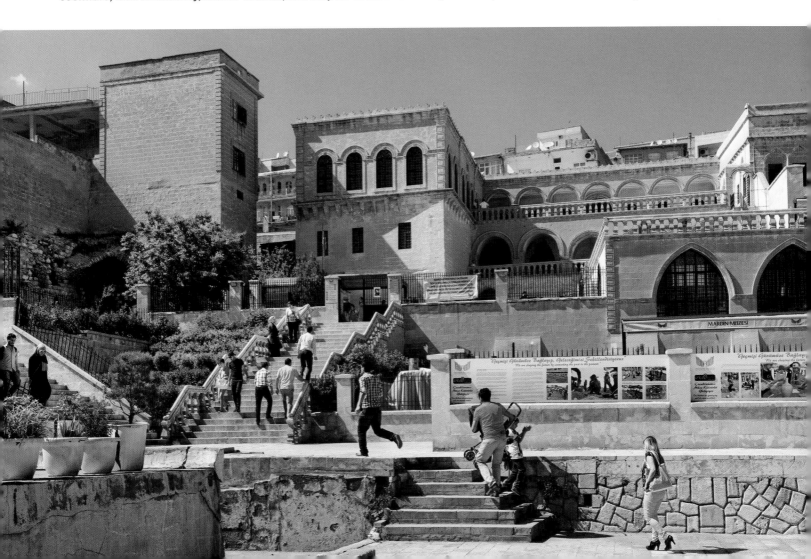

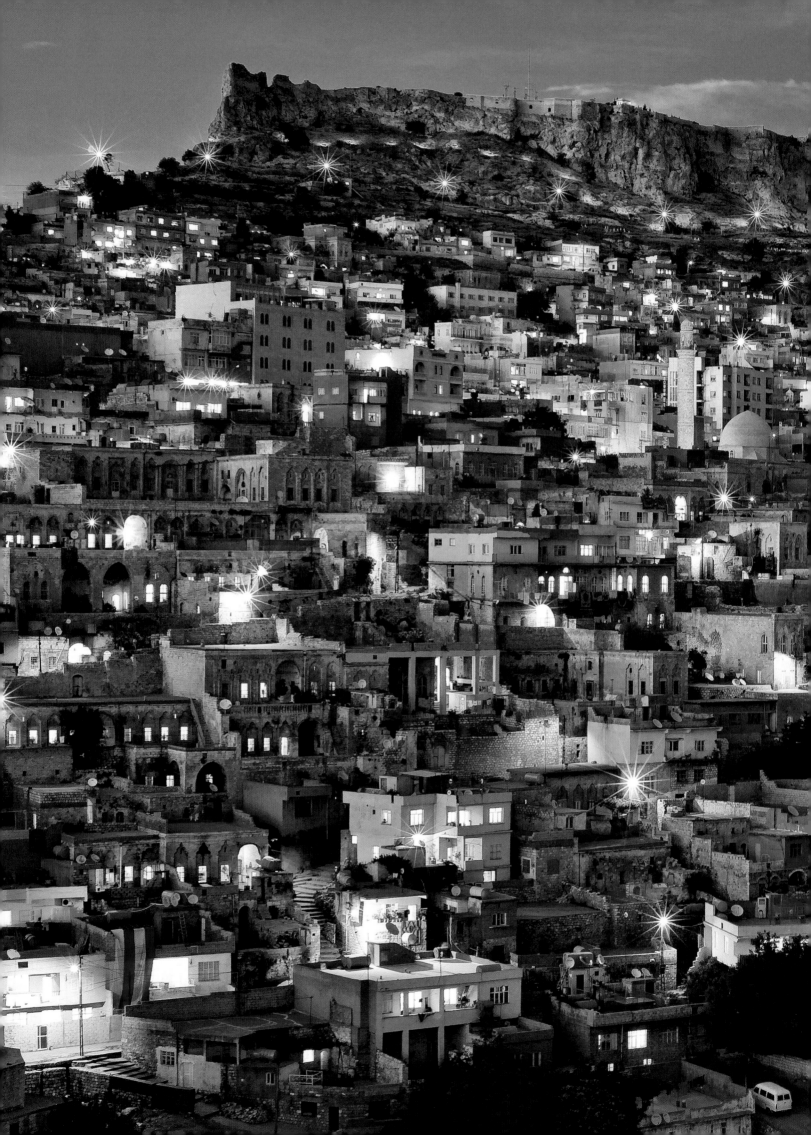

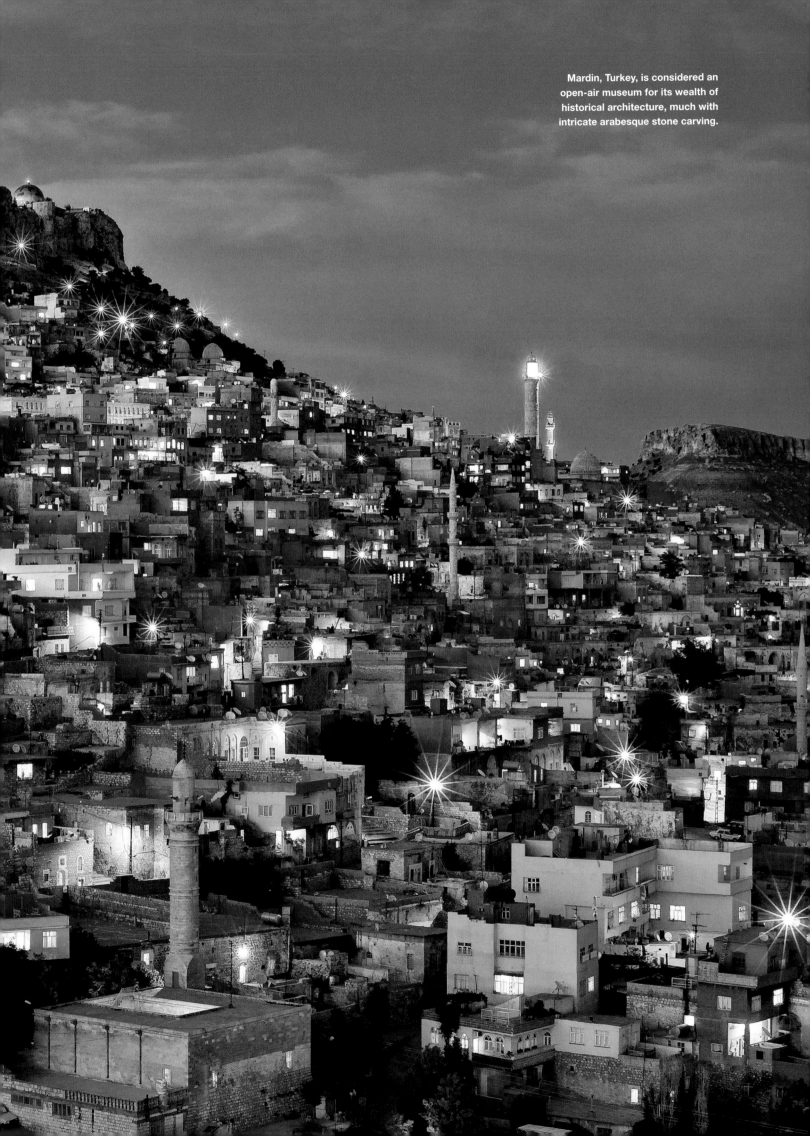

Mardin, Turkey, is considered an
open-air museum for its wealth of
historical architecture, much with
intricate arabesque stone carving.

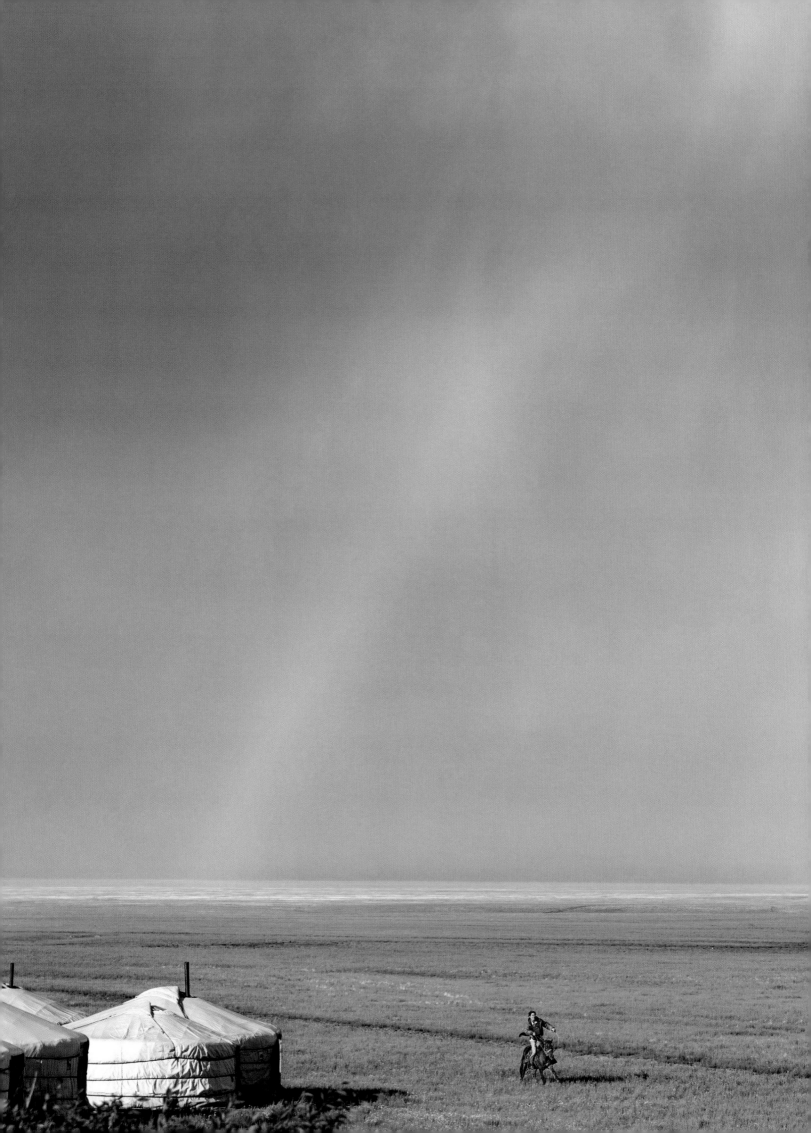

MY SHOT
Gobi, Mongolia

The weather had been changing constantly in Mongolia's southern Gobi, not far from the border with China. After a storm passed a rainbow appeared, then a second one. The *gers* (yurts) added scale and depth to my composition, but when I saw the rider on horseback I knew this was my chance to add motion to my photo. I waited until they were between the rainbows and started shooting as fast as I could to capture the moment, the light, the rainbows, and the stormy sky.

– Ira Block, *National Geographic* photographer

INDIA
OLD GOA
Forgotten sanctuaries close by the beach

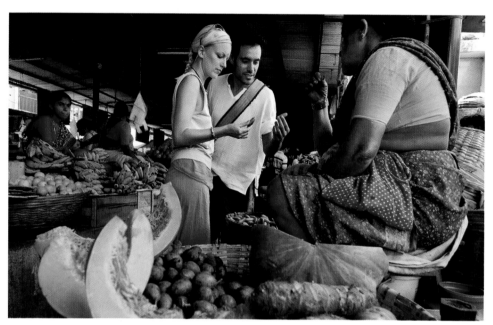

Local vendors have no doubt been selling fruit to tourists visiting Old Goa since the Church of Our Lady of the Immaculate Conception (opposite) was built here in 1540.

Most visitors come to Goa to lounge on its balmy beaches fringed with palm trees, unaware of the historic sanctuaries less than an hour away. A Portuguese territory for nearly five centuries (until 1961), Goa has retained much of its European traditions. Nowhere is this intriguing past more palpable than in Velha Goa, or Old Goa, a town of baroque domes and Renaissance belfries, sanctuaries that have earned their berth on the UNESCO World Heritage List.

More than 140 convents and churches exist within the city wall, many of them in ruins. Some of those still standing include the eclectic Se Cathedral, completed in 1619, which showcases Portugal's might in Asia Pacific. Within the structure, itself larger than any church in Portugal, gilded decor and soaring barrel vaults bring together various styles like Tuscan and Corinthian. Nearby, the handsomely domed Corinthian-style 17th-century church of St. Cajetan is said to have been modeled after the Vatican's Basilica of St. Peter—perhaps explaining Old Goa's former nickname, Rome of the Orient. You can wander through the white colonnades and tranquil courtyard of the Professed House, a former Jesuit seminary. This imposing but melancholic outdoor gallery is a reminder that even the mightiest empires fall.

▶ UNFORGETTABLE EXPERIENCES

Marrying India's colorful spices with old European techniques, Goa's food stands out even in a continent famous for its diverse cuisine. Goa gave the world vindaloo (from *carne de vinha d'alhos,* a Portuguese meat dish with wine and garlic) and makes generous uses of fresh fish and pork, an ingredient seldom seen elsewhere in the country. Head to Viva Panjim *(No. 178 Rua 31 de Janeiro, Panjim)* for mouthwatering Goan fare like *cafreal,* spicy chicken marinated in green chilies and ginger.

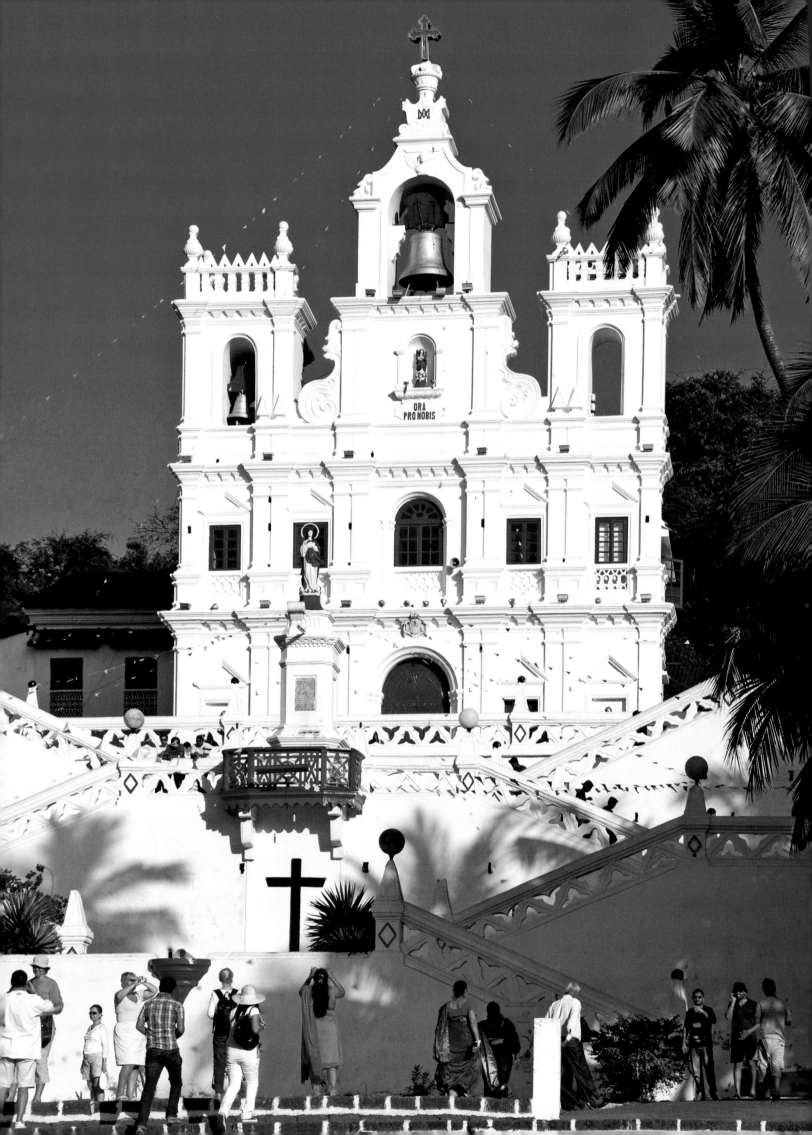

KANAZAWA
Old Japan meets 21st-century modernity

Kanazawa city (above), home of Kenroku-en Garden (opposite), its name meaning "having six factors" for a perfect garden: spaciousness, tranquillity, artifice, antiquity, water, and magnificent views

An immaculately preserved Edo-era time capsule, this mountainside temple town is surrounded by snowcapped Mount Hakusan, rolling hills, and lush rice paddies, a spectacularly beautiful area newly opened to visitors with the introduction of high-speed rail service in 2015. Touted as "little Kyoto," the handsome city of 464,000 hosts a well-kept samurai ward and some of the nation's few active geisha districts.

The surrounding Hokuriku region, famous within Japan for sashimi, sushi, and sake, might as well be Japan's microcosm, combining the bounty of the sea and the magnificent vistas of the Japanese Alps. In winter, abundant snowfalls bring cold-sport enthusiasts in droves; in spring, the hills blush with flowering cherry blossoms. Traditional *ryokans* abound near mineral-rich hot springs that dot this mountainous terrain.

Long beloved by the Japanese (and increasingly by foreign travelers in the know), the city of Kanazawa packs in superlative attractions. Kenroku-en Garden, considered the zenith of Japanese strolling-garden design, flourishes in pink, azalea red, gold, and white according to season. The 17th-century Myoru-Ji, better known as Ninja Temple, is full of intriguing trapdoors and hidden rooms. In Higashi-no-Kuruwa, or Eastern Pleasure Quarter, you might see a geisha in a kimono scurry down its historic alleys lined with wooden shop fronts and teahouses.

▶ UNFORGETTABLE EXPERIENCES

The *ryokan,* or old-fashioned Japanese inn, is an immersive introduction to Japanese culture, bringing together traditional lodging and sumptuous delicacies. Poach in a hot mineral bath, sleep on a futon-crowned tatami floor, and enjoy traditional breakfast of soup and grilled fish, often served in the room. Splurge for a night and enjoy an exquisite dinner at Asadaya *(asadaya.co.jp/ryokan),* near the fish market, or opt for humbler Kikonuya *(kikunoya.ninja-web.net),* a ten-minute walk from Kenroku-en Garden and other major sites.

More than any glorious monuments or historic buildings, however, the city's traditional artisans keep the city's proud heritage alive. Kutani pottery, noted for its bold designs and brilliant colors, and Kaga yuzen silk, meticulously painted with five vivid tones, are some of the region's most famous products. Kanazawa also accounts for practically all the gold leaf used in lacquerware and other traditional handicraft produced in Japan. These authentic craftsmen may be visited in their studios on the city's outskirts, with the help of an intrepid guide.

Despite all the trappings of an open-air museum, Kanazawa isn't an ossified relic of the past. The 21st Century Museum of Contemporary Art, designed by Pritzker Prize–winning architects Ryue Nishizawa and Kazuyo Sejima, is a futuristic white medallion that amazes visitors up close yet blends into the cityscape from afar, refusing to steal attention from the city's historic sights. Transparent galleries scattered about the stupendous space contain works by contemporary visionaries like Olafur Eliasson, Gerhard Richter, Matthew Barney, and Atsuko Tanaka.

The city's train station, opened in 1898 and redesigned in 2005 to incorporate a glass dome and a tsuzumi drum–shaped gate, perhaps best encapsulates Kanazawa's spirit. Forward thinking yet with an old foundation, this pulsing hub pays homage to traditions while ushering in the future.

> *"Kanazawa's castle is beautiful, yes, but you can't see what Kanazawa really is about by only looking at the outside. We have unparalleled standards of craftsmanship in everything we make. Look closer."*
>
> – Masaru Nishimura, *traditional lacquer artist*

▶ UNFORGETTABLE EXPERIENCES

Kanazawa's suburban district of Ono, by the sea, holds a concentration of small, family-owned soy sauce manufacturers that have been brewing small-batch artisan soy sauce for generations. Some soy sauce shops have become galleries or tearooms, but more than 40 producers remain active, such as Hyakunen-gura, literally "100-year brewery." Visit the showroom of Yamato *(4-1-170 Ono-machi; www.yamato-soysauce-miso.com)* to sample miso, shoyu, and even soy sauce made specifically for ice cream.

A huge wooden gate marks the entrance to Kanazawa's rail station, now welcoming high-speed train service to and from Tokyo.

HOLY GRAILS OF THE SPORTING WORLD

Maracanã Stadium, Rio de Janeiro, Brazil

Maracanã Stadium, Rio de Janeiro, Brazil

Around 200,000 spectators crowded into Rio's massive arena to witness the final of the 1950 World Cup, still a single-game soccer record. A refurbished Maracanã will stage the opening and closing ceremonies of the 2016 Rio Olympics.

Campo Argentino del Polo, Buenos Aires, Argentina

Located in the posh Palermo district of Buenos Aires, the "Cathedral of Polo" (opened 1918) hosts summer tournaments (Nov.–Dec.) attended by the Argentine elite. Equally fast and furious is the socializing in bars and hospitality tents around the grounds.

Col du Tourmalet, Pyrenees, France

With grades of 10 to 12 percent near the summit, one of cycling's most famous climbs soars through the central Pyrenees near Barèges. Introduced to the Tour de France in 1910, the 6,939-foot (2,115 m) Col has appeared in the race more than any other pass.

Lord's Cricket Ground, London, England

With a history stretching back to 1814, this London landmark is rightfully called the home of cricket. Developed by cricketer Thomas Lord, the stadium also holds one of the world's oldest sports museums—the MCC collection of cricket memorabilia.

St. Andrews Golf Course, St. Andrews, Scotland

Duffers have been whacking small balls around St. Andrews since the 15th century. Golf's governing body—now called the Royal & Ancient Golf Club—was founded there in 1754, shortly before the "Old Course" was reduced from 22 to 18 holes.

Holmenkollen Ski Jump, Oslo, Norway

Located on the outskirts of Oslo, Holmenkollen has showcased ski jumping since the 1890s, including the 1952 Winter Olympics. The slope has been reshaped 19 times, with the latest iteration (2010) a vertigo-inducing 439 feet (134 m) from top to bottom.

Churchill Downs,
Louisville, Kentucky

Churchill Downs, Louisville, Kentucky

Its iconic twin towers soaring above Louisville, Churchill Downs is shrine to both late 19th-century American architecture and the sport of Thoroughbred horse racing. The oval track and its legendary Kentucky Derby were both born on the same day: May 17, 1875.

Colosseum, Rome, Italy

Hoping to obliterate the memory of his controversial predecessor, a Flavian emperor had the world's first large amphitheater built on the site of Nero's Roman villa and private lake starting in A.D. 70. The arena hosted gladiatorial duels for nearly 400 years.

Ryōgoku Kokugikan, Tokyo, Japan

The dream of every sumo wrestler is winning a tournament *(honbasho)* at this paramount Japanese sumo hall. Perched on the banks of the Sumida River in north-central Tokyo, the 13,000-seat arena also features a sumo museum.

Indianapolis Motor Speedway, Indianapolis, Indiana

Since opening in 1909, the "Brickyard" has been home to the Indy 500 as well as Formula One, NASCAR, and motorcycle races. The 2.5-mile (4 km) oval, originally paved with bricks, can seat 268,000 people—more than any other global sports venue.

Marco Andretti at the
Indianapolis Motor Speedway

HANGZHOU

Verdant tea plantations and a sacred lake reveal China's spiritual heart

Pluckers pick the famous Longjing tea leaves (above). In town, the graceful curves of a lakeside board-walk are met by a parkside pagoda (opposite).

TRAVELER'S NOTEBOOK

***WHEN TO GO**
Spring to summer is harvest season and a good time to visit, but be forewarned: June and Sept. mark the rainiest months. April and May host the informative Sage of Tea festival, while autumn months can produce a mixed bag weatherwise with throngs of tourists. Winter is a great time to avoid crowds, but cold weather and occasional snows can hamper experiencing those shades of green.

***PLANNING**
To get here from Shanghai, take the 60-minute bullet train. There are ten tourism offices in Hangzhou, including info pagodas and kiosks at the temples and the lake.

***WEBSITES**
en.gotohz.com

There might be 50 shades of green among the lush terraced tea plantations of Hangzhou's Longjing (Dragon Well) plantation. Or there might be 50 million. Stepping into this misty, emerald canyon is like taking a dry bath of green tea, appropriate for a city long prized for its production of Longjing, an exceptionally high-quality and delicate style of roasted green tea. Hangzhou is also celebrated for its quality of life, claimed by many to be the highest in China, with purportedly some of the country's cleanest water, greenest parks, and best preserved cultural sites.

The city of Hangzhou, capital of Zhejiang Province, is one of the seven ancient capitals of China, alongside Xi'an, Nanjing, Luoyang, Beijing, Kaifeng, and Anyang. Marco Polo is said to have declared it "the City of Heaven, the most beautiful and magnificent in the world." About an hour's ride on the bullet train from the smoggy urban jungle of Shanghai, it still delivers on the promise of giving travelers a bucolic slice of the classical China seen in traditional paintings, with an undulating jade-colored terrain and tranquil lake at its heart. Recent developments have ushered the city into the modern age, but the government has made explicit efforts to protect and retain Hangzhou's natural beauty, an unusual but increasingly popular step in China.

▶ UNFORGETTABLE EXPERIENCES

Situated on 35 acres (14 ha) on the lush outskirts of Hangzhou, the serene Amanfayun resort is close to a pilgrimage circuit of seven historic Buddhist temples. Traditional stone and wood dwellings are connected by stone paths shrouded by bamboo, tea bushes, and magnolia trees and include a bath house, reflexology room, tai chi studio, gym, and swimming pool, with spa treatments incorporating traditional Chinese medicine. *amanresorts.com*

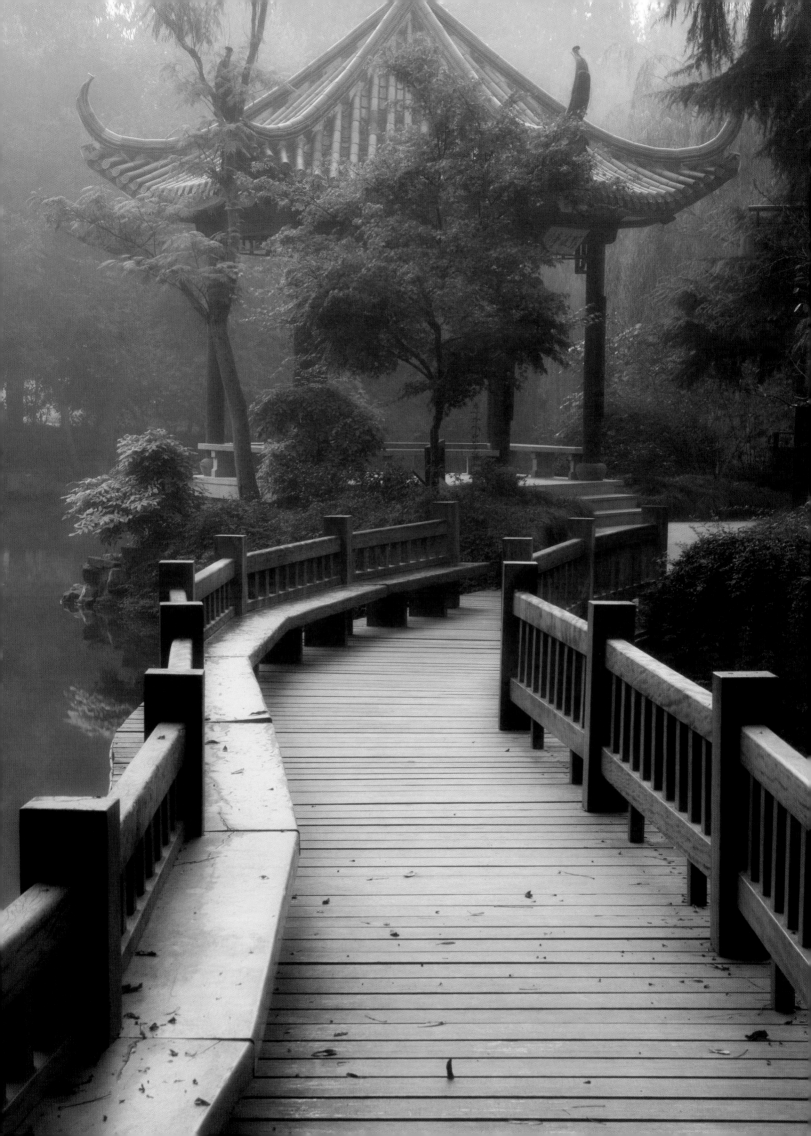

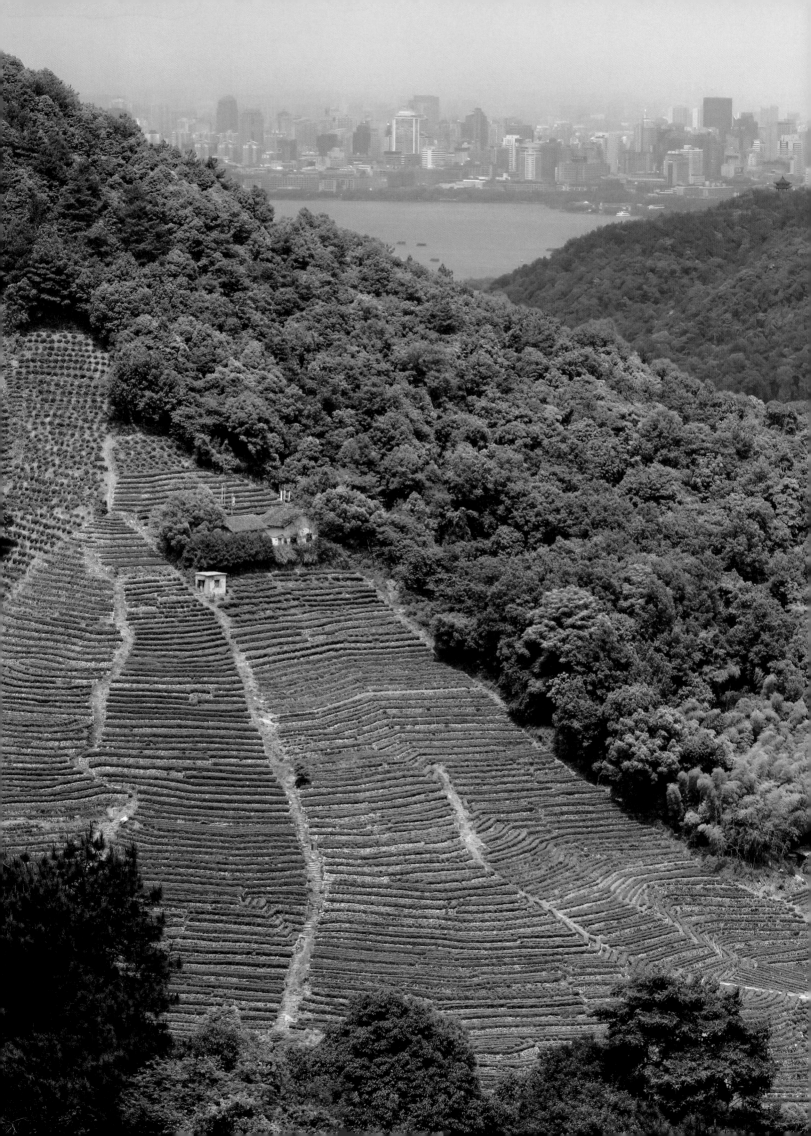

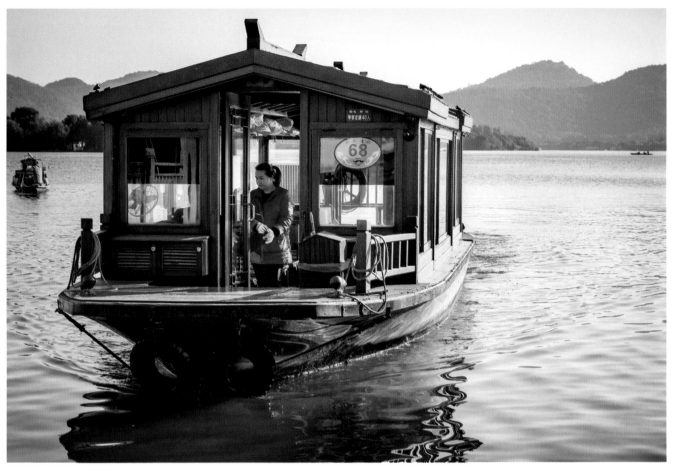

The serene blue waters of West Lake (above) are matched in intensity by the verdant hills of the Longjing tea plantation in Hangzhou (opposite).

West Lake, settled along with Hangzhou 2,200 years ago during the Qin dynasty, is the city's biggest draw. It is inscribed on UNESCO's list of World Heritage sites for the way its landscape embodies the principles of harmony between humankind and nature, a design that spread through China to Japan and Korea over the centuries. Here a jigsaw landscape of mist-covered waters is connected by stone causeways, and droopy willow trees shade photo-snapping tourists along the numerous promenades circling the lake. Visit by boat in the evening to experience West Lake's waterside pagodas, illuminated each night as if in an ancient dream.

Hallowed cave temples and rare and ancient carved rock Buddhas are also must-sees. Of the seven temples and monasteries in Hangzhou, the most renowned is the active temple Lingyin Si (Soul's Retreat), founded at the beginning of the Eastern Jin dynasty, A.D. 326. At its peak under the Kingdom of Wuyue (A.D. 907–978), Lingyin Si temple featured nine multistory buildings, 18 pavilions, 72 halls, and more than 1,300 dormitory rooms to house 3,000 monks. Although its grand scale has been reduced, the hidden ponds, rock gardens, and Buddha-cloaking caves make it one of the most beautiful and important Buddhist temples in China today.

> *"For people who love trekking or photography, try this mountain trail for the most beautiful shots of Hangzhou: Starting from Faxi Temple, the small stone-paved path of Shiren Peak leads to deep bamboo forests and bird's-eye views—without crowds."*
>
> – Pang Ying, *tea master*

▶ **VISIT LIKE A LOCAL**

The Meijiawu Tea Plantation, 30 minutes outside the city on the western bank of West Lake, is a traditional tea village made up of more than 160 picturesque teahouses. This is the perfect place to sip a cup of premium Longjing at its freshest while enjoying local specialties like tea-soaked shrimp or crispy skin chicken with tea soup. More important, it's considered one of the city's best spots to see tea being picked and hand-roasted at 200 degrees. Sadly, no website.

YAP ISLAND
Old Pacific customs meet an ocean filled with angels

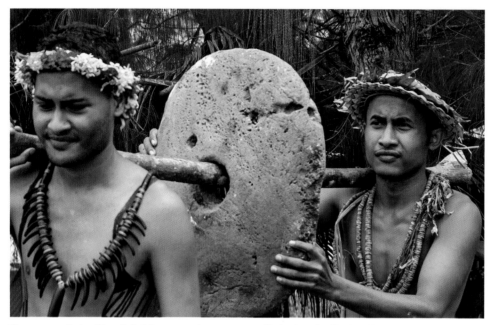

Yapese men in traditional clothing carry stone money, called *rai,* at the Yap Day Festival (above). New mangrove shoots (opposite) are part of the life cycle on this slow-paced tropical island.

Off in a corner of the ocean, protected by reefs and giant manta rays, Yap has remained itself, an island where tourism is only a trickle and no megaresorts crowd the beaches. An island with beliefs of powerful witches, an island where kids get off the school bus chewing betel nut (the fruit of the *Areca catechu* palm tree), topless women shop in the grocery store, and in the handcrafted Men's Houses—each village has one—roll-down reed shutters are barrier enough to keep business secret.

Yap is perhaps best known for its stone money, *rai,* wheels as large as 12 feet (3.7 m) in diameter, carved in Palau using only seashells, stone, and coral as tools and then brought the 300 miles (483 km) back to Yap. No one is exactly sure how this practice caught on; the tradition lost hold when motors made getting to and from Palau too easy, essentially causing rampant inflation. But even today most real estate purchases use stone money. A rai's value is not just about its size, but rather the quality of the carving and the story behind the stone's history. There's always time for a story on Yap, where giant fruit bats—good for soup—hang 50 feet (15 m) up in the mangrove swamps, and the island is so quiet that you can hear the break of waves 2 miles (3.2 km) off on the reef.

▶ UNFORGETTABLE EXPERIENCES

Outside the reef that surrounds Yap, giant mantas like to come to clean and feed themselves. This means animals that look like soft, swimming bats, with wings 20 feet (6 m) across, doing slow barrel rolls. The rays do sometimes come into the shallows, close enough for snorkelers, but the real show is 60 feet (18 m) down—a bucket list item for scuba divers. During winter mating season, the rolls turn into elaborate dances, beautifully slow and gentle.

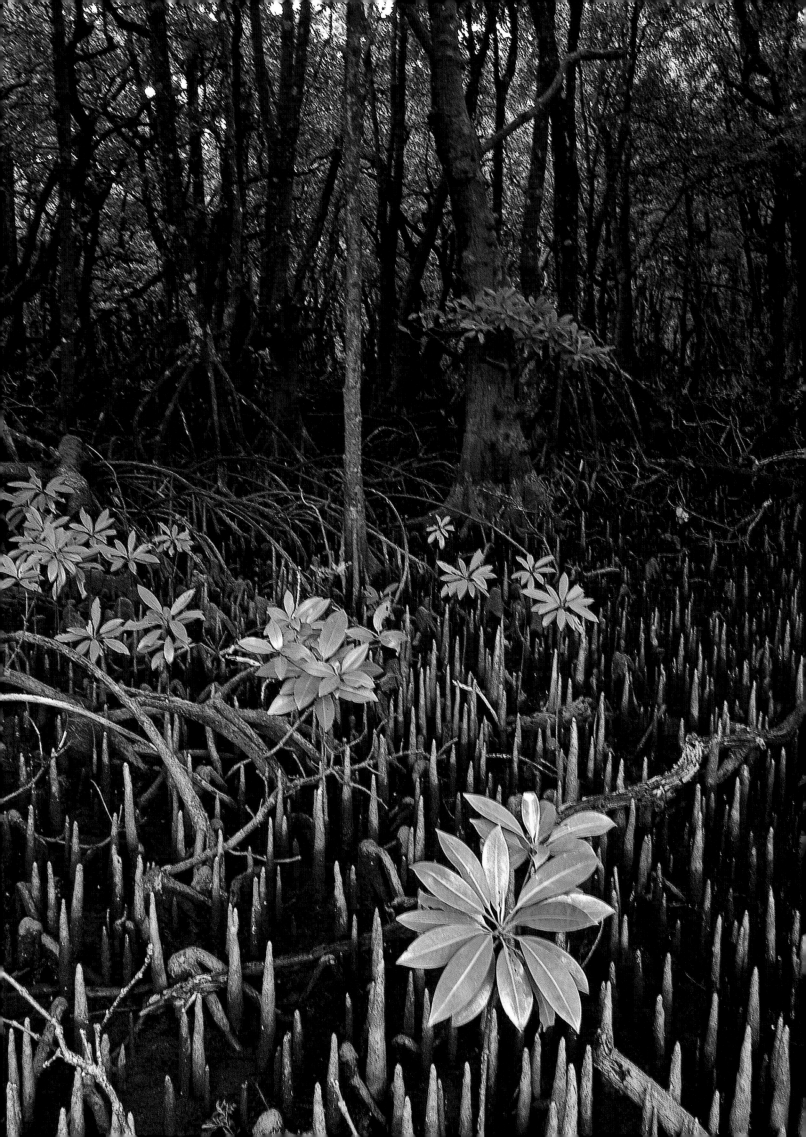

INDEX

ILLUSTRATIONS CREDITS

NGC = National Geographic Creative

Cover, Peter Boehi; 2-3, George Steinmetz/NGC; 4, Pola Damonte via Getty; 7, travelstock44/Alamy; 10, Xavier Arnau/Getty; 12, Babek Tafreshi/NGC; 13, John Burcham/NGC; 14, Ben Herndon/TandemStock .com; 15, Mark Newman/Getty; 16-17, Dan Dady; 18-19, Pete McBride; 20, Frans Lanting/NGC; 21, Frans Lemmens/Getty; 22, Andre Baertschi; 23, Peter Mark Mercieca; 24, Takashi Nakagawa; 25, T photography/ Shutterstock.com; 26-7, George Steinmetz/Corbis; 28 (UP), Brzozowska/ iStockphoto; 28 (LO), akinshin/iStockphoto; 29 (UP), JOSE MIGUEL GOMEZ/Reuters/Corbis; 29 (LO), Skarphedinn Thrainsson/Caters News Agency; 30, RooM the Agency/Alamy; 31, Guy Edwardes/Robert Harding World Imagery; 32, Faba-Photography/Getty; 33, Yanfeng Chen/NG Your Shot; 34, June Jacobsen; 35, Paul Nicklen/NGC; 36-7, Wild Wonders of Europe/Liodden/Nature Picture Library/Corbis; 38 (UP), Frans Lanting/NGC; 38 (LO), Lisa Thornberg/iStockphoto; 39 (UP), Susan Metz; 39 (LO), Joel Sartore/NGC; 40-41, Stephen Alvarez; 42, Krista Rossow/NGC; 43, Karin De Winter/Alamy; 44-5, Zute Lightfoot; 46, Jan-Uwe Reichert/500px Prime; 47, Annie Griffiths/NGC; 48-9, Michael Nichols, NGS; 50, Marko König/imageBROKER/Corbis; 51, Eric Cheng; 52, Mitsuhiko Imamori/Minden Pictures; 53, Stephen Alvarez/NGC; 54, John Doogan; 55, Clemens Emmler/laif/Redux; 56, Randy Olson/NGC; 58, Doug Dolde/TandemStock.com; 59, Thomas Peter/Alamy; 60, Daniel Thibodeaux; 61, Walter Bibikow/JAI/Corbis; 62, Matt Bradley; 63, Bill Parsons/Mira.com; 64, Karsten Moran/The Riverdale Press; 65, Art Directors & TRIP/Alamy; 66 (UP), LOOK Die Bildagentur der Fotografen GmbH/Alamy; 66 (LO), greatpapa/ iStockphoto; 67 (UP), Linda Ching/Getty; 67 (LO), By2Photographers; 68, Kennan Harvey/Aurora Photos; 69, Dave Allen/500px Prime; 70, John Coletti/JAI/Corbis; 71, Images-USA/Alamy; 72, espixx/Alamy; 73, Blaine Harrington III/Alamy; 74, Blaine Harrington III/Alamy; 75, Steve Bly/Alamy; 76, Kent Kobersteen/NGC; 77, Gabby Salazar/NGC; 78-9, Jim Richardson/NGC; 80, Randy Olson/NGC; 81, Manfred Gottschalk/ Getty; 82-3, Jim Richardson; 84, Ludovic Maisant/Hemis/Corbis; 85, Fabrizio Bensch/Reuters; 86, Laurie Chamberlain/Corbis; 87, Paul Williams—Funkystock/imageBROKER/Corbis; 88, Mark Mawson/ Robert Harding/Corbis; 89, Binod Khadka/NG Your Shot; 90, SIME/ eStock Photo; 91, Huber/SIME/eStock Photo; 92-3, Loop Images Ltd/ Alamy; 94 (UP), Gavin Hellier/Robert Harding/Corbis; 94 (LO), holwichaikawee/Shutterstock; 95 (UP), Guy Vanderelst/Getty; 95 (LO), Samart Mektippachai/Shutterstock; 96, Buonarroti, Michelangelo (1475-1564)/Vatican Museums and Galleries, Vatican City/Bridgeman Images; 97, Bella Falk/Alamy; 98-9, neeraj chaturvedi/500px Prime; 100, Ecaterina Leonte/500px Prime; 101, Gerard Lacz - VWpics; 102, Matthew Williams-Ellis/Robert Harding World Imagery; 103, Keren Su/ China Span; 104-105, Matthew Williams-Ellis/Robert Harding World Imagery; 106, Sérgio Nogueira; 107, Heimo Aga; 108, Richard Cummins/robertharding/Getty Images; 109, Artur Bogacki/500px Prime; 110, DEA/G.SIOEN/Getty; 111, Andras Jancsik/Getty; 112-13, Izzet Keribar/Getty; 114-15, Bob Krist; 116, Axiom Photographic/*/Design Pics/Corbis; 117, Fabian von Poser/imageBROKER/Corbis; 118-19, Anadolu Agency/Getty; 120, Gavin Hellier/Robert Harding/Corbis; 121, Pascal Deloche/Godong/Corbis; 122 (UP), age fotostock/Getty; 122 (LO), Vincent J. Musi/NGC; 123 (UP), Sisse Brimberg and Cotton Coulson/ NGC; 123 (LO), David Bargalló/500px Prime; 124, Jose Fuste Raga/ Robert Harding World Imagery; 125, Nadine Rupp/Getty; 126, Jane Sweeney/JAI/Corbis; 127, Frank Fell/Robert Harding World Imagery; 128 & 129, O. Louis Mazzatenta/NGC; 130-31, Ami Vitale; 132, Calvste/Dreamstime.com; 133, Steve Davey/stevedavey.com 2006; 134, Marcelo Castro; 135, Dima Chatrov/NG Your Shot; 136, Helen Woodford/WideScenes Photography; 138, Design Pics Inc/Alamy; 139, Joel Sartore/NGC; 140, Jeff Foott/Getty; 141, Richard Wong/Alamy; 142-3, Stephen Matera/TandemStock.com; 144 (UP), Henry Georgi/All Canada Photos/Corbis; 144 (LO), Dimedrol68/Shutterstock; 145 (UP), Ralf Hettler/Getty; 145 (LO), Shaun Egan/JAI/Corbis; 146, Carsten Ruthemann/500px Prime; 147, Terry Donnelly; 148, Brian Black/500px Prime; 149, age fotostock/Alamy; 150-51, Susan Seubert; 152, Marc Muench/Alamy; 153, Masa Ushioda/CoolWaterPhoto.com; 154, PYMCA/Getty; 155, Mike Theiss/NGC; 156-7, Marcos Ferro/Getty; 158, Joel Sartore/NGC; 159, Frans Lanting/NGC; 160, Frans Lanting; 161, Annie Griffiths/NGC; 162, Londie G. Padelsky; 163, Nico Stengert/ Novarc/Corbis; 164-5, Jay Dickman; 166, Frans Lanting/NGC; 167, Paul Nicklen/NGC; 168, Frans Lanting/NGC; 169, Matthieu Paley/NGC; 170, Huber/SIME/eStock Photo; 171, WILD WONDERS OF EUROPE/ HAMBLIN/naturepl.com/NGC; 172-3, Sisse Brimberg and Cotton Coulson; 174, Claus Diseth/500px Prime; 175, Franck Guiziou/Hemis/ Corbis; 176, Peter Adams/JAI/Corbis; 177, Alexander Nesbitt; 178, Frits Meyst/Adventure4ever.com; 179, byheaven/iStockphoto; 180-181, enjomathew/Getty; 182 (UP), Robert Harding World Imagery/Alamy; 182 (LO), jclegg/iStockphoto; 183 (UP), AF archive/Alamy; 183 (LO), AJSGreece/Alamy; 184, Robert Clark; 185, Paul Spierenburg/laif/Redux; 186, SOPA/eStock Photo; 187, Fritz Hoffmann; 188, Sergi Reboredo/ VWPics; 189, Chad Ehlers/Alamy; 190-91, Manfred Gottschalk/Alamy; 192, Rainer Jahns; 194, Per Breiehagen/Getty; 195, Frans Lanting; 196, Frans Lanting/NGC; 197, Cultura/Image Source; 198-9, Michael Melford; 200, Kyle Hammons/TandemStock.com; 201, Chad Case/Idaho Stock Images; 202-203, Susan Taylor Fine Art Photography/www. susantaylorphoto.com; 204, Mike Theiss/NGC; 205, Tyler Stableford/ Aurora Photos; 206, Heiko Meyer/laif/Redux; 207, Last Refuge/Robert Harding World Imagery; 208, Jami Tarris; 209, Yves Garneau/Outdoor-Archiv/Aurora Photos; 210, Kike Calvo; 211, Jan Drahokoupil/500px Prime; 212, Joel Santos/Aurora Photos/Corbis; 213, Luis Filipe Catarino/4SEE/Redux; 214 (UP), Florin Stana/Shutterstock; 214 (LO), Jan Martin Will/Shutterstock; 215 (UP), imagehub88/iStockphoto; 215 (LO), Greir/Shutterstock; 216, Rainer Jahns; 217, Anita Back/laif/Redux; 218-19, Prisma Bildagentur AG/Alamy; 220, Lesya Polyakova/Demotix/ Corbis; 221, Tom Schandy/Wild Wonders of Europe; 222, ZUMA Press, Inc/Alamy; 223, Clive Rose/Getty; 224, Michael Wheatley/All Canada Photos/Corbis; 225 (UP), Hacienda San Antonio; 225 (LO), Gstaad Palace; 226-7, Massimo Bassano; 228, Ariadne Van Zandbergen/Alamy; 229, David Pluth/NGC; 230, Michael Melford/Getty; 231, Boyd Norton; 232, Terry Donnelly; 233, Alison Wright/Corbis; 234-5, Amy Toensing; 236, Frans Lanting/NGC; 237, Mike Theiss/NGC; 238, Frans Lanting/ NGC; 239, Robert Wallace/Corbis; 240-41, Amy Toensing/NGC; 242, Jose Fuste Raga/Corbis; 244, Diane Cook and Len Jenshel/NGC; 245, Brown W. Cannon III/Intersection Photos; 246, Taylor Kennedy/NGC; 247, Jon Hicks/Corbis; 248-9, Dan Barnes/Getty; 250 (UP), Monastero Santa Rosa; 250 (LO), MaxFX/Shutterstock; 251 (UP), Agros Cappadocia; 251 (LO), Manuel Zublena; 252, TONY CENICOLA/The New York Times/Redux; 253, Tony Shi Photography/Getty; 254, Ron Chapple/500px Prime; 255, Dawna Moore/Alamy; 256, Michael Melford/ Getty; 257, AP Photo/David Goldman; 258-9, Pete McBride; 260, Hemis/ Alamy; 261, Widmann/CHL/Alamy; 262-3, ImageBROKER/Alamy; 264, Shaun Egan/Getty; 265, LEMAIRE Stephane/Hemis/Corbis; 266-7, Sisse Brimberg and Cotton Coulson; 268, PHOTOCREO Michal Bednarek/ Shutterstock; 269, Laurent Yokel/500px Prime; 270, Justin Cox/ jcoxphotography.com; 271, Rainer Jahns; 272, Reinhard Schmid/SIME; 273, Daniel Karmann/dpa/Corbis; 274, AndrashJ/iStockphoto; 275, Cody Duncan; 276, Henryk T. Kaiser/Robert Harding World Imagery; 277, Pavel Daněk/NG Your Shot; 278 (UP), Felix Lipov/Shutterstock.com; 278 (LO), Serg64/Shutterstock; 279 (UP), Luciano Mortula/Shutterstock.com; 279 (LO), Styve Reineck/Shutterstock.com; 280, Tuul & Bruno Morandi/ Corbis; 281, Hemis/Alamy; 282, Robert Harding Picture Library Ltd/ Alamy; 283, Massimo Bassano; 284, Walter Bibikow/JAI/Corbis; 285, Agron Beqiri/500px Prime; 286-7, Orion Hasanaj/500px Prime; 288, Oliver Tjaden/laif/Redux; 289, ANDREW TESTA/The New York Times/ Redux; 290 & 291, Lola Akinmade Akerstrom/NGC; 292, Images & Stories/Alamy; 293, Westend61 GmbH/Alamy; 294-5, Marc Dozier/Hemis/ Corbis; 296-7, Ira Block; 298, ROB ELLIOTT/Getty; 299, Dennis Cox/ Alamy; 300, Christian Kober/Alamy; 301, JTB MEDIA CREATION, Inc./ Alamy; 302-303, Judy Bellah/Alamy; 304 (UP), SIME/eStock Photo; 304 (LO), Dan Thornberg/Shutterstock; 305 (UP), Jim Owens/Icon SMI/ Corbis; 305 (LO), STEVEN C. MITCHELL/epa/Corbis; 306, Dorothea Schmid/laif/Redux; 307, Jochen Schlenker/Robert Harding/Corbis; 308, Hemis/Alamy; 309, Eugene Sergeev/Alamy; 310, Keren Su/China Span; 311, Gunther Deichmann.

DESTINATIONS OF A LIFETIME

225 OF THE WORLD'S MOST AMAZING PLACES

PREPARED BY THE BOOK DIVISION

Hector Sierra, *Senior Vice President and General Manager*

Lisa Thomas, *Senior Vice President and Editorial Director*

Jonathan Halling, *Creative Director*

Marianne R. Koszorus, *Design Director*

Barbara A. Noe, *Senior Editor*

R. Gary Colbert, *Production Director*

Jennifer A. Thornton, *Director of Managing Editorial*

Susan S. Blair, *Director of Photography*

Meredith C. Wilcox, *Director, Administration and
 Rights Clearance*

STAFF FOR THIS BOOK

Lawrence M. Porges, *Editor*

Mary Luders Norris, *Project Editor*

Elisa Gibson, *Art Director*

Laura Lakeway, *Photo Editor*

Linda Makarov, *Designer*

Christine Blau, Marlena Serviss, *Researchers*

Carl Mehler, *Director of Maps*

Michael McNey, *Map Research and Production*

Mark Baker, Larry Bleiberg, Karen Carmichael, Olivia
 Garnett, Conner Gorry, Adam Graham, Graeme Green,
 Jessica Gross, Chaney Kwak, Michael Luongo, Barbara A.
 Noe, Christine O'Toole, Ed Readicker-Henderson, Emma
 Rowley, Jenna Schnuer, Kelsey Snell, April White, Joe
 Yogerst, *Contributing Writers*

Marshall Kiker, *Associate Managing Editor*

Judith Klein, *Senior Production Editor*

Constance Roellig, Rock Wheeler, *Rights Clearance Specialists*

Katie Olsen, *Production Design Assistant*

Nicole Miller, *Design Production Assistant*

Bobby Barr, *Manager, Production Services*

Patrick J. Bagley, Carol Clurman, Moira Haney,
 Marlena Serviss, *Contributors*

Jasmine Lee, *Imaging*

Since 1888, the National Geographic Society has funded more than 12,000 research, exploration, and preservation projects around the world. National Geographic Partners distributes a portion of the funds it receives from your purchase to National Geographic Society to support programs including the conservation of animals and their habitats.

For more information, please call 1-800-647-5463 or write to the following address:

National Geographic Partners, LLC
1145 17th Street NW
Washington, DC 20036-4688 USA

Become a member of National Geographic and activate your benefits today at natgeo.com/jointoday.

For information about special discounts for bulk purchases, please contact National Geographic Books Special Sales: ngspecsales@ngs.org

For rights or permissions inquiries, please contact National Geographic Books Subsidiary Rights: ngbookrights@ngs.org

ISBN 978-1-4262-1564-3

Printed in the United States of America

16/WOR-LSCML/5